THE CULT *of* BEAUTY

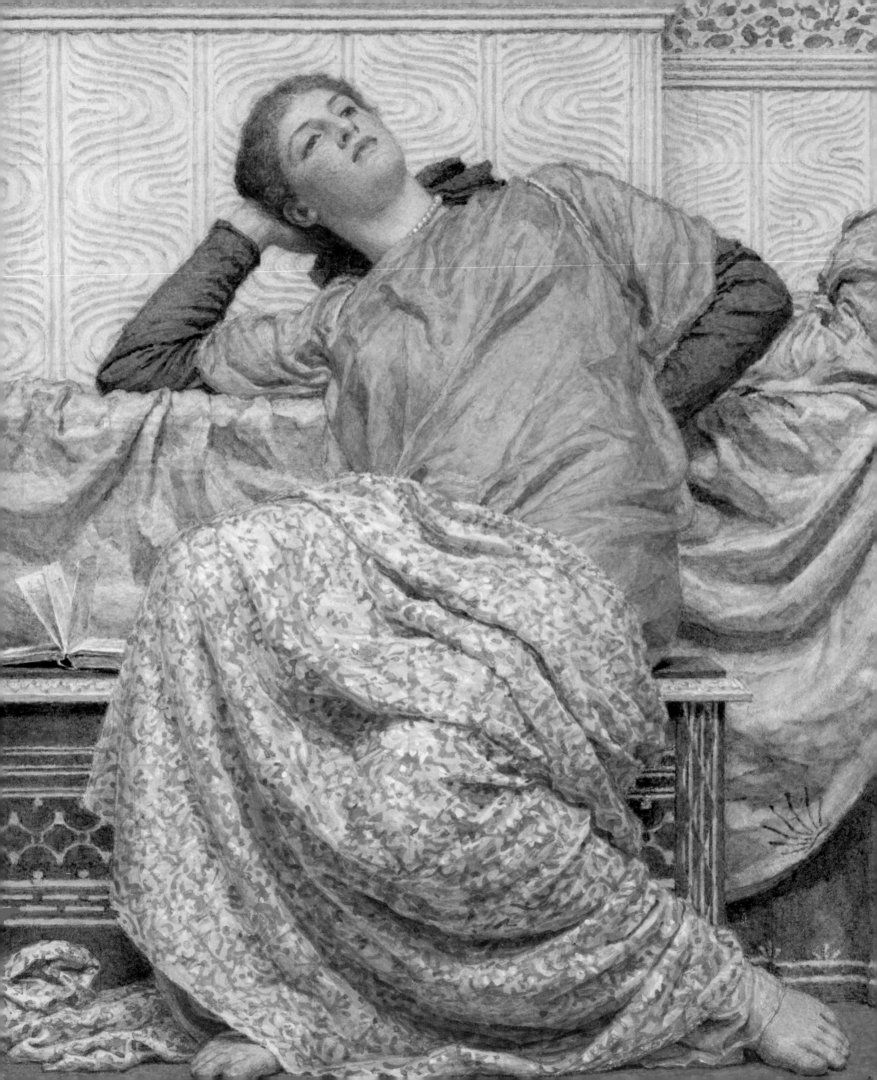

THE CULT *of* BEAUTY

The Victorian Avant-Garde 1860–1900

Edited by Lynn Federle Orr
and Stephen Calloway
assisted by Esmé Whittaker

V&A Publishing
Fine Arts Museums of San Francisco

First published to accompany the exhibition *The Cult of Beauty:
The Aesthetic Movement in Britain 1860–1900*
Organized by the Victoria and Albert Museum, London
and the Fine Arts Museums of San Francisco in collaboration
with the Musée d'Orsay, Paris.

V&A: 2 April – 17 July 2011
Musée d'Orsay: 12 September 2011 – 15 January 2012
Legion of Honor, San Francisco: 18 February – 17 June 2012

First published by V&A Publishing, 2011
V&A Publishing
Victoria and Albert Museum
South Kensington
London SW7 2RL

Distributed in North America by Harry N. Abrams Inc., New York
© The Board of Trustees of the Victoria and Albert Museum, 2011

The moral right of the author(s) has been asserted.

Hardback edition
ISBN 978 1 85177 694 8

Paperback edition
ISBN 9781 85177 695 5

Library of Congress Control Number 2011935133

10 9 8 7 6 5 4 3 2 1
2015 2014 2013 2012 2011

Front jacket/cover illustration: Frederic Leighton, *Pavonia*, 1858 (plate 2, detail)
Back jacket/cover illustration: William de Morgan, earthenware dish, late 19th century
(V&A: C.261–1915)
Endpapers/inside cover: Lewis F. Day, design taken from his book *Everyday Art:
Short Essays on the Arts Not Fine* (London 1882)
Half-title: Thomas Jeckyll/Barnard, Bishop & Barnard, sunflower andirons, *c.*1876
(plate 136, detail)
Frontispiece: Albert Moore, *An Open Book, c.*1884 (plate 6, detail)
Opposite: James Jacques Joseph Tissot, *Spring (Specimen of a Portrait)*, 1878
(Collection of Diane B. Wilsey)
Overleaf: Edward William Godwin, design for *Bamboo* wallpaper, 1872 (plate 112)

Designer: Price Watkins Design
Copy-editor: Johanna Stephenson

Printed in Singapore by C S Graphics

V&A Publishing
Supporting the world's leading
museum of art and design,
the Victoria and Albert
Museum, London

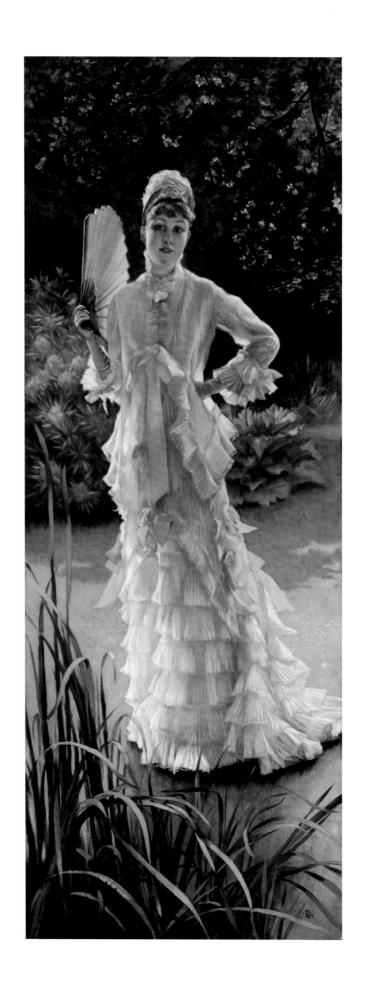

CONTENTS

*The San Francisco exhibition is
presented with the special patronage of*

*Diane B. Wilsey
Grand Patron*

and

*Their Royal Highnesses Prince and Princess Michael of Kent
Honorary Patrons*

DIRECTOR'S FOREWORD

The Fine Arts Museums of San Francisco and the Victoria and Albert Museum, London, are proud to present *The Cult of Beauty: The Victorian Avant-Garde 1860–1900*. This is the first international celebration of the exquisite and often idiosyncratic work of a truly vanguard group of British painters and designers, the creators of the Aesthetic Movement. An eye-opening exhibition, it recasts contemporary opinions about these Victorian artists and reveals them to be artistic, and often social, revolutionaries.

The idea of a project devoted to the Aesthetic Movement originated in San Francisco, was warmly embraced by the V&A, and was developed as a collaboration between our two institutions. In London it joined a sequence of major exhibitions devoted to key movements and styles showcased at the V&A; in San Francisco it will be staged at the Legion of Honor in Lincoln Park as the fifth exhibition to be shared by the Fine Arts Museums and the V&A.

The extraordinary reign of Queen Victoria spanned more than six decades, from 1837 to 1901. Not since the sixteenth-century reign of Elizabeth I had an English monarch presided over such an extended period of dynamic social change and expansion of British political and commercial power into the wider world. The Victorian age laid the foundations of our own contemporary society through its technological achievements, political constructs, social engineering, and cultural developments. Led by men and women of business, invention, insight, and common sense, British Victorian society also fashioned a world with material comforts such as gas lighting, heating, plumbing, and readymade items of every kind—a world that we today can recognize as modern.

The term *Victorian* also conjures up images of demure women in beribboned dresses and elegant men in top hats, all constrained by a strict moral code and a rigid sense of class. While true in part, this paradoxical age fostered liberating social movements still valued today, such as universal franchise, women's legal and property rights, unionism, proportional democracy, and socialism. Reform movements took shape in all sectors of society and enterprise, including the democratization of the cultural milieu. Among the age's great achievements was the liberalization of the visual arts embodied in British Aestheticism. Challenging the Royal Academy of Art's power and disregarding the public's taste for conventional style and traditional content, a small group of artists and writers celebrated 'art for art's sake,' identifying Beauty as the subject of greatest significance. These Aesthetes, as they became known, in fact deified Beauty. Through their efforts the Victorian age, narrowly known throughout the last century for its ascribed prudishness, unexpectedly produced artworks of haunting sensuality. These progressive artists formed a Victorian avant-garde whose aesthetic commitment to the 'Cult of Beauty' redirected the trajectory of British arts and design.

The late nineteenth-century phenomenon of International Exhibitions brought the Aesthetic Movement to wider attention in America and elsewhere. By 1882, the year often considered the high-water mark of popular awareness in Britain, Oscar Wilde crisscrossed North America proclaiming the Aesthetic gospel. His yearlong, ten-thousand-mile lecture tour brought him to San Francisco, where on 4 April he took the stage at Platt's Hall and told his audience of the enthusiasm of the poets and painters of artistic Chelsea for peacocks and pale lilies. Some 130 years after Wilde's sensational engagement, we are thrilled to reintroduce the Aesthetes and their achievements to museumgoers in the Bay Area.

We extend our deep appreciation to the many private collectors, museums, galleries, and dealers who have lent to this exhibition. Although not all of their treasures have been reproduced in this catalogue, it is only thanks to the individual generosity of the lenders that this sumptuous exhibition has thrilled museum visitors in Europe and America. Collectively, these outstanding artworks have allowed us to present for the first time a full and rounded representation of the British Aesthetic Movement. We are delighted that the exhibition appeared at the Musée d'Orsay, Paris, a highly appropriate venue given the Orsay's renewed emphasis on later nineteenth-century decorative arts and design. We are also grateful to Diane B. Wilsey, Penny and James George Coulter, Athena and Timothy Blackburn, Rosemary Baker, Charles and Ann Johnson, and the Ross Auxiliary of the Fine Arts Museums for their support of the San Francisco presentation.

John E. Buchanan, Jr.
Director of Museums
Fine Arts Museums of San Francisco

THE SEARCH FOR A NEW BEAUTY

Stephen Calloway

ONE CLEAR AND revolutionary aim emerged from the confusion of styles and cacophony of conflicting theories that beset the worlds of art and poetry, architecture and design in the middle decades of the nineteenth century in Britain: the desire to escape the ugliness and increasingly vulgar materialism of the age and create a new ideal of beauty. The Aesthetic Movement, as it came to be known, sought nothing less than the elevation of this new beauty as the guiding principle of life and the touchstone of all the arts. Antithetical alike to the precepts of the old art establishment embodied in the Royal Academy and to social convention, the adherents of the emerging movement aspired above all to live 'artistically' and, through the worship of beauty, to create new kinds of art set free from stale patterns of thought, outworn establishment ideas and confining Victorian rules of propriety and bourgeois morality. The Aesthetes aimed in their various ways to write 'pure' poetry; to paint beautiful pictures that had no need to tell stories, preach sermons, or rely upon sentimental cliché; and to create sculptures that simply offered visual and tactile delight and dared to hint at sensuous pleasures. Theirs was to be 'Art for Art's sake' – an art self-consciously absorbed in itself, aware of the past but created for the present age, and existing only in order to be beautiful.

In the 1860s a novel and exciting 'Cult of Beauty' united, for a while at least, romantic bohemians such as Dante Gabriel Rossetti and his younger 'second-generation' Pre-Raphaelite followers including William Morris and Edward Burne-Jones, maverick figures such as James McNeill Whistler, then fresh from Paris and full of 'dangerous' French ideas about modern painting, and the 'Olympians', the painters of grand classical subjects who belonged to the circle of Frederic Leighton and G.F. Watts. Choosing unconventional models, such as Rossetti's pale, red-headed muse Lizzie Siddal or Leighton's favourite Nanna Risi ('La Nanna') with her sultry Roman features and glossy black hair, neither of whom remotely conformed to stereotypical notions of genteel good looks, these painters created entirely new types of female beauty, portraying them with an unconcealed and at times disconcertingly frank sensuality (plates 1, 2).

In these years of experiment in the fine arts, something of the same daring spirit motivated innovation in the relatively new discipline of design. Following the poor impression made by the British offerings at the Great Exhibition of 1851, the already broad groundswell of calls for reform in design education and practice and improvement in the manufacture of furnishings and domestic goods became increasingly insistent. At the International Exhibition of 1862, staged on the site subsequently developed as the South Kensington Museum (later the V&A), there was a markedly improved showing, with unthinking historicism giving way to progressive 'reformed' design. Among the new firms that made their debut at the 1862 Exhibition, one of the most significant was that of

2
Frederic Leighton, *Pavonia*
Oil on canvas, 1858
Private collection

OPPOSITE
1
John R. Parsons, *Jane Morris
posed by D.G. Rossetti*
Albumen print from wet collodion-on-glass
negative, 1865
V&A: 1737–1939

3
Edward William Godwin,
designer; William Watt, maker
'Greek' chair
Ebonized oak, with replaced
leather back and seat covers,
c.1885
V&A:Circ.258–1958

4
'Crane' jardinière. Japanese
Glazed porcelain, 1860–62; purchased
by the South Kensington Museum 1862
V&A: FE.11–2004

'Morris, Marshall, Faulkner and Company, Art Workmen', founded by William Morris with the artists Rossetti, Burne-Jones, Ford Madox Brown and an architect, Philip Webb, as designers.

Morris, Rossetti and their immediate friends had been among the first to try to realize the imaginative world of their pictures in the creation of actual pieces of painted furniture and the evocative decoration of real rooms. Their earliest attempts in their own houses remained essentially exercises in an earnest medievalizing style,[1] but these experiments initiated two important ideas: the need for a painterly concern for colour and pattern in decoration, and a new desire to make interiors expressively personal spaces.

Within this context of both official interest and now growing public awareness of the decorative arts, during the crucial decade of the 1860s avant-garde architects and designers such as E.W. Godwin and Christopher Dresser (both ardent devotees of Japanese art and design) sought, through individual design projects and by direct intervention into the processes of mass-production, to transform utterly the strident, banal and pretentious furnishings and meretriciously overwrought domestic objects of the middle-class home. With a refined sensibility to line and geometrical form (strongly influenced by their studies of Japanese stylistic models) (plates 4, 5) or, in the case of Morris, with an unprecedented feeling for natural ornament and harmonious colour, these designers' aim was at first simply to make chairs and tables worthy of the name 'Art Furniture' and to create ceramics, textiles, wallpapers and other 'Art Manufactures' entirely unlike ordinary 'trade' wares. These were to be household goods of a quality to please the eye of the artist and grace the houses of the most exacting of Aesthetic patrons, collectors and connoisseurs. If sufficiently refined in form, materials and their quality of making, and carefully considered in colour, such furnishings – and, indeed, the decorative arts in general – could, it was argued, rise to a new level and chime with the new beauty in art.

In the following years, artists' houses and their extravagant lifestyles became to an unprecedented degree the object of public fascination. The influence of the 'Palaces of Art' created by Rossetti, Burne-Jones and Morris, Leighton and Alma Tadema was curiously out of all proportion to the numbers of people who ever actually gained access and saw for themselves these numinous spaces, but for the many a flood of books and illustrated articles offered ample inspiration whilst instructive manuals supplied the necessary detail. The ideal of 'the House Beautiful' sparked a revolution in building and interior decoration; in perhaps more abstract terms, it led ultimately to a more widespread recognition of the necessity of beauty in everyday life that would have lasting impact not only on architecture but also on social theory and political thinking for years to come.

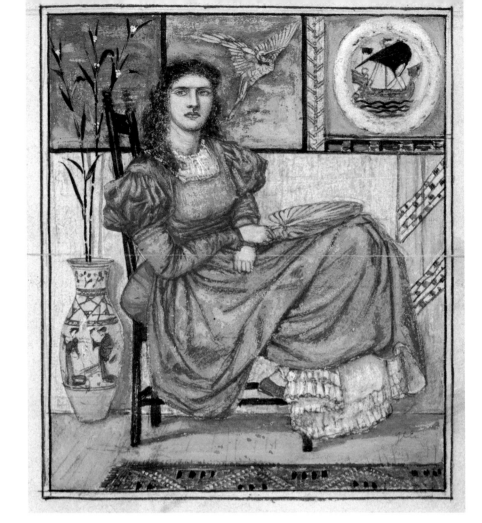

5
Edward William Godwin,
Woman in a Japanesque Interior
Watercolour and pencil on paper,
1870s
V&A: E.286: 29–1963

'THE AESTHETIC MOVEMENT'

As will be immediately apparent, those who came to be identified in this period as protago-
nists of the Cult of Beauty – the poets and painters, makers or thinkers – were perhaps
more united in their opposition to prevailing orthodoxies concerning art and design than
in any comfortably shared vision or precise definition of the beautiful. They had, indeed,
often quite disparate aims and tastes and this led at the time to a serious questioning of
what, exactly, Aestheticism was. This has remained a central question for those seeking to
define the movement in its broadest cultural terms and a problem that has continued in
particular to exercise scholars working in the fields of literary and art history.

In 1882, the year in which Dante Gabriel Rossetti died and Oscar Wilde came to
prominence through his highly publicized lecture tour of America proclaiming the Aesthetic
gospel, Walter Hamilton published *The Aesthetic Movement in England*.[2] In this pioneering
study, the first to treat the subject seriously and with any breadth, Hamilton elucidated
both Aestheticism's intellectual underpinnings and its more immediate artistic manifesta-
tions as he saw them, making a creditable attempt to show art, poetry, architecture and
interior decoration as related aspects of a larger whole. He was however careful to establish,
as indeed others noticed at the time, and as much recent scholarship has taken pains to
affirm, that Aestheticism was not in reality a 'movement' – in the modern sense of the term
– with a cohesive agenda, a programmatic set of aims or even any consistent membership.
Rather, it consisted, Hamilton suggested, of a loose association of the sometimes shared

aims, enthusiasms and ideals of a shifting cast of characters united for the most part by ties of comradely friendship, but also animated by occasional rivalries and even at times instances of carefully honed enmity. Only as the protagonists became better known and their work in various media came to the wider notice both of an increasingly admiring public and of satirists could anything approaching the present definition of a 'movement' be said to have come into existence. In the course of his narrative exploring beginnings and setting out his cast of characters, Hamilton also drew attention to the significant geographic and social groupings of the Aesthetes.

AESTHETICISM IN KENSINGTON, HOLLAND PARK AND CHELSEA

It can be argued that the Aesthetic Movement had its essential origins in the still emerging quarter of London centred on South Kensington (as previously noted, the sites of the Exhibitions of 1851 and 1862 and the nascent South Kensington Museum) and extending through old Kensington (the 'Court Suburb' in the days of Queen Anne) as far as leafy Holland Park to the west, and bounded to the south by Brompton and the riverside village of Chelsea.[3] Already, by the 1860s, artists were forsaking the enclave traditionally favoured since the eighteenth century by Royal Academicians, artists' colourmen and the old copperplate engravers that lay to the north of the eastern end of Oxford Street around Rathbone Place and Newman Street; now far from the fashionable district it once had been, this had become little more than a network of dark, crowded streets lined by that date with grubby tenemented houses. Lured by better light and the less polluted air of the west, many painters sought studios or began to build their own studio-houses in an area that, until the great building boom of the 1870s and '80s overran it, would remain an almost semi-rural paradise. Here almost all the key figures associated with the early phase of Aestheticism either found temporary accommodation or made their permanent homes.

At first the recognizable nexus of the 'movement', as we may conveniently refer to it, consisted of little more than two relatively small, compact, but nevertheless intricately interlocking groups. The first, 'the Holland Park set', could be said to have centred on the home of the Prinsep family. Throughout our period the Prinseps' Little Holland House, where Leighton and Watts, its principal stars, encountered Tennyson, Julia Margaret Cameron and other luminaries, played a key role as meeting place for artists and patrons, writers and thinkers, and might justifiably be designated one of the artistic, literary and intellectual headquarters of Victorian London.[4]

6
Albert Moore, *An Open Book*
Watercolour, *c.*1884
V&A: 42–1884

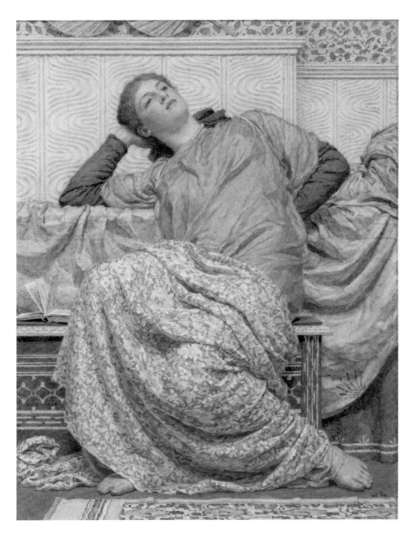

The second main group was focused on Rossetti, whose magnetic personality drew a fascinating circle of followers to Tudor House, the dilapidated old mansion on Cheyne Walk by the river in Chelsea which he occupied from 1862 until his death. This rather more bohemian group included Rossetti's particular protégés Morris and Burne-Jones, other friends who were painters, such as Frederick Sandys, Simeon Solomon and most notably James McNeill Whistler, but also writers and critics including Rossetti's brother William Michael and the young Algernon Swinburne, both of whom would make a significant contribution to the definition of Aestheticism as a recognizable set of literary and artistic attitudes and aspirations. A few other key figures were also attached by complex links of friendship: Albert Moore, though geographically one of the Holland Park–Kensington group with a studio near that of Watts, remained the painter closest in artistic sympathy with Whistler, whilst the designer E.W. Godwin, Whistler's intimate collaborator in forging a distinct decorative repertoire, had originally trained as an architect under Rossetti's old friend of the 1850s, the genius of the Gothic Revival, William Burges.

Initially, that is to say well into the decade of the 1860s, the highly various experiments in art, literature and criticism, decorative design and the 'artistic' lifestyle essayed by this heterogeneous cast of characters, remained to a surprising degree essentially private activities, seen by few and, at first, with little significant wider influence. Rossetti, cautious after the largely hostile critical handling that his early Pre-Raphaelite pictures had received, eschewed exhibiting in public. With the exception of Leighton, whose precocious success at the Royal Academy with *Cimabue* was spectacular,[5] most of the other painters had gained only limited recognition at the main public exhibitions and garnered merely modest praise in the press, other than from friends such as William Michael Rossetti and Swinburne or allies like the critic Sidney Colvin, all of whom attempted to demonstrate the artistic links between seemingly disparate works by members of the movement and to offer some general explanation of Aesthetic ideals.

'ART FOR ART'S SAKE' AND AESTHETICISM

Aestheticism had been talked of for some time and the slogan '*L'art pour l'art*' (customarily rendered in English with slightly less dash as 'art for art's sake') had served as a stirring rallying call for a very different band of radical and politically engaged artists and writers in France at least since 1830, when, at the famous 'Battle of *Hernani*' on the first night of the play, the Romantics and Bohemians, led by Théophile Gautier and the play's author Victor Hugo, had claimed victory over the forces of conservatism and classicism.[6] Gautier gave the phrase further currency in a brilliantly impudent preface to his novel *Mademoiselle de Maupin* of 1835, which became a key text for his own and subsequent generations of Aesthetic romantics, eagerly devoured by Swinburne and later mined by Oscar Wilde. By the middle years of the century Gautier himself and Charles Baudelaire had established the concept of *l'art pour l'art* as the central tenet of the Parisian literary avant-garde. Swinburne seized eagerly upon Baudelaire's insistence that art should concern itself only with beauty, free from all religious, moral and ethical constraints. He was the first to promote such daring and attractive French ideas in England.[7]

'Aesthetics', a term coined from the Greek *aesthesis* denoting simply 'perception of things by the senses', entered philosophical discourse first in 1735 in the writings of the German Alexander Gottlieb Baumgarten and became, gradually, the accepted term for all discussion concerning the nature of beauty in both its theoretical and concrete aspects.[8] Notions of ideal beauty and consideration of its importance in life and art were developed in differing ways in the writings of Immanuel Kant (in particular in his *Critique of Judgment*, 1790), Friedrich Schiller (in *Letters on Aesthetic Education*, 1795) and other late eighteenth- and early nineteenth-century German thinkers such as Johann Joachim Winckelmann who elaborated quasi-scientific systems of analysis to arrive at general principles of beauty and to propose canons of taste discoverable through the examination of pictures or the sculpture of the ancient world.

In England in the 1830s the word was adopted by intellectuals such as Samuel Taylor Coleridge and, whilst still remaining something of a specialist term, thereby took on a significant literary dimension in addition to its stricter Continental connotations of the study of beauty in the visual and plastic arts. Though the definition was initially rejected by the leading British art theorist John Ruskin (who objected at this date to any notion of beauty divorced from moral and religious considerations),[9] by the 1850s and '60s 'Aestheticism' came to signify in a much more general sense the appreciation of beauty in works of art or, indeed, in things of many kinds. Thereafter, within a decade, the word rapidly gained wider currency and acquired its specific meaning of a pursuit of beauty in both art and life. Soon, too, it embraced the yet subtler connotation of a devotion to that pursuit for its own sake.

ATTACK

Wider public awareness of Aesthetic ideals and any sense that a movement might exist came first as a result of the literary activities of members of the group. This, incidentally, is the interpretation offered by Walter Hamilton in his 'interim report' on the development of Aestheticism, and it is certainly a factor which affected the ways in which the wider movement was first received. As with the case of the response to Pre-Raphaelitism, reactions were for the most part characterized by suspicion and often outright hostility. Swinburne's volume *Poems and Ballads*, published in 1866, was the first to attract this kind of adverse attention. The general perception, which, it has to be said, is for the most part entirely justifiable, was that Swinburne's verses, such as 'Laus Veneris', 'Dolores' and many others in similar vein greatly influenced by Baudelaire, dwelled to an unhealthy degree upon the subjects of sensual love, lust and cruelty and that their author, with his evidently degenerate obsessions with femmes fatales and themes of blood, punishment and death, lacked what the Victorians liked to describe as 'moral fibre'. Following the publication of Rossetti's *Poems* in 1870, the imputation of outright immorality was again levelled at the writers of the movement in an article with the deliberately coded title 'The Fleshly School of Poetry'.[10] Written by the mediocre poet Robert Buchanan though published pseudonymously, the vitriolic but poorly argued farrago of special pleading and selective quotation attacked Rossetti and Swinburne in particular, but also attempted to impute decadence

and unmanliness to the emotionally complex but utterly robust medieval ballads in Morris's 1857 volume *The Defence of Guenevere*.

It is worth dwelling upon this incident because Buchanan's cowardly attack on Rossetti, Swinburne and Morris not only brought their particular kind of poetry considerable and altogether unwelcome notoriety, but also served to direct much wider attention to the perceived lack of a moral dimension in Aesthetic art in general. By raising this pertinent and, to the mainstream Victorian mind, crucial issue at the very time when the leading artists of the group, Whistler, Leighton, Watts, Albert Moore, Burne-Jones and of course Rossetti himself, were evolving a new kind of self-consciously exquisite painting in which mood, colour harmony and beauty of form were all, and subject played little or no part, Buchanan did much to set an agenda for discussing whether such 'amoral' art and writing was desirable or even acceptable. This debate would continue to reverberate throughout the 1870s and come to the fore again as the pivotal issue during the trials of Oscar Wilde in the final decadent phase of the movement in the 1890s. For the moment it focused considerable attention upon the complex questions of what was meant by this troublesome term 'Aestheticism' and just what sort of art and poetry it was that gathered under the rubric of 'Art for Art's sake'.

WALTER PATER AND AESTHETIC RESPONSE

In 1873 a previously obscure Classics don at Oxford, Walter Pater, published a collection of essays, *Studies in the History of the Renaissance*.[11] In addition to a handful of elegantly phrased, highly subjective meditations on Italian painters, the book also included some studies of subjects which apparently fell outside the period which the title of the book suggested; these ranged from early French poetry of the thirteenth century to the life of the eighteenth-century German aesthete and connoisseur Winckelmann. In fact, examination of these extraneous subjects shed useful sidelight on the main era of artistic activity under consideration and helped Pater to frame his belief that the significance of art extended beyond the artist and the work of art to embrace the individual as viewer. Beauty, according to Pater, is not merely to be observed and classified, but experienced fully and appreciated through the senses.

The book might well have passed unnoticed were it not for the 'Conclusion', a brilliant short piece of highly charged writing in which the author somewhat unguardedly laid out a startling credo based upon the need for directness and intensity in one's responses not to art only, but also, he boldly asserted, to life as well. As Pater put it, the first thing is to realize one's own sensations and ask 'what is this song or picture, this engaging personality presented in life or in a book to *me*?'[12] This privileging of sensitivity to the work of art and insistence upon intensity of aesthetic response lies at the heart of Pater's philosophy. It led him towards the dangerous position of arguing that in art and in life, too, experience is all and that considerations of morality, and the dictates of convention, should play no part in constraining that experience. Not surprisingly, such 'passionate attitudes', as Pater termed them, were considered inappropriate for a don; he was denounced from the pulpit by the Bishop of Oxford and called to account by the university authorities.

Pater was effectively forced to recant and in a second edition of his book, now given the somewhat more explanatory title *The Renaissance; studies in art and poetry*, he rewrote some key passages, toning down the Conclusion and later admitting that in its original form it might well have 'led astray' the susceptible minds of young men. However, this was not a genie that could easily be put back into the bottle: Pater's particular take on the meaning of Art for Art's sake and his exhortation to 'burn always with this hard, gem-like flame' became rallying calls for a younger generation of disciples and decadent aesthetes, among whom the most prominent would be Oscar Wilde.

THE MOVEMENT WIDENS

If the first half of the 1870s can be characterized as a period in which the work of the artists and writers associated with Aestheticism became gradually better known, it is also true to say that wider knowledge of their activities and ideas brought relatively little wholehearted public support for what, to many observers, still seemed the preserve of a self-regarding and possibly immoral artistic elite. However, almost unexpectedly and with the growing support of enlightened patrons and increasingly favourable critical response, in the second half of the decade the movement seemed to make more positive progress. It was neverthe-less still a bold move when Sir Coutts Lindsay formulated a plan to create a gallery in which the leading painters would be invited to show their work in a spacious, purpose-built and sympathetically decorated environment. Created specifically to show the new art iso-lated, as it were, from the teeming, ill-hung mass of populist and often embarrassingly bad work that assailed the visitor at the Academy's annual Summer Exhibition, the Grosvenor Gallery opened for its first season in 1877 and caused an immediate sensation.

The opening of the Grosvenor brought about a major shift in public awareness of the new kind of pictures – subtle, poised and magisterial in both conception and scale, which Leighton and Watts, Burne-Jones, Whistler and Moore were evolving. With the pictures by each artist grouped elegantly together rather than scattered, it was a setting designed for the first time to show individual painters to their best advantage. Burne-Jones, who had exhibited nothing in public for the best part of a decade, was especially favoured in this respect, his new work revealed to great effect. In the Grosvenor's conspicuously opulent rooms, the lavish red silk of the walls (famously changed to 'greenery-yallery' in the second year at the request of the artists but at further enormous expense to Lindsay), gilded pilas-ters, and marble-topped side-tables bearing flowers suggested the ambience of a great aristocratic house rather than that of a public gallery and commercial enterprise. It was an effect precisely calculated to endorse the importance of the 'Grosvenor artists' and to sig-nify their position in a scheme of things no longer dominated by the old establishment.

In spite of Ruskin's famous vituperative attack on Whistler's pictures at the first Grosvenor show[13] and the subsequent almost ludicrous fiasco of the Whistler v. Ruskin libel action which followed,[14] the general effect of the emergence of a new elite London art world that for the first time could challenge the Academy in terms of social prestige and confidence in its proposal of an entirely new artistic credo was crucial. As a result of the immense success of the Grosvenor, Aesthetic painting now became the fashionable

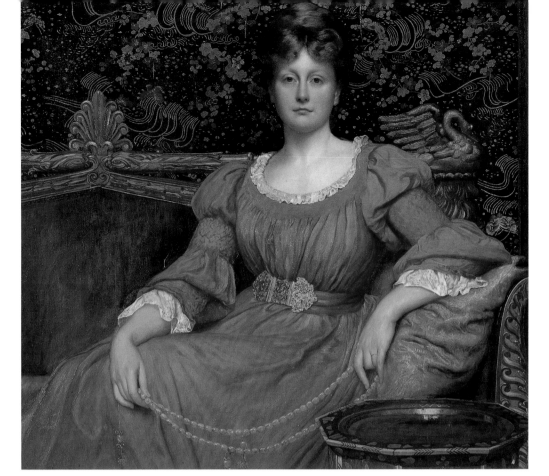

7
William Blake Richmond, *Mrs Luke Ionides*
Oil on canvas, 1882
V&A: E.1062–2003

enthusiasm of a grand, somewhat intellectual and certainly well-to-do circle, a clientele anxious not only to acquire the new pictures, but also to commission portraits, adopt the new artistic lifestyle in their interiors and even the Aesthetic manner in their dress. Although both the aesthetic and ethical values of the new art continued to be discussed, and Whistler, the instinctive polemicist, kept up his spirited defence of the ideals of Art for Art's Sake both in his writings[15] and by the staging of his own exhibitions, there was in general a growing sense of a battle won. As the great world bought into the movement, Aestheticism irrevocably passed from its early phase as the recherché enthusiasm of the few, to an artistic and lifestyle choice of the many.

BEAUTIFUL PEOPLE AND AESTHETIC HOUSES 1870s–80s

The rise of Aestheticism in painting was paralleled in the decorative arts by a new and increasingly widespread interest in the decoration of houses. Many of the key avant-garde architects and designers interested themselves not only in working for wealthy clients but also in the reform of design for the middle-class home. The notion of 'the House Beautiful' became an essential touchstone of cultured life at a surprisingly wide range of levels in society.

At the upper end of the scale, the major collectors and patrons who bought Aesthetic paintings and furnished their houses in the new style came in fact from two distinct groups: one an old aristocratic and intellectual circle, the other drawn from the new class of ambitious, self-confident and largely self-made men who enjoyed unprecedented success in mid-Victorian England through their efforts as manufacturers, industrialists and entrepreneurs.

8
James McNeill Whistler, detail of The Peacock Room from the house of Frederick Leyland. Autochrome by Alvin Langdon Coburn showing the room after its removal to the house of Charles Lang Freer, Detroit, *c.*1910 National Media Museum, Bradford

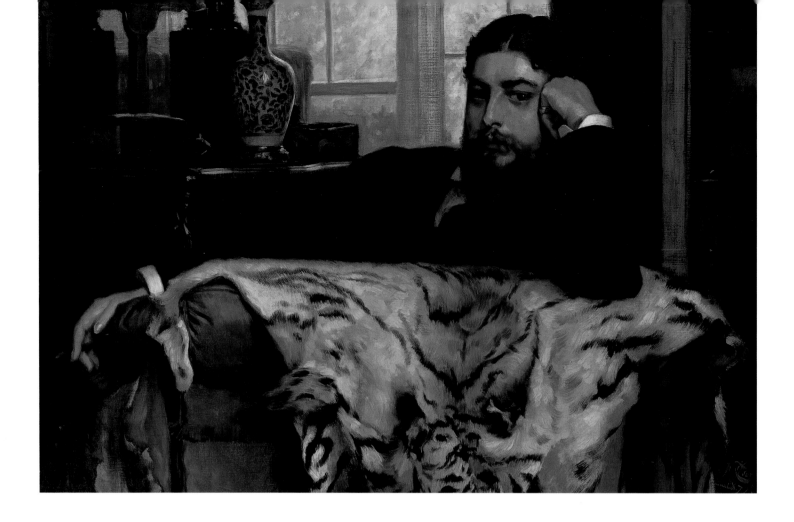

Figures from both groups are well represented in portraiture (see plate 9). Whether motivated by the desire to express refinement of taste or worldly success, the choices made by members of these elite circles – in dress, in furnishings and in what we now call lifestyle – exerted a considerable influence on a wider public.

Attracted by the growing popularity of Aesthetic ideas, many of the leading firms making furniture, ceramics, domestic metalwork and textiles courted artists such as Walter Crane (plate 10) and a growing band of professional product designers such as Lewis Foreman Day, Bruce Talbert and, most notably, Christopher Dresser. Coinciding with a period of unprecedented expansion of domestic markets, the styles favoured by Aesthetic designers were among the very first to be exploited and disseminated widely through commercial enterprise.

A further conspicuous effect, and indeed evidence of the very considerable extent of this trickle-down, as we now term it, of stylistic influence, can be seen in the very large numbers of publications issued around this time aimed at raising awareness of beauty in the ordinary home. Aimed at the would-be fashionable middle-classes and owners of ordinary houses with aspirations to be 'artistic', throughout the 1870s and '80s a constant

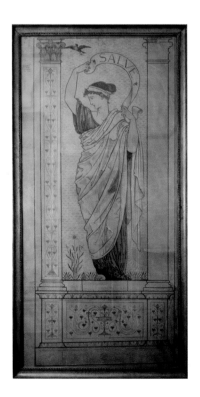

stream of written advice and illustrative material appeared in the form of substantial books on taste, design manuals, trade catalogues and pattern books, and a vast array of shorter pieces in more ephemeral periodical publications.

THE AESTHETE AND SATIRE OF THE MOVEMENT

The figure of the Aesthete, whose super-subtle sensibility and passionate response to works of art might be expressed through either creation or connoisseurship, had emerged fully fledged in the 1870s. Held at first, and perhaps rightly, to be tainted by unhealthy and possibly dangerous foreign ideas as well as those of Pater, the Aesthete was treated with some considerable degree of suspicion by journalistic commentators and public alike. However, by the beginning of the 1880s the Aesthete with his self-proclaiming attachment to poetry, pictures and to the nuances of interior decoration – in short, the character so astutely adopted by Oscar Wilde – had become the popular butt of for the most part amiable satire. In both George Du Maurier's long-running series of sharply observed cartoons in *Punch* (which had began as early as 1876) and in Gilbert and Sullivan's enduringly popular *Patience* the velvet-clad Aesthetes were targeted with extraordinary precision, ridiculed for their 'stained-glass attitudes', overly precious speech, and enthusiasm for the curious appeal of 'pale lilies', sunflowers, peacock feathers, fragile blue-and-white china and Japanese fans.

SWANSONG AND DECADENCE, LATE 1880s AND 1890s

In many previous accounts of Aestheticism it has been suggested that at a point in the 1880s satire and parody so overwhelmed the credibility of the movement as to effectively preclude any worthwhile development of the Aesthetic ideal. According to this interpretation, vigour – perhaps never exactly a defining characteristic of the movement – became fatally vitiated, painting and poetry faltered and lost their momentum and in the decorative sphere, furnishings were scaled down for ordinary life in the suburbs.

A contrary view can however be advanced, for whilst the deaths of Rossetti in 1882 and Godwin in 1886 undoubtedly deprived the movement of two of its most innovative and influential protagonists, even well into the 1890s several of the great figures were still at work. Morris, who died very much 'in harness' in 1896, had, in addition to his startlingly progressive political activities, continued to work with astounding energy, embarking only in the final five years of his life on his last great enterprise, the production of 'the Book Beautiful' at his Kelmscott Press.[16] Among the major painters Burne-Jones (died 1898) who had been Morris's life-long collaborator, Leighton (died 1896), and Watts (died 1904) all continued painting their increasingly dreamy visions on ever grander scale (plate 11). More than this, however, these grand old men also used their position and influence to encourage a rising generation of artists who sought to continue many of the ideals of the movement. In this way Burne-Jones offered initial help to the brilliant young draughtsman Aubrey Beardsley,[17] whilst Leighton, in his last years the single most important figure in the London art world, systematically helped promote the careers of young artists by acquiring works for his own collection. Most notable among these munificent acts of encouragement were purchases including Charles Ricketts's early drawing *Oedipus and the Sphinx*[18] and his

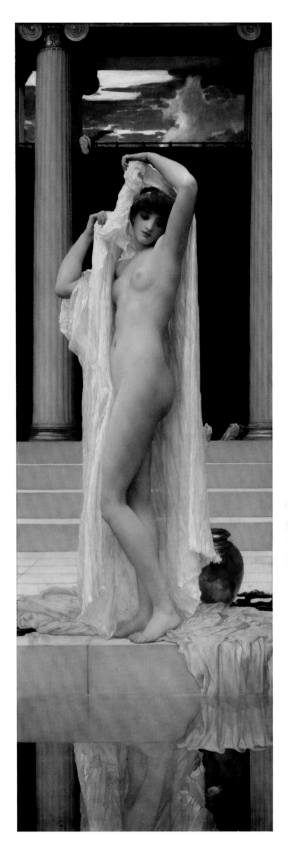

11
Frederic Leighton, *The Bath of Pysche*
Oil on canvas, *c.*1889–90
Tate, London

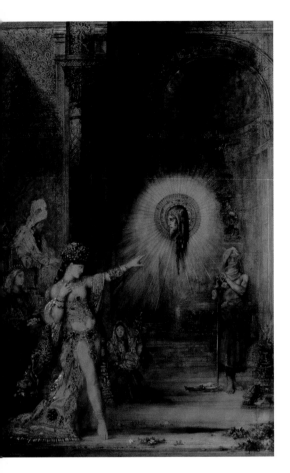

12
Gustave Moreau, *L'Apparition*
Watercolour, 1876
Musée du Louvre, on loan to
Musée d'Orsay, Paris
Exhibited at the Grosvenor Gallery, 1877

commissioning of the large bronze figure of *Icarus* by Alfred Gilbert, now widely held to be the key work of the so-called New Sculpture.[19]

In considering the artistic milieu of London in the 1890s, it becomes readily apparent that many of the concerns of the emerging poets, painters and designers clearly echo those which shaped the earlier phases of the Aesthetic Movement. The overwhelming preoccupation with style expressed in form and colour recalls the search for a new 'formal beauty' of the 1860s. Similarly, the 1890s obsession with the concept of synaesthesia (see p.30) harks back directly to the interrelationship between painting, music and poetry that had previously fascinated Rossetti and his circle and also found pictorial expression in the work of both Leighton and Moore. Pater, acknowledged as a major stylistic model for writers of the period, also through his philosophy of intensity of artistic response informed so many of the later Aesthetes' patterns of thought as to suggest that his influence was well-nigh universal.

Thus the precepts of the early days of the movement were revisited by a younger generation, its ideas played out with a sharper sensibility and given a darker cast that has been conveniently labelled 'decadent'. But the Decadence of the 1890s, as it is called, is more than merely the last gasp of played-out art theories and cultural enthusiasms at the end of the century and of the long reign of an elderly widowed queen, just as it is certainly far more than the delinquent outbursts against artistic manners and social propriety suggested by trite phrases such as 'the naughty nineties'. It is, in short, something quite specific: the decadence of the ideals of the Aesthetic Movement, the final expression of a sensibility that we might define as the ultimate refinement of aesthetic response, the final flowering of Aestheticism's intellectual and artistic pose. It is a dandyism of the senses, perhaps, and like the dandyism of the early nineteenth century it is an extraordinary, precious ideal which we observe in its final splendour, in Baudelaire's beautiful phrase, 'like the sunset of a dying star … glorious, without heat and full of melancholy'.[20]

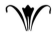

THE CHAPTERS and shorter pieces in this book aim to examine the Cult of Beauty as a cultural phenomenon, looking at the Aesthetic Movement either broadly or in highly focused detail and from a wide variety of perspectives, treating the material both historically and thematically. In the same way, the exhibition which this volume accompanies seeks to present a coherent narrative of the movement, to elucidate the major themes and, above all – and in the spirit of the movement – to present the works of art for the delight of the eye.

The Cult of Beauty is the first exhibition ever to bring together many of the greatest Aesthetic pictures as well as the finest furniture, decorative arts and fashion of this extraordinary movement, setting them in the context of a glittering cast of characters featuring artists, poets and their muses, the designers and makers of exquisite things, and the aesthetes and collectors who devoted their lives to the pursuit of Beauty.

OPPOSITE
13
Maxwell Armfield, *Faustine*
Oil on canvas, *c*.1900
Musée d'Orsay, Paris

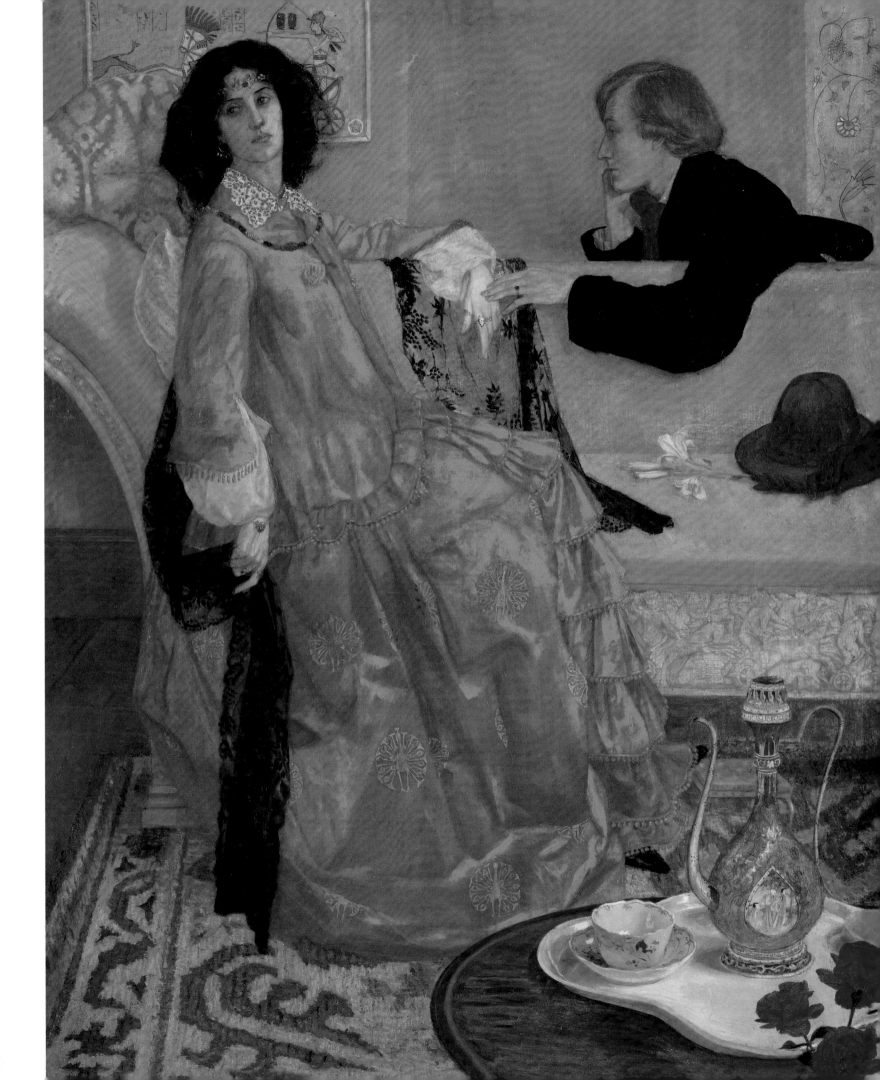

THE CULT OF BEAUTY: THE VICTORIAN AVANT-GARDE IN CONTEXT

Lynn Federle Orr

The hours when the mind is absorbed by beauty are the only hours we live…
Richard Jeffries, 1884[1]

Beauty has as many meanings as man has moods. Beauty is the symbol of symbols. Beauty reveals everything, because it expresses nothing. When it shows itself, it shows us the whole fiery-coloured world.
Oscar Wilde, 1890[2]

FORMAL BEAUTY – emphasizing nuanced yet luscious colour, functional yet elegant form, and abstract yet compelling pattern – is the hallmark of Aestheticism in Britain, the artistic vocabulary of the Victorian avant-garde. The participants in this Cult of Beauty practiced a 'worship of things formally beautiful' that coloured their every design.[3] Desiring escape from restricting convention and the materialism of the industrial age, the Aesthetes took liberties with both artistic and personal style. Their idiosyncrasies produced individual celebrity and crafted some of the most sophisticated and sensuously beautiful artworks of the Western tradition (plate 14). With the concept of beauty ever before them, the painters, architects, designers of household furnishings, photographers, and even dressmakers of the Aesthetic Movement remade the domestic world of the British middle classes. Collectively these artists, joined by the new style consultants, celebrated the power of beauty to mesmerize, enthrall, enchant and uplift the beholder. Like a fine Victorian novel, the story of the Aesthetic Movement is one centred around serious social debates – shifting class structures, the confrontation between science and religion, art's place in society, the impact of new market forces, and a unique emphasis on the middle-class home. These issues were animated by the motivations and changing circumstances of sharply etched characters, their public successes and failures, and all played out before a rich and challenging historical background.

This is a fascinating and rewarding story, revealed through a succession of exquisite objects of every type.[4] A distinct intellectual and artistic moment linking the Pre-Raphaelite Brotherhood (1848–53) and the *fin de siècle* Art Nouveau, the Aesthetic Movement was also the wellspring of the international Arts and Crafts Movement. In its four-decade run the Aesthetic Movement initiated sweeping artistic and design changes and its modern concepts of middle-class lifestyle and domestic environment reverberate even into our own time. Today Aestheticism is acknowledged for its revolutionary renegotiation of the relationships between the artist and society, between art and ethics, and between the fine and decorative arts, all of which prepared the way for the art movements of the twentieth century.[5]

14
James McNeill Whistler,
Symphony in White No.1: The White Girl
Oil on canvas, 1862
National Gallery of Art, Washington

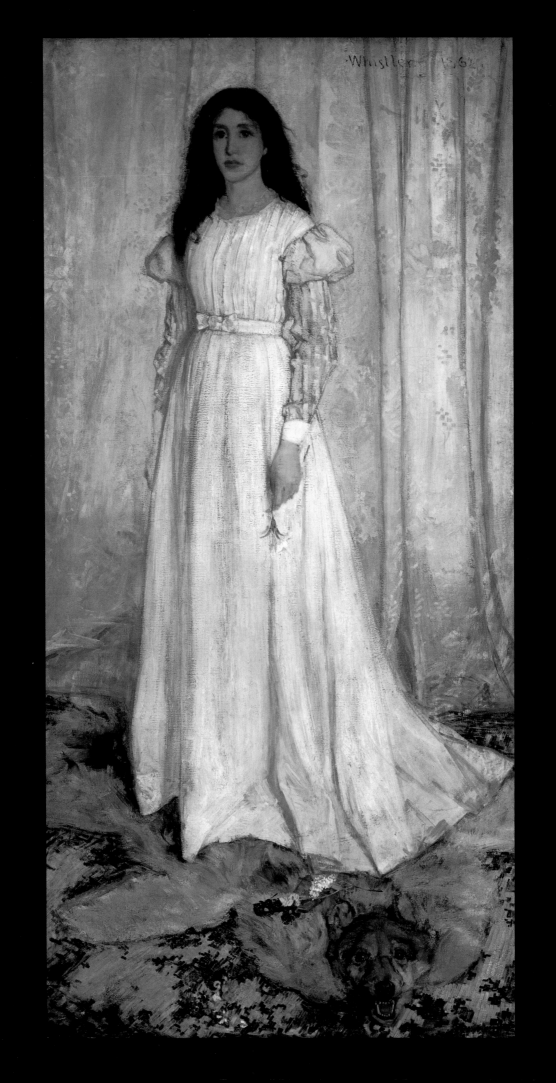

SHAPING THE VICTORIAN ERA

All art emerges from the convergence of social, economic and political events that mould historical periods and individual artists. Queen Victoria's reign benefited from an uncommonly long period of peace between Britain and Continental Europe. However, growing out of the technological advances and commercial enterprises of the late eighteenth century, the Victorians lived with the startling changes brought by a domestic upheaval of a different sort – the industrial revolution. England's previously stable agriculture-based society evolved rapidly into an industrial society dominated by a factory system of large-scale machine production centred in the cities. An unprecedented succession of mechanical and scientific innovations transformed manufacturing, transportation, communications and agriculture; these changes in turn created turbulent shifts and realignments in the political, economic and religious culture of the nation, as well as in its hierarchical social structure.

As computers drive today's technological advances, the steam engine fuelled by coal powered the industrial revolution. With easy access to large deposits of coal and iron, Britain was uniquely positioned to take advantage of the new technologies and jumped far ahead of her historic competitors to dominate global markets. Automation and dramatic population growth forced job-seeking farmworkers into urban centres. Absorbed into the new factory system or the growing caste of domestic servants required by affluent upper- and middle-class households, the new working poor filled London and manufacturing cities such as Manchester, Birmingham and Liverpool. Details of their circumstances animate Victorian literature and concerned contemporary social critics, becoming the focus of evangelical, philanthropic and political efforts.

Exhilarating change created an appetite for further progress, but it also caused anxiety. The 1830s and 1840s proved determinative decades characterized by unrest and political reform in direct response to social pressures. Before mid-century, the aristocracy and landed gentry experienced the zenith of their power. Privileged by wealth and birth, they had benefited from hereditary ownership of land and the profits of agriculture; they also dominated British social, political, economic and religious life. However, as industrial development made steady progress, men of commerce – the manufacturers, financiers, merchants and landlords – prospered and became restless for proportional political power. Fearing the violent revolutions that similar social change had recently caused across Continental Europe, the British government passed a series of moderate reform acts acknowledging growing middle-class commercial power.[6] Living conditions generally improved for the middle classes during the Victorian period and salaries could buy an ever-increasing range of goods thanks to cheaper raw material costs, mass production at home and inexpensive imports from abroad. Britain's expanding global reach, maintained by force of maritime supremacy, encompassed vast possessions, constituting the most powerful political and economic empire in modern history. Driven by advancing technology, maritime strength and material wealth, the British nation felt its power, confident in its intellectual, cultural and commercial superiority.

DESIGN REFORM

The Aesthetic Movement materialized after several decades of efforts to reform British commercial design, an aspect of manufacturing challenged by two related problems. First, rapid market expansion and economic expediency had degraded the quality of British mass-produced goods. Product design and ornament, unimaginatively recycling conventional historicist vocabularies, had not kept up with advances in technology, thus threatening Britain's international trading position. Second, while historically the British ruling class, possessing discernment through education and upbringing, had dictated style, now the dramatically expanding middle classes drove production. With limited experience of art or tasteful design to guide them, yet wishing to emulate the patterns of aristocratic consumption, the nouveau riche bought indiscriminately. Mass-produced, heavy and often dark furnishings, such as overwrought imitations of French eighteenth-century furniture, as well as florid upholstery, wallpapers and carpets, found a ready market as the trappings of newly acquired wealth. Noted Gothic Revival designer A.W.N. Pugin commented that 'Cheap deceptions of magnificence encourage persons to assume a semblance of decoration far beyond either their means or their station'.[7]

These related problems – one of production, one of demand – could be addressed only through coordinated effort: British manufacturers would improve production only if there were demand for better goods and there could be such demand only if the middle classes were educated in taste. To improve the quality of British manufacturing, education was required all along the supply chain, from industrial designer through manufacturer to the consumer. The reformers' campaign also had an evangelical dimension, maintaining that taste exercised a moral power.[8] Thus efforts began to provide 'the enjoyment of taste to the enormous and now all-powerful Bourgeois class'.[9] Familiarity with beauty could mould taste and by extension the everyday acquaintance with domestic objects of good design could elevate individual social behaviour. So the ordinary middle-class home became the focus of educational efforts by the government and manufacturers invested in social stability, increased foreign trade, and thus design reform. Subsequently architects, artists, and designers of Aesthetic temperament cultivated the mystique of the 'Artistic' home – a beautiful environment to nourish the souls and enrich the lives of its inhabitants.

THE GREAT EXHIBITION, 1851

London's *Great Exhibition of the Works of the Industry of All Nations* opened in 1851 (plate 15), a grand endeavour envisioned by Henry Cole and Albert, the Prince Consort. Together Cole – designer, educator and reformer – and the Prince Consort hoped the great gathering of goods from around the world would foster peace across cultures through knowledge and cooperation. The British people welcomed this, the first international trade show, with pride

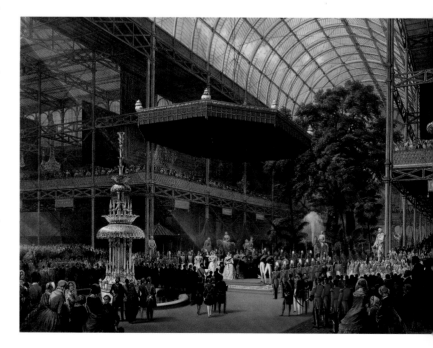

15
Louis Haghe, *The State Opening of the Great Exhibition*
Colour lithograph printed by Day & Son, 1851
V&A: 19603

and confidence, secure in the nation's industrial pre-eminence. Increased foreign trade, an education in taste for the British consumer, and the organizers' other worthy motives were probably lost on the fair's six million visitors.

The primary exhibit was the marvellous structure itself. Crafted like a giant greenhouse of machine-milled plate glass suspended on a frame of iron and wood, its dazzling effect on a nineteenth-century audience is difficult to imagine:

> The vast fabric … an Arabian Nights structure, full of light, and a certain airy unsubstantial character about it which belongs more to [an] enchanted land than to this gross material world of ours.… the whole looks like a splendid phantasm, which the heat of the noon-day sun would dissolve, or a gust of wind scatter into fragments, or a London fog utterly extinguish.[10]

Displays included a staggering array of the raw materials, cultural artefacts, manufactured goods and automated marvels of a diverse world, presenting visitors with a visual spectacle of unprecedented breadth.

Wildly successful, the Great Exhibition legitimized Britain's sense of superiority in all but one aspect. British product design – understood by design reformers as the suitability of an object's form and ornament to its purpose or function – proved inferior to that of other countries, specifically her Continental rivals France and Germany. Tasked with re-invigorating educational programmes for both industrial artisans and the British public, Henry Cole put the Exhibition's profits to work, including founding the Museum of Manufactures. Relocated and renamed the South Kensington Museum in 1857 (the predecessor of the Victoria and Albert Museum), that institution started a teaching collection that is today the world's premier museum of decorative arts and design.

THE 1850S: THE AVANT-GARDE TAKES SHAPE

While reform efforts occupied the design community, a band of aspiring artists grappled with perennial challenges: developing a personal artistic voice, choosing a subject range on which to focus, working out how to relate to the establishment and how to find an audience. Their unique solutions and dedication to formal beauty, which would be labelled Aestheticism, ultimately fashioned the character of Victorian high art. Serious, intelligent, literary and young, they gave everything a new inflection. They sought retreat from dreary urban realities and the growing materialism of a changing world. In part escapism, Aestheticism was also a revolt against what cultural critic Matthew Arnold termed 'Philistinism' – the smugly narrow and conventional views and tastes of the Victorian middle class, deemed lacking in cultural and aesthetic values.[11] Deviating from polite Victorian parameters, these aesthetic adventurers developed an unexpected world view expressed in a range of creative endeavours: painting, graphic and decorative design, poetry, art criticism, and collecting.

Foremost among this progressive group, Dante Gabriel Rossetti had debuted in the Pre-Raphaelite Brotherhood. That short-lived alliance venerated the simplicity of early

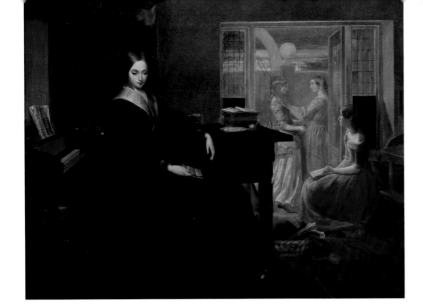

16
Richard Redgrave, *The Governess*
Oil on canvas, 1844
V&A: FA.168

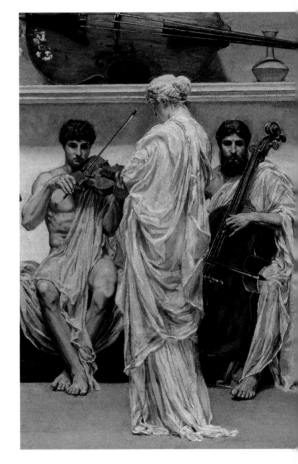

17
Albert Moore, *A Quartet: A Painter's Tribute to the Art of Music, AD 1868* (detail)
Oil on canvas, 1868 (exhibited 1869)
Private collection

Italian painting above later embellishments typified by Raphael, whom they considered the high priest of idealized beauty (hence the name Pre-Raphaelite). Their initial efforts gained the important support of John Ruskin, Britain's leading critic. Through voluminous and complex writings on painting, architecture and social and economic reform Ruskin exercised enormous influence on Victorian taste. He championed the beauty of 'truth to nature' and encouraged the Pre-Raphaelites' exacting naturalistic detail. Meanwhile, Rossetti and company bristled under the Royal Academy's structured curriculum, which upheld Raphael's supremacy and was designed to produce forthright moral value as well as artistic skill. Traditionally European artists had relied on narrative content to engage the viewer: a painting's pictorial elements were to be read as a text, whether of literary themes, historical or contemporary events, recognizable topography, or, in portraiture, individual biography. However, in reality there was little demand in Victorian England for the high-minded 'history' paintings preferred by the Academy. Across England more mundane themes – portraiture, landscape, and genre – prevailed. Richard Redgrave's *The Governess* (1844; plate 16), alluding to the Victorian governess's ambiguous status within the household she serves, exemplifies the contemporary anecdotal or 'subject' painting so popular with Victorian audiences.

It is in paintings that the British Cult of Beauty came to its earliest and most sumptuous fruition. Never stylistically cohesive as a group, individual Aesthetic artists drew thematic and stylistic inspiration from a variety of cultures and periods, often composing unique anachronistic combinations (plate 17). They found beauty in Renaissance, particularly Venetian, painting; ancient Greek sculpture, including the Elgin marbles and newly excavated figurines from Tanagra; and art forms of the Orient, most especially Japanese prints. Rossetti and Burne-Jones even amassed extensive collections of photographs of Old Master paintings, images used as documentation and inspiration. This rich eclecticism remains one of the Aesthetic Movement's most intriguing characteristics. It is one of the strategies Whistler, Moore and others exploited to stimulate novel reactions to their self-consciously exquisite compositions. And while a painting's title might establish a literary or historical tie, artists were interested in only the most limited narrative, preferring rather to evoke a mood or prompt vague associations. This unnerved a public set adrift from the

traditional signposts of content. But if art's sole purpose is beauty, Aesthetic paintings present opportunities to enjoy the sheer pleasure of potently sensuous figures, nuanced colour harmonies of the greatest refinement, and elegant patterning.

Another idea that permeates Aesthetic painting is synaesthesia. This stimulation of one sense through another, such as evocative imagery activating one's sense of smell, produces a layering of responses deepening the viewer's experience. Similarly, musical references abound in Aesthetic painting, both in imagery and titles (famously, Whistler's many *Nocturnes* and *Harmonies*). Musical vocabulary also pervades the language of Aesthetic criticism, as when Swinburne comments on the 'melody of colour' and 'the symphony of form'.[12] Eliding the abstract nature of music with a painter's compositional orchestration of colour and form underscored the intellectual process of painting and the intellectual pleasure a painting could render divorced from didactic purpose. And surely Pater's declaration that 'All art constantly aspires towards the condition of music' is the signature phrase of Aestheticism.[13]

THE AESTHETIC MOVEMENT, ARCHITECTURE AND DECORATION

If you want a golden rule that will fit every body, this is it: have nothing
in your houses that you do not know to be useful or believe to be beautiful.
William Morris, 1880[14]

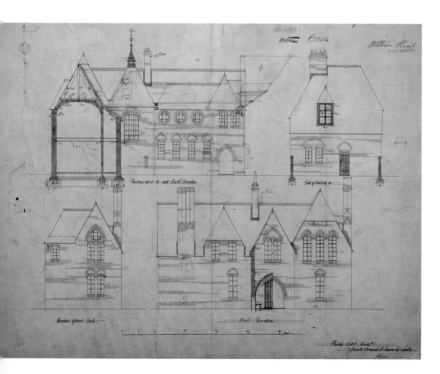

18
Philip Webb, design showing the north
and south elevations for the Red House,
Bexleyheath, Kent, built 1859–60
Pen and ink with coloured wash
V&A: E.60–1916

Beyond their activities as painters, a few key members of Rossetti's circle took unprecedented interest in the design arts, trying their hands at creating 'artistic' furnishings and decor. Pioneering efforts to furnish their own dwellings inexpensively but with taste echoed and impacted evolving attitudes toward the home as a statement of personal discernment. William Morris's Red House (plate 18), designed by architect Philip Webb, is an important precursor to the Aesthetic studio-home. Embodying Ruskin's reverence for the Gothic as symbolic of honest construction and honest labour, the Red House is medieval in character yet not slavishly so, being adapted to modern convenience and comfort. Rossetti characterized the final product as 'more a poem than a house'.[15] Its coordinated style, aptly described as 'neo-vernacular mellowness with high art seriousness', would become Morris's trademark.[16] In need of furnishings for the house he would share with his new wife and Pre-Raphaelite muse, Jane Burden, Morris later declared that finding 'all the minor arts were in a state of complete degradation … I set myself to reforming all'.[17] He enlisted the help of his wife and friends, believing, as the prospectus of Morris & Co. would later enunciate, 'The growth of Decorative Art in this country, owing to the efforts of English Architects, has now reached a point at which it seems desirable that Artists of reputation should devote their time to it'.[18] And so they did, transferring their skills from one format to the next, a breadth of

creativity without regard for the Royal Academy's strict division between the 'fine' arts of painting, sculpture, and architecture and so-called artisan crafts – decorative arts design and fabrication (plates 20, 21). The Red House collaboration consolidated the Pre-Raphaelites' interest in the applied arts. And with the ultimate success of Morris & Co. (plate 19) William Morris established a widely influential commercial enterprise focused on the home as a centre of simple comfort and beauty, with designs based on simplicity of form, quality workmanship and truth to materials.

Few Victorian artist studio-houses survive intact, the grand exception being Leighton's house in Holland Park, now a museum.[19] But architects Webb, Richard Norman Shaw, William Eden Nesfield and Edward Godwin, among others, built homes and planned interior schemes for 'artistic' people as well as practising artists. The Gothic Revival gave way to the Queen Anne style based on seventeenth- and eighteenth-century Dutch and English designs. Its charming characteristic elements – exposed red brick, crisp white trim, moulded terracotta ornament and a play of solids and voids – became the rage in the 1870s and 1880s. Today a walk through London's Bedford Park, the first planned garden suburb, re-creates the charming atmosphere achieved when Aesthetic principles took over the streets.

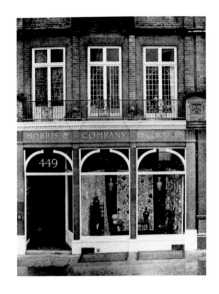

19
Morris & Co.'s shop on Oxford Street, London
Photograph, c.1885

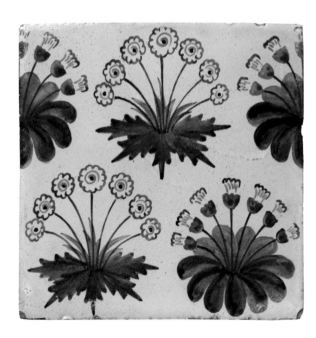

20
William Morris, *Daisy* tile
Hand painted on tin-glazed earthenware Dutch blank by Morris, Marshall, Faulkner & Co., 1870s
V&A: C.58–1931

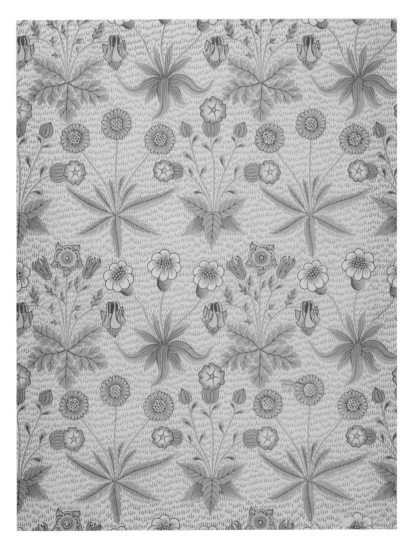

21
William Morris, *Daisy* wallpaper
Block printed in distemper colours by Jeffrey & Co. for Morris, Marshall, Faulkner & Co., 1864
V&A: E.442–1919

BEAUTY IN THE HOME: FURNISHING THE ARTISTIC INTERIOR

I have found that all ugly things are made by those who strive to make something beautiful, and that all beautiful things are made by those who strive to make something useful.
Oscar Wilde, 1883[20]

22

James McNeill Whistler, *Harmony in Grey and Green: Miss Cicely Alexander*
Oil on canvas, 1872–4
Tate, London

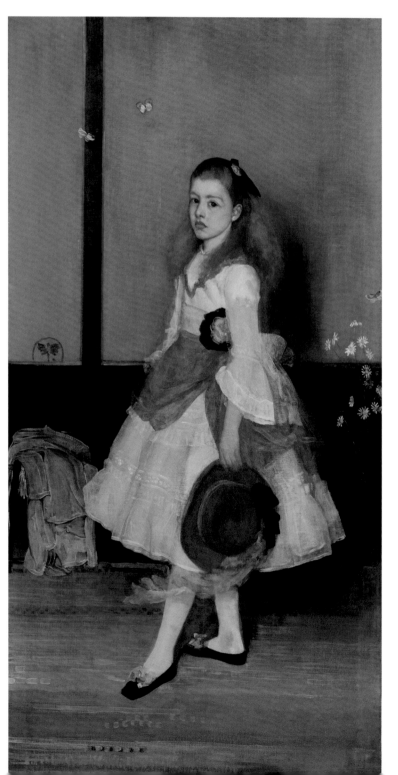

The Aesthetes' eccentric lifestyles piqued public fascination, fuelling a vogue for things 'Artistic', whether an expensive redesign by a fashionable architect or the acquisition of a single Japanese fan for the mantelpiece. Manufacturers and new commercial ventures responded to the demand, making distinctive items available at various price points, attractive to even a modest budget. The middle-class home became the object of Aesthetic proselytizing and an avalanche of 'How To' publications offered guidance. This vast literature, the precursor of our modern magazine and self-help industries, addressed the entirety of the domestic sphere: dress and self-adornment, household management, gardening and flower arranging, and 'Painting, Woodwork, and Furniture': room-by-room decoration 'From Kitchen to Garret'.[21] Emphasis fell on no particular style, but rather on the graceful disposition of eclectic but artful furnishings expressive of personal taste.

The flamboyant author and self-appointed style guru Oscar Wilde had much to say about creating 'The House Beautiful'.[22] He covered each aspect of domestic decoration and (looking beyond marvellous linguistic flourishes) gave some common sense advice. For example, stained glass can reduce the glare from a large window and fill a room with more subtle lighting.[23] Wall colour, of course, establishes the mood of any room and Morris famously instructed, 'Whatever you have in your rooms, think first of the walls'.[24] The artistic palette consisted of secondary colours (orange, green and purple) and tertiary colours (any mixture of secondary colours). Whether walls were painted or papered or both, favourites included soft natural varieties of gold, terracotta, blue, grey, brown, and an imaginative range of greens: blue-green, yellow-green, moss-green, 'Nile-green', etc., as well as delicate yellow, peach, and violet. Often these colours played against black woodwork, creating handsome harmonies (plate 22). As Wilde explained, one's brightly coloured treasures show most effectively against a muted colour scheme.[25] Artistic wallpapers feature flat, abstracted

or stylized patterns that coordinate in novel treatments, most characteristically the wall's tripartite division into zones of different colour and/or pattern. George Aitchison's tightly choreographed *Design for a Staircase Well, No. 1 Grosvenor Crescent, Belgravia, London* (plate 23) provides one interpretation. Numerous suppliers featured wallpapers and complementary textiles to add sophistication to any room. The most fashionable 'Art Fabrics' were marketed by Liberty's department store, London's new showcase and emporium of Aesthetic furnishings, many of Asian design.

The artful home showcased an array of Artistic bric-a-brac, items of modern production or favoured antiques collected and tastefully incorporated into the mix. But items of Japanese origin or inspiration took pride of place. Japan's forced opening to foreign trade in 1853 revitalized the European veneration of things Japanese exemplified by England's passion for old 'Blue-and-White' Asian ceramics. Extensive displays at the Old Water Colour Society and the 1862 International Exhibition's Japanese Court (plate 24) introduced a wider audience to enticingly 'exotic' Japanese forms. A Japanese inflection – featuring asymmetry, flat patterning, simplified form and elegant surface ornament – became a hallmark of the Aesthetic vocabulary, evidenced in paintings and throughout the applied arts from furniture to ceramics, wallpapers, textiles and metalwork (plate 25).

Furniture forms also received retooling by Aesthetic designers. Unlike the heavily ornamented curvilinear Louis XIV and XV styles so popular with Victorian consumers, Artistic furniture is elegant and spare in its linear form and surface ornament. It appears deceptively 'modern' to today's eye; but in actuality Aesthetic designs reference Asian, Egyptian, Greek, vernacular, and even delicate eighteenth-century English examples. Preferred furniture types – most popularly sideboards, corner and hanging cupboards, and overmantels – created the display platform for treasured items, including the ever-present blue-and-white china. Three-dimensional compartments for display were echoed in compartmentalized and asymmetrical surface decoration, a ubiquitous design strategy adapting Asian aesthetics. A magnificent example designed by Godwin and painted by Whistler was featured in London furniture maker William Watt's exhibition stand (itself called 'Harmony in Yellow and Gold') at the 1878 Paris Exposition Universelle, bringing international notoriety to British Aesthetic design (plate 26). Manufacturing and commercial establishments launched their own 'Art' lines engaging versatile celebrity designers, including Godwin, Dresser, Walter Crane, and Lewis Foreman Day to produce designs for all types of furnishings, including ceramics and metalwork (plate 27). Although 'one of the motivating forces of the Aesthetic Movement was the antipathy of the art world to the products of industry and the machine … ironically enough, by the early 1870s "art" was becoming a profitable adjunct of many an established business'.[26]

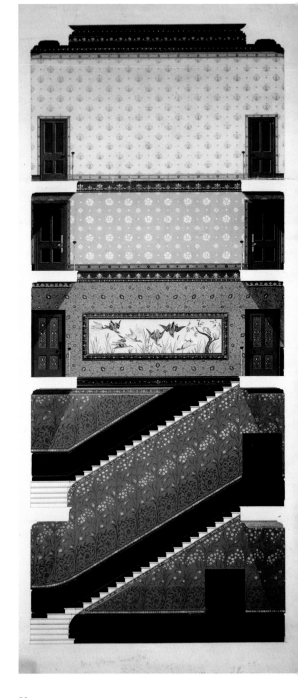

23
George Aitchison, *Study for a Staircase Well, No. 1 Grosvenor Crescent, Belgravia, London*
Watercolour on paper, c.1887
Royal Institute of British Architects, London

AESTHETICISM COMMERCIALISED: FASHION AND POPULAR TASTE

Victorian England shaped many modern patterns of consumerism, including the commodification of art and the art experience. To collect Aesthetic paintings or Artistic decorative works underscored personal discernment and could, in turn, bestow social distinction on the collector; thus the artworks themselves had inherent and social as well as commercial

24
The Japanese Court at the International
Exhibition of 1862, South Kensington
Engraving from the *Illustrated London News*,
20 September 1862
V&A: NAL

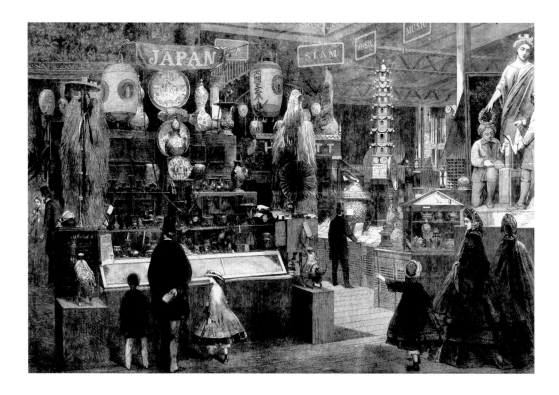

25
Edward Godwin, easel
Ebonized wood, tooled leather, brass fittings,
c.1870,
Wolfsonian-Florida International University,
Miami, Florida

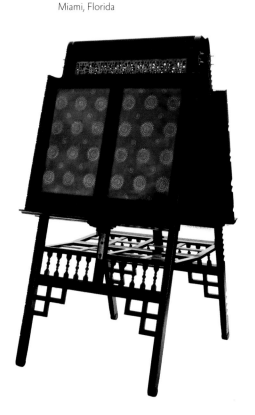

value. In the 1880s Frederic Leighton acknowledged that 'the works of artists [are] sought for indeed but too often as a profitable merchandise or a vehicle of speculation'.[27] How 'to reconcile Art with industrial capitalism' and to create for a role for the artist in a consumer society remains an issue to this day.[28] And, as amateur artist and businessman Sir Coutts Lindsay, founder of the Grosvenor Gallery, understood, artists who wished to live as bohemian elites nonetheless needed to function within society and the realm of commerce.[29]

The contentious and ever-strengthening bond between art and commerce during the late Victorian period can be traced through proliferating outlets for the consumption of art and artistic wares. Aestheticism spread beyond its original narrow confines and even beyond special venues like the Grosvenor Gallery and Bedford Park into mainstream material culture. The Cult of Beauty was appropriated – some would say vulgarized – by ardent devotees, as well as business interests hoping to capitalize on the craze.

In the 1880s the Aesthetic Movement, as any fad, became an object of parody, most wittily satirized in the operetta *Patience or Bunthorne's Bride: An Aesthetic Opera* (see plate 166) and in *Punch* cartoons presenting a delightful cast of thinly disguised players. Indeed, the public identities crafted by leading Aesthetes seemed ready-made parodies of themselves, and the comedy theatre took advantage of their affectations. Such playful spoofs, combined with the ridicule embodied in all those witty cartoons, undermined the Aesthetic Movement's ultimate goal to bring beauty into the everyday lives of ordinary people. Producer Richard D'Oyly Carte suggested this in his apologia for *Patience*:

The 'movement' in the direction of a more artistic feeling … doubtless did
much to render our everyday existence more pleasant and more beautiful.

26
Edward Godwin, 'Butterfly' cabinet
Mahogany with oil-painted
decoration, yellow tiles, brass
mouldings, glass, made by
William Watt, with painted
decoration by James McNeill
Whistler, 1877–8
Hunterian Museum and Art
Gallery, University of Glasgow

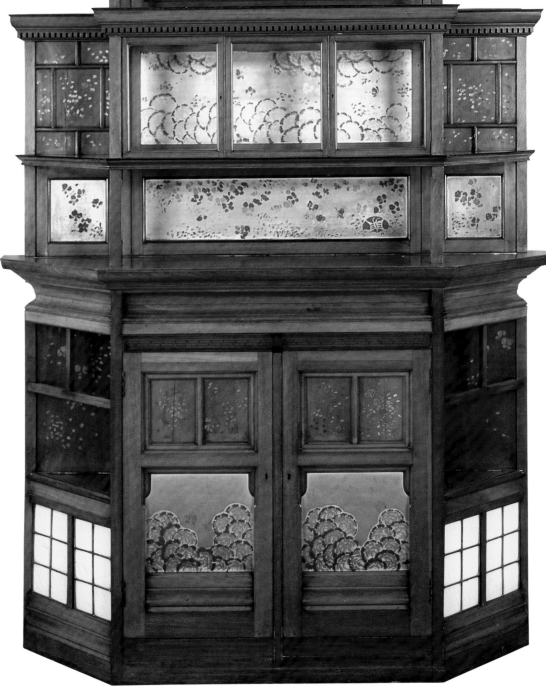

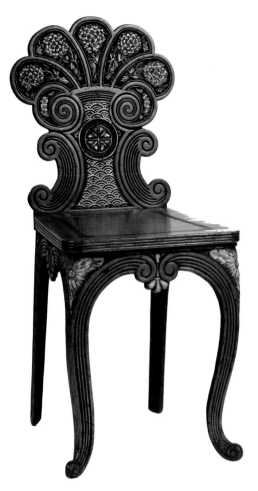

27
Thomas Jeckyll, hall chair
Cast iron, made by Barnard,
Bishop & Barnard, Norwich, c.1878
The Birkenhead Collection

Latterly, however, their pure and healthy teaching has given place to the outpourings of a clique of professors of ultra-refinement who preach the gospel of morbid languor and sickly sensuousness … the authors of *Patience* have not desired to cast ridicule on the true aesthetic spirit, but only to attack the unmanly oddities which masquerade as its likeness.[30]

This last comment boded ill for Wilde and the Aesthetic Movement.

LATE-FLOWERING BEAUTY, 1880s–90s

In the 1880s and 1890s Aesthetic painting had a last, grand flowering. These masterworks share a powerful suggestiveness of suppressed emotion, an internalization that speaks eloquently, particularly when intensified by heightened physicality. 'Beauty reveals everything, because it expresses nothing'[31]: the truth of Wilde's statement is borne out in commanding late paintings of magnificent scale, colour and form. Through the consummate handling of paint and choreographed composition, Leighton and others conjured up images removed from the contemporary world, yet evocative of the modern human condition (see plate 11). Parallel achievements are seen in the sister arts of photography and the brief revitalization of British sculpture, termed 'The New Sculpture'. Regardless of medium, the Aesthetic artists sought subtle and elegant effects.

DECADENCE

Aestheticism's late, mannered form found expression in the Decadence of the 1890s. However, from the first, Aestheticism had detractors suspicious of the lifestyle of its artists and the amorality of its imagery. By the 1890s, new French inflections, much more dangerous than Whistler's importations of the 1860s, coloured the British Aesthetic voice. Self-indulgent and self-destructive ideas of Paul Verlaine, Stéphane Mallarmé, Arthur Rimbaud and Joris-Karl Huysmans found resonance with those familiar with Pater's admonition to seek passion and sensation for their own sakes. Criticism intensified, as personified in the brief career of Aubrey Beardsley. The exquisite beauty of his tenuous calligraphy and consummate balance of black and white and solids and voids could not outweigh the self-consciously provocative imagery.

The intersection of homosexuality (outlawed in 1885), Aestheticism and resurgent Catholicism tainted the Aesthetic project. Some found disturbing parallels between Aestheticism's deification of beauty and the Catholic Church's linkage of beauty, piety and the senses – senses purposely stimulated by ornate architectural spaces, elaborate rituals, music and incense, costly vestments of velvet and gold thread, and images of passionate saints. Scarred by more than a century of virulent sectarian violence, which subsided only with the Restoration of Charles II (reigned 1660–85), Protestant England held Catholicism as highly threatening. Not until 1832 had the prohibition against Catholics serving in the English government been lifted. And religious issues still deeply troubled the Victorians. Indeed, Wilde identified Ernest Renan along with Charles Darwin as determinant figures in human history: 'Not to recognize this is to miss the meaning of one of the most important

eras in the progress of the world.'[32] Wilde noted one to be 'the critic of the Book of nature, and the other the critic of the books of God'[33]. The scientific and critical arguments of Darwin, Renan and others undercut Christian beliefs; their cumulative revelations provoked cynicism and religious tensions that unsettled British society and coloured public discourse.

Aestheticism could not withstand the further scandal of the 1895 trial, conviction and imprisonment of Oscar Wilde for homosexuality. The fall of Wilde effectively discredited the Aesthetic Movement with the general public. However, with new devotion to the cultivation of any experience for its own sake, Aestheticism had been transmuted into Decadence. And it is in part this association that initially hindered the objective reassessment of Aestheticism and its role as a crucial step in the late-nineteenth-century movement toward modernity. 'These Victorians are intolerable', proclaimed British critic Clive Bell in 1914, staking Modernism's independence from the previous generation.[34] In 1910 Roger Fry had established the twentieth-century narrative repudiating British Aestheticism and privileging instead French Post-Impressionism with its insistence on '"significant form" rigorously divorced from "associated ideas"'.[35] It is now recognized that Fry and Bell, and later the American critic Clement Greenberg, adopted the vocabulary of Aesthetic criticism, while ignoring Aestheticism's own formalism as a precursor to modernist concerns.[36] This prejudice continued late into the twentieth century and has only begun to be rectified. Discounted on numerous grounds – reticent technique, historicizing imagery, disengagement from contemporary political or social events, gender issues – Victorian Aestheticism has also been tainted by its association with artistic beauty, a concept much debased in our own time.

As our story unfolds here, the extraordinary breadth of creative power exhibited by the artists, architects and designers of Aesthetic temperament will be evident. Initially materializing in poetry, painting, and art criticism, the Cult of Beauty celebrated art for art's sake and delighted in elegant form and nuanced colour without the necessity of specific subject. Elegance itself became a vehicle for expression. Widely popularized, the Aesthetic Movement introduced into the Artistic home exquisite objects to be handled, contemplated and appreciated for their physical qualities. This invitation to savour formal beauty unites all the various areas of Aesthetic creation, from its poetry and paintings to the wealth of furnishings designed to make beauty part of the rhythm of daily life and thus nourish the spirit. The aim is a spare and elegant harmony of form and decoration so compelling that it holds our attention long enough to enjoy and ponder the physical realities of beauty. Disenchanted with the materialism of the modern industrial age, Aestheticism's true adherents believed that the company of artists formed a cultural elite who could lead the initiated to beauty. Once there, Aestheticism promised a rich visual experience that resonates with deep but unspecified meaning, because truly 'the hours when the mind is absorbed by beauty are the only hours we live'.[37]

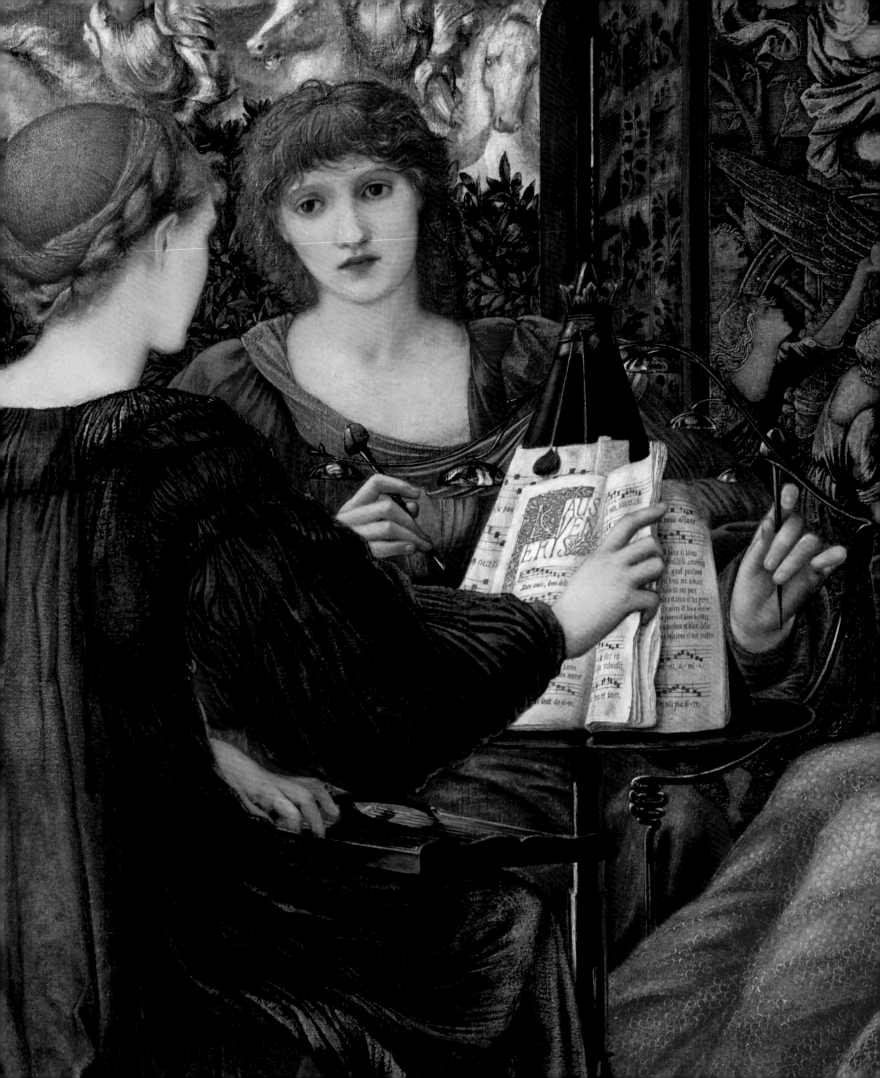

I Literature and the Aesthetic Movement

LITERATURE AND THE AESTHETIC MOVEMENT

Susan Owens

IT IS A PARADOX of Aestheticism that just when painting was becoming less 'literary' than ever before, its relationship with literature itself was a notably close one. From the late 1850s onwards, friendships, collaborations and shared interests between artists and poets gave rise to numerous connected or parallel projects, establishing a close link between painting and poetry which became a defining characteristic of the Aesthetic Movement.

Some of the most fruitful of these friendships were made in 1857 when Algernon Charles Swinburne (plate 28), then an undergraduate at Balliol College, Oxford, first entered the circle of Dante Gabriel Rossetti, Edward Burne-Jones and William Morris. At this time the three older friends were engaged in a collaborative project to decorate the walls and ceiling of the Oxford Union debating chamber with frescoes of subjects from Thomas Malory's cycle of Arthurian legends, the *Morte D'Arthur*. As this suggests, visual art and literature were of equal importance to the group. Rossetti and Morris were both poets as well as painters, and Burne-Jones was one of the most literary of artists; Henry James later remarked that he 'paints, we may almost say, with a pen'.[1] Their interests chimed with those of the literary scholar Swinburne, who even at this date was passionate about the visual arts, and who would go on to write many poems directly inspired by individual paintings and sculptures.

Their common interests soon resulted in shared subject matter. Three densely detailed watercolours with medieval subjects, painted by Rossetti around 1857 – *The Tune of Seven Towers* (Tate, London), *The Blue Closet* (plate 29) and *A Christmas Carol* (Fogg Art Museum, Cambridge, MA) – directly inspired poems by Morris and Swinburne.[2] Rossetti's pictures lacked ostensible narratives (he laconically described *The Blue Closet* as 'some people playing music') and in keeping with this, Morris's poem 'The Blue Closet' sets out principally to evoke a series of moods rather than to relate an involved story. It does this through the musicality and repetitive rhymes and refrains of the medieval ballad form:

> Lady Alice, Lady Louise,
> Between the wash of the tumbling seas
> We are ready to sing, if so ye please;
> So lay your long hands on the keys;
> Sing, 'Laudate pueri.'
>
> And ever the great bell overhead
> Boom'd in the wind a knell for the dead,
> Though no one toll'd it, a knell for the dead.[3]

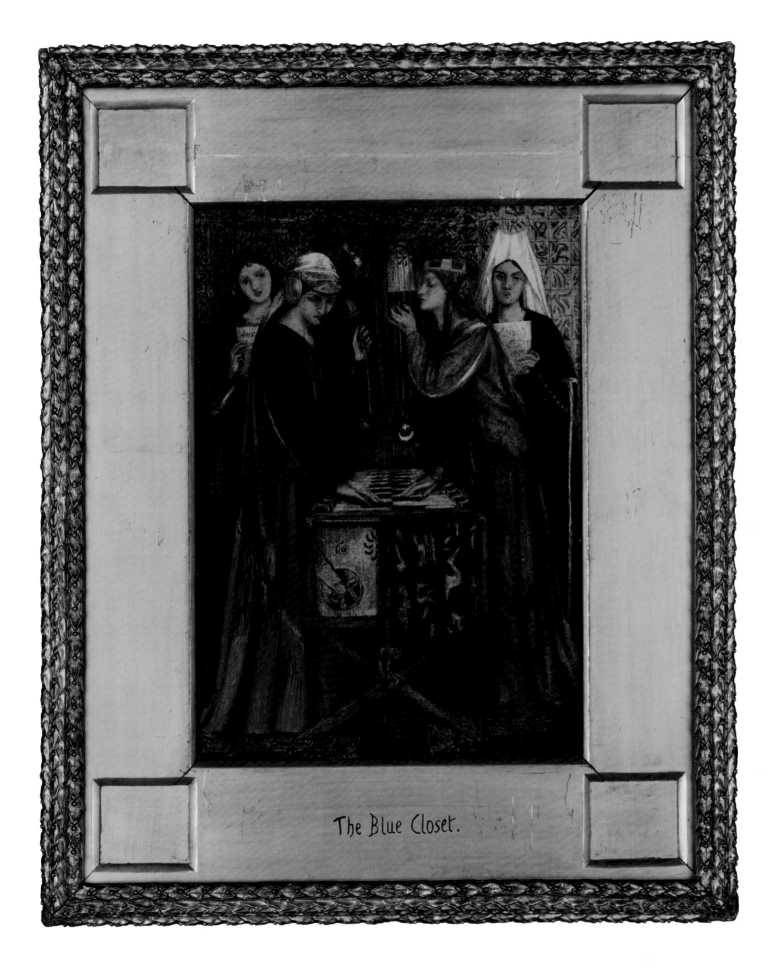

The Blue Closet.

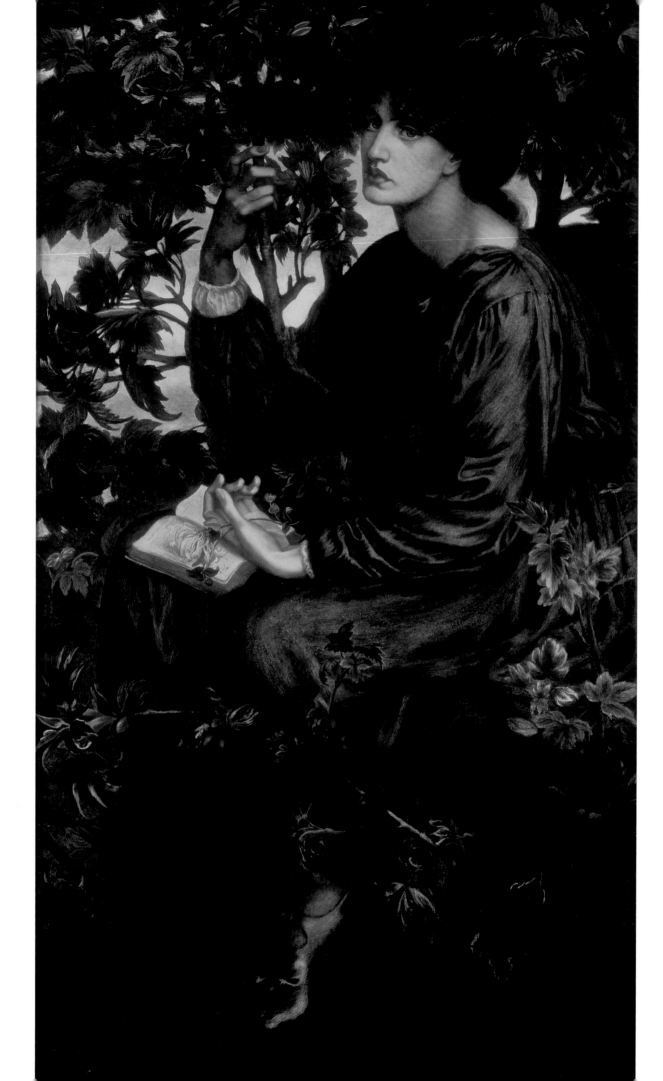

Rossetti later stressed that Morris's and Swinburne's poems were independent works, and that they did not illustrate his watercolours: 'the poems were the result of the pictures, but don't at all tally to any purpose with them though beautiful in themselves.'[4] This idea of common inspiration but mutual independence – a symptom of art's intrinsic value – would be a defining factor in the developing relationship between Aesthetic painting and literature.

This idea is powerfully reflected in Rossetti's own artistic practice. He had composed poems to accompany his paintings throughout his career, from his first oil *The Girlhood of Mary Virgin* (1849; Tate, London) to his last, a version of *Proserpine* (1882; Birmingham Museums and Art Gallery), and wrote a number of sonnets on Old Master paintings, published in his 1870 *Poems* as a section entitled 'Sonnets for Pictures'. Rossetti's poems generally do not seek to give verbal descriptions of paintings, but rather to explore related themes. The sonnet to accompany *The Day Dream* (plate 30), written after the painting's completion, is a meditation on temporality which was suggested by the prolonged process of the painting's execution, during which the spring theme planned by Rossetti became untenable because of the burgeoning foliage of the sycamore tree in which his model, Jane Morris, was posed:

> The thronged boughs of the shadowy sycamore
> Still bear young leaflets half the summer through;
> From when the robin 'gainst the unhidden blue
> Perched dark, till now, deep in the leafy core,
> The embowered throstle's urgent wood-notes soar
> Through summer silence. Still the leaves come new;
> Yet never rosy-sheathed as those which drew
> Their spiral tongues from spring-buds heretofore.
>
> Within the branching shade of Reverie
> Dreams even may spring till autumn; yet none be
> Like woman's budding day-dream spirit-fann'd.
> Lo! Tow'rd deep skies, not deeper than her look,
> She dreams; till now on her forgotten book
> Drops the forgotten blossom from her hand.[5]

The sonnet is inscribed on the picture frame, a literal manifestation of a pairing which became known in Rossetti's oeuvre as the 'double work of art', a phrase usefully suggesting an equal relationship between painting and poetry. And as Swinburne remarked, even in these 'double works' each element retained its essential independence, with 'no confusion of claims, no invasion of rights'.[6]

Back in London in the late 1850s and early 1860s there followed several years of intense cross fertilization, when Rossetti, Burne-Jones, Morris and Swinburne, much in each other's company, continued to share subject matter. During this time Rossetti used Swinburne, who lodged on and off in his Chelsea house, as a model on numerous

OPPOSITE
30
Dante Gabriel Rossetti, *The Day Dream*
Oil on canvas, 1880
V&A: CAI.3

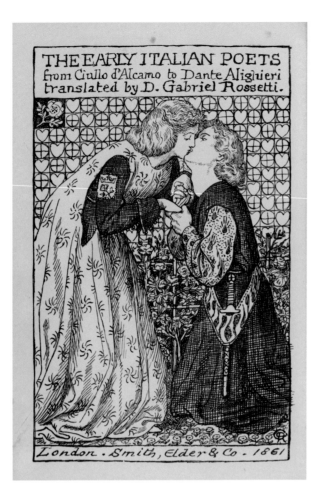

31
Dante Gabriel Rossetti,
wood engraving for
which Swinburne posed
Intended as a frontispiece
for *The Early Italian Poets
from Ciullo d'Alcamo to
Dante Alighieri, translated
by D.G. Rossetti*, published by
Smith, Elder & Co., 1861
Stephen Calloway collection

occasions (plate 31). One passionate enthusiasm common to all at this time was Edward FitzGerald's translation, published in 1859, of the twelfth-century Persian poem, *The Rubáiyát of Omar Khayyám*. Rossetti first heard about this book in January 1861 after it had been remaindered and was on sale for a penny outside a London bookshop, at which point he and Swinburne bought numerous copies, one of which Swinburne presented to Burne-Jones.[7] The poem, cynical about human grandeur and divine providence, exalts the pleasures of the senses and the fleeting moment with a sentiment anticipating Walter Pater's 'conclusion' to *Studies in the History of the Renaissance* (1873):

> Here with a Loaf of Bread beneath the Bough,
> A flask of Wine, a Book of Verse – and Thou
> Beside my singing in the Wilderness –
> And Wilderness is Paradise enow.

The *Rubáiyát* became a talismanic book for the group, who responded to its hedonistic affirmation of the pleasures of the here and now.[8] Swinburne recited the poem to his friends,[9] and Burne-Jones later wrote of Omar Khayyám's 'splendid blasphemies'.[10] Such was the importance they attached to the poem that when in the early 1870s Morris began to

practise calligraphy he made four versions of the *Rubáiyát*, including one with illustrations by Burne-Jones (plate 32).[11] According to George Meredith, another lodger in Rossetti's house, Swinburne's poem 'Laus Veneris', a version of the medieval Venus and Tannhäuser legend and eventually published in *Poems and Ballads* (1866), was begun shortly after their discovery of FitzGerald's translation as 'a compliment' to the *Rubáiyát*.[12] The subjects of the two poems are very different; what Swinburne sought to replicate was the form, the four-line stanzas or quatrains (the *rubais* of the title) and FitzGerald's iambic pentameter:

> Asleep or waking is it? for her neck,
> Kissed over close, wears yet a purple speck
> Wherein the pained blood falters and goes out;
> Soft, and stung softly – fairer for a fleck.

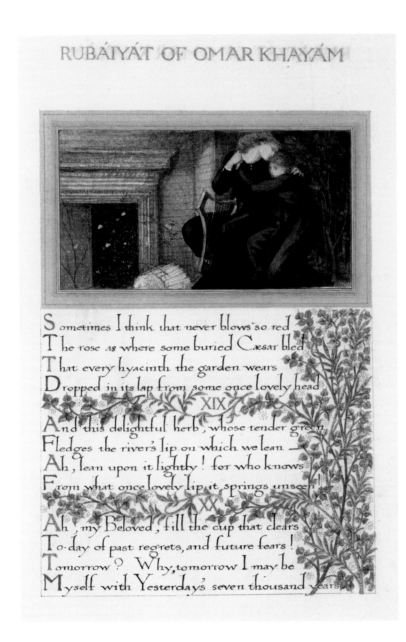

32
William Morris and
Edward Burne-Jones,
*The Rubáiyát of
Omar Khayyám*
Illuminated manuscript,
1872
Private collection

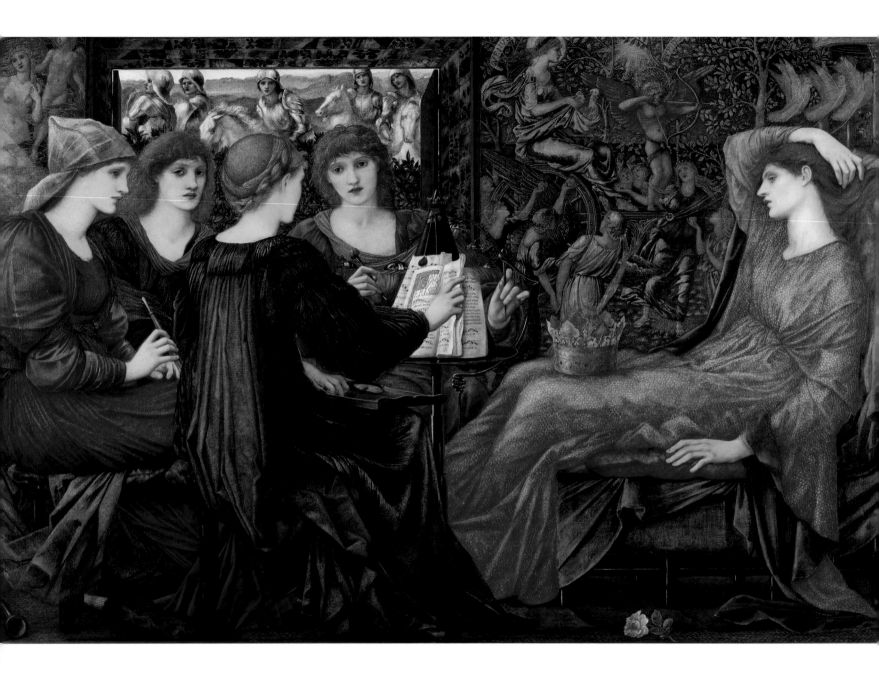

33
Edward Burne-Jones, *Laus Veneris*
Oil on canvas, 1873–8
Laing Art Gallery, Newcastle upon Tyne

Burne-Jones, at this time an intimate friend of Swinburne, painted a watercolour composition entitled *Laus Veneris* (now lost) also in 1861, on which he was later to base his oil painting of the same name (plate 33). The paintings were almost certainly made as parallels to Swinburne's poem. They share a heady, sensual atmosphere, and the poem's repeated use of the words 'blood', 'fire', 'hot' and 'red', its frequent evocations of perfume, steam and fumes, and lines such as 'Inside the Horsel here the air is hot;' and 'Night falls like fire; the heavy lights run low' correspond closely to the rich orange and red tones of the painting and its claustrophic space.[13]

A new interest in sixteenth-century themes began to supersede the group's previously entrenched medievalism at the end of the 1850s. This enthusiasm was almost certainly introduced to the group by Swinburne, a passionate devotee and early champion of the

Elizabethan and Japlateean dramatists at a time when they were little regarded, who published valuable studies on George Chapman, Christopher Marlowe, Thomas Middleton and Cyril Tourneur. The resulting period of transition from medievalizing works to those with Renaissance themes is exemplified by Swinburne's 1860 volume (dedicated to Rossetti) containing the verse-plays *Rosamond* and *The Queen Mother*, which encompassed both areas of historicist interest. Rosamond told the story of Rosamund Clifford, the mistress of the twelfth-century English king Henry II, while *The Queen Mother* concerned Catherine de' Medici and the massacre of St Bartholomew of 1572. Similarly, Rossetti's painting *Fair Rosamund* (plate 34) adopted the same medieval subject as Swinburne but applied to it a treatment derived from a sixteenth-century Venetian model, recalling the rich colouration of Palma Vecchio and Titian.[14]

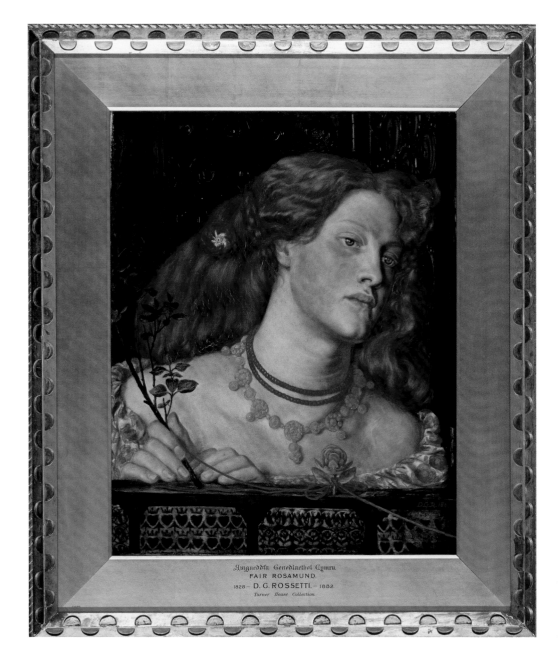

34
Dante Gabriel Rossetti, *Fair Rosamund*
Oil on canvas, 1861
National Museums and Galleries
of Wales, Cardiff

35
Dante Gabriel Rossetti, *Borgia*
Watercolour, 1851–9
Tullie House City Museum and Art
Gallery, Carlisle

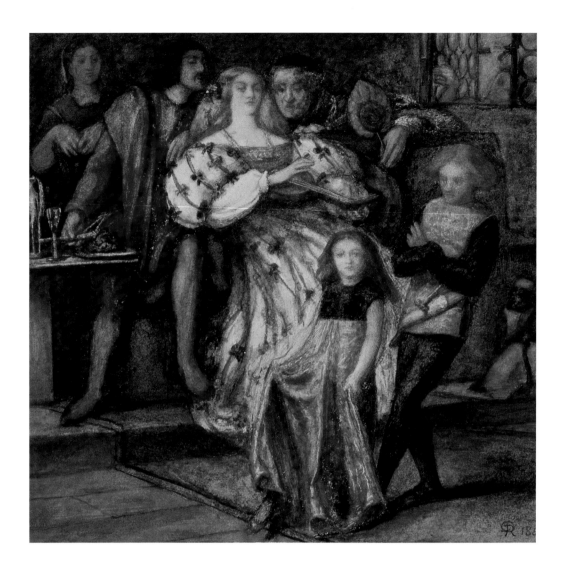

Renaissance crimes, especially those committed by femmes fatales, were of compelling interest to the group at this time. The Borgia family was the subject of a watercolour by Rossetti, originally conceived in 1851 as a scene from Shakespeare's *Richard III,* but which, tellingly, he retrieved and converted into a Borgia subject at the end of 1858 or beginning of 1859 (plate 35).[15] In 1861 Swinburne described plans to write a story about the infamous Lucrezia Borgia, with whom he was fascinated, referring to her as his 'blessedest pet'.[16] This idea eventually produced the pair of poems 'A Ballad of Life' and 'A Ballad of Death'. These seem to have been inspired by Rossetti's watercolour, which shows Lucrezia Borgia playing a lute, accompanied by two men (an earlier pen-and-ink study shows three) who cluster lecherously around her.[17]

> There were three men with her, each garmented
> With gold and shod with gold upon the feet;
> And with plucked ears of wheat
> The first man's hair was wound upon his head:

His face was red, and his mouth curled and sad;
All his gold garment had
Pale stains of dust and rust.
A riven hood was pulled across his eyes;
The token of him being upon this wise
Made for a sign of Lust.[18]

What is significant is how these shared themes reveal a marked shift of affiliation away from a Ruskinian medievalism, which implied a profound sense of the craftsman's engagement with society, towards the Renaissance, when the status of the artist was highly privileged. This reflects the trajectory which the group – with the exception of Morris – was to follow into the elitist position associated with Aestheticism.

Another vital source of Aesthetic thought arrived from France in the early 1860s. Again, Swinburne, who was well read in the mainstreams, tributaries and some underground streams of French literature, was the principal conduit for the introduction of these new ideas. The seminal book was Théophile Gautier's *Mademoiselle de Maupin* (1835), which, in a sonnet, Swinburne named his 'golden book of spirit and sense' and 'holy writ of beauty'. Perhaps more important than the novel itself was the author's lengthy preface to the book, a passionate and provocative argument against utilitarianism. Gautier rails against modern philistine materialism and declares his exclusive love of beauty: 'I would most gladly renounce all my rights as a Frenchman and a citizen to see an authentic Raphael painting, or a beautiful woman in the nude.'[19] Swinburne made frequent admiring references to *Mademoiselle de Maupin* both in published works and private letters; for him it was and remained the fundamental articulation of art for art's sake.

The other work which exerted a great influence on Swinburne's thought was Charles Baudelaire's collection of poems *Les Fleurs du Mal* which had been published in Paris in 1857. These poems, which dwell on the profoundly degenerate themes of degrading lusts and sickening ennui, and the squalor and ugliness of contemporary life, created a sensation. Reaction was swift: the book was seized by the authorities on its publication, and the poet charged with offences against public morality. Swinburne's enthusiastic review – or defence – of *Les Fleurs du Mal*, published in the *Spectator* in 1862, the year of the book's reissue in expurgated form, was the first critical notice of the poems in England.[20] In his review Swinburne argued for the supremacy of art, articulating the central Aesthetic idea that artistic treatment rather than subject matter was pre-eminently important: 'even of the loathsomest bodily putrescence and decay [Baudelaire] can make some noble use.'[21] Swinburne used the review as a platform from which to argue the sheer irrelevance of a moral agenda to poetry, writing that 'a poet's business is presumably to write good verses, and by no means to redeem the age and remould society'.[22] This was a position to which he would return in 1866 after the publication of his own *Poems and Ballads* – a collection which owed much to Baudelaire.[23]

French models were important in other ways, too. Baudelaire, like Swinburne, was one of the principal art critics of the day and a close friend of artists. Among his friends was

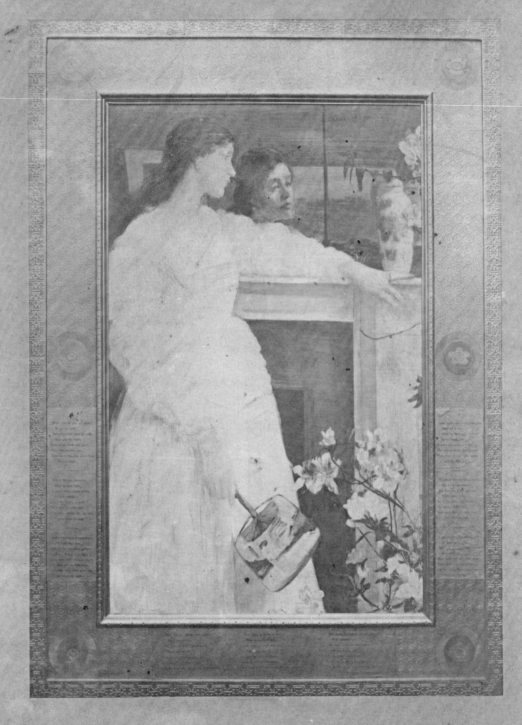

To Swinburne — from J McNeill Whistler

Edouard Manet, and when in March 1863 Manet's painting *Lola de Valence* (Musée d'Orsay, Paris) was exhibited at the Société Nationale des Beaux-Arts, it was with a short poem by Baudelaire attached to the frame.[24] Swinburne and the Francophile James McNeill Whistler, who had met each other through Rossetti in the early 1860s and became close friends, initiated a comparable collaboration, probably resulting directly from having seen *Lola* during a visit they made to Paris together during the time of its exhibition.[25] Swinburne wrote the poem 'Before the Mirror' in response to Whistler's painting *The Little White Girl* (plate 36), and when the painting was exhibited at the Royal Academy in 1865 the poem, inscribed on gold paper, was pasted to the frame.[26] The painting itself offers no obvious narrative, and Whistler's title, which hinted little enough at an anecdotal meaning, was later changed to *Symphony in White No. 2*, which – deliberately – intimated even less. Swinburne's poem 'Before the Mirror' addresses this question:

> Behind the veil, forbidden,
> Shut up from sight,
> Love, is there sorrow hidden,
> Is there delight?[27]

The second stanza-group is spoken by the young woman herself, as she reflects on her image in the mirror and concludes that there is no access to her own narrative:

> I cannot see what pleasures
> Or what pains were;
> What pale new loves and treasures
> New years will bear;
> What beam will fall, what shower,
> What grief or joy or dower;
> But one thing knows the flower; the flower is fair.[28]

Her conclusion speaks for the importance of a contemplation of beauty, a central tenet of Aestheticism, and evokes Keats's 'Beauty is truth, truth beauty, – that is all / Ye know on earth, and all ye need to know'. There is no attempt in Swinburne's poem to explain the painting or to offer a narrative. The parallelism of painting and poem is essentially the same here as in Rossetti's double works of art.

In addition to numerous direct collaborations, literature shared more general territory with painting, and the classicism of painters such as Leighton and Poynter had a literary counterpart. William Morris's interests, once so firmly embedded in the medieval, had become attached to classical tales. Following his first published collection of poems *The Defence of Guenevere* (1858), all of which had medieval settings, *The Life and Death of Jason* (1867) and the verse tales forming the cycle of the *Earthly Paradise* (1868–70) all largely derive from classical myth. Swinburne, a considerable scholar in this area, wrote the verse drama *Atalanta in Calydon* (1865) in classical Greek metre. This work, which established

OPPOSITE
36
James McNeill Whistler, *The Little White Girl*, in its original frame with Swinburne's poem, inscribed on gold paper, pasted to it
Photograph inscribed 'To Swinburne / from J. McNeill Whistler'
Mark Samuels Lasner collection

his reputation as a master of metrical form, offers even more specific parallels to the kinds of paintings which were being popularized at this time by Albert Moore and Alma Tadema with classical subjects and suppressed narratives:

> And Pan by noon and Bacchus by night,
> Fleeter of foot than the fleet-foot kid,
> Follows with dancing and fills with delight
> The Maenad and the Bassarid;
> And soft as lips that laugh and hide
> The laughing leaves of the trees divide,
> And screen from seeing and leave in sight
> The god pursuing, the maiden hid.[29]

The musicality of individual words coupled with the bouncing rhythm and rapid pace of the lines create a series of fleeting impressions rather than a defined narrative. As Pater was to write in his essay 'The School of Giorgione', 'the very perfection of such poetry often appears to depend, in part, on a certain suppression or vagueness of mere subject, so that the meaning reaches us through ways not distinctly traceable by the understanding…'.[30]

Swinburne's most important collection, *Poems and Ballads*, was published in 1866 with a dedicatory poem to Burne-Jones: '… receive in your palace of painting / This revel of rhymes'.[31] These poems amply demonstrate a renewed interest, characteristic of Aestheticism, in the varieties of poetic form. During this period a number of virtually obsolete kinds were resurrected; Swinburne himself experimented with more verse forms than any other major Victorian poet, using around 420 to Tennyson's 240 and Browning's 200.[32] Poems in the collection adopt the French *ballade*, *alba* and *rondeau*, the Italian *canzone* and the medieval carol, in a virtuoso display of metrical versatility.[33]

This experimentation with metrical form reflects the increased value which Aesthetic literature placed on formal values and the deliberate crafting of a work of art. The displacement of value in a literary work from subject to treatment had been forcefully advocated by Edgar Allan Poe, whose writings, adopted by French poets and in particular Baudelaire, who became his translator, greatly influenced Aesthetic theories. In his essay 'The Philosophy of Composition' of 1846 Poe adopts a radical position, disputing the idea that poems are composed in moments of inspiration – what he calls a 'species of fine frenzy' – and describing his method of writing the poem 'The Raven' as purely mechanical:

> It is my design to render it manifest that no one point in its composition is referable either to accident or intuition – that the work proceeded, step by step, to its completion with the precision and rigid consequence of a mathematical problem.[34]

Essentially, here Poe discredits the Romantic idea of art as an expression of inmost feelings and proposes instead a model of creation achieved by artful construction.

In *Poems and Ballads* Swinburne frequently used or adapted unusual metres, including the trochee (a metrical foot consisting of a stressed followed by an unstressed syllable) and the dactyl (a stressed followed by two unstressed syllables), both of which produce falling rhythms. These metres were common in classical verse, but did not reflect the natural rhythm of English speech like the most commonly used iamb (an unstressed followed by a stressed syllable). Swinburne's interest in reviving classical verse forms is reflected in a poem written in the characteristic metre of Catullus, in which each line has a rather awkward eleven syllables: 'In the month of the long decline of roses / I, beholding the summer dead before me, / Set my face to the sea and journeyed silent…'.[35] The poem's title, 'Hendecasyllabics', indicates that Swinburne's chief focus in this case was on the rigorous application of an exacting poetic metre.

A number of works in *Poems and Ballads* which use classical metres also have a corresponding classical setting. However, the Olympian respectability brought to the use of classical themes in Aesthetic painting by the involvement of the Royal Academicians Leighton and Alma Tadema was absent from literature. Classicism for Swinburne was not merely an intellectual exercise in the recreation of antiquity or an aesthetic *mise-en-scène*; rather, it was exploited as an opportunity to challenge Christianity. In the 'Hymn to Proserpine' the speaking voice mourns the demise of the old pagan gods in the face of Christian doctrine, and defiantly addresses Christ in what at the time was a breathtakingly blasphemous statement:

> Thou hast conquered, O pale Galilean; the world has grown grey from thy breath;
> We have drunken of things Lethean, and fed on the fullness of death.[36]

Other notorious verses in *Poems and Ballads* extended the remit of the frank sensuality which had begun to emerge in oil paintings to include extreme sexual passion. 'Anactoria', spoken by the seventh-century Greek poetess Sappho to her unfaithful lover, contains emphatic expressions of physical cruelty:

> I would my love could kill thee; I am satiated
> With seeing thee live, and fain would have thee dead.
> I would earth had they body as fruit to eat,
> And no mouth but some serpent's found thee sweet.
> I would find grievous ways to have thee slain,
> Intense device, and superflux of pain;
> Vex thee with amorous agonies, and shake
> Life at thy lips, and leave it there to ache;
> Strain out thy soul with pangs too soft to kill,
> Intolerable interludes, and infinite ill;[37]

The poem 'Dolores' evokes a vivid, almost parodic, image of the ultimate femme fatale with distinctly Baudelairean imagery, probably drawing on two specific poems from *Les Fleurs du*

Mal, 'A une Madonne' and 'Les Litanies de Satan'. In stately metre but with evident gusto the poem describes Dolores, a blasphemous inversion of the Virgin Mary:

> Cold eyelids that hide like a jewel
> Hard eyes that grow soft for an hour;
> The heavy white limbs, and the cruel
> Red mouth like a venomous flower;
> When these are gone by with their glories,
> What shall rest of thee then, what remain,
> O mystic and sombre Dolores,
> Our Lady of Pain?[38]

For Swinburne, art for art's sake was not a morally neutral position; art was beginning to be liberated from moral constraints, and he exploited his opportunity to the utmost.

The overtly sexual and blasphemous subject matter of the contents exposed *Poems and Ballads* to exceptionally choleric attacks. One critic, parodying the phrase 'art for art's sake', complained that Swinburne was 'unclean for the sake of uncleanness', while another accused him of 'grovelling down among the nameless shameless abominations which inspire him with such frenzied delight'.[39] As a result, *Poems and Ballads* was withdrawn by its dismayed publisher Moxon, although it was immediately reissued by the distinctly less respectable firm of Hotten.[40] Swinburne replied to his critics in a pamphlet, inveighing against those 'who seek for sermons in sonnets and morality in music'.[41]

The literary background against which this collection shone so luridly was one of unprecedented moral earnestness. The 1840s and 1850s had been the heyday of the so-called 'condition of England' novel, a response to problems caused by a number of factors: the new Poor Law of 1834, which forced many people into workhouses; the failed harvests of the 1840s; and the overcrowded and dangerous living and working conditions in rapidly expanding cities and factories. Numerous works of literature, including Benjamin Disraeli's *Sybil*, or the *Two Nations* (1845), Elizabeth Gaskell's *North and South* (1854–5), Charles Kingsley's *Alton Locke* (1850) and Charles Dickens's *Hard Times* (1854), set out to expose and examine the acute social problems of the time. The writer cast him or herself as an agent of social change.

Related to this literary mission was the belief, upheld by the two of the most influential and didactic critics of the nineteenth century, John Ruskin and Matthew Arnold, in the redemptive capacity of art. It was against these powerful orthodoxies that the exponents of Aestheticism reacted by rejecting the idea that art should advance a moral agenda; this was most trenchantly expressed by Swinburne: 'Handmaid of religion, exponent of duty, servant of fact, pioneer of morality, [art] cannot in any way become.'[42] If art was to be independent of external agendas, whether moral, factual or religious, a consequence of this was an expansion of creative freedom, allowing sensuous lyricism, psychological frankness and vivid evocations of physical sensation.

The violent critical attacks meted out to Swinburne were repeated with interest

four years later, in 1870, when Rossetti published his *Poems*, a volume which included 'Jenny' ('Lazy languid laughing Jenny, / Fond of a kiss and fond of a guinea'), in which the poet muses sympathetically over the thoughts of a prostitute as she rests her head on his knee.[43] Most notoriously, it included the overtly sensuous sonnet 'Nuptial Sleep':

> At length their long kiss severed, with sweet smart:
> And as the last slow sudden drops are shed
> From sparkling eaves when all the storm has fled,
> So singly flagged the pulses of each heart.
> Their bosoms sundered, with the opening start
> Of married flowers to either side outspread
> From the knit stem; yet still their mouths, burnt red,
> Fawned on each other where they lay apart.[44]

While Swinburne could descant on amorous agonies for hundreds of lines, what Rossetti offers here is intensely physical, visceral imagery, seemingly drawn directly from the poet's own experience. In the context of another poem Pater called this 'a definiteness of sensible imagery, which seemed almost grotesque to some'.[45]

Because of their intense sensuality and Baudelairean use of modern urban subjects, Rossetti's *Poems* received one of the most vicious and personal critical attacks of the nineteenth century, Robert Buchanan's 'Fleshly School of Poetry'. In comparing Rossetti's poetry to his painting, Buchanan concluded:

> There is the same thinness and transparence of design, the same combination
> of the simple and the grotesque, the same morbid deviation from healthy forms
> of life, the same sense of weary, wasting, yet exquisite sensuality; nothing virile,
> nothing tender, nothing completely sane.[46]

Swinburne was included, and even Morris named, in Buchanan's lambast, which essentially took the very concept of art for art's sake to task. The effect on Rossetti, however, was devastating, bringing about a nervous breakdown from which he would never fully recover.

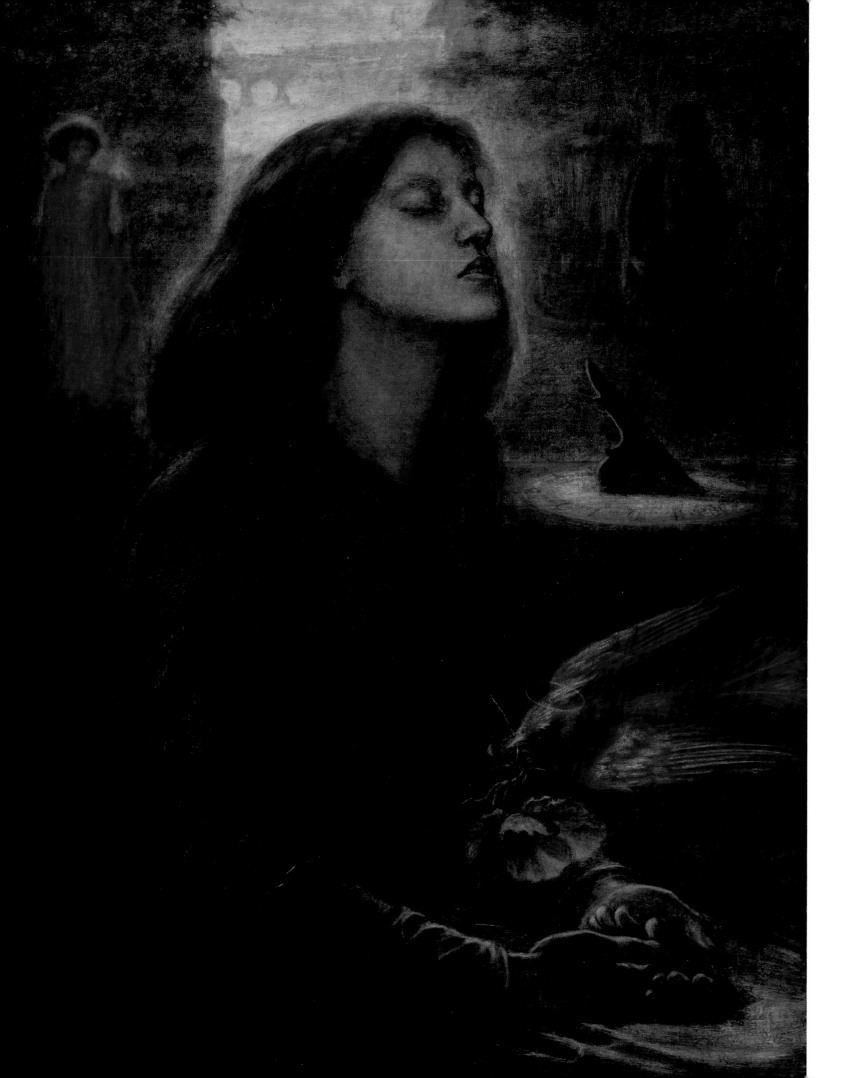

PROSE WAS AN equally important dimension of literary Aestheticism, and essays and critical writings shaped and articulated Aesthetic thought at every stage of its development. Two years after the furore of Swinburne's *Poems and Ballads* he published what was to become one of the central works of Aesthetic prose, the pamphlet *Notes on the Royal Academy Exhibition* (1868). In this essay Swinburne wrote about paintings by the artists principally associated with Aestheticism (and by no means limiting himself to those exhibited at the Royal Academy, or indeed anywhere else), including G.F. Watts's *The Wife of Pygmalion* (1868), Albert Moore's *Azaleas* (1868), Frederick Sandys' *Medea* (1868), oil sketches by Whistler, and Rossetti's *Lady Lilith* (1868) and *Sibylla Palmifera* (1866–70).

Swinburne's essay pioneered a new kind of art criticism which had ekphrasis, the literary evocation of works of art, at its heart. Unlike conventional criticism, which set out to describe, explain, contextualize and judge, Swinburne's writing created an arena for the intense contemplation of a picture. A typical passage, in this case on Rossetti's *Beata Beatrix* (plate 37), exemplifies the ways in which Swinburne conveys his own aesthetic sensations:

> Her beautiful head lies back, sad and sweet, with fast-shut eyes in a death-like trance that is not death; over it the shadow of death seems to impend, making sombre the splendour of her ample hair and tender faultless features.[47]

The language, in what is essentially a Rossettian 'double work of art', is flamboyantly poetic. The lulling rising and falling rhythm of the first part of this sentence changes abruptly at the first use of the word 'death'; in the phrase 'death-like trance that is not death' each word is stressed equally, the insistent beat creating an incantatory effect.[48] The sibilant s and f sounds are alliterated: sad/sweet; sombre/splendour; faultless/features. If Swinburne's critical writing here anticipates Pater's prose poems in the essays of *The Renaissance*, it also predicts Wilde's assertion that the critic is indeed an artist.

Walter Pater, then a young Fellow of Brasenose College, Oxford, entered the scene in November 1868 with a review, 'Poems by William Morris', an essay which did much to define Aesthetic poetry, acknowledging its tendency to historicism and contextualizing it in terms of its refinement, its separation from the 'actual world'.[49] However, it was Pater's collection of essays on subjects ranging from medieval French stories to the eighteenth-century antiquary Johann Winkelmann, published in 1873 as *Studies in the History of the Renaissance*, which became the closest thing Aestheticism ever had to a manifesto, although so strident a word could hardly be applied to Pater's oblique, subtle and allusive style. This book's message above all was that criticism could be – could only be – an entirely subjective procedure; the writer's responsibility was to convey the nuance of his own impressions. In his preface to *The Renaissance*, Pater set out questions the critic should ask: 'what is this song or picture … to *me*? What effect does it really produce on me? Does it give me pleasure? and if so, what sort or degree of pleasure?'[50] In Pater's model the critic is invited to become a discerning connoisseur of his own experiences. Even his use of the personal pronoun contrasts strongly with the established tradition of art and literary criticism of using the impersonal plural or third person.

OPPOSITE

37
Dante Gabriel Rossetti, *Beata Beatrix*
Oil on canvas, *c.*1864–70
Tate, London

38
Leonardo da Vinci, *Portrait of
Lisa Gherardini, wife of Francesco
del Giocondo* (the *Mona Lisa*)
Oil on panel, *c.*1503–6
Louvre, Paris

Like Swinburne, whose influence he acknowledged, in conveying sensations created by his intense contemplation of paintings Pater enshrined numerous highly imaginative prose-poems in these essays. As Arthur Symons put it in his 1896 essay on Pater, 'Here was criticism as a fine art, written in prose which the reader lingered over as over poetry; modulated prose which made the splendour of Ruskin seem gaudy'.[51] Among the strangest passages was that on the *Mona Lisa* (plate 38) in 'Leonardo da Vinci', in which Pater broods on the essential mystery of the painting:

> She is older than the rocks among which she sits; like the vampire, she has been
> dead many times, and learned the secrets of the grave; and has been a diver in
> deep seas, and keeps their fallen day about her; and trafficked for strange webs
> with Eastern merchants: and, as Leda, was the mother of Helen of Troy, and, as
> Saint Anne, the mother of Mary; and all this has been to her but as the sound
> of lyres and flutes, and lives only in the delicacy with which it has moulded the
> changing lineaments, and tinged the eyelids and the hands.[52]

Remarkably, Pater does not write metaphorically here, in terms of 'it is as though'; rather, he writes as if stating the actual case: she *is* older; she *has been* dead. In his essay on Giorgione, incorporated into the third edition of *The Renaissance*, Pater deprecates the narrowing of Giorgione's accepted oeuvre which had recently been carried out and posits instead what he calls the '*vraie vérité*': an idea of underlying truths which are more important than discoverable facts.[53] Pater's prose poem on the *Mona Lisa* is no mere flight of fancy; rather, it communicates what he, an exceptionally sensitive critic, has thought and felt.

However, it was the short essay included as the conclusion to *The Renaissance* which made the greatest impact because of its passionate advocacy of a life constantly enlivened by attention to beauty and the seeking of intense experiences.[54] The most extraordinary aspect of the conclusion was its apparent call to action: 'While all melts under our feet, we may well catch at any exquisite passion…'.[55] Pater was criticized for the frank invitation to pursue hedonistic behaviour which it appeared to extend to susceptible young men, and as a result he omitted the conclusion from the second edition of the book. However, one of the young men who had already accepted the invitation, indeed who later called Pater's *Renaissance* 'that book which has had such a strange influence over my life', was Oscar Wilde.[56]

Although Wilde's principal success was achieved with his plays, it was in his dialogues and essays that he expounded Aesthetic ideas most fully. Based on a classical prototype, Wilde's dialogues use the conceit of extended repartee between two young men to dramatize and develop, sometimes *ad absurdum*, attacks on concepts such as literary realism and the idea of art as self-expression. 'The Critic as Artist' (1890) develops the idea implicit in Swinburne's art criticism, and explicit in Pater's, that the critic's role is a truly creative one:

> Criticism is, in fact, both creative and independent.… Criticism is no more to be judged by any low standard of imitation or resemblance than is the work of poet or sculptor. The critic occupies the same relation to the work of art that he criticizes as the artist does to the visible world of form and colour, or the unseen world of passion and of thought.[57]

Wilde extends the argument even further, and the critic's art is found, paradoxically, to transcend the artist's, its double remove from the raw material of nature conferring the greater imaginative freedom.

A surge of imaginative freedom was responsible for shaping both major strands of Aesthetic writing. It allowed a poem or prose-poem written in response to a painting to be both 'creative and independent', making virtually a new category of the 'double work of art'. Most far-reachingly, Aesthetic poetry's disregard for the moral conventions of mid-Victorian Britain resulted in a pioneering expansion of poetic territory which had profound consequences for the *fin de siècle* and beyond.

Walter Pater (1839–1894)

Colin Cruise

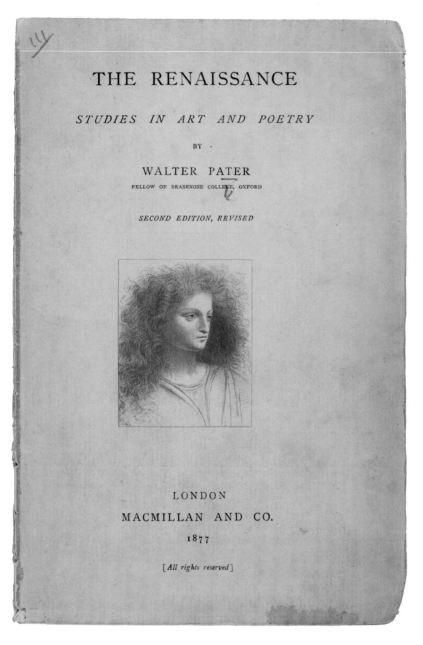

39
Title page of Walter Pater, *The Renaissance: Studies in Art and Poetry*,
with vignette after a drawing attributed to Leonardo da Vinci
Published by Macmillan & Co, London, 1877
The British Library, London

PATER's reputation as the most influential critic of the Aesthetic Movement is due chiefly to the success of his *Studies in the History of the Renaissance* (1873), known in later editions simply as *The Renaissance* (plate 39).[1] Wilde's verdict, that it was 'the golden book' and that 'the last trump should have sounded when it was written',[2] sums up the extravagant reception it received from some enthusiasts who used the book as a manual, following its message of the importance of sensual experience and its emphasis upon the cultivation of personality.

Although many of Pater's terms and concepts were anticipated in the experimental critical essays of Swinburne, such as 'Old Master Drawings in Florence' (1867), much of the book is original: the musicality of his prose and his use of particular words ('strange', 'peculiar', 'mysterious') to describe pictorial qualities, for example. The emphasis of the book was neither upon an artistic style nor the biography of the artist, but upon the activity of criticism itself. As Pater explained in the Preface, 'What is important, is not that the critic should possess a correct abstract definition of beauty for the intellect, but a certain kind of temperament…'.[3] For Pater the refinement of one's critical position is essential for the more perfect understanding of life. In this he is strikingly different from Lord Lindsay, Anna Jameson and Ruskin, his predecessors as historians of Italian Renaissance art, or contemporaries such as J.A. Symonds. He neither promoted connoisseurship nor detected a moral narrative in art, but emphasized the personal impression the work of art made upon the spectator.

Pater rejected conventional ways of ordering an account of the Renaissance. He charted its development from the literature of medieval France to the art historical writings of Winckelmann in the eighteenth century, surveying, on the

way, the scholarly investigations of Pico della Mirandola, Michelangelo's poetry and Leonardo's paintings. He drew attention to overlooked figures such as Botticelli (plate 40), in whose paintings of the Madonna he found 'a distinct and peculiar type'.[4] Botticelli enjoyed an unprecedented fame in Aesthetic Movement circles, where he was rivalled only by Leonardo. Pater's text was augmented in later editions of the book by essays on related subjects such as 'The School of Giorgione', in which he aired one of his most famous opinions: 'all art constantly aspires to the condition of music'[5] – an observation which helps explain both an aesthetic interest in form rather than narrative, and the musicality of Pater's own prose.

The book's conclusion was deliberately disturbing: the reader is thrown into the hectic modernity of the late nineteenth century, science and optics, flux, instability and uncertainty. It challenged the reader to find passion in every moment; an amoral, if not immoral, injunction. In making it, Pater severed links with Ruskinian criticism which held that aesthetic pleasure was, in the end, moral rather than sensuous. The list of phenomena recited in 'The Conclusion' suggests an extended critical repertoire:

> While all melts under our feet, we may well grasp at any exquisite passion, or any contribution to know-ledge that seems by a lifted horizon to set the spirit free for a moment, or any stirring of the senses, strange dyes, strange colours, and curious odours, or the work of the artist's hands, or the face of one's friend.[6]

Pater's other writings explored important tendencies in Aestheticism – religious belief and self cultivation in his novel *Marius the Epicurean* (1885), myth, identity and personality in the stories of *Imaginary Portraits* (1887), and memory and aesthetics in the autobiographical fragment 'The Child in the House' (1894). Pater presents characters absorbed by external phenomena, particularly their surroundings; they are unworldly yet sophisticated, equally engaged with intellectual endeavour and sensual experience.

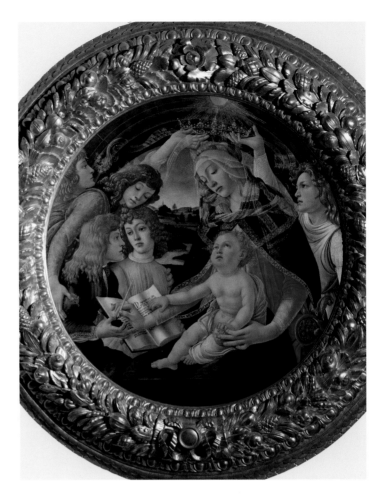

40
Sandro Botticelli, *Madonna of the Magnificat*
Tempera on panel, 1481
Galleria degli Uffizi, Florence

Such traits provided material for the character of 'Mr Rose', the Aesthetic critic satirized in W.H. Mallock's *The New Republic* (1877). Mallock's character announces that, when visiting 'ugly houses' he carries 'a scrap of artistic cretonne … as a kind of aesthetic smelling salts'.[7]

Despite populist hostility, Pater's influence was felt by a whole generation of readers. The argument of *The Renaissance* is obvious in critical writings by Wilde and Lionel Johnson, among many others. Yeats, deeply impressed by the beauty of Pater's description of Leonardo's *Mona Lisa*, versified it for his edition of *The Oxford Book of Verse* in 1936.

2 Aestheticism in Painting

AESTHETICISM IN PAINTING

Elizabeth Prettejohn

ESTHETICISM, IN ONE VIEW, is exciting above all for the way it breaks down the traditional boundaries between the fine and decorative arts – for levelling the time-honoured hierarchy that placed painting at the summit. Painting, according to this radical vision for the arts, would merely be one means of sensuous expression amidst a panoply of beautiful things. To go one step further: if the aim is beauty for its own sake, rather than for the sake of conveying important messages about human beings and the world they live in, then painting (as the most resourceful of representational media) must lose the claim to intellectual leadership that it had held in art theory since the Renaissance. For the aesthetic critic, as Walter Pater wrote in 1873, 'the picture, the landscape, the engaging personality in life or in a book, *La Gioconda*, the hills of Carrara, Pico of Mirandola, are valuable for their virtues, as we say, in speaking of a herb, a wine, a gem; for the property each has of affecting one with a special, a unique, impression of pleasure'.[1]

Note, however, that the first object in Pater's list is 'the picture', and that Leonardo's painting *La Gioconda* (more familiarly known as the *Mona Lisa*, plate 38) is the only work of art he names. Was it mere force of habit that led him thus to leave painting in its traditional role at the head of the list, and to cite a famous painting of the past as a prime example, one that would make instant sense to his readers as something to be counted among the special pleasures of the senses and the imagination? Or was he making a more subtle point about the distinctive role that painting might play amidst the panoply of beautiful things? All the arts – indeed all the objects of sensory delectation – are equal in Pater's list. Yet painting is first among equals, *primus inter pares*.

That is not the only way to interpret Pater's list, as we shall see, but it makes sense in relation to the history of Aestheticism in Victorian England: a small number of paintings came first, chronologically, in setting the agenda for an art that would be for the sake of beauty before all else. An example that might have been cited by many artists of the Aesthetic Movement is Dante Gabriel Rossetti's *Bocca Baciata* (plate 42) of 1859, the first to strike its viewers as overpowering in its appeal to the senses, and the catalyst for a new engagement with the art of Titian and the Venetian Renaissance that would play out later in all manner of media. Yet Rossetti's painting may also be placed in dialogue with a work that predates it by a matter of months, Frederic Leighton's *La Nanna* (plate 41), seen

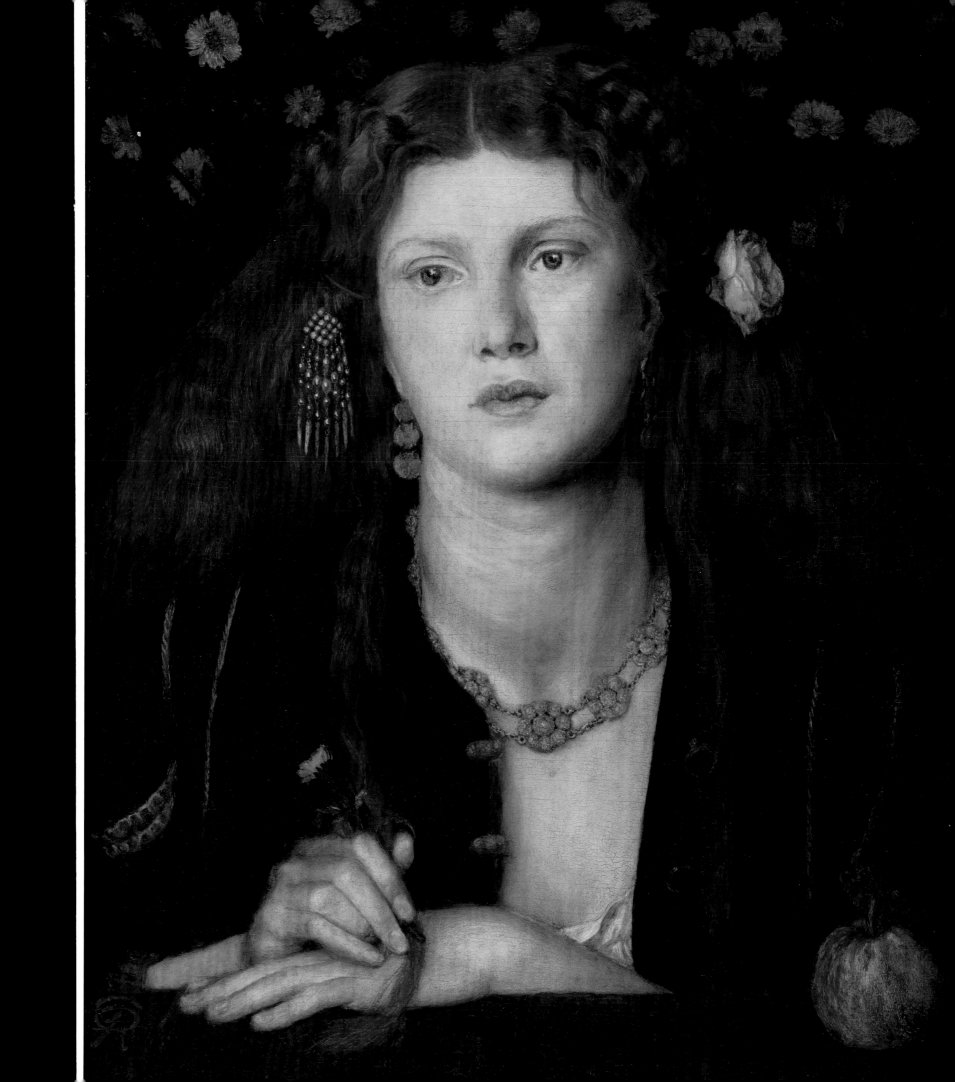

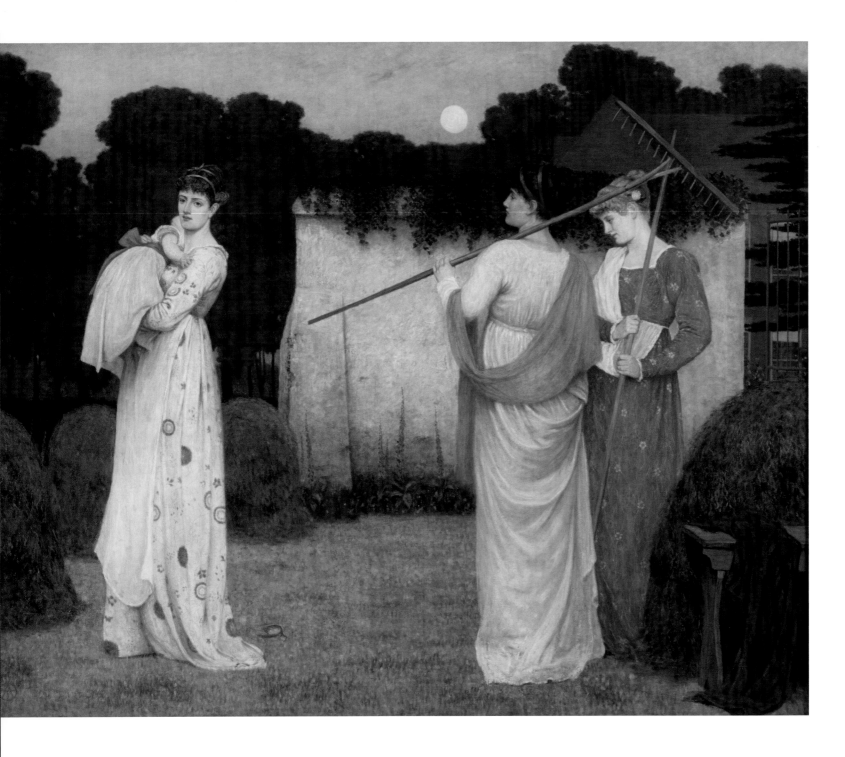

43
Thomas Armstrong, *The Hay Field*
Oil on canvas, 1869
V&A: P.9–1917

at the Royal Academy exhibition in the early summer of 1859. Together the two paintings describe a spectrum of possibilities for making the image of a beautiful woman activate a distinctive aesthetic response, one that draws the viewer into communion with another human being and with another time and place. Both figures inspire the viewer with desire to make contact, yet neither quite satisfies that desire. We may exchange glances with *La Nanna*, but her heavy-lidded gaze will humble us and her extravagant satin sleeve sets a barrier between figure and viewer. Rossetti's figure, instead, faces us abruptly, yet her eyes focus not on us but on something elsewhere, to the side, or perhaps not in the external

world at all. In each case the pleasure of looking is tinged with the sense that we shall not succeed in making complete sense of what we see.

An art historian might phrase this differently: both pictures depart, quietly but firmly, from the conventions of narrative painting in which the viewer is given enough visual information to weave a story around the depicted figure. A sign of this is the clues that do not add up. Leighton's figure wears the gathered white blouse and close-fitting bodice of an Italian *contadina* or peasant-girl, yet her pearls, the satin sleeve and the carved pilaster that would be at home in a Mannerist portrait seem instead to characterize a woman of rank. In Rossetti's painting the marigolds of grief are in counterpoint with the rose of love and the apple of Eve (or Venus); it is difficult to decide whether 'the mouth that has been kissed' (the *bocca baciata* of the title) promises the heady delight of love or the guilty pleasure of sin.[2] So subtle, indeed, are the clues to further meaning in either picture that any of these alternatives, on its own, may seem to overinterpret the images. But that does not mean that the paintings exhaust themselves in the purely sensuous experience, for example of the rippling red hair in the Rossetti or the billowing sleeve in the Leighton. There are delights for the mind as well, all the more intriguing in that they fail to arrive at a definite conclusion. Simple as the formula may appear – a woman, facing the viewer, with eclectic or enigmatic accessories – the paintings stir the thoughts of the observer into a chain of reflections with no logical endpoint.

There may be a danger, for the late-coming observer, that the confusing clues or deliberate anachronisms in Aesthetic painting will seem merely whimsical – the garden rakes and the baby juxtaposed with the classical-cum-Regency gowns in Thomas Armstrong's *The Hay Field* (plate 43), or, in Albert Moore's *A Quartet* (plate 48), the sturdy violoncello amidst figures who seem to have wandered from the Parthenon frieze. These two paintings, both exhibited at the Royal Academy exhibition of 1869 (and thus a decade into the development initiated by *La Nanna* and *Bocca Baciata*), perhaps mark the extreme point of this line of experiment – the point at which the confusing clues threaten to become too conspicuous. The risk is evident in these examples, or in Leighton's *Greek Girls Picking up Pebbles by the Sea* (plate 44) two years later – *pebbles*, one may ask in not unreasonable astonishment? Would not beautiful shells have served the purpose better? The discrepancy between the complexity of the figures' classical drapery and the triviality of their activity compels the viewer to try to solve the problem, to trace the rhythms of the compositional lines, to follow them zigzag fashion from one figure to the next into the depth of the scene. That will not, however, reveal who the figures are or what motivates their mannered poses, as we should expect were this a representational painting of the traditional kind. Looking must be its own justification, if we are unable to make the leap from what we see to what it means.

That might be one way of making an art that exists for the sake of beauty alone, but thus far it is a negative one: by blocking the longstanding habit of interpreting visual forms for their underlying meanings, it forces the viewer to fall back on sheer contemplation. For nineteenth-century viewers this could be frustrating, and it could lead paradoxically to a refusal to credit the paintings with precisely the quality at which the process seems to aim: beauty. In response to *Haytime* the critic for the *Art-Journal* could find nothing intelligible,

FOLLOWING PAGES
44
Frederic Leighton, *Greek Girls Picking up Pebbles by the Sea*
Oil on canvas, 1871
Private collection

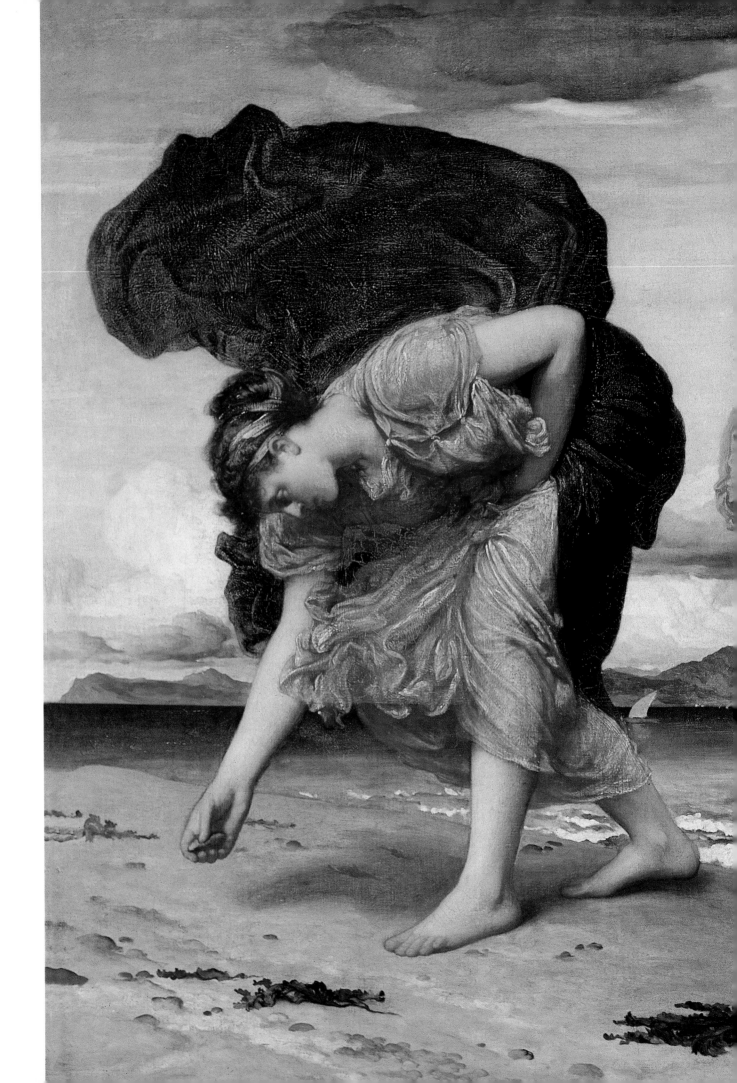

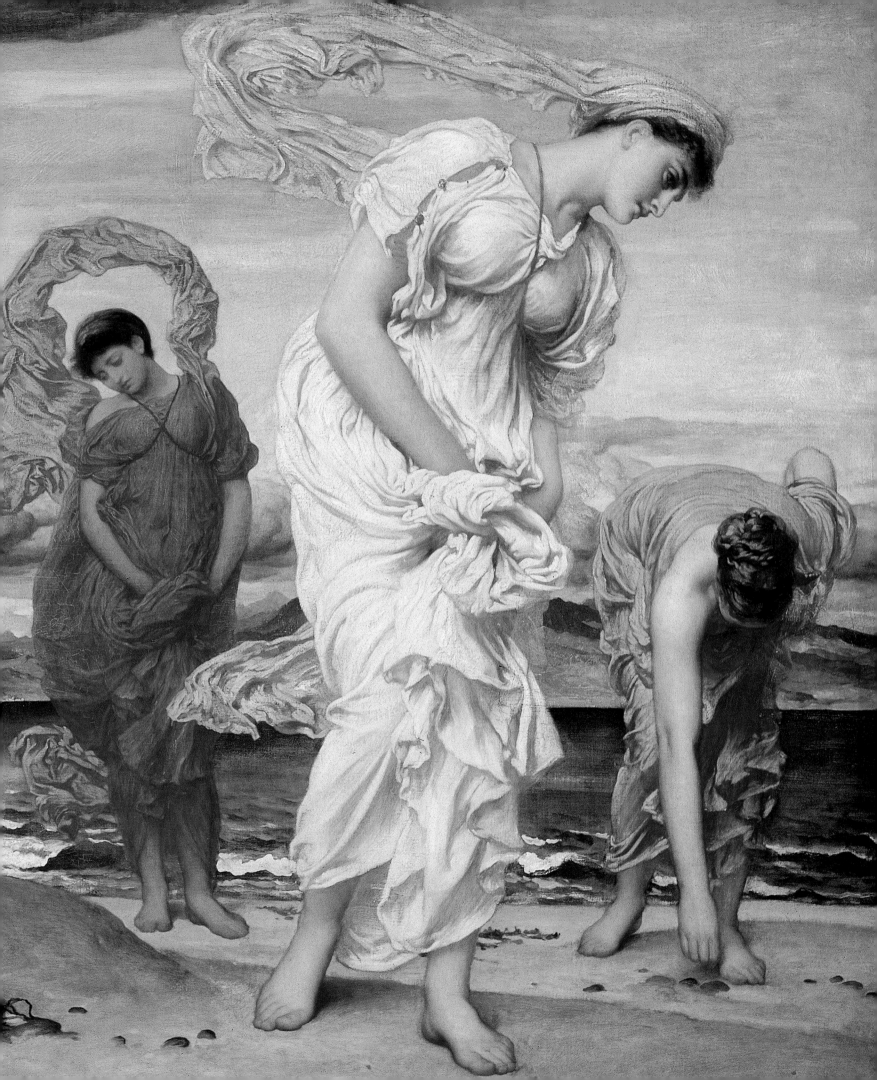

and resorted to a series of bewildered questions: 'When and where did these long and lanky women live? Why did nature make them so defiant in angularity and ugliness?'[3] A more sympathetic critic, the young Sidney Colvin (later to enjoy a distinguished curatorial career at the Fitzwilliam and British Museums), was prepared to enter into the spirit of the confusing clues: 'One of [the women] shoulders a rake; the other a baby (which will catch cold, but *that* doesn't matter. I do not think that any one of them is its mother)'.[4] The joke is perceptive: Armstrong's painting, like the others we have been exploring, goes to some length to block any conventional narrative interpretation of the mother-and-baby kind.

But do these paintings stop there, in the negative mode, or do they offer viewers some better alternative to their old habit of decoding the narrative clues? A standard answer has been that Aestheticism replaces narrative or intellectual meaning with sensuous beauty, and that is certainly part of the project. It is important to stress that Aestheticism is not Formalism in the twentieth-century meaning of the term: what is proposed is not so much a concentration on the purely visual or 'optical' aspects of painting as a search for ways of delighting the senses, if possible going beyond the visual to involve the other senses as

45
Frederic Leighton, *Golden Hours*
Oil on canvas, 1864
Private collection

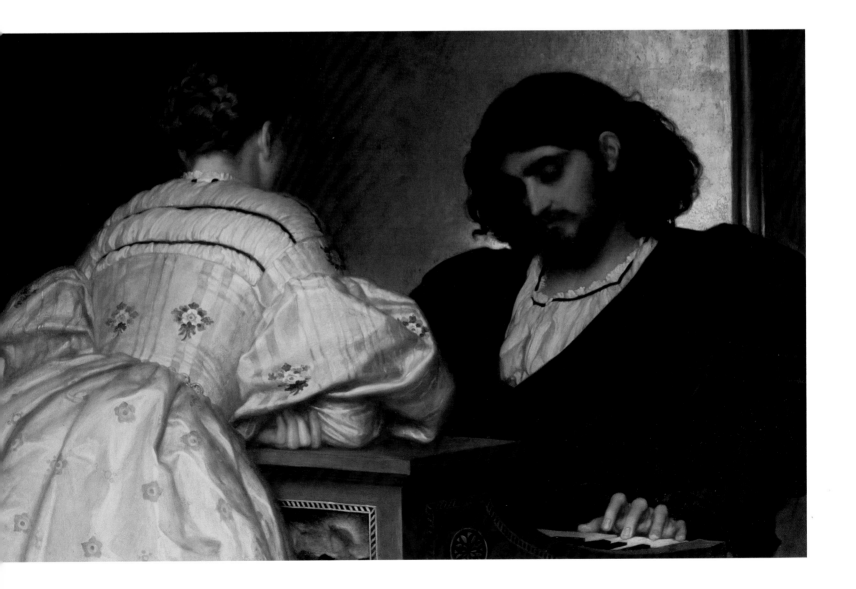

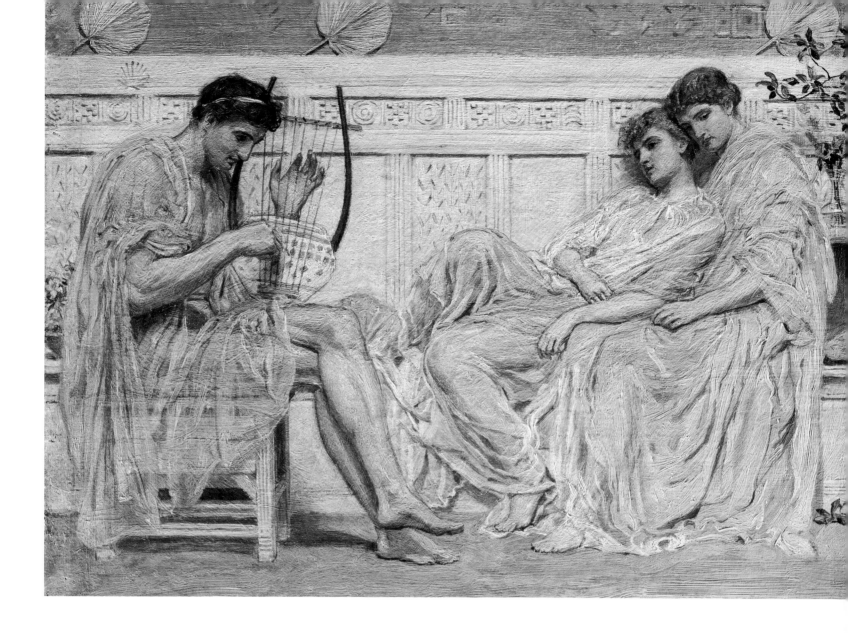

46

Albert Moore, *A Musician*
Oil on canvas, 1865–6
Yale Center for British Art
(Paul Mellon Fund), New Haven

well. Thus Colvin thought that viewers of *Haytime* 'will find it delightful to the eye as well as to the other senses delightfully suggestive; – suggestive of the pleasant heats and the happy sights, sounds, and odours of June'.[5] If that is plausible, it is a matter not just of the contents of the picture – the haystacks and garden tools that tell us the season is summer – but also of the light effect that transfigures the scene, at the moment when the full moon appears just above the horizon, before the daylight is quite extinct, when fragrances are at their most intense. The viewer is drawn into the strange transitional world of the painting, between daylight and dusk on a summer's day. In Leighton's *Greek Girls Picking up Pebbles* a clearer light, crisper lines and vibrant colours help to evoke the keen wind that agitates the draperies and the lapping waves on the seashore.

Other paintings invite the viewer to imagine the sounds of music. The male and female figures in Leighton's *Golden Hours* (plate 45) face one another over a decorated keyboard instrument. Without such clues to narrative interaction as an exchange of glances or a demonstrative gesture, the figures are united by their absorption in listening – or perhaps, more elusively, in preparing to listen, for the man's fingers, poised on the keyboard, do not yet depress its keys. Thus the spectator may share the figures' rapt attention to music un-

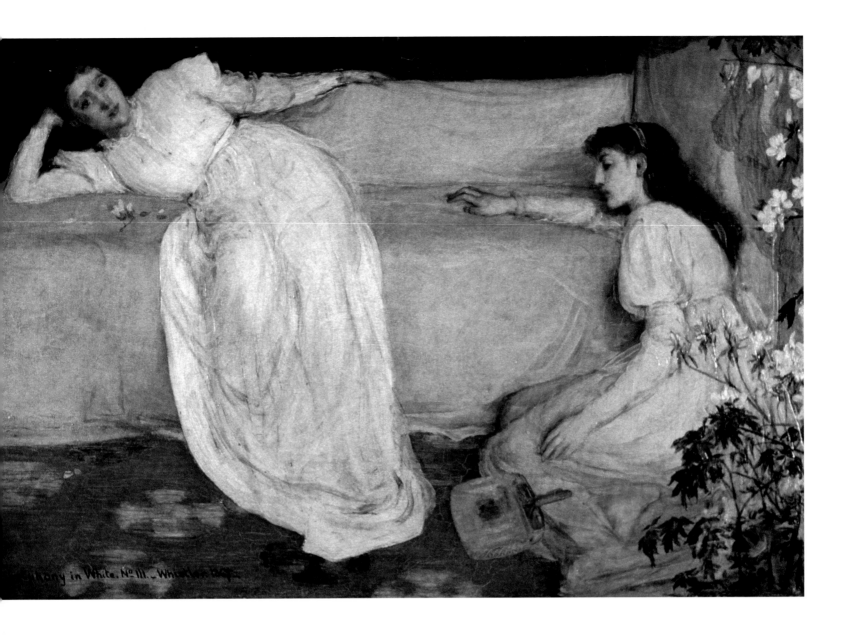

47
James McNeill Whistler,
Symphony in White No. 3
Oil on canvas, 1867
The Barber Institute of Fine Arts,
University of Birmingham

heard, its radiance suggested by the golden glow behind the man's head. Costume, theme and sumptuous colour recall the music-making paintings of the Venetian Renaissance, and with them, perhaps, the splendour of Venetian Renaissance music; it is up to the spectator to decide how far to take this chain of reflections. Albert Moore's *A Musician* (plate 46) chooses, instead, a classical setting, its listening figures compulsively reminiscent of the reclining goddesses of the Parthenon pediment. Moore's painting appeared at the same Royal Academy exhibition (1867) as a painting by his close associate James McNeill Whistler, *Symphony in White No. 3* (plate 47), with which it has obvious compositional affinities, not only in the frieze-like deployment of the figures but also in the sprays of flowers, Japanese in effect, cut off by the right edge in both pictures. In Whistler's painting the sensuous delight of musical sound is implied rather than depicted, something confirmed by the title, inscribed for good measure along the bottom edge. Through this breathtakingly simple device Whistler clarifies, at a stroke, what had perhaps been the aspiration of

the entire series of musical paintings: not to represent any scene or story of music-making, but rather to make painting the visual equivalent for the sensuous delight of musical sound. Two years later Moore alluded to something of the kind in the subtitle to his painting *A Quartet: A Painter's Tribute to the Art of Music, AD 1868* (plate 48).

At first thought the modern date in Moore's title, and the modern musical instruments depicted in the painting, might seem the clumsiest of Aestheticism's deliberate anachronisms. With unmannerly abruptness they block any attempt to interpret the painting as a scene or event from classical antiquity, leaving the viewer with no alternative but to enjoy the painting for its lovely colours and forms alone. That, though, can scarcely be the whole story. If Aestheticism meant simply to replace painting's traditional meanings and messages with sensuous delight, why the obsessive pattern of allusion to styles and motifs from the history

48
Albert Moore, *A Quartet: A Painter's Tribute to the Art of Music, AD 1868*
Oil on canvas, 1868 (exhibited 1869)
Private collection

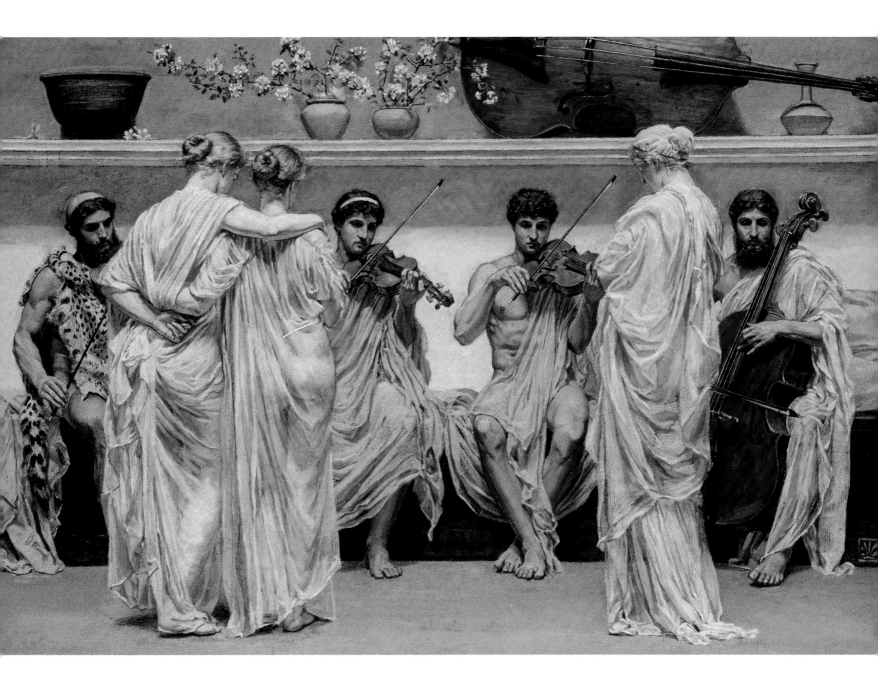

of painting and the other arts? For most of the twentieth century, when Victorian art was at its lowest critical ebb, this simply proved the poverty of invention in a moribund artistic tradition, incapable of generating its own ideas and thus doomed to inert repetition of received motifs. Nor has Aestheticism fared much better in the social history of art, the dominant art-historical paradigm since the 1970s, for which the obsessive recurrence to the art of the past could be nothing but a conservative backlash, wilfully oblivious to the political and social concerns of nineteenth-century modernity. Can we, however, find something to take more seriously in Aestheticism's retrospection?

Sidney Colvin was already aware of these problems in 1877, when he reviewed the first exhibition of the new Grosvenor Gallery, which quickly established itself as the prime venue for Aestheticism in painting (see pp.166–77 below). 'With the battle between classicist, romanticist, *fantaisiste*, and realist, let us have nothing to do', wrote Colvin: 'The past is ours and the present is ours and imagination is ours; let us do with them all the best we severally can.'[6] This suggests a more complex interpretation of Aestheticism's deliberate anachronisms: a way not merely to thwart the viewer's expectations of narrative coherence, but to move the picture from the time-bound to an aesthetic experience that can leap over temporal boundaries. Something of the sort was perhaps implicit from the very first pictorial experiments in drawing the viewer into communion with a figure from another time and place, as we have already seen with *Bocca Baciata* and *La Nanna*. Some of the grander paintings seen at the Grosvenor use allegorical subject matter to move the thoughts of the viewer beyond any specific historical context.

One of the most ambitious paintings at the first Grosvenor exhibition, John Roddam Spencer Stanhope's *Love and the Maiden* (plate 49), shows a reclining female figure who starts, as if waking from sleep, to encounter a winged youth with a bow. This might easily represent a familiar episode from the end of the mythological tale of Cupid and Psyche, when Cupid awakens Psyche from the deathlike slumber into which she has been cast, having disobeyed the divine order not to open the casket she was tasked with retrieving from the underworld. That might have been an Aesthetic subject *par excellence*, for the forbidden casket contained the secret of beauty. Yet Stanhope does not include a casket in his scene, and his title generalizes the story. This might be the story of any girl's romantic or sexual awakening, and the classical associations of the story are complicated by unmistakable allusions to the paintings of Botticelli. The maiden's pose and draperies instantly recall the figure of the reclining Venus in Botticelli's *Venus and Mars*, acquired by the National Gallery just three years earlier, and the group of three dancing women with a male figure in the background brings to mind the similar group in Botticelli's *Primavera* (Uffizi, Florence). The modern viewer contemplates a classical myth through the intermediary of fifteenth-century painting; the work thus activates three distinct historical moments, any of which may start a chain of reflections in the viewer's mind.

At the same Grosvenor exhibition G.F. Watts showed an allegorical subject with more sombre resonances: *Love and Death* (plate 150). Again a winged youth stands for Love, but in this case he recoils before the inexorable approach of a massive figure, seen from behind and swathed in pallid draperies that recall the majestic folds of the Parthenon

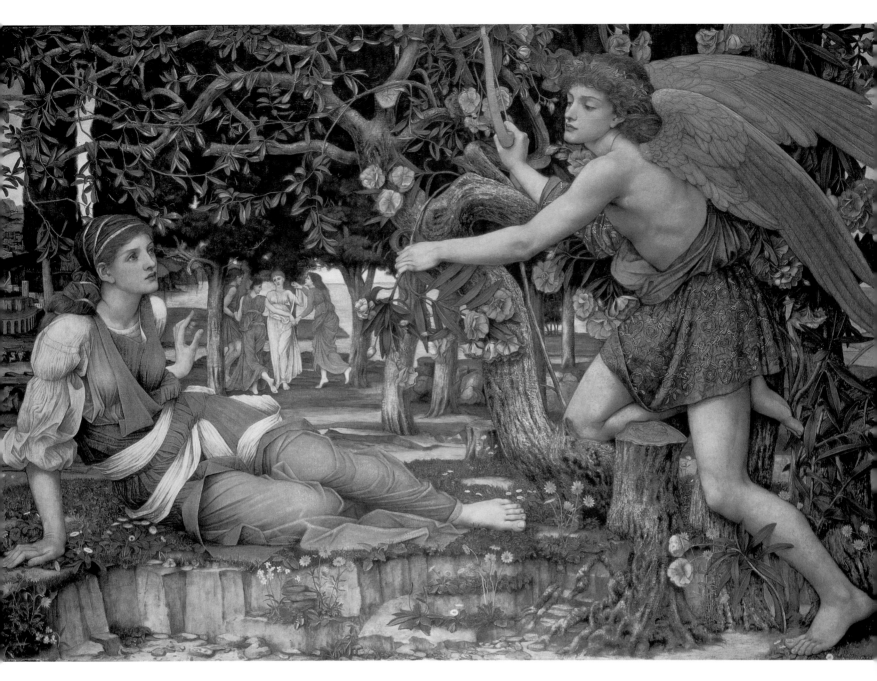

49
John Roddam Spencer Stanhope,
Love and the Maiden
Tempera, gold paint and gold leaf on canvas,
1877
Fine Arts Museums of San Francisco

sculptures. In these sumptuous allegorical paintings, allusions to historically specific styles and motifs read no longer as confusing clues or deliberate anachronisms, but rather as pointers to kinds of meaning that go beyond the mind's effort to compass them, from the awakening of love to the inexorability of death.

Painting, in these examples, has not relinquished the intellectual dimension that gave it high rank in traditional art theory, but it has changed the intellectual game, and in a way that works in concert with the works' sensuous address to the viewer. Visually and intellectually, the pictures stimulate rather than satisfying desire – the desire to understand as well as to look. Perhaps it is this that painting, with its long history of intellectual ambition, has to teach the other arts in Aestheticism. Pater's list might be reread as a sequence: we start with painting, in relation to which we are accustomed to seeking intellectual meaning, and discover that the search for meaning may be more intriguing and long-lasting when it does not conclude in a piquant narrative or a neatly delineated concept. Then, when we turn to the 'minor' arts – those which never depended on conceptual meaning – we find that they too may initiate the search for meaning, so long as we do not expect to arrive at a pat conclusion. In this context the *Mona Lisa*, with her enigmatic smile, may be reinterpreted as a sister to *La Nanna* and the figure in *Bocca Baciata*. It is the history of painting in the Renaissance tradition that instructs us to read visual signs for intellectual meaning. Perhaps the most important device for starting the chain of reflections, in Aesthetic art, is a reference to painting's history: something activated visually, like the Titianesque look of the Rossetti or the Mannerist look of the Leighton, but bringing with it a host of associations through reminiscences of the art of the past. As we have already seen, the associations need not add up – better, indeed, if they do not, so that we may continue indefinitely to explore the chain of reflections, and in retrospect that turns out to apply to Leonardo's painting as much as to any of the Aesthetic works. Mona Lisa's smile, or the meandering streams of her landscape background, may (or may not) have been clues to precise meanings long since forgotten, but from the perspective of Aestheticism their 'virtue' is to set speculation in motion.

A final example may demonstrate with special clarity how Aestheticism could transform its inheritance from the history of painting into what might be called decorative art. No artist was more learned in the history of art than Leighton, whose surviving pocket notebooks show him ever alert to the works of past art he encountered on his multifarious travels. His first Aesthetic masterpiece, *Syracusan Bride leading Wild Beasts in Procession to the Temple of Diana* (plate 50), arrays across its four-metre length some two dozen figures, each of them fascinating for the way it rings the changes on the repertoire of poses and gestures inherited from the art of the past. In the manner of a traditional History Painting, it draws on a passage from a classical source, Theocritus' second *Idyll*, but it recasts its borrowed narrative in Aesthetic terms. There is no attempt to illustrate the story of the *Idyll*, in which the speaker, Simaetha, mixes a potion to win back the affections of her errant lover. Instead the painting gives us the scene that Simaetha remembers as she mixes her potion: her first glimpse of her lover in the throng attending a religious procession.[7] Rather than representing Simaetha, it invites the viewer to share the thrill of beauty that she experiences

again in memory. Thus the meaning of the scene is indivisible from its sensuous impact, and looking at the painting is tantamount to understanding its intellectual implications. Painting here aspires to the condition of decorative art: the sumptuous display of figures, animals and draperies in endless variation is its own end. Yet in its transformation of its classical source, or in the motifs assembled from old pictures, the painting also leads the way towards a new kind of aesthetic experience, in which beauties patent to the eye have their counterparts in those recalled to mind.

Many twentieth-century observers, trained in the 'formalist' conventions of modernist painting, could see nothing beyond visual resemblance in Aestheticism's recurrence to the art of the past, and branded it accordingly as mindless imitation. Yet Simaetha's story suggests a different possibility: the remembrance of beauties past has the capacity not just to delight the eye, but also to stir the thoughts of the observer. Moreover, there is no reason why a wallpaper, a vase, or a gown should not make similar demands on the imagination, once the possibility has been mooted. The retrospective aspect of Aestheticism, its obsessive recurrence to the art of the past, which has so often seemed a failing, may on the contrary be its most important lesson. It is in such retrospection that an object, no matter where in the traditional hierarchy it falls, may absorb the mind as well as the eye.

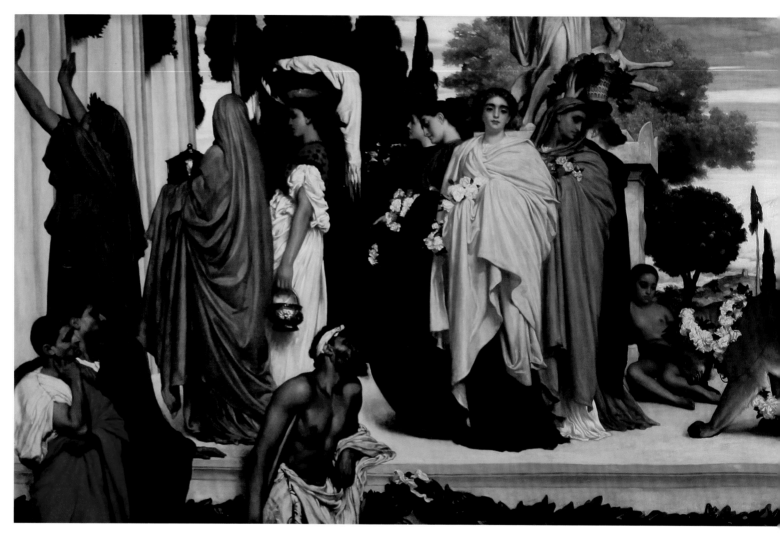

50
Frederic Leighton, *The Syracusan Bride leading*
Wild Beasts in Procession to the Temple of Diana
Oil on canvas, 1865–6
Private collection

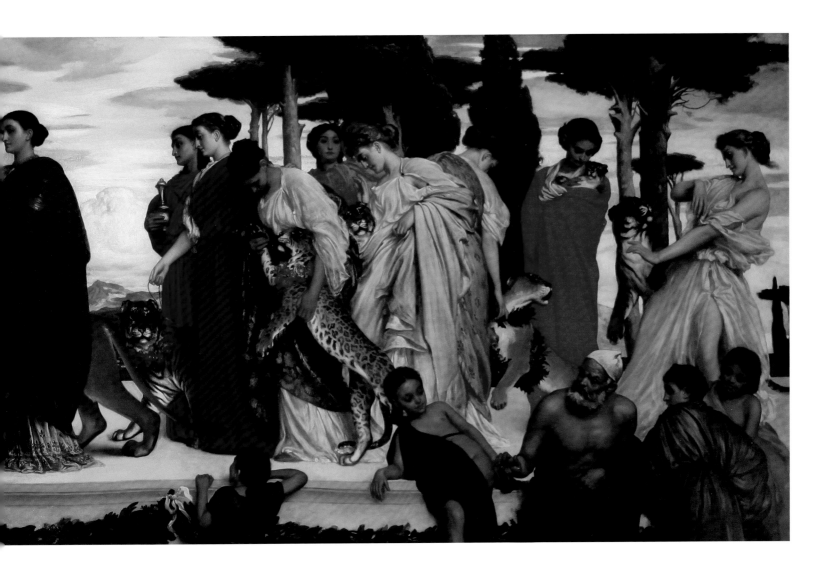

Early Aesthetic Photography:
Julia Margaret Cameron and David Wilkie Wynfield

Hope Kingsley

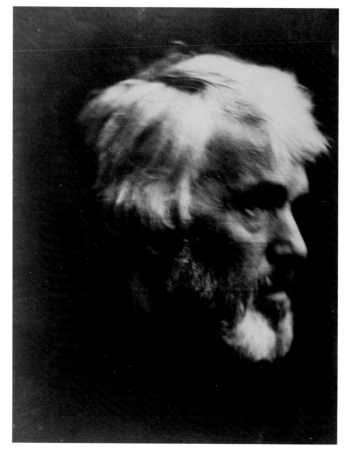

IN 1864 the *British Journal of Photography* lamented a dismal lack of visitors in the exhibition rooms of the Photographic Society of London:

A photographic picture is too natural for their tastes. 'We can see that any day,' say the sensation hunters, and then they pass on to the Academy to fall into ecstasies over the possible and impossible representations of nature by the Academicians and the P. R. (we do not mean the prize ring) brethren, and to gloat over … saucer eyes, red-hot lips, and indescribable hair – none of which, unless the present order of nature be reversed, they can ever hope to see realized by the human eye.[1]

Fine art was more conspicuous and more extravagant than photography, which was limited to reproducing the prosaic natural world. Twenty-five years after

51
David Wilkie Wynfield, *Portrait of Frederic Leighton*
Carbon print on later mount with textured paper surface layer,
image *c*.1862, printed later
Royal Academy of Arts, London

52
Julia Margaret Cameron, *Thomas Carlyle*
Albumen silver photograph, *c*.1867
The Wilson Centre for Photography, London

53
David Wilkie Wynfield, *Architect (Barber)*,
identified as William Swinden Barber
Albumen silver photograph on later mount with
textured paper surface layer, undated (1860s)
Royal Academy of Arts, London

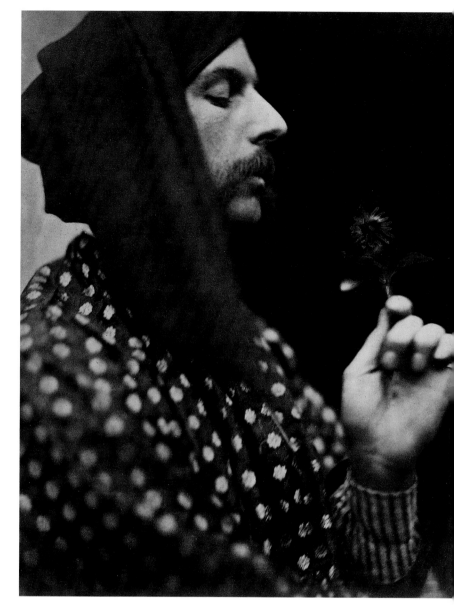

its invention, the medium had achieved a technical
sophistication that produced images looking very much
like reality, and the general public failed to see the art in
that. While the photographer was credited with mechanical
skill, the building blocks of picture-making, such as the
management of emphasis through tonal values and focus,
were thought to be serendipitously captured by the camera.

1864 was also the debut of two groups of
conspicuously unconventional photographic portraits.
The painter David Wilkie Wynfield published *The Studio:
A Collection of Photographic Portraits of Living Artists, Taken in
the Style of Old Masters, by an Amateur*. Many of his sitters were
fellow members of the St John's Wood Clique; other artistic
celebrities included G.F. Watts and William Holman Hunt.
Later that year portraits of Watts and Holman Hunt were
shown at the Photographic Society, made by Julia Margaret
Cameron in her first year as a practising photographer.

Unlike commercial studio photographs – typically
small, sharply focused, brightly lit full-figure shots – Wynfield
and Cameron's pictures were large bust portraits whose
dramatic combinations of light and shadow presented strong
effects of chiaroscuro. Also compelling was the illusion of
spatial depth given by a shallow depth of field and diffused
periphery that made the forms seem to project from the out-
of-focus background. Many of those visual characteristics
were produced by the optics of Cameron and Wynfield's long
focal length portrait lenses. Yet one of the most contentious
issues was the lack of sharp focus, which photographic critics
attributed to technical ineptitude. Art reviews were more
forgiving. The *Illustrated London News* judged Wynfield's
'out of focus' images to have resolved the 'greatest artistic
defect' of photography in opposing the 'rigid sharpness and
stark precision' that gave commercial portraits 'a death-like
stillness'.[2] Likewise, P.G. Hamerton excepted Cameron from
his usual disdain for photography, writing that she 'deflated
the obtrusiveness of photographic detail' in the compass
of 'a massive breadth not unlike the gloom and obscurity of
some old pictures'.[3]

Reviews consistently defined the work in terms
of older art, a perspective echoed by the photographers

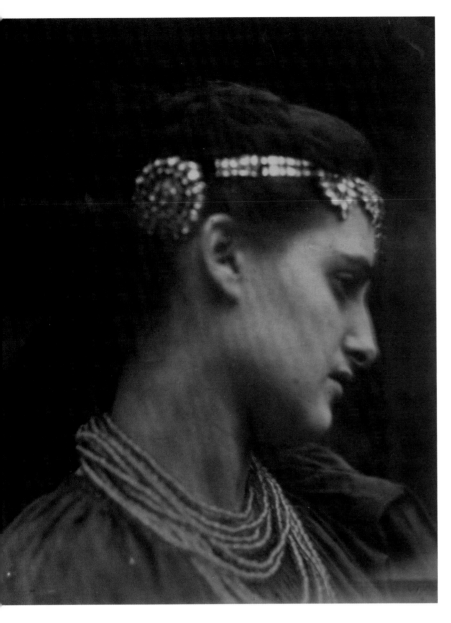

54
Julia Margaret Cameron, *Zoe*
Albumen silver photograph, 1870
The Wilson Centre for Photography, London

themselves. Wynfield's citations included Van Dyck, Holbein and Velásquez, while Cameron's sources encompassed Old Master Italian art, validated by her membership of the 'missionary aestheticist' Arundel Society. Contemporaneous associations with Pre-Raphaelite work are missing, largely because the conventional understanding of that movement focused on its early ruthless naturalism, an approach for which photography was believed a problematic model. Cameron's Aesthetic connections were closer to the second phase of Pre-Raphaelitism, and her access to that milieu was strengthened when she set up a photographic studio at her sister's house in Holland Park. Sara Prinsep's salon hosted many Aestheticist protagonists, and some sat for Cameron, including Marie Spartali and G.F. Watts, who became her friend and artistic mentor.

Watts was also photographed by a Swedish painter-turned-photographer, Oscar Gustav Rejlander, who was Cameron's entrée to photographic practice. Some of her earliest images resemble photographs made by Rejlander while visiting Alfred Tennyson on the Isle of Wight. Cameron was Tennyson's neighbour, and she appeared in several Rejlander photographs. Three of her own photographic albums include Rejlander's works, and she printed from his negatives, most notably making a photomontage by surrounding a Rejlander portrait with a photogram of ferns (plate 56). This compares with Dante Gabriel Rossetti's large female heads of the late 1850s and 1860s, which were later echoed in Cameron's full-frame heads (plate 54). Rossetti owned 41 Cameron photographs, some sent by the photographer, who nevertheless failed to persuade him to sit for her, though she captured his siblings, William Michael and Christina Rossetti.

Although Cameron never acknowledged Rejlander's tuition, she credited Wynfield with artistic inspiration Watts may have encouraged this, for he advised her to copy Wynfield's work in order to improve the technical faults in her own. Wynfield and Cameron both addressed the historicizing trend of Victorian art and literature. His photographs might be seen as artist's studies for the English history subjects of his paintings, while her key project was a collaboration with

Tennyson on a photographically illustrated edition of *Idylls of the King and Other Poems* (plate 55).

Cameron promoted her work energetically, submitting it to public exhibitions and showing in private galleries at her own expense. Wynfield's photographs lacked a wider audience until 1896, when they appeared at the Photographic Salon of the Linked Ring (see pp.248–50). Cameron, too, was better appreciated a decade after her death, when such progressive art photographers as William Adcock lined up to applaud her precocious aesthetics. Her idiosyncratic use of technology in the pursuit of pictorial photographic art was cited as a foil to the mainstream, as in an 1886 anecdote recasting her sentiments on the relative value of photographic technique:

'I like the picture, but I cannot compliment you on the photography,' said one [critic] to Adcock … 'Oh! blow the photography, if the picture is all right,' was the reply. A … similar reply of Mrs. Cameron's is on record, only she expressed her feelings in a somewhat more conventional manner.[4]

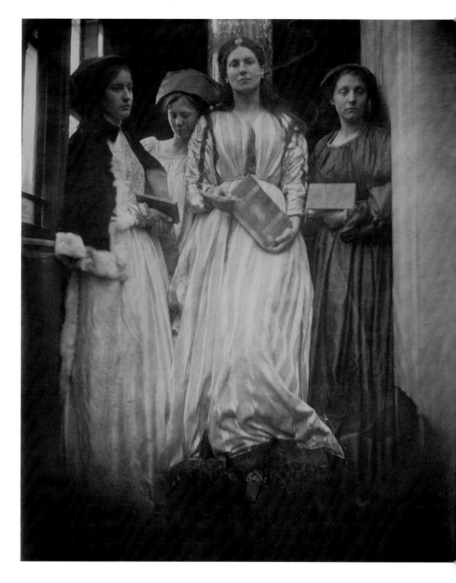

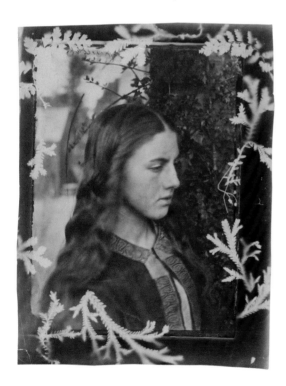

ABOVE
55
Julia Margaret Cameron, *The Princess*
From Cameron's portfolio album of Tennyson's
Idylls of the King and Other Poems, vol.II, plate v
Albumen silver photograph, 1875
The Wilson Centre for Photography, London

LEFT
56
Oscar Gustav Rejlander, *Portrait of Kate Dore*,
with plant forms
Albumen silver photograph from Rejlander
negative with photogram additions, final
combination print attributed to Julia Margaret
Cameron, *c.*1864
V&A: PH.258–1982

The Musical Ideal in Aesthetic Art

Suzanne Fagence Cooper

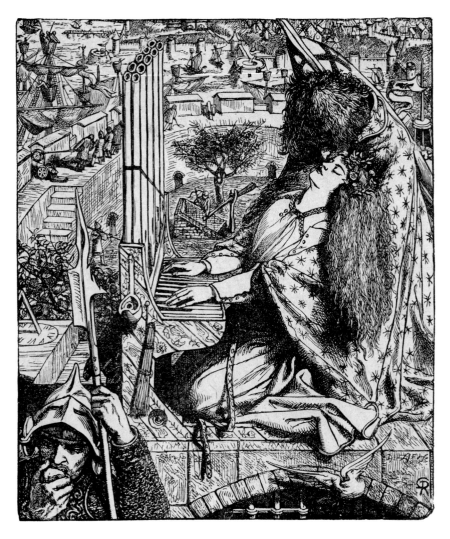

57
Dante Gabriel Rossetti, *The Palace of Art: St Cecilia*
Wood engraving by the Dalziel Brothers for
The Moxon Tennyson, 1857
V&A: E.2926–1914

Music has become the modern art.[1]
Edward Dannreuther, 1876

MUSIC SUGGESTED many meanings to Victorian audiences: spirituality, sex, death. The mutable nature of its symbolism made it attractive to Aesthetic artists. Musical subjects, often combined with images of women, sidestepped the constraints of narrative and moral frameworks. Even conventional subjects, like the figure of St Cecilia, could be subverted to create new and troubling works of art. In the 1850s music was usually signified by esoteric props: organs, psalteries, flutes. But as musical ideas started to suffuse the concrete arts of painting and design, so music stopped being a collection of unexpected objects and emerged as an avant-garde subject.

Dante Gabriel Rossetti's engraving of St Cecilia (plate 57) pioneered this transition, reworking her legend and transforming it from a sacred to a sensual drama. Cecilia's floral halo slips as her guardian angel kisses her passionately. Traditionally Cecilia's music broke down boundaries between earth and heaven, so Rossetti shows the saint being touched by an angel. But he also plays on contemporary anxieties about musical women, signalling her sexualization by her choice of instrument – a large positive organ, rather than the traditional portative organ. Cecilia's positive organ needs two people to work it, one pumping the bellows, the other on the keyboard, and so it becomes a metaphor for love-making.[2]

In a domestic setting, music could be a respectable female discipline. Playing the piano 'makes a girl sit upright and pay attention to details'.[3] But the piano itself, 'the very altar of homes', was often a design disaster, dominating the drawing room.[4] Edward Burne-Jones collaborated with Broadwood to create an instrument based on the outline of

58
Kate Faulkner and Edward Burne-Jones, grand piano
Oak, stained and decorated with silvered and gilt
gesso for Broadwood, 1884–5
V&A: W.23–1927

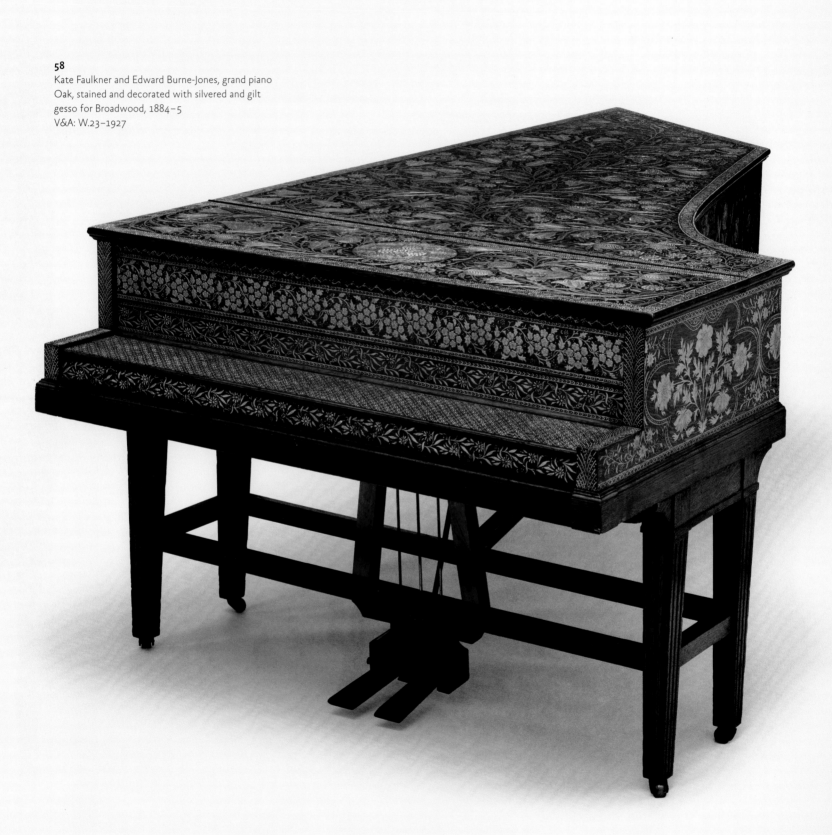

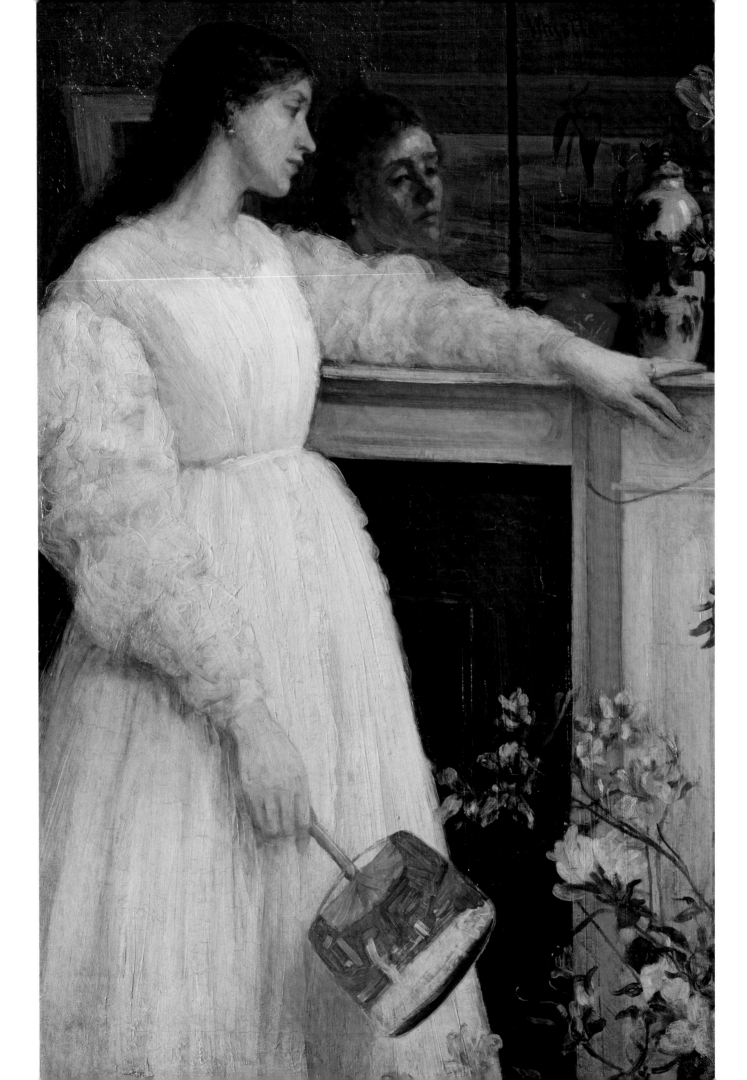

59
James McNeill Whistler, *Symphony in White No.2:*
The Little White Girl
Oil on canvas, 1864
Tate, London

a harpsichord, better suited to the subtleties of the Aesthetic interior. His patron Alexander Ionides commissioned one such instrument for his house at 1 Holland Park (plate 58). It was played by the Ionides women, their music enhancing the visual pleasures of evening parties: like the women in their Liberty gowns, the piano was meant to be seen as well as heard, its surface, shimmering by candlelight, covered with a pattern of lilies. This decoration was created by another, invisible, woman, Kate Faulkner, who studied Renaissance gessowork in the South Kensington Museum, and, with Burne-Jones's blessing, applied it to the Broadwood case.

The Ionides piano, embellished and played by women, embodied the intimate relationship between music and femininity. In other Aesthetic objects this intimacy was less overt, but still essential. In 1867 Whistler renamed his painting *The Little White Girl* as *Symphony in White No.2* (plate 59). The new title emphasized that this was not a portrait but a study of mood to be consumed like a piece of music. Whistler did not want his audience to be concerned about the girl's life-story; instead, by weaving music into his picture of a woman and her mirror-image, he evoked abstract notions of nostalgia and loss. Like Rossetti, he was experimenting with the idea that music was a 'kind of borderland upon which internal emotion becomes wedded to external sound'.[5] Whistler and his Aesthetic colleagues recognized that realism was a cul-de-sac. Instead, art should glimpse a place where all senses were satisfied, where nature, for once, sang in tune. As music did not try to replicate the real or the visible, it offered the ideal pretext for exploring a landscape of the imagination.

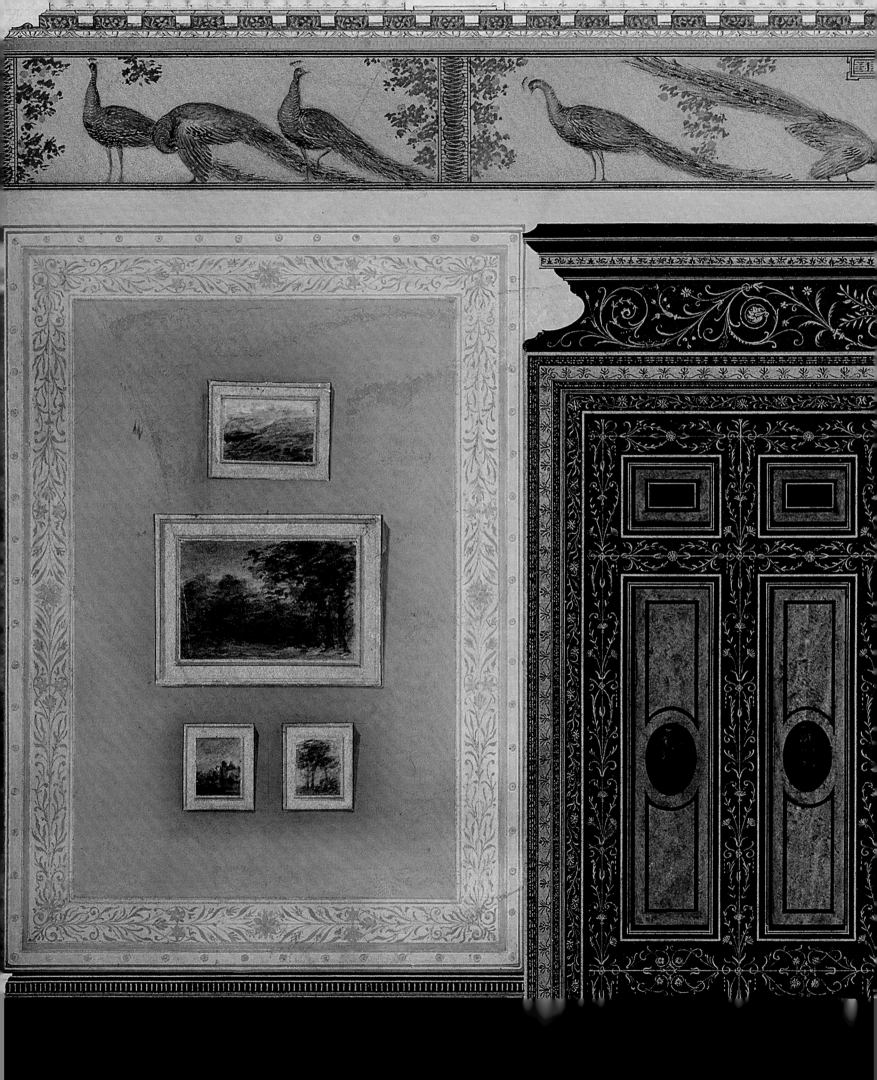

3 'The Palace of Art': Artists, Collectors and their Houses

'THE PALACE OF ART':
ARTISTS, COLLECTORS AND THEIR HOUSES

Stephen Calloway

I built my soul a lordly pleasure-house,
Wherein at ease for aye to dwell.[1]
Alfred, Lord Tennyson, 1857

Beautiful art can only be produced by people who have beautiful things about them[2]
John Ruskin, 1859

ONE OF THE MOST intriguing aspects of the cultural scene of the 1860s and 1870s is the extent to which, piqued by what little was publicly known of the way in which painters such as Dante Gabriel Rossetti, James McNeill Whistler or Frederic Leighton actually lived, people began to be highly curious not just about works of art, but about artists themselves. As the ideal of Art for Art's Sake began to gain currency in the 1860s, so increasingly the life devoted to art came to be perceived as a high calling. The idea took hold that artists' studios were in some way sacred spaces consecrated to introspective rites practised by the votaries of a new cult of beauty. By the 1870s Walter Pater was exhorting his followers to respond with passionate intensity to aesthetic stimuli of all kinds. His championing of the importance of the viewer's individual sensibility did much to inform contemporary attitudes to art and, perhaps paradoxically, refocused attention on the special nature of the artist's temperament, making the act and locus of artistic practice a matter of consuming interest.

Earlier notions, nurtured during the Romantic era, of the artist as wild, unfettered genius were gradually mediated by the very different aims of the emerging Aesthetic Movement which sought to redefine the artist primarily as a super-sensitive seeker after ideal beauty. Artists engaged in the creation of this new kind of exquisite art had a need, it was held, to look constantly upon beauty, to surround themselves only with exquisite things, and to keep every instance of the mundane and the ugly at bay. Should, therefore, the artist's studio be a public or a private space, it was asked. Should the arts provide, as Pater hoped, 'a refuge, a sort of cloistral refuge from a certain vulgarity in the actual world'?[3] Tennyson's poem 'The Palace of Art', brought to renewed prominence by re publication in the celebrated Moxon edition of his verses in 1857, seemed topically to reflect upon these questions of the equivocal desirability of artistic ivory towers at the very moment when more and more painters began to build for themselves surprisingly opulent houses and ever-grander studios.[4]

The poet's evocative phrase 'the palace of art' might aptly have been coined to describe the house and studio of Peter Paul Rubens in seventeenth-century Antwerp. Architecturally grandiloquent and filled with the painter's impressive collections of works

of art, antiquities and other costly goods, this indeed palatial residence was created as a conspicuous statement of worldly success. But Rubens's house was an exceptional case, his collections well beyond the usual artist's assemblage of casts and other studio paraphernalia. Though it is true that throughout history many successful artists, such as Mantegna in his Mantuan years, Dürer in Nuremburg or Poussin and later Ingres in Rome, lived at times in houses that if not actually 'lordly' were certainly exceedingly pleasant, generally the actual rooms in which they and their assistants worked (and which they would have called workshops or painting-rooms rather than studios) were essentially utilitarian spaces. Indeed, from the later seventeenth century onwards, most representations of the working studios of even prominent painters are characterized by the sparseness of their furnishings, by bare plaster walls and uncurtained windows with simple wooden shutters to control the all-important light. An anonymous watercolour of 1825, 'Mr Fuseli's painting room at Somerset House' (plate 60) reveals the same earnest frugality and lack of superfluous contents as we see recorded in images of David's famous Parisian atelier and later in Courbet's celebrated depiction of his own crowded but barn-like painting-room.[5]

The suggestion that painters of the imagination like Fuseli, or the creators of austere neoclassical scenes, such as David, had no need for studio props, but that the men of the 1840s and 1850s, diligently elaborating their medieval, Renaissance or 'olde Englishe' historicizing set-pieces, were obliged to surround themselves with armour, antique pots and scraps of old brocade offers only a partial explanation of the new fashion for bric-a-brac-filled studios and for the wider remarkable change in the lifestyles of artists. How then do we account for the revolution in taste that created in the 1860s, 1870s and 1880s the great number of extraordinarily richly furnished 'show-studios' built by successful London artists, and the introduction into the residential street pattern in Kensington and Chelsea, St John's Wood and the western suburbs of an almost entirely new London building-type, the substantial studio-house?[6] Often cited is the unprecedented broadening of the base of the picture-buying public from traditional aristocratic patrons, who had largely bought Old Masters, to include newly-rich merchants and manufacturers who preferred to buy contemporary works. The directly consequent increase in the revenues from picture sales and royalties on reproductive prints achievable by living artists is certainly a key factor in explaining how so many painters (including a good many whom we now regard as relatively mediocre) became possessed of the means to house themselves so lavishly. In a disgruntled letter the amateur

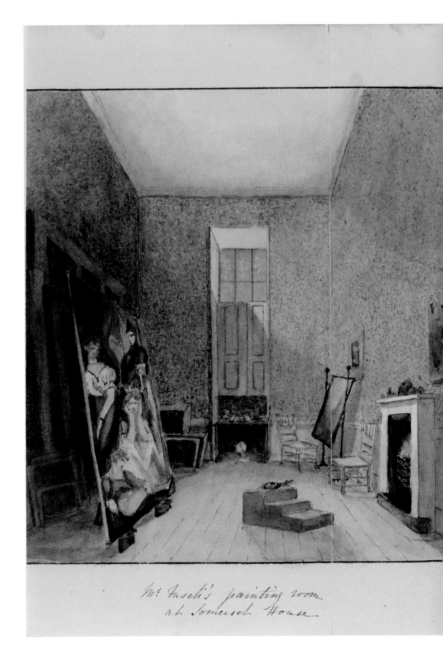

60
Mr Fuseli's Painting Room at Somerset House
Watercolour, c.1825
V&A: E.794–1994

etcher Philip Gilbert Hamerton went so far as to complain of 'the too great prosperity of the profession in these days … they tell me an artist's life is a princely one now'.[7]

The desire of the new, well-to-do, art-loving public to visit favourite artists at home and view their works, participating enthusiastically in the novel, semi-formal social ritual of 'Show Sundays', also led to a subtle but certainly perceptible rise in the social standing of artists. It accounts, too, for the increasing pressure upon artists aiming at the highest level of popularity and commercial success to meet expectations that their establishments should be at once more entertainingly theatrical and more grandly domestic than the spartan, workaday studios of the past, and above all that they should be accessible. Though some claimed to find the social obligations of the polite world irksome, many more seemed happy enough to fulfill this new role and put their furnishings, their families and themselves, as well as their pictures, on regular display. Paradoxically, seen against this emerging trend, the idea of the 'palace of art', and the complex concept of the princely artistic lifestyle which the phrase frames, could seem equally applicable in an ironic or even derogatory way to the frankly vulgar marble-halled mansion erected by John Everett Millais at Palace Gate, or in an altogether different, admiring sense to Frederic Leighton's far more subtly magnificent studio house in Aesthetic Holland Park. Perhaps on the whole, the Victorian public – and certainly the Metropolitan cultural elite – whilst always admiring conspicuous success and lauding the achievements of the industrious, self-made man even in the artistic sphere, preferred an interpretation that essentially recognized art as a finer and more mysterious calling than commerce, its practitioners inspired geniuses who ranked with the poets, not with tradesmen.

Moreover, such was the glamour and appeal of the lifestyle of artists that, for much of the period, the desire to emulate the sometimes quirky tastes of a small number of painters, all key protagonists of the Aesthetic Movement, became surprisingly widespread. Indeed, for twenty years, the way in which certain artists decorated their houses and filled their studios with types of object previously unconsidered by serious collectors but now unexpectedly discovered to be beautiful, became, for those with sufficient means to indulge their tastes, probably the single most important influence in smart interior decoration. Naturally, manufacturers and tradesmen at every level attempted to meet this demand, which rapidly extended from the exalted heights of William Morris's firm conducted by his band of 'art-workmen' to the opportunistic enterprise of provincial high-street purveyors who spotted a market for 'art furniture' and 'art-pottery'. Everyone, it seemed, aspired to be 'artistic'; though, as Du Maurier's cartoons and other satires in *Punch* from the late 1870s onwards clearly reveal, many such aspirants to the elevated ground of 'high art' were content at best to add a fashionable gloss of misunderstood Aestheticism or theatrical Bohemianism to their otherwise safe and reassuringly bourgeois lives.

In the smart London world, however, to seem authentically 'Aesthetic' and preferably 'intense' and to reflect – and parade – the rarefied nature of one's Paterian sensibility through the arranging of exquisite rooms became a touchstone of cultivation. Where once fine houses, elegant rooms and extensive collections had been seen as direct markers of wealth and social status, now the possession or, even better, creation of the 'house

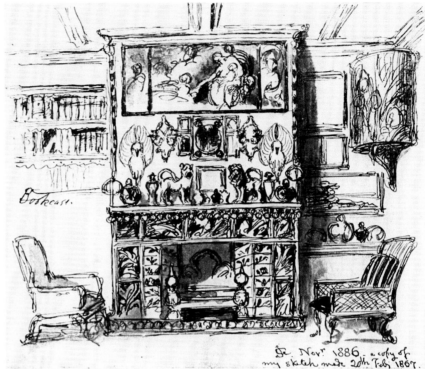

beautiful' increasingly came to be interpreted as the necessary expression of a subtle 'artistic' nature. However, more than one set of fashionable decorative preferences were in competition here, for Aesthetic tastes could be disconcertingly varied. Some consideration of the houses of three of the key figures of the Movement, Leighton, Whistler and Rossetti, will reveal three clearly differentiated ideas of 'the house beautiful'. But in each case, the ways in which these artists chose to live, arrange their houses and display their collections came to be seen as an inevitable and indeed crucially indicative expression of their individual artistic sensibilities. Mary Eliza Haweis, that self-proclaiming expert on the subject of being 'artistic' in one's dress and comportment as well as house decoration, caught this crucial nuance when she wrote in her book *Beautiful Houses* (1882) of 'houses … which are typical of certain minds, and arranged with exquisite feeling'.[8] By no means all of Mrs Haweis's choices in that influential little volume were the dwellings of artists – several in fact belonged to rich collectors and connoisseurs – but all conformed to Aesthetic notions of exquisiteness and individuality. It is perhaps significant that the first she described was the Holland Park Road studio-house of Frederic Leighton, the artistic figure who for many epitomized the new cult of beauty.

From the moment of his arrival in London in the 1850s Leighton, trained in the Continental tradition and thus in possession of an impeccable painterly technique to match his high ideals, seemed destined for success. That success, both pecuniary and in terms of reputation and honours, came quickly. By the 1860s Leighton was marked as one of the most promising artists of the day; if he was to fulfil already lofty ambitions he would require his own establishment. The studio-house which he commissioned from the

ABOVE LEFT
61
Henry Treffry Dunn, *Corner of the dining-room at No.16, Cheyne Walk*
Pen and sepia wash, present location unknown
From Henry Treffry Dunn, *Recollections of Dante Gabriel Rossetti and his Circle; or Cheyne Walk Life*, London 1904
Stephen Calloway Collection

ABOVE
62
John Gilbert, sketch of the sitting room at Tudor House, 16 Cheyne Walk
Replica made in 1886 of the original, drawn 20 February 1867
From Ernestine Mills, *The Life and Letters of Frederic Shields*, London 1912
V&A: NAL

OPPOSITE
63
George Aitchison, design for the Arab Hall,
Leighton House
Watercolour on paper, 1880
Royal Institute of British Architects, London

little-known architect George Aitchison was begun in 1866. Initially a compactly planned, provocatively brick-faced structure, it provided the elegant bachelor painter with modest, even austere living quarters and, significantly, no spare rooms for distracting house-guests. On the ground floor, facing the garden, there were elegant but by no means extravagant drawing and dining rooms suitable for entertaining. These relatively conservative rooms opened from a rather more grandiose stair-hall which resembled the roofed-over court-yard of a small palazzo. From here the splendid staircase rose in three stately and heavily balustraded flights to the first-floor studio. With its impressive proportions the studio was at once the centre of the house and the reason for its existence, ideally suited not only to painting and modelling, but also to the display of work in progress on show-days and as the setting for the lavish musical soirées and other social events to which Leighton began to draw an ever-widening circle of influential friends and supporters.

Over time, and as imagination suggested and growing resources permitted, Leighton added significant architectural and decorative elements to the original plan. He greatly improved the arrangements of the main studio, formed a small, elegant library and a silk-hung gallery room (plate 64), and created the celebrated Arab Hall (plate 63), one of the most memorably successful examples of Victorian exoticism, rich with Damascus tiles, painted, carved and incised ornament and gilding. Mrs Haweis in her description of the house grasped not only the delightful interplay of colour and pattern throughout, but also the all-important architectural flow of the spaces:

> The main feature of the house is this gradual progress and ascent to the studio, and the arrangement of the ground floor, where hall opens out of hall, reviving now antique, now mediaeval, now Renascence Italy, from Florence to Rome, down through regal Naples, on to Cairo itself; and yet is not Rome, nor Sicily, nor Egypt, but a memory, a vision seen through modern eyes.[9]

Thus attentive to the historico-geographic influences to be discerned in the architecture and decoration, Mrs Haweis alerts us to the idea that in plan, form and detail the house was intended to be powerfully allusive. First, there are the obvious and often accurate nods to the architecture of Italian Renaissance houses, to Byzantine carved ornament and, of course, to later Middle Eastern and Sicilian Islamic decorative work. All Leighton's major decorative effects (as realized by Aitcheson and talented collaborators such as Walter Crane) are in that sense programmatic in a very similar way to those contrived by certain great eccentric collectors and builders of the previous generation. But beyond a mere sort of Regency fancy-dress styling, the sheer conviction of the conceit of Leighton's Arab Hall and his creation of spaces such as the inner 'Narcissus Hall', named from the sculptural figure that formed its centrepiece, have the undoubted ring of Sir John Soane or Thomas Hope, both of whom sought to contrive similarly precisely informed poetic atmospheres around key objects in their respective collections.

There are curious parallels, too, between Leighton's decorations and the effects created by William Beckford, especially in the latter's last enterprise, the small but numinous

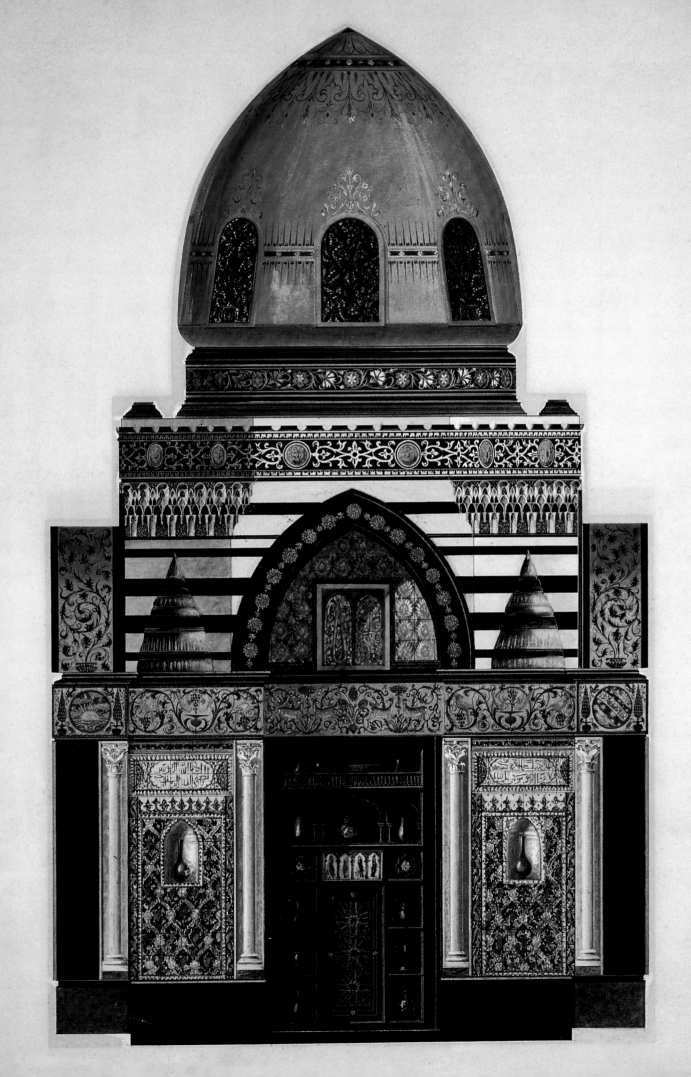

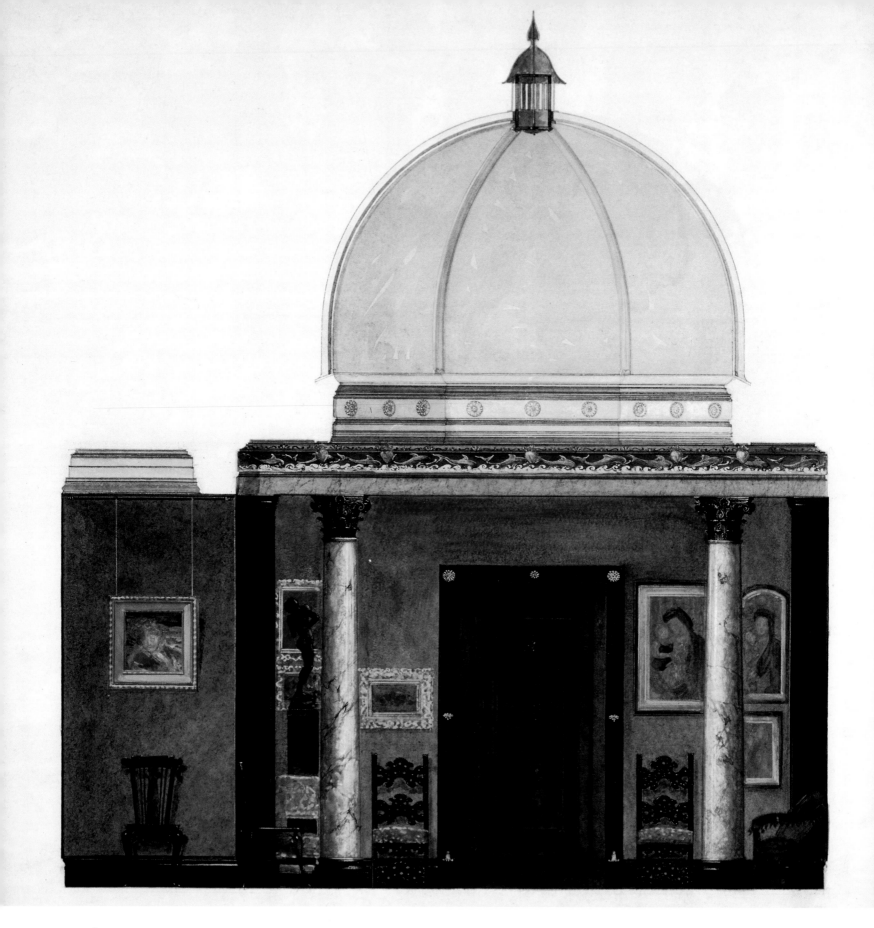

64
George Aitchison, design for the Silk Room, Leighton House
Watercolour on paper, 1895
Royal Institute of British Architects, London

rooms in his Lansdowne Tower at Bath. There heavy and plain, over-scaled mouldings and rich, deep colours hint at magnificence, but also in this case at melancholic seclusion. Beckford was a self-styled patrician recluse, building his vision of the Palace of Art solely to house his remaining treasures and to indulge his own whims and fantasies; Leighton, who was a discriminating collector (of paintings and drawings, of Iznik and other ceramics, but not, it appears from old photographs of the house, of furniture) also planned his living quarters for occupancy by himself alone.[10] By contrast, however, and from the start he conceived his studio and grander rooms as semi-public parade spaces to serve, if not too blatantly as an advertisement for his work, then certainly as a confident declaration of taste, and as the essential backdrop for the career of a successful painter, the scene against which to play out his chosen role of social lion.

Such grandeur and social ambition would have amazed the Bohemian artists of 1840s Paris. Brilliantly fictionalized by Henry Mürger in his *Scènes de la Vie de Bohème*, their lives revolved around the search for the day's dinner and the next quarter's rent as much as dedication to their art. The backdrops to their lives were bare, often semi-derelict studios, each with its central symbolic feature, the all-important stove on which in times of direst need they were compelled to burn their meagre furniture or even their drawings. Writing towards the end of our period, George du Maurier in his popular novel *Trilby* (1894) offered an equally romanticized account of Parisian studio life in the 1850s drawn from recollections, forty years on, of his days as a member of the group known as the 'Paris Gang', which included Edward Poynter, the Ionides brothers Luke and Alecco and, most notably, James McNeill Whistler. Their existence was undoubtedly less exiguous than that of Mürger's desperate romantics, but equally undoubtedly, the Parisian model of relatively austere studios lastingly informed Whistler's attitude to his surroundings. The fact that in Whistler's character a certain inherent ascetic trait, together with the hint also of inherited New England puritanism, was combined with the most highly developed appreciation of colour and decorative effect and the subtlest sensibility to atmosphere and the placing of works of art, led him to create some of the least obviously palatial, yet most beautiful, significant and influential rooms of the Aesthetic period.

By the end of the 1850s Whistler, intermittently quitting Paris, had more or less settled in London, coming initially in order to find new subjects and, he hoped, new purchasers for his etchings. Drawn inevitably to the river, he fell in love with Chelsea Reach, at that time cheap and dilapidated but still picturesque before the building of the Embankment changed its character forever. In 1863 he established himself at number 7 Lindsey Row (now 96 Cheyne Walk), a house that formed the modest western end of a terrace, by then divided and fallen upon hard times, that had in the late seventeenth century been the single handsome riverside residence of the Earls of Lindsey. There he was immediately taken up and befriended by the bohemian coterie that gathered around Dante Gabriel Rossetti, who had taken the equally ramshackle Tudor House (16 Cheyne Walk) in the previous year. Describing the old, part-wainscoted Lindsey Row house, in which Whistler was obliged to make do with two ordinary rooms for his painting studio and printmaking workshop, his biographers, Joseph and Elizabeth Pennell, remarked

OPPOSITE
66
James McNeill Whistler,
The Artist in his Studio
Oil on paper mounted on
mahogany panel, 1865–6
The Art Institute of Chicago

laconically that it was 'humble when compared with the palaces Royal Academicians were building'.[11] In fact, neither Whistler nor Rossetti had any desire to establish grand show-studios, but each in his way had an obsession with contriving entirely unconventional environments sympathetic to their very different temperaments. Nor did Whistler at this date – or Rossetti at any time – seek to court the beau monde; both preferred to surround themselves only with interesting and convivial acolytes who understood their aims and could appreciate the peculiar charm of rooms with idiosyncratic schemes of decoration. Within this circle there were, as it happened, several who shared the painters' newly developed and still highly unusual interest in 'artistic' bric-a-brac.

Well before he settled in London, Whistler was already gripped with the craze for Japanese and other 'oriental' art that had but recently seized artists and connoisseurs in Paris. Though rarely in funds, he had somehow managed to acquire from the handful of French dealers who specialized in such things a considerable number of good pieces, including Japanese books and woodblock prints and the first of many fine examples of blue-and-white ('Nankin') porcelain (see plate 82). Arriving with this nascent collection, Whistler's passion and evident discrimination as a collector, as well as the sheer visual novelty of the objects, did much to enthuse his new English friends, spreading this hitherto almost exclusively Parisian fashion to London's artistic circles, initially in particular within the Rossetti set.

At this date, Whistler's taste for plain painted walls in colours and tones which he mixed himself with a painter's eye, was very remarkable. In the Lindsey Row dining room (where he painted his favourite model, Jo Hiffernan, as *Symphony in White No.2: The Little White Girl* (plate 59) the walls and woodwork formed an unlikely 'harmony' in flesh-colour, yellow and white. In this setting and in the top-floor painting studio with its scheme of exquisitely modulated, warm greenish greys (seen in the 1865–6 self-portrait *The Artist in his Studio*, plate 66) and other rooms with soft greens and yellows for the walls and black lacquered woodwork, Whistler displayed his already considerable groups of oriental objects. On the walls he hung his Japanese prints in plain, thin frames, various embroideries and hanging scroll paintings, and 'flights of fans'. Everything was precisely placed with the same sense of restraint and balance that characterized Whistler's pictures and etchings; even the many pieces of blue-and-white china were mostly massed in shelved alcoves or cabinets to maximize their effect. This Whistlerian manner of decoration, a style that made old rooms look fresh and stylish, became influential and was for many years much imitated, though not always with the subtlety of the master. Even as late as 1908 the Pennells were still complaining that 'people, afterwards, copying him unintelligently stuck up fans everywhere, and hung plates from wires as ornaments. Whistler's fans were arranged for a beautiful effect of colour and line'.[12]

Whistler's ideals of decoration were effectively fixed during these first years at 7 Lindsey Row; in essence, they would change little thereafter. Just as he disliked too much, or even any, demonstrative pattern in a room, he also avoided a clutter of cumbersome furniture, tending always towards light and delicate pieces, arranged sparingly. At this date he favoured the plain, neat chairs and tables of Hepplewhite or Sheraton; later,

65
Photograph of the drawing room at
7 Lindsey Row, *c.*1863–6, showing
Whistler's arrangement of Japanese scroll
paintings, screen and fans
From E.R. and J. Pennell, *The Whistler Journal*,
Philadelphia 1921
Stephen Calloway Collection

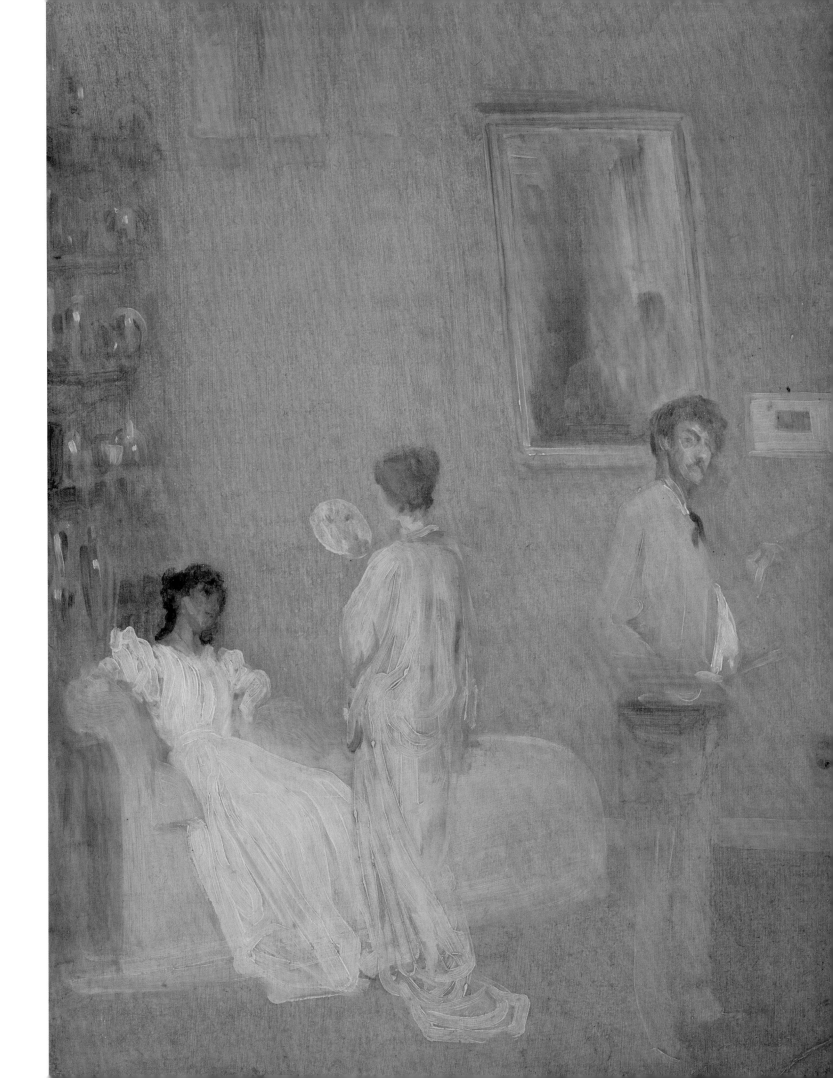

back in Paris he would be among the first to revive the taste for *Louis seize* simple painted neoclassical furniture. In 1866 he moved to the somewhat grander house, number 2 at the opposite end of the row. There, in the happy and productive decade which followed, he painted the best of his *Nocturnes* and the great portraits including those of his mother and Thomas Carlyle, in which we can appreciate, incidently, the beauty and assurance of the perfectly judged, low-key colour schemes of the walls. It was in these years that Whistler and the architect E.W. Godwin became close and refined a distinctive shared aesthetic.

Much has been written concerning the innovative nature of the White House in Tite Street which Godwin designed for Whistler in 1877. Its conception and details have been rightly hailed as one of the earliest and most intelligent assimilations of Japanese ideas in the West, and also more contentiously as 'proto-modern'. It is, however, worth observing that in many respects the building did conform to the emerging pattern of the purpose-built artist's house fronting the street and incorporating at its heart a high, well-lit studio; in its layout it was therefore not unlike the first phase of Leighton's house, though of course planned on a far more modest scale. In terms of decoration and furnishing the White House impressed by its extreme novelty. Artist and architect together contrived schemes which effectively recapitulated their agreed ideas about the use of colour and the sparing disposition of furniture, ideas that had origins in various individual and collaborative experiments of a decade and more before. The two most important rooms in the house were the upper main studio and the smaller studio drawing room on the ground floor. The latter had a memorable scheme of terracotta walls above a white painted dado supporting a shelf bearing a sequence of startling orange Kaga vases (plate 67). This dado was composed of *sgraffito* plaster panels resembling the texture of Japanese matting, of which both Whistler and Godwin were advocates. Very little furniture interrupted the open floor space which was covered here, as throughout the house, with geometric patterned matting. The main studio, with light from huge windows softly

67
Edward William Godwin, detail of the design for the White House, 35 Tite Street, Chelsea, London, for James McNeill Whistler
Pen and ink on paper, 1877
V&A: E.544–1963

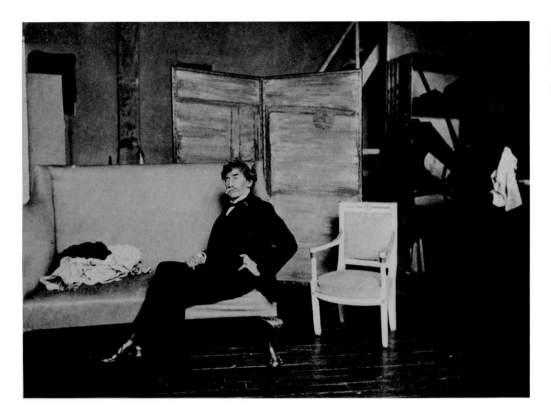

68
Photograph of James McNeill Whistler
in his studio, rue du Bac, Paris
From E.R. and J. Pennell, *The Life of
James McNeill Whistler*, London 1911
Stephen Calloway collection

suffused by white blinds, was even more spare in effect. Apart from pictures on easels, and practical items such as paint cabinets, tables and a few caned chairs, almost the only ornamental piece was the famous folding screen which the artist had decorated on one side with a stylized *Nocturne* of Battersea Bridge (Hunterian Museum and Art Gallery, Glasgow); Whistler held this screen in high affection and kept it always by him (plate 68).

Following the forced sale of the White House that resulted from Whistler's bank-ruptcy after his court action against Ruskin (see p.225), the new owner Harry Quilter, another old antagonist, crammed the rooms with furniture, spoiled the artist's colour schemes and unpardonably altered the architecture. Whistler took a studio-apartment a few doors away in Tite Street ('living next door to myself', as he put it), where he continued to entertain guests at his famous breakfasts of eggs served at a table laden with blue china and late eighteenth-century silver, each piece engraved with a perfectly placed butterfly. Descriptions by those who visited these later Tite Street rooms emphasize above all the effects of colour, especially the artist's favoured yellows; they barely mention furniture or, more surprisingly, the pictures. Given the radical approach taken to decor-ation by Whistler and Godwin, it was always likely that their ideas would be largely misunderstood by those who judged by the conventional standards of the day. One visitor to the White House dismissively observed that 'all over the house there is a remarkable absence of effect, both from the artist's and the auctioneer's point of view'.[13] It is fair to say that Whistler's achievement as a creator of domestic and exhibition interiors did attract some praise – especially from fellow artists – but also much uncomprehending criticism, in the same way and in about equal measure as his art.

69
Edward Burne-Jones,
Sketch of Red Lion Square in 1857
Pen and ink, drawn *c.*1890
Mark Samuels Lasner collection

At two crucial periods in his life, Rossetti's concern with furnishing and decoration, collecting and the invention of 'artistic' interiors seems to have been of sufficient importance to influence his work and absorb much of his attention. Though involved in 1856–7 with his young friends and protégés William Morris and Edward Burne-Jones in painting clumsy, medieval-style chairs for their studio at Red Lion Square (plate 69), he appears to have first taken a serious interest in the potential of interior decoration to create a visual effect and poetic mood when Elizabeth Siddal set up home and studio with him at Chatham Place, Blackfriars, in 1860. Significantly, this moment coincided with the early domestic phases of the lives of Morris and Burne-Jones, both then newly married, and with the bachelor William Burges's highly idiosyncratic experiments in his nearby chambers in Buckingham Street, which he filled with painted decoration and a strange mix of medieval and Japanese artefacts. On a shoestring budget, Rossetti contrived to trick out his rooms to the admiration of his immediate circle, introducing a distinctive scheme of green paintwork. Most importantly, he proposed an entirely novel wallpaper with a stylized pattern of repeating trees bearing fruits (plate 70). This design was perhaps inspired by a background detail in a one of the set of engravings by Lasinio of medieval frescoes in the Campo Santo at Pisa, a favourite book of the Pre-Raphaelite Brotherhood. Rossetti described his intention thus:

> I shall have it printed on common brown packing paper and on blue grocer's
> paper, to try which is best … The trees are to stand the whole height of the room
> … Of course they will be wholly conventional. The stems & fruit will be Venetian
> Red – the leaves black … The red & black will be made of the same key as

the brown or the blue ground so that the effect of the whole will be rather sombre but I think rich also. When we get the paper up we shall have the doors & wainscotting painted summer house green.[14]

Though perhaps never realized, it is this startling application of painterly ideas in a domestic context rather than the group's more famous 'jovial campaign' frescoing a public building, the Oxford Union's debating hall, with figurative scenes, that really foreshadows much of what Morris would achieve in subsequent decades.

Following his wife's death in February 1862, Rossetti could not bear to remain at Chatham Place. He moved into Tudor House on Cheyne Walk, intending at first to share the large and handsome, early eighteenth-century house with his brother William Michael and various friends such as Algernon Swinburne and George Meredith, who described it as a 'strange, quaint, grand old place, with an immense garden, magnificent panelled staircases and rooms – a palace'.[15] Fanny Cornforth, consoling companion and model for the series of frankly sensual female figures which began with *Bocca Baciata* (plate 42), was also installed, notionally as housekeeper. For several years Rossetti was entranced by the house, gradually taking it over entirely. Until debilitating anxieties, a breakdown as a re- sult of attacks in the press and a gradual addiction to the drug chloral conspired to make him a sullen recluse, he continued to entertain his amusing circle of friends, delighting in showing off the most recent acquisition as much as the latest poem or picture. In these years he lavished much of his time and attention – as well as all the money he could get – on outlandish furnishings and other objects, including a remarkable number of mirrors in every room, and on an exotic menagerie of birds and animals coralled in the extensive, wildly overgrown garden. In this second and more sustained period of interest in interiors Rossetti became absorbed in the creation of carefully contrived schemes of decoration, dictated in considerable part by his new-found enthusiasm for old chests and cabinets, Chinese hardwood furniture and other oriental pieces including Indian and Islamic brass- wares, Japanese prints and blue-and-white china (plates 61, 62).

70
Dante Gabriel Rossetti, sketch of design for wallpaper for Chatham Place, 1861
Pen and ink
Present whereabouts unknown

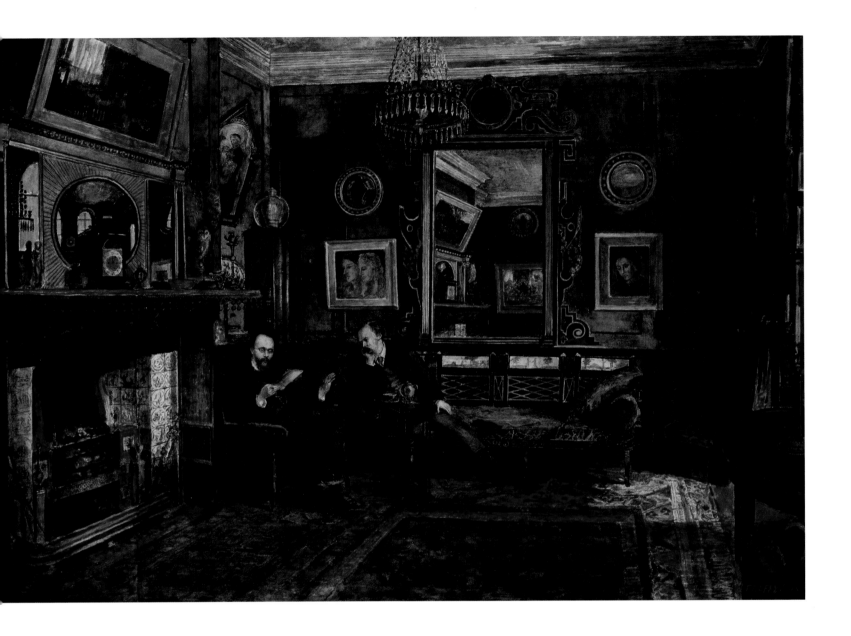

71
Henry Treffry Dunn, *Dante Gabriel
Rossetti and Theodore Watts-Dunton
in the Sitting Room at Tudor House,
Cheyne Walk*
Gouache on paper, 1882
National Portrait Gallery, London

Fortunately we know a good deal about the appearance of the main rooms of Tudor
House from contemporary descriptions and from a group of meticulous watercolours made
by Rossetti's studio assistant Henry Treffry Dunn. Also, from the individual lot details
recorded in the hastily compiled catalogue for the sale of the household goods immedi-
ately after Rossetti's death in 1882, we can track much of the the contents of every room,
identifying surviving objects such as the ancient Chinese bronze bull (miscatalogued as
seventeenth-century Japanese) bought by Constantine Ionides for £5, the pair of Chinese
armchairs (bought from the sale by Millais and subsequently acquired after his death by
Holman Hunt) or the sofa made to Rossetti's own design for his bedroom.[16] From these
complementary sources a picture emerges of sombre, richly coloured schemes closely re-
lated to the palette of colours of the artist's cavases in which peacock blues and greens
with relieving touches of red predominate (plate 71). In some of Rossetti's paintings, in
addition to many single objects employed as props, we can even recognize specific aspects

72
Henry Treffry Dunn, *Rossetti's Bedroom*
at Tudor House, Cheyne Walk
Watercolour on paper, c.1875
Wightwick Manor, The National Trust

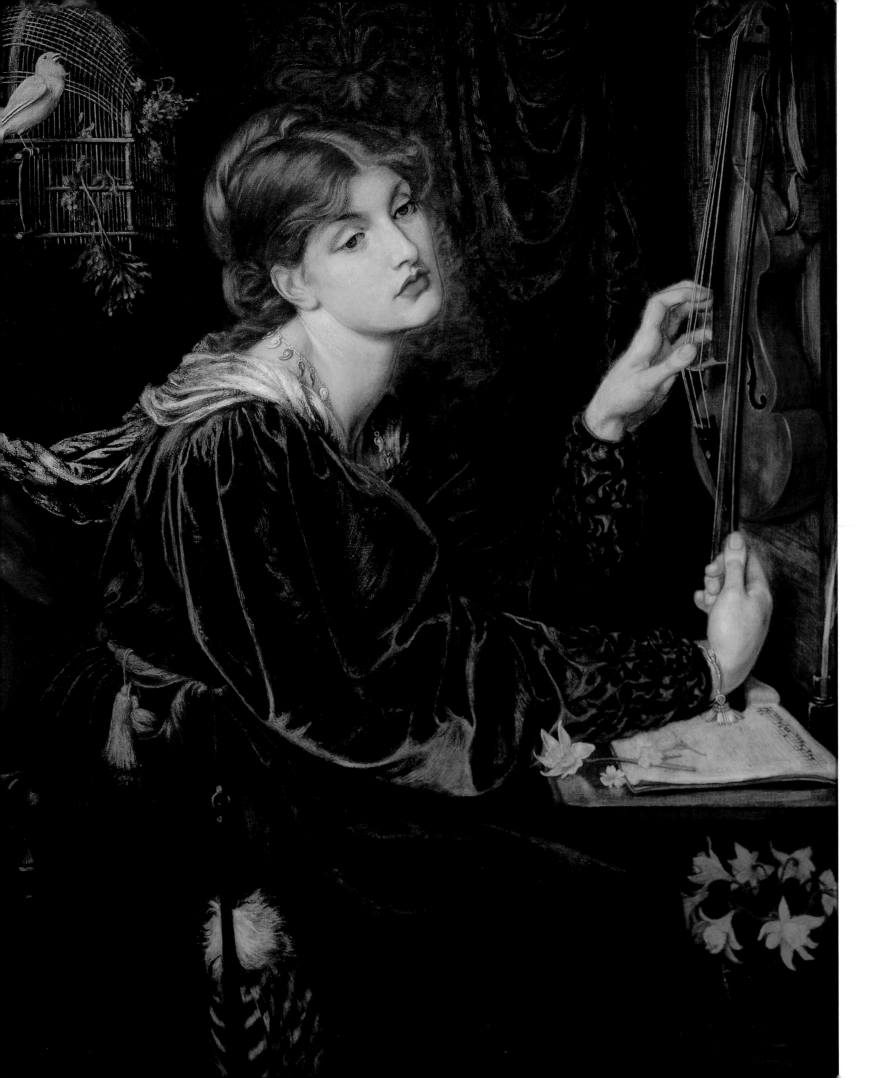

of the decoration at Tudor House. The background of *La Bella Mano* (1875; Delaware Art Museum, Wilmington, DE), for example, includes an accurate view of the bedroom as reflected in a convex glass; in Treffry Dunn's watercolour study of this detail (plate 72) we clearly discern Rossetti's four-poster bed hung with seventeenth-century crewel-work curtains ('bought out of an old furnishing shop somewhere in the slums of Lambeth', according to Dunn) and the heavy black chimneypiece surmounted by shelves laden with old candlesticks, brass and china. Similarly, *Veronica Veronese* (plate 73) employs as a most telling feature of its setting the green figured velvet of the window curtains and seat covers, thereby suggesting the lush but airless atmosphere of the bedroom. This oppressive feel was recalled by Dunn in his *Recollections* and later by Mrs Haweis, who took the room as her own when she moved into Tudor House following Rossetti's death.[17]

Rossetti's collections filled the house densely, imparting something of the flavour of the antiquarian interiors of the eighteenth and early nineteenth century in which objects were prized for their oddity and associative qualities. The sale of Horace Walpole's Strawberry Hill as recently as 1842 had revived criticism that the pursuit of curios was a frivolous pastime. Rossetti, delighting in his own Bohemian eccentricity, seems rather to have considered the search for old inlaid furniture and cloudy mirrors in brokers' shops around The Strand and for more exotic items in the East End as an important way of creating suggestive interiors in which his poetry and his art could flourish. In assembling such eclectic rooms full of old furniture for use rather than as collectors items, Rossetti anticipated and indeed to a great degree initiated the craze for 'decorating with antiques' which has held sway in cultivated circles to this day.

In considering the houses of Leighton, Whistler and Rossetti in relation to other artists' and patrons' houses it is clear that each of the three gave a lead to many followers. For example, Lawrence Alma Tadema in his two extraordinarily extravagant houses clearly delighted in Leighton's programmatic mode, mingling together cool neoclassical, rich Byzantine and quirkier 'old Dutch' elements (plate 74). Whistler's friends, such as the painter Frank Miles (for whom Godwin also built a Tite Street studio house), and such loyal supporters as Lady Archibald Campbell and the Alexanders at Aubrey House, enthusiastically embraced his exacting ideas for colour schemes, though not perhaps the austerity of his taste in furnishings. Writing in 1908, the Pennells, always partisan on behalf of their hero, understood very well what it was about Whistler's schemes that also made them appealing to a rising generation of architects and designers: 'The beauty of [his] decoration … was its simplicity, an innovation when men were wavering between the riot of Victorian vulgarity and the overpowering opulence of Morris mediaevalism.'[18] However, with rather less grasp, they went on to add that 'from descriptions, Rossetti's house was a museum, an antiquity shop, in comparison'.[19] In thus denigrating Rossetti, they failed both to recognize the importance of the interaction between the two artists and collectors, who it must be remembered had formed their admittedly very different tastes together, or to realize the very great extent to which the Rossettian version of the House Beautiful had become the ideal, not just for artists, but for all aspiring Aesthetes.

OPPOSITE
74
Anna Alma Tadema, *The Drawing Room,
Townshend House*
Watercolour over pencil and pen
and ink on card, 1883
Royal Academy of Arts, London

That the house of a recluse, lost in his own visions, should have come to exert such a powerful and enduring influence is indeed strange. Harry Marillier, curiously echoing the Pennell's assessment of Whistler's influence, explained it thus:

> Rossetti in spite of his entire indifference to the outside public, had a wonderful way of infecting it with his own predilections and taste. He had born a leading share in the Morris decorative movement; and now he was destined to pave the way for the modern craze for old oak furniture and blue china. Bric-a-brac was not of much account in England when Rossetti first began rummaging the dealers' shops … it was a purely original idea in those days to buy up old furniture for use, and to enrich the walls of a house with … treasures from Japan. Those who follow the fashion today do it in many cases vulgarly and unintelligently, turning their houses into museums of costly and incongruous objects. So far as decoration went Rossetti knew to a hairbreadth what would harmonise and what would not, and however wide the range of his purchases might be he was never guilty of errors of taste. In such matters, it is generally conceded, his judgement was a touchstone.[20]

That the styles of decoration invented by Rossetti, Whistler and even Leighton were so much imitated is fascinating; that it was so often done 'vulgarly and unintelligently' is hardly to be wondered at, when few outside the charmed circles of the artists entered their houses and sensed their exquisite atmosphere for themselves. No matter how widespread the desire to be 'artistic' and to create the 'house beautiful', in an age when photography could still record little of the true effect of an interior and no sense of the colour, in the Palace of Art the eye of the artist was all.

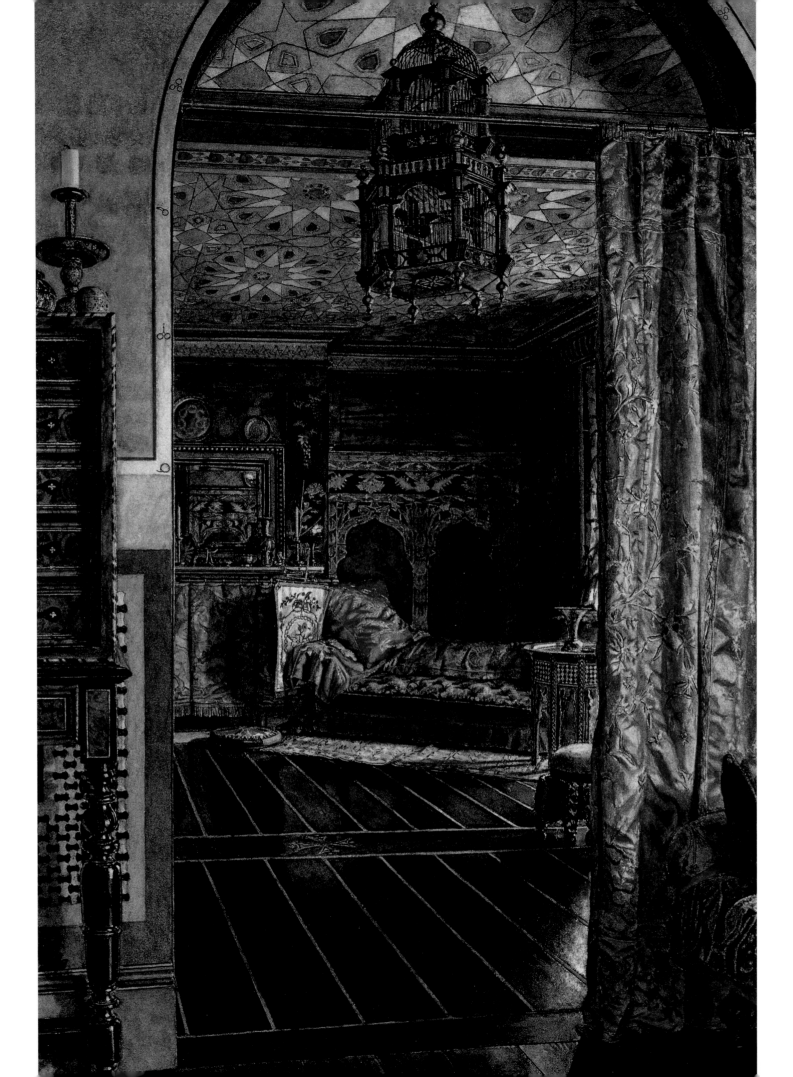

Japonisme

Christine M.E. Guth

NO SINGLE STYLE or medium defines Japonisme, the fashion for all things Japanese that swept Britain, Europe, and North America between the 1860s and the first decade of the twentieth century. This creative adaptation and transformation of Japanese arts and crafts impacted the decorative and fine arts as well as architecture, interior decor and fashion. Its varied expressions were rooted in a desire to recuperate the handcrafted values lost to the industrial revolution, closely allied to efforts to reform British design in the face of declining standards and to improve dehumanizing conditions in the workplace. The middle classes – who had benefited most from the industrial revolution – were also those most attracted to Japonisme. Although traditional Japan was represented as an aesthetic counter to modern materialism, the creative expressions it inspired satisfied growing public demand for goods that could help fashion new lifestyles.

Japonisme celebrated exoticism, sensuality, novelty and, in Britain especially, the cult of beauty: the consumption of Japanese or Japanese-style furniture, ceramics, textiles and metalwork played a key role in the aestheticization of the British home and its inhabitants. The belief that the Japanese lived a life in harmony with nature, with art and beauty overriding material considerations, was fundamental to its appeal among proponents of art for art's sake. Responses to this romanticized image of Japan were not uniformly laudatory, however. In his response to Whistler's claim that Japanese was the equal of Greek art, Swinburne declared: 'Japanese art is not merely the incomparable achievement of certain harmonies in colour; it is the negation, the immolation, the annihilation of everything else.'[1]

Whatever their views, for most British Aesthetes Japan was as distant in space and time as medieval Europe and

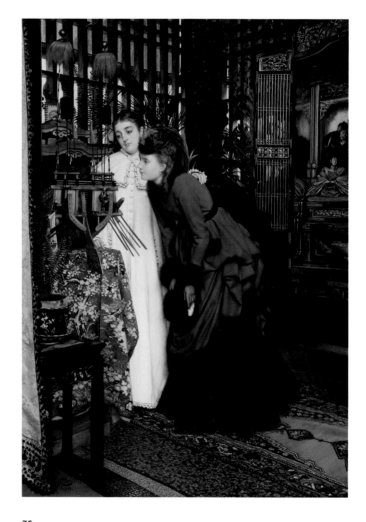

75
James Jacques Joseph Tissot, *Young Women Looking at Japanese Articles*
Oil on canvas, 1869
Cincinnati Art Museum

classical Greece, with which it was often conflated, and it was defined not by living people but by material things. When Oscar Wilde wrote during his lecture tour of America of his 'irresistible desire to wander, and go to Japan, where I will pass my youth, sitting under an almond tree in white

blossom, drinking amber tea out a blue cup, and looking at a landscape without perspective', he visualized that country through textile patterns, ceramics, and woodcuts, in a palette of blue and white that was influenced by the porcelains from China and Japan so avidly collected and displayed in the 'house beautiful'.[2]

The flood of imports from Japan following the London International Exhibition of 1862 stimulated among artists and designers a heightened appreciation of materials, techniques, forms and colours. Bamboo, both real and imitation, was widely adopted for furnishings, its honeyed tones and slender lines in keeping with the lighter palette newly advocated for walls. Edward Godwin's sleek, ebonized furniture evoked the glossy black finish of Japanese lacquer (plate 76). The sophistication of Japanese metalwork, with its complex alloys and rich colouristic effects, was a catalyst for experimentation with base metals previously ignored by designers in favour of silver and gold. Christopher Dresser was one of the few British designers to actually travel to Japan, giving him an opportunity to see Japanese arts and crafts in the context of their domestic production and consumption. His first-hand study of ceramic manufacture during a four-month tour made at the invitation of the Japanese government may have contributed to his own idiosyncratic expressions in this medium.

The embrace of Japan also manifested itself in an eclectic new grammar of ornament, ranging from geometric fretwork and crackled effects to a repertory of flora and fauna in which cranes, carp and chrysanthemums figure prominently (plate 77). Japanese crests, *mon*, became especially popular design elements, alone and in combination with other motifs. Asymmetrical disposition of pattern and overlapping patterns with contrasting dynamic foreground and still background were also typical. Japanese woodcuts offered an alternative source of subjects, styles and palette that profoundly influenced graphic design, book design and illustration. The striking cover of Swinburne's *Songs Before Sunrise* (plate 80) speaks to the assimilation of a Japanese sense of space as well as to the way that *mon* were creatively

76
Edward William Godwin, Anglo-Japanese furniture designs
Pen, ink and watercolour on paper, *c*.1875
V&A: E.482–1963

77
Attributed to Edward William Godwin,
Japonesque fabric swatch-book
Silk and wool furnishing fabric for J.W. & C. Ward,
c.1870–5
V&A: T.97–1953

78
Silver Studio, design for a
border pattern using Japanese
stencil (*katagami*) fillings
Gouache on brown waxed
tracing paper, 1893
Museum of Domestic
Design & Architecture,
Middlesex University

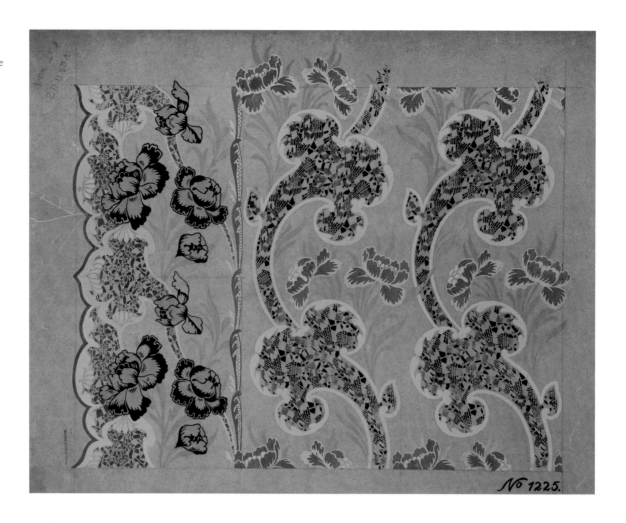

79
Katagami stencil
Layers of Japanese paper
glued with wheat starch
paste, stained and
waterproofed with
persimmon juice,
late 19th century
Museum of Domestic
Design & Architecture,
Middlesex University

80
Dante Gabriel
Rossetti, cover of
Algernon Charles
Swinburne, *Songs
Before Sunrise*, 1871
Blocked in gold
on blue-green
publisher's cloth
Stephen Calloway
collection

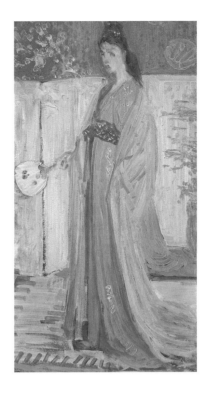

81
James McNeill Whistler,
sketch for *Rose and Silver:
La Princesse du Pays
de la Porcelaine*
Oil on fibreboard, 1863–4
Worcester Art Museum,
Massachusetts

reinterpreted to suit the theme of this collection of poems. The visual repertory of wallpaper and textiles designed by Arthur Silver integrated a wide array of exotic motifs in their designs (plate 78). Silver collected Japanese materials as sources of inspiration, even experimenting with the use of paper stencils, *katagami*, originally used for textiles to create unusual decorative effects in wallpaper (plate 79).

Japonisme was simultaneously a conservative and a progressive movement into which a range of cultural, social and gender positions were woven. While it has often been seen as leading inexorably towards the simplicity and austerity of modernism, this drive was not always true of the work of the artists and designers associated with the Aesthetic Movement. For Whistler, Japanese colour woodcuts opened up a new approach to painting that focused on formal rather than narrative values. Yet his representations of kimono-clad women standing before folding screens relegated them to the beautification of the domestic interior (plate 81). The kimono itself occupied an ambiguous place in the transformation of nineteenth-century dress, on the one

hand suggesting the languorous sensuality of the Orient, and on the other a mode of draped clothing that might free women from the confines of the corset. Similarly, the rectilinear form and sleek lines of Godwin's furniture may be contrasted with his more intricately ornamental textiles.

During the four decades spanned by the craze the values ascribed to Japan changed, as what had initially been a taste associated with a small avant-garde elite was commercialized by firms such as those founded by Arthur Silver and Arthur Liberty. At the same time, as craft production in Japan became increasingly mechanized and its exports made to accommodate perceived Western tastes, its culture was increasingly decried as decadent. This same label, suggestive of an erosion of spiritual, artistic and moral values, was also applied to Aubrey Beardsley's graphics, whose compositional devices, motifs and linear economy were informed by his study of early Japanese woodcuts. Beardsley's subversive challenge to the repressed sexuality of Victorian culture also forced viewers to acknowledge that Japan was not to be seen as Europe's lost youth, caught in a state of childlike innocence.

Blue-and-White China

Stephen Calloway

A TASTE FOR 'Old Blue', 'Blue-and-White' or 'Nankin' china, as it was variously known, became a touchstone of the Aesthetic sensibility in the 1860s and lingered until around the turn of the century.[1] Perceived at that time as a facet of the interest shown by artists, collectors and connoisseurs in the styles and furnishings of the 'good old days of Queen Anne', the almost fetishistic admiration for these oriental wares was indeed a fascinating revival of a sensibility with an already long tradition.

From the moment of their first arrival in Europe in the late medieval period, Eastern porcelains were highly prized for their novel forms, subtle colouring and the perfection of their glazes. In the cabinets of Renaissance princely collectors individual pieces, often set in gilt mounts, were proudly displayed as rarities. By the seventeenth century mercantile contact, especially by Dutch traders, brought vast cargoes of Asian ceramics, in particular blue-and-white, expressly made for export to the West, into the hands of collectors and decorators.[2] Where once individual specimens had been prized, increasingly profusion came to be valued over rarity. A frenzy of 'Chinamania' seized the courts of Europe; in England the Anglo-Dutch palace style adopted by William and Mary at Hampton Court created a taste for richly sombre interiors in which 'blue-and-white' added an opulent and

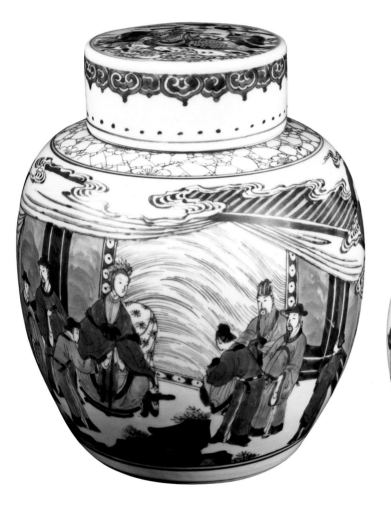

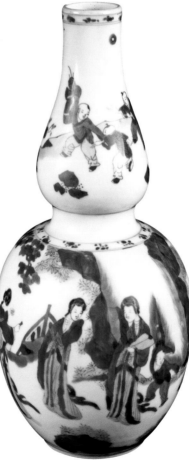

82
Ginger jar
Porcelain, decorated in underglaze cobalt blue, Kangxi period, 1662–1722
V&A: C. 836–1910, C.836A–1910

This piece was owned by James McNeill Whistler and can be seen in the background of *Purple and Rose* (plate 84).

83
Vase
Porcelain, decorated in underglaze cobalt blue, Kangxi period, 1662–1722
V&A: C.935–1910

This piece was owned by Dante Gabriel Rossetti.

OPPOSITE
84
James McNeill Whistler, *Purple and Rose: The Lange Leizen of the Six Marks*
Oil on canvas, 1864
Philadelphia Museum of Art

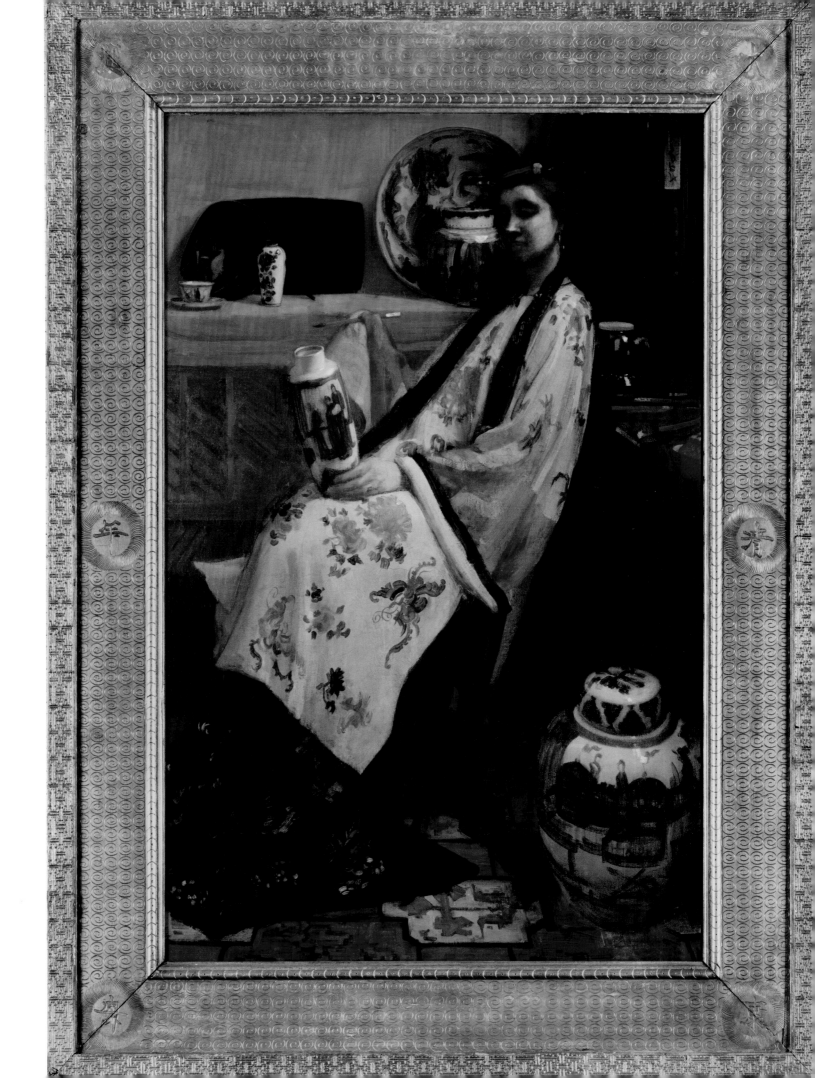

distinctive note.[3] As a result, such pieces became a feature of English country houses, remaining so long after the fashionable enthusiasm for such china evaporated in the eighteenth century.[4]

The Aesthetic craze for 'Blue', dating from the early 1860s, seems to be traceable to the joint enthusiasms of Dante Gabriel Rossetti, at that time furnishing Tudor House with a miscellaneous collection of old furniture and bric-a-brac, and James McNeill Whistler, then lately arrived from Paris and fascinated by all things Japanese. Together they established a jokey nomenclature for their pieces, describing the classic 'prunus' pattern as 'hawthorn' and calling round lidded pots 'ginger jars' and the tall, straight vases depicting female figures 'long Elizas' (plates 82–4).[5] Rossetti also favoured 'willow pattern' dishes; Whistler, it appears, had a more discriminating eye for the better examples of Kangxi wares.[6]

In their search for good old pieces the artists were aided by Charles Augustus Howell, shadowy factotum to the Pre-Raphaelites, and Murray Marks, an astute art dealer who did much to spread the taste for blue china among their circle of rich patrons (plate 85).[7] Marks supplied to Frederick Leyland most of the hundreds of pieces that formed the display – and indeed original point – of the Peacock Room, the project so notoriously hijacked for his own ends by Whistler (see p.165). In his own rooms Whistler seems to have massed the vases and dishes in his distinguished collection in profusion both in shelved alcoves and cabinets, and also, like Rossetti, even to have used fine individual pieces as tableware.

Marks also formed the collection of Sir Henry Thompson which was recorded in a catalogue illustrated with drawings by Whistler, published to celebrate a semi-private exhibition in 1878 (plate 86).[8] By this date,

85
Henry Treffry Dunn (?), previously attributed to William Morris, Dante Gabriel Rossetti and James McNeill Whistler, trade card of Murray Marks
Colour wood engraving, c.1875
Stephen Calloway collection

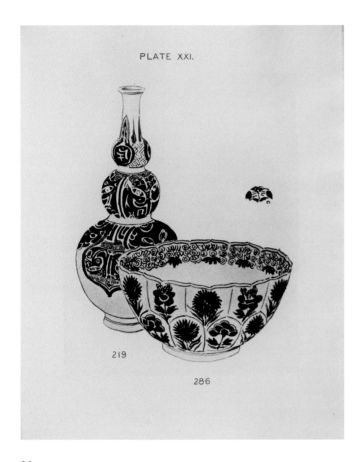

86
James McNeill Whistler, treble-gourd vase
with long neck and bowl with scalloped edge
Illustration in Murray Marks, *A Collection of
Blue and White Nankin Porcelain*, 1878
Stephen Calloway collection

87
George Du Maurier, *The Six-Mark Tea Pot*
Illustration from *Punch*, 30 November 1880
V&A: NAL

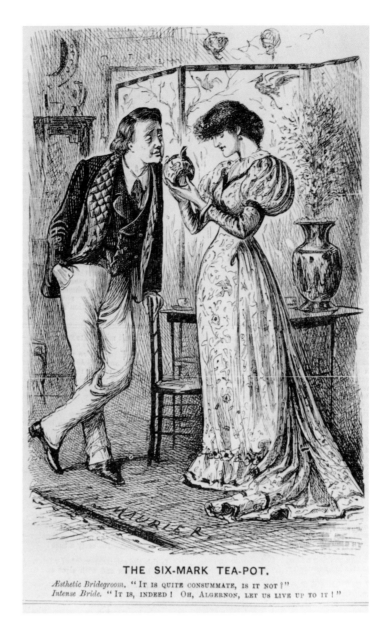

THE SIX-MARK TEA-POT.
Æsthetic Bridegroom. "IT IS QUITE CONSUMMATE, IS IT NOT?"
Intense Bride. "IT IS, INDEED! OH, ALGERNON, LET US LIVE UP TO IT!"

however, the originally recherché taste for 'blue' was already becoming widespread among artists, would-be Aesthetes and even commercial decorators. Oscar Wilde, catching the trend whilst still a student at Oxford, had filled his rooms with china and claimed that he found it difficult to 'live up to it'.

To some degree china collecting and the over-fastidious care in arranging pieces was often stigmatized as 'feminine'.[9] Seizing upon the fad, Du Maurier made it one of the recurrent targets of his defining series of *Punch* cartoons satirizing the follies and pretensions of the Aesthetes; one of the most famous reworks Wilde's insouciant quip (plate 87).[10] Similarly, in Gilbert and Sullivan's *Patience* Bunthorne is characterized not only as a 'greenery-yallery' but also a 'blue-and-white young man'. By the 1880s, just as in the 1690s, no fashionable interior was now complete without a mass of oriental vases balanced on every available cabinet and shelf.

Leighton and Aitchison

Esmé Whittaker

THE COMMISSION to design a studio-house at 2 Holland Park Road for the artist Frederic Leighton was a turning point in George Aitchison's architectural career. Aitchison had seemed destined to follow in his father's footsteps as a designer of wharves and warehouses when 'in 1865, he was, through the instrumentality of Leighton, given the opportunity of devoting himself to the more purely artistic side of his profession'.[1]

Leighton was Aitchison's friend, his long-term patron and his means of introduction into the circle of wealthy art collectors that were to form his client base.[2] In the 1870s and 1880s Aitchison's interior design schemes for London townhouses, with their delicate patterning, subtle colour harmonies and underlying classicism, were seen as the ideal

88
The Drawing Room, Leighton House, designed by George Aitchison
Photograph by Bedford Lemere & Co., c.1890
Royal Institute of British Architects, London

environment for the display of Aesthetic works of art. At 2 Holland Park Road, now known as Leighton House, Aitchison developed his approach to integrating a client's art collection into the domestic interior. During the earliest phase of construction fine art became part of the fabric of the building, with paintings by Jean-Baptiste-Camille Corot displayed in the drawing room 'in panels wrought in cement, and intended to be fixtures' (plate 88).[3]

A similar integration of paintings into the interior was achieved in the home of Thomas Eustace Smith at 52 Prince's Gate, as one visitor commented: 'The wainscot was high and plain, but was really inlaid with a delicate design of pearl and ivory scroll-work, the walls above were dull gold, with several large canvases set into them'.[4] The paintings, which were by Thomas Armstrong, became another element of the incised decoration.[5]

The same artists who experimented with decorative effects in the oil paintings that hung upon, or were embedded into, the walls of Aitchison's interiors also produced the decorative friezes that patterned the upper portion of these walls. Albert Moore was commissioned to paint a decorative peacock frieze as part of Aitchison's extensive design scheme for the home of Frederick Lehmann at 15 Berkeley Square (plate 90). Moore's frieze for the drawing room (plate 89), a series of carefully posed peacocks with their trains in repose, harmonized with the other bird motifs that dominated the decoration of this property to create a unified decorative scheme. However, by painting this frieze on canvas rather than directly upon the wall surface, Moore's work could also

be removed if Lehmann decided to move house. While oil paintings had become part of the fixtures and fittings, a decorative frieze had become a portable work of art that retained its value once removed from its decorative context.

89
Albert Moore, cartoon of a portion of the peacock frieze for the Front Drawing Room, 15 Berkeley Square, London
Charcoal and white chalk on brown paper, c.1872–3
V&A: D.260–1905

90
George Aitchison, design for the decorative scheme for the Front Drawing Room, 15 Berkeley Square, London
Watercolour and oil on paper, 1873
Royal Institute of British Architects, London

Moncure D. Conway, after a tour of 15 Berkeley Square in 1882, proclaimed that Aitchison had

made the most of very favourable conditions, has called to his aid congenial artists and carvers, and has completed rooms which one would fain see themselves hung upon the walls of the Royal Academy[6]

By integrating fine art into the interior and commissioning the leading Aesthetic artists to create decorative panels, Aitchison broke down the boundaries between fine art and decoration and transformed the domestic interior into a work of art worthy of exhibition at the Royal Academy.

The Aesthetic Movement and Architecture

Stefan Muthesius

ENGLISH ARCHITECTURE in the nineteenth century was driven by profoundly held convictions and enduring controversy. Much of that controversy was incited by the architect and polemicist Augustus Welby Pugin's near-total polarization of Gothic and classical. For Pugin, Gothic was above all a moral style. His ideal of the morality of the practical plan and of not hiding the nature of materials in construction lay at the heart of a doctrine that spread quickly and thoroughly among self-respecting designers; all the architects who were involved with the Aesthetic Movement in one way or another were Pugin's disciples – or rather, disciples of his disciples. But the argument was also carried forward by reactions against many of his tenets. His exclusive devotion to Gothic was gradually dismantled; his Catholic fervour was laid aside and, for the designers of the Aesthetic movement, especially E.W. Godwin, replaced by a new doctrine of a purer kind of

beauty in design. At this point another polarization arose, between the design of the architectural exterior and the interiors of buildings.

Going back little more than a generation, an Early Victorian Renaissance palace would show much the same detail on both its exterior and interior – the familiar architectural vocabulary of columns, pilasters, arches, architraves – and it did not matter much whether they were made of stone or stucco. On the face of it, it could be argued that the Aesthetic Movement had nothing to do with architecture. An interior of 'Beauty' was a world of delicate wooden frameworks, of smooth white or lightly coloured surfaces and gently flowing fabrics. It seemed obvious that all this was diametrically opposed to stone, bricks and mortar and all the forms resulting from the use of those materials. This contrast may, indeed, underscore the very novelty of the Aesthetic interior as such, of the whole concept of interior design as a task *sui generis*.

These rival claims of exterior and interior were first successfully reconciled by E.W. Godwin, the brilliant pupil of William Burges, who excelled both as architect and as designer of furniture and schemes for rooms (plate 91). Godwin's architecture of the 1870s and 1880s was not entirely decisive in its direction, still embracing heavy Gothic for public buildings while adopting some lighter, cottagey features for his smaller houses in Bedford Park from the mid-1870s. For this domestic architecture he had embraced the 'Queen Anne Revival', the style pioneered

91
William Burges, Summer Smoking Room at Cardiff
Castle, designed *c*.1870
V&A: E.519–1933

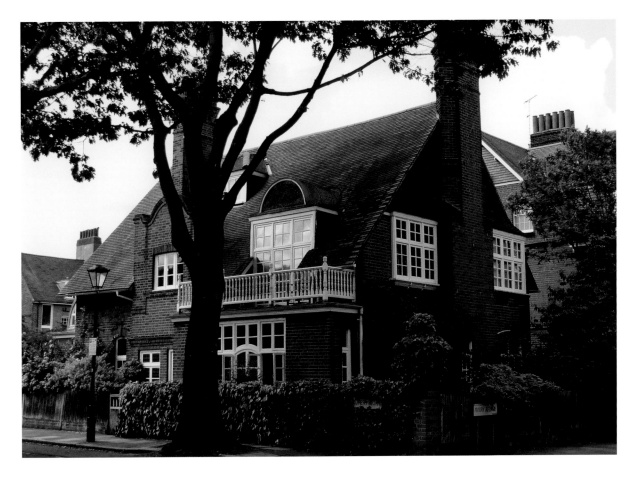

92
Richard Norman Shaw,
house in Bedford Park,
designed in 1879
Photograph by
Stephen Calloway

by Richard Norman Shaw, which appeared to offer a panacea for those seeking a resolution of questions of style in a new Aesthetic architecture. Jettisoning severe principles – notably Pugin's insistence on 'truthfulness' – and unburdened by prescriptive texts, the proponents of the Queen Anne Revival came across as having a light touch, whilst entertaining the strongest views about the 'domestic' character of their house designs and insisting rigorously on certain elements of form and colour: the intense red-brown of the brickwork and decisive white of all the timber shown in and around doorways, windows and balustrades or railings (plate 92). A crucial aim of Shaw's domestic architecture of the 1870s was to let in as much light as possible, yet he hated the standard Victorian large-paned sash window – hence the trellis-like net of small panes (plates 93, 95). Here one may say that the

lightness and delicacy of the interiors did shine through on the exterior.[1]

The Queen Anne Revival also introduced another set of meanings: the vernacular. The decorative motifs were not 'high' classical, correctly proportioned and detailed, but rather taken from a lower sphere, that of the artisan builder; who had often only a limited understanding of polite architecture. This primitiveness appeared the essence of domesticity, of a relaxed homeliness. This spirit of homeliness was in turn identified with the spirit of 'Old London'.

'Old English', the catchword for England's picturesque and comfortable past, had in the 1830s referred to medieval and Elizabethan architecture, but was now extended to embrace the Queen Anne period and even Georgian houses. These exteriors seem to

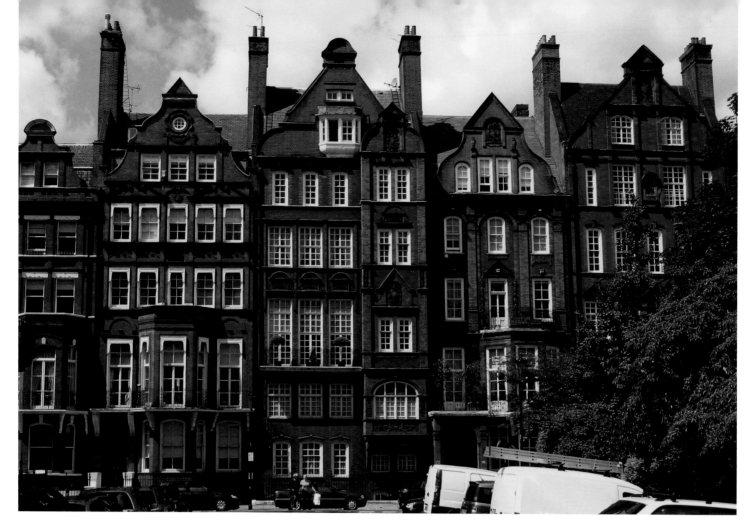

93
Richard Norman Shaw, 68 (far right) and 72 (centre)
Cadogan Square, London designed in 1878
Photograph by Stephen Calloway

94
Detail of sunflower decor, The Avenue, Bedford Park,
London, designed *c*.1880s
Photograph by Stephen Calloway

belong to a different world from the interiors, which,
in Aesthetic enclaves like Bedford Park, so often
contained exotic, foreign objects or startlingly lightweight
furniture of the kind designed by Godwin himself. There
was, however, one common motif, one sign of subscribing
to Aesthetic taste, which could occur inside as well as
outside: the sunflower (plate 94). A walk through West
London will reveal the occasional sunflower in red brick,
embedded into the architectural Queen Anne decor.

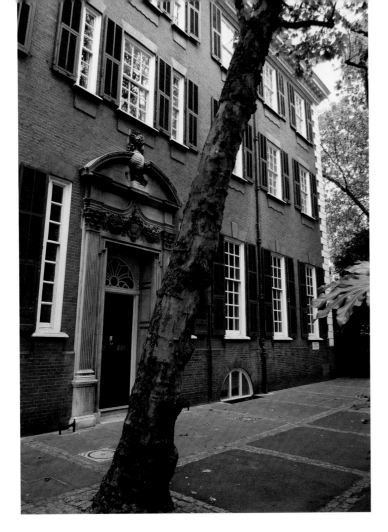

95
Richard Norman Shaw, 170 Queen's Gate,
South Kensington, London, designed 1888–90
Photograph by Stephen Calloway

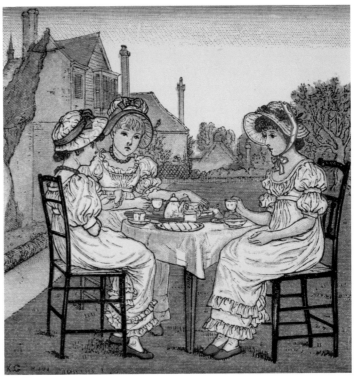

96
Kate Greenaway, illustration from *Birthday Book for Children*,
published by George Routledge & Sons, 1880
Colour wood engraving
V&A: E.244 6–1953

In the 1880s another new catchword for a design movement was formulated: 'Arts & Crafts'. It appeared to side principally with the vernacular revival trend and it held the rough country cottage or manor house as the ideal for domestic design. This movement now embraced both architecture and interior decor, building design as well as product design. One of its chief tenets was 'simplicity'. It was a dangerous term; William Morris's archaizing language and subsequently the rhetoric of modernism could lead to the evaluation of nineteenth-century 'simplicity' as merely leaving things out, of reducing design to what is practically required. But even a brief look at Kate Greenaway's illustrations of domestic scenes in her ever-popular almanacs and other gift books will reveal the sophistication in the way late nineteenth-century 'simplicity' was devised, combining gentle Aesthetic tertiary colours with tenderized vernacular furniture and a subdued atmosphere of cottagey homes and gardens (plate 96).

One of Morris's powerful statements of the early 1880s helps us to see Aestheticism and the vernacular revival, the sophisticated interior design and the rough, cottagey exterior as two sides of the same coin: in his lecture entitled 'The Prospects of Architecture in Civilisation', he claimed that 'simplicity of life, even the barest, is not misery but the very foundation of refinement'.[2]

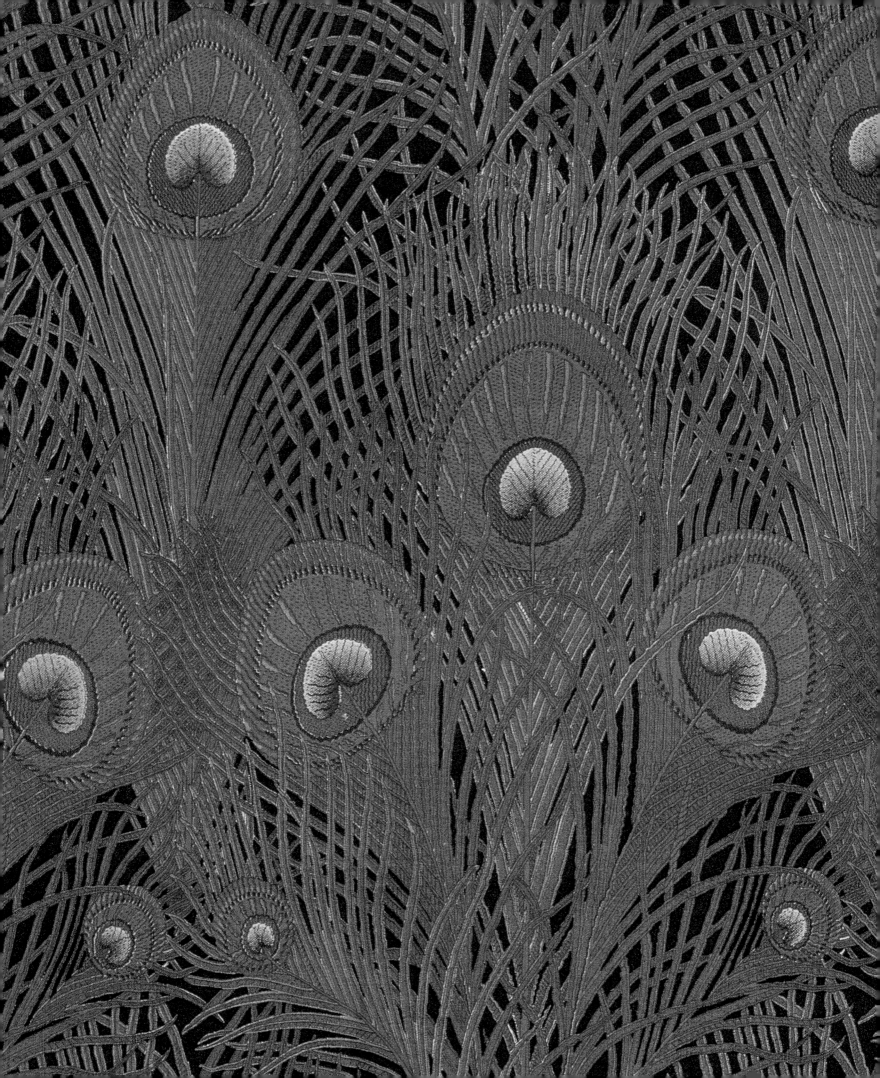

4 Furnishing the Aesthetic Interior: Manuals and Theories

FURNISHING THE AESTHETIC INTERIOR: MANUALS AND THEORIES

Penny Sparke

> Most people are now alive to the importance of beauty
> as a refining influence.
> The appetite for aesthetic instruction is even ravenous.[1]
> *Mrs Haweis, 1889*

ENGLAND IN THE 1870s and 1880s witnessed the publication of a vast body of literature relating to domestic decoration that aimed to help the new, aspiring middle-classes define and distinguish themselves through the application of their personal taste to the furnishing of their homes. What looked like a simple phenomenon, however, was, in fact, dependent upon a fairly complex set of historical and contextual circumstances.

First, it was the result of a continuous picture of social, economic and technological change, through the late eighteenth and nineteenth centuries, that had engendered a hugely expanded middle-, and, in the latter years, lower-middle-class population that inhabited the cities, and, increasingly, the leafy suburbs constructed around them, and which sought new ways of establishing and communicating its new social position and level of aspiration, both to itself and others. This in turn depended upon a shift in the broad meaning of the concept of 'home', from one that had, in the early nineteenth century, reflected religious and moral ideals, to a more secular domesticity that valued decor for its own sake. Also taste, which was inextricably linked to the workings of the fashion system and the market place and had to be learnt by the aspiring middle classes, rather than wealth, had become a marker of social status in its own right. The new conceptualization of the home was also linked to the Victorians' profound belief in the possibility of self-improvement (in, that is, what Judith Nieswander has called 'the optimal life'[2]), which was encouraged by the liberal climate of the day. This new phenomenon could not have come about without the emergence of a new, easily emulated visual language of domesticity which was rooted in a set of converging discourses (i.e. those of the design reform movement – articulated in the writings and work of A.W.N. Pugin (plate 98), John Ruskin, William Morris, Lewis F. Day (plate 97), Richard Redgrave (plate 99), Christopher Dresser and others – and Aestheticism, associated with the writing and work of James McNeill Whistler, E.W. Godwin, Bruce Talbert, Thomas Jeckyll, Oscar Wilde and others[3]). Finally, and perhaps most importantly in this context, without the mediating role of exhibitions, of the retail trade, of the furnishing and decorating trades, of mechanized furniture production, and of the multiple forms of publication – trade catalogues and journals, as well as the new advice books, among them – that proliferated in those years, the Aesthetic interior could not have been exposed to, or emulated by, a large audience.[4]

A number of other significant themes and developments also contributed to the complex web of converging factors that supported the emergence of a body of advice literature relating to domestic decoration. These included the development of the idea of the domestic interior as a coordinated assemblage rather than, as it had been in earlier decades, a set of disparate objects and furnishings; the changes that were taking place in women's lives, especially in relation to their consuming practices and responsibilities in the home; and, on a broader cultural level, the emergence of the concept of 'modernity', its links with enhanced individual subjectivity and the need for self-expression, and the growing dominance, within the emerging consumer culture of those years, of the eye over the other senses.[5] Together these contextual circumstances and themes provide a necessary frame for understanding, and a set of lenses through which to view, the subject under discussion.

97
'Early 19th-Century Wool Damask',
illustration in Lewis F. Day's
The Application of Ornament, 1891
V&A: NAL

98
Pugin tile illustrated in Richard Redgrave's
Manual of Design
Undated
Penny Sparke collection

99
Upholstered sofa representing 'meretricious
splendour' illustrated in Richard Redgrave's
Manual of Design
Undated
Penny Sparke collection

Although, through the 1870s, 1880s, and 1890s, advice literature on domestic interior design was closely bound up with the emergence and fate of the Aesthetic interior, it also had its own independent trajectory. According to Stefan Muthesius its origins lay in the husbandry manuals of earlier centuries, while Emma Ferry has viewed it as a specialized form of the general, nineteenth-century domestic economy publication, such as Mrs Beeton's 1861 *Book of Household Management*.[6] Whatever its roots, the genre came into its own in the late 1860s and has, in one form or another, remained in place ever since.[7] As a medium for the popular dissemination of the Aesthetic interior, however, it began to disappear with the demise of the style itself, in the final years of the nineteenth century, to be suddenly and very visibly superseded by a new form of domestic advice book that prioritized rationality, functionality and health in the home over its appearance.[8]

An especially close alliance existed between the Aesthetic interior, as created by the elite group of artistic individuals who helped to formulate it, and the early decorating and furnishing advice literature. They emerged simultaneously, arguably as part of the same impetus to highlight the home and its increasingly self-consciously acquired and arranged furnishings and decoration, as a social and cultural priority and the main means through which people (especially women) established their modern identities. The 1870s and 1880s saw (middle-class) women taking more responsibility for the decoration of the home and many of the advice books targeted them directly. Indeed, a significant number were written by women.[9] As manifested in the paintings of Whistler, the writings of Oscar Wilde and the architecture and design of Richard Norman Shaw, William Nesfield and E.W. Godwin, Thomas Jeckyll and others, the Aesthetic Movement only involved women in a passive sense, as symbols of the beauty they sought to inject into in their immediate environments – as a mirror, some have claimed, for their own narcissism.[10] As Aestheticism moved down the social ladder, however, woman became active agents of its entrance into the middle-class home, albeit with more conservative values and intentions than their progressive male counterparts. In an attempt to resolve this apparent contradiction, the decadence of Aestheticism, it has been suggested, needed the conservatism of middle-class domesticity to rescue it.[11] Interestingly, given this gender divide and the social transformations that it underwent, the language of the Aesthetic interior remained remarkably consistent as it moved from the arena of artistic innovation to that of domestic conservatism. Dependent as it was upon a specific set of recognizable colours, symbols, decorating devices and furniture types – typically olive brown, green or peacock blue; sunflowers, lilies, Japanese fans and blue-and-white china displayed in dressers or on conspicuous overmantels; and dados, stencilled friezes and Queen Anne-style chairs among them – it was easily emulated, superficially at least, and successfully mediated by advice books.

1868 saw the publication in England of Charles Eastlake's *Hints on Household Taste, in Furniture, Upholstery and Other Details* (plate 100), which offered a model for subsequent home decoration and furnishing advice books. Eastlake's ideas had appeared four years earlier in an article in *The Cornhill Magazine* entitled 'The Fashion of Furniture', and they had also been published in *The Queen* in 1865 and 1866.[12] Their presence in the latter publication suggests an intended female readership for the book, an assumption

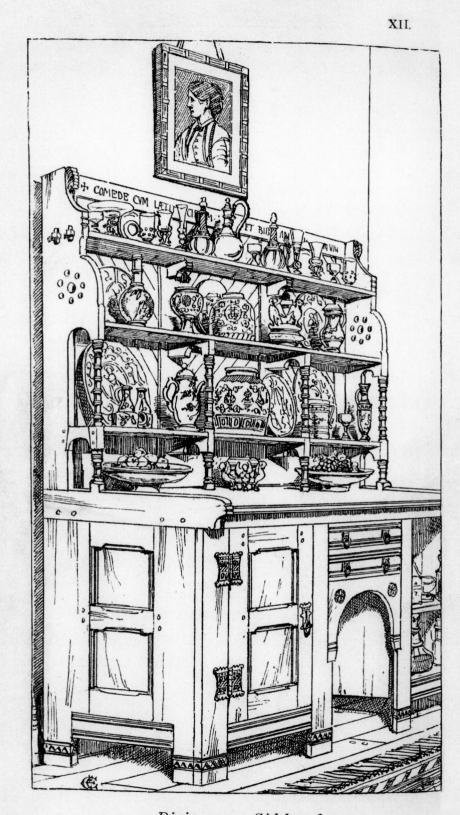

Dining-room Sideboard,

executed from a Design by Charles L. Eastlake.

100
'Dining-room Sideboard
executed from a Design by
Charles L. Eastlake', illustrated
in Eastlake's *Hints on
Household Taste*, 1872 [1868]
V&A: NAL

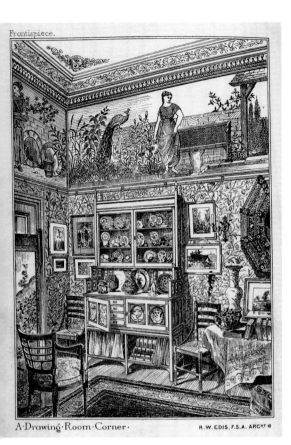

Frontispiece.

A·Drawing·Room·Corner· R·W·EDIS, F.S.A. ARCHT ❀

101
'A Drawing Room Corner', frontispiece
to Robert Edis's *Decoration and Furniture
of Town Houses*, 1881
V&A: NAL

OPPOSITE
102
Walter Crane, frontispiece to Clarence
Cook, *The House Beautiful: Essays on beds
and tables, stools and candlesticks*, 1878
V&A: NAL

that is supported by the text itself.[13] Much has been written about the misogynistic tone of Eastlake's text, and there can be little doubt that, because of what he, like many others before and after him, saw as their weakness for fashionable goods, their commitment to amateur 'fancy-work' and their gullibility in the presence of persuasive salesmen, he blamed women for lowering the taste standards in the British interior. Rather than aiming his text at men and using women as scapegoats, however, by portraying them to themselves in their worst light Eastlake was more likely addressing women and exhorting them to change their behaviour.[14] In his preface he wrote that his book was intended 'to suggest some fixed principles of taste for the popular guidance of those who are not accustomed to hear such principles defined'.[15] He supported the Gothic style but, inasmuch as he was the first to use the term 'art furniture' ('A feeling is, I trust, being gradually awakened in favour of "art furniture"'), he also anticipated, and arguably influenced, the Aesthetic interior.[16] He advocated the use of dados and friezes, and of a sideboard in which to display old china vases, decorative and furnishing features that came to characterize the Aesthetic interior of the 1870s and 1880s.[17]

Hints on Household Taste went into multiple editions on both sides of the Atlantic and between 1870 and 1890 a flurry of new home decorating advice books appeared. Some of the most notable examples of the 1870s included five titles in the 'Art at Home' series, published by Macmillan and Company between 1876 and 1883;[18] Mrs Haweis's *The Art of Beauty* (published in the *St Paul's Magazine* in 1876 but later in book form); and H.J. Cooper's *The Art of Furnishing in Rational and Aesthetic Principles* of 1876. The 1880s, the decade in which the Aesthetic interior was at its most popular, saw the appearance of many more, among them Mrs Haweis's *Artistic Homes, or How to Furnish Them* of 1880 and her *The Art of Decoration* of the following year; Robert W. Edis's *Decoration and Furniture of Town Houses* of 1881 (plate 101) and his *Healthy Furniture and Decoration* of 1884; Lewis F. Day's *Everyday Art: Short Essays on the Arts Not Fine* of 1882; Lucy Crane's *Art and the Formation of Taste* of 1882; and Mrs Panton's *From Kitchen to Garrett* of 1887. The genre continued into the 1890s (and beyond) with the publication of, among others, Mrs Panton's *Homes of Taste: Economical Hints* of 1890 and R.M. Watson's *The Art of the Home* of 1897.

This rush of books was accompanied by a significant growth in the numbers of magazines and journals focusing on domestic decoration from a range of perspectives. These included *The Architect*, founded in 1869; *The House Furnisher and Decorator*, founded in 1871; *The Furniture Gazette*, founded in 1872; *The Art Workmen*, founded in 1873; *The Magazine of Art*, founded in 1878; *The Journal of Decorative Arts*, founded in 1881; and *The Studio*, founded in 1893. While many were oriented either towards the trades or to professional architects and designers, others sought a wider audience. Both *The Lady's World* and *The Ladies' Gazette of Fashion*, for example, also included articles on the subject of home decoration aimed at their female readers. Indeed, a number of advice book authors – Eastlake, Mrs Haweis and Lady Barker among them – first committed their thoughts to print in magazines and journals, thereby increasing their sphere of influence.

Four out of the five books on home decoration in the 'Art at Home' series were written by women – Rhoda and Agnes Garrett's *Suggestions for House Decoration in Painting, Woodwork*

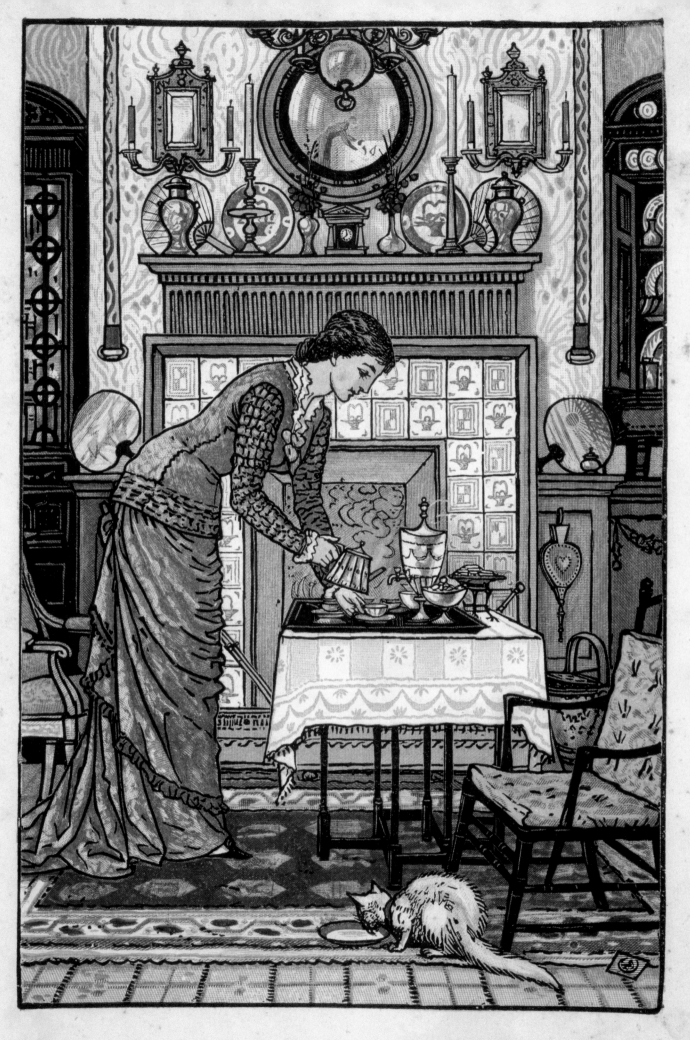

"MY LADY'S CHAMBER."

and Furniture (1876); Lady Barker's *The Bedroom and the Boudoir* (1878); Mrs Orrinsmith's *The Drawing Room, its Decoration and Furniture* (1877) and Mrs Loftie's *The Dining Room* (1878). The Garretts' book was written in strong support of the Queen Anne Style. It also acted as a counterpoint to Eastlake's misogynistic account, sardonically replacing his 'hints' with their 'suggestions' and his patronizing critique of the '*Materfamilias*' with theirs of the '*Paterfamilias*'.[19] Emma Ferry has persuasively argued that the book operated simultaneously on two levels, both as a support for female home decorators and as a response to the anti-women rhetoric embedded in much of the writings of the design reformers, from John Ruskin to Christopher Dresser to Eastlake himself.[20] While the Garretts addressed women in their capacity as 'angels of the house', they evaded that label themselves: both worked as professional house decorators and furniture designers and were involved with the women's suffrage movement.[21] There were strong links between the design reform movement and the 'Art at Home' series – for example, Mrs Orrinsmith was in fact Lucy Crane, the wife of Walter Crane. Furthermore, knowledge about the books' production – the fact, for example, that both Lady Barker and Mrs Loftie's texts were written around illustrations provided by the American publisher Charles Scribner's Sons, and had already been used in Clarence Cook's book *The House Beautiful* of 1878 (a fact that Mrs Haweis pointed out in 1881) – should make historians wary of simplistic readings of such texts and of using them as evidence of what English interiors actually looked like at the time.[22]

The 'Art at Home' series was clear that its intended audience was composed of 'people of moderate means or small income', a fact that was reflected in their price of two shillings and sixpence for each volume.[23] This compared with the sixteen shillings that had to be parted with for a copy of Eastlake's book, while Mrs Haweis's *The Art of Beauty* (1878; plates 103, 104), cost ten shillings and sixpence. Mrs Haweis's three books were all aimed at a higher class of female home decorator than those addressed by the Macmillan books. In both *The Art of Beauty* and *The Art of Decoration*, which covered much of the same ground, Mrs Haweis was critical of the slavish adherence to fashionable style that she observed in the adoption, by a large sector of society, of the key features of the Aesthetic interior – whether the use of the familiar colours, 'the inescapable blue china',[24] or Japanese parasols. She was also critical of the Garretts' book, which, she felt, offered very limited suggestions. Going against the grain of the design reformers who sought a democratic solution to the problem of taste, Mrs Haweis encouraged people to discover and implement their own individual tastes. This does not mean that she was averse to offering her readers a set of abstract principles to guide them in the decoration of their homes, such as decorating with 'feeling, devotion and knowledge',[25] but she was remarkably liberal is her definition of taste, explaining that 'good taste has a wider margin than some would allow'.[26]

The interiors that Mrs Haweis admired contained work by members of the design reform and Aesthetic movement elites, Walter Crane, William Morris and Owen Jones among them. She also named several of the firms of decorators known for their expertise in creating Aesthetic interiors, such as Jackson & Graham, Crace, Daniel Cottier, and a certain Mrs Cameron, who is less well documented, no doubt in the hope that her readers might avail themselves of their services. She was adamant, though, that the 'angel of the house'

103
'"Chippendale"Fine Art', from
Mrs H.R. Haweis, *The Art of Beauty*, 1878
Penny Sparke collection

104
'The Upholsterer's Darling', from
Mrs H.R. Haweis, *The Art of Beauty*, 1878
Penny Sparke collection

should maintain control over the decoration and furnishing of the home, advising tradesmen appropriately.

Several other advice books also indirectly recommended the services of particular decorating firms. Robert Edis, for example, named Messrs Gillow, Messrs Jeffrey and Messrs Morris & Co.[27] (Interestingly, in the pragmatic, commercial context of decorating and furnishing advice Morris was not seen as the leading theorist of the Arts and Crafts Movement that he has subsequently become, but simply represented one of the high-class decorating firms of the period).

Like Mrs Haweis, Sir Robert Edis – whose audience for his lectures, published together as *Decoration and Furniture of Town Houses*, was the Society of Arts, rather than a group of middle-class housewives – claimed that he did not 'desire to enter into any battle of styles',[28] but preferred to offer general advice rooted in design reform ideals. 'The house', he wrote, should be 'fitting as possible … subservient to comfort, truth of construction, utility and general convenience'.[29] Like the Garretts, though, he defended the Queen Anne style of architecture which, he claimed, 'if properly applied is really bringing us back to old English work'.[30] He also strongly defended Eastlake's book.[31] In *The Art of Furnishing on Rational and Aesthetic Principles* of 1879 H.J. Cooper also supported the Queen Anne style, although, again, not exclusively, explaining that much of his book would 'be useful to the dweller in a house of the new Queen Anne style, among others'.[32] Like Eastlake, Mrs Haweis and Edis he claimed to abhor fashionable decoration but, also like them, he still encouraged his readers to engage with a number of decorative features and tactics that characterized the Aesthetic interior – such as dados, stencilling and the use of olive brown.

Many of the authors of advice books of the 1870s and 1880s were clearly faced with a dilemma. While on the one hand they empathized with many of the features of the Aesthetic interior, seeing there a freshness and vitality as well as a practical means through which their readers could leave the gaudiness of nouveau-riche Victorian interiors behind them to raise the level of 'tastefulness' in their own homes, on the other their backgrounds in design reform had alerted them to the dangers of adhering to a single style that would inevitably lose its freshness, be emulated by people lower down the social scale, commodified, transformed into a fashion or fad and, ultimately, replaced by another. At the same time, however, the main aim of these writers was naturally to sell as many books as possible; with that in mind, the fashionable appeal of the Aesthetic interior was undoubtedly significant to contemporary readers. It was a tension that could not be resolved, however, and one is left with the (unanswerable) question: did the home decoration advice book serve to popularize the Aesthetic interior, or did the popular Aesthetic interior create a market for the home decoration advice book?

105
Cover of Mrs H.R. Haweis, *Beautiful Houses; Being a Description of Certain Well-Known Artistic Houses*, 1882
Stephen Calloway collection

Wallpapers
Gill Saunders

BY THE EARLY nineteenth century wallpaper was established as a luxurious and elegant decoration; but with the advent of mechanization it became commonplace, and the designs themselves deteriorated as the volume of production increased. By the 1860s the upper end of the market was dominated by two stylistic types: 'French' (overblown florals and patterns imitating textiles) and 'reformed' (flat patterns with formalized motifs from nature, or simple geometries).

The revitalization of wallpaper design can be largely credited to William Morris, who was prompted to design wallpapers because he could not find any he liked well enough to use in his own home. Morris revolutionized the art of designing flat repeating pattern; his originality lay in his ability to incorporate a controlled naturalism in flat, stylized patterns and his skill in disguising the repeat. Unlike his reforming predecessors, he maintained that 'any decoration is futile … when it does not remind you of something beyond itself'.[1]

His first wallpapers, *Trellis* (1862; issued 1864), *Daisy* (1864), and *Fruit* (*c*.1866; also known as *Pomegranate*, plates 106, 107), share a medieval character that links his early decorative work to the Pre-Raphaelite painters and the ideas of Ruskin. His sources were plant forms, observed at first hand, but also mediated through more stylized representations as found in woodcut herbals, illuminated manuscripts and tapestries. His most accomplished designs – notably *Jasmine* (1872; plate 108) – have two layers, interwoven. This kind of delicate layered foliage pattern was to become almost a cliché of Aesthetic wallpaper design. Though few designers achieved the same sophisticated complexity, many adopted the basic strategy and it can be seen in certain patterns by Walter Crane, as well as the more workaday designs by such as Bruce Talbert, Lewis F. Day, and A.F. Brophy.

Morris believed that wallpaper was integral to any scheme of interior decoration, and advised 'think first of your walls'. Indeed, wallpaper became an essential feature of the Aesthetic interior, and our definition and understanding of Aestheticism as a style is to a large extent founded on the style and muted colour palette of the wallpapers of the period,[2] particularly the designs of Morris himself. At first Morris's wallpapers were dismissed as 'too peculiar',[3] but they were taken up by a progressive 'artistic' circle, and by

OPPOSITE

106
William Morris,
Fruit/Pomegranate wallpaper
Block printed in distemper colours,
*c.*1866
V&A: E.447–1919

107
William Morris, design for
Fruit/Pomegranate wallpaper
Pencil, pen and ink, watercolour
and bodycolour on paper, 1862
V&A: E.299–2009

the 1870s they were being recommended in the new guides to home decorating.

Morris papers soon became synonymous with the Aesthetic style; we find them quoted repeatedly as key components of an Aesthetic decorative scheme. One early example is E.W. Godwin's 1868 proposal (never realized) for wall decoration at Dromore Castle, Ireland, with panels of *Trellis* incorporated rather in the manner of Japanese paper screens. In the 1870s Mrs Humphrey Ward, the novelist,

lived in Oxford, opposite art critic Walter Pater, and described his 'exquisite' house with its drawing room decorated 'with a Morris paper' and other Aesthetic accessories. The Wards adopted a similar style themselves, being part of a clique 'anxious to be up-to-date, and in the fashion, whether in aesthetics, house-keeping or education'.[4] The frontispiece to Robert Edis's *Decoration and Furniture of Town Houses* (1881) shows his own sitting room, with *Pomegranate* wallpaper and Aesthetic furnishings. George Du Maurier, describing a stage

108
William Morris, *Jasmine* wallpaper
Block printed in distemper colours, 1872
V&A: E.475–1919

set for Frank Burnand's *The Colonel* (1881), a satire on the
Aesthetic movement, began 'Try & have a room papered with
Morris's green *Daisy*…'.[5]

The elaboration of the papered wall, with a tripartite
division of dado, filling and frieze, became a distinctive feature
of Aesthetic decorative schemes, though some – including
Morris – disapproved of the 'busy-ness' of such walls.[6] The
V&A has several 'decorator's specimen panels' in which the
three elements are presented as a single drop, for display
purposes and to demonstrate to customers how best to mix
and match the various patterns.[7] A light floral or foliage
pattern was generally preferred for the filling, as being most
suitable as a background to pictures; the dado was often

predominantly geometric, or divided into pictorial panels
(as seen in Brightwen Binyon's scheme, illustrated, right,
in *The Building News,* 1879; plate 109); the frieze would have
a bolder floral or pictorial motif. Crane designed friezes
featuring variously swans, peacocks, and cupids; his *Alcestis*
frieze (1876; designed to accompany the *Daisy*-like filling
paper *La Margarete*) has figures in the Greek style representing
the domestic virtues of Diligence, Order, Providence and
Hospitality (plate 110).

109
Page from *Building News*, March 1879,
showing wallpaper decorations by Jeffrey & Co.
V&A: 29502.D.60

110
Crane, *La Margarete* wallpaper with
portion of *Alcestis* frieze
Block printed in distemper colours, 1876
V&A: E.1837–1934

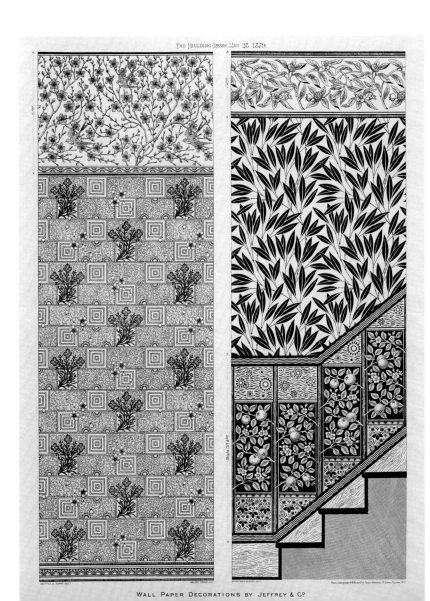

WALL PAPER DECORATIONS BY JEFFREY & CO.

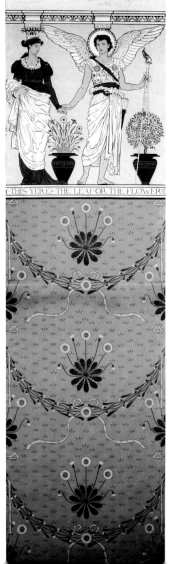

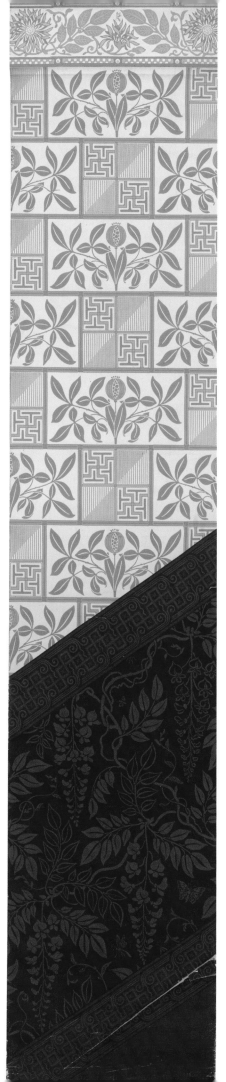

111
Designer unknown (possibly Bruce Talbert), decorator's specimen
panel showing dado, filling and frieze for staircase
Block printed in distemper colours, c.1877–80
V&A: E.663–1953

The specimen panels offer a synthesis of Aesthetic
motifs, derived from disparate sources – medieval, chinoiserie,
Japanese – and colours, typically reddish-pinks, greenish-blues,
olive, and the 'greenery-yallery' shades of popular caricature.
An unattributed staircase paper from this set, printed in
shades of terracotta, has chrysanthemums in the frieze, stylized
pomegranates and a fragmented Greek key pattern in the filling,
and naturalistic trails of wisteria on the dado (plate 111).

Japanese influence was especially pronounced in wallpapers
by E.W. Godwin. The motifs in his *Peacock* dado (1873) were
taken from a design manual published in Japan. This paper
and *Bamboo* (1872; plate 112) were commissioned by Metford
Warner for Jeffrey & Co., by then a leading manufacturer and
already printing wallpapers on behalf of Morris & Co. Jeffrey &
Co. marketed themselves as makers of 'art' wallpapers, and their
advertising made much of the fact that their papers were designed
by noted artists and architects.

Decorative schemes in the Aesthetic style often featured
Japanese-made papers which imitated embossed and gilded
leathers. Oscar Wilde (who positively disliked Morris papers)
advocated the use of these luxurious wall-coverings in his
lectures on interior decoration, and chose one for the drawing
room of his personal incarnation of 'the house beautiful' at
16 Tite Street. British manufacturers capitalized on this fashion
and produced gilded 'leather' papers (some in Japanese styles,
others copying sixteenth- and seventeenth-century designs;
plate 113), embossed wallcoverings (such as Lincrusta), and
even designs in real leather (by William Woollams & Co.).

In time Aesthetic styles and colour schemes were
popularized in diluted form (and as cheaper machine prints,
as well as hand-block prints) and by the end of the century
there was a wide choice of papers (both printed and embossed)
adorned with stock Aesthetic motifs such as peacock feathers
and sunflowers, lilies and almond blossom.

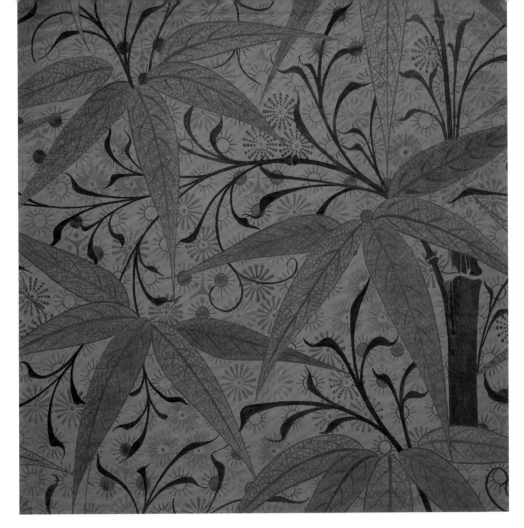

112
Edward William Godwin,
design for *Bamboo* wallpaper
Watercolour on tracing paper, 1872
V&A: E.515–1963

113
Bruce Talbert, panel of embossed
and gilded leather, *c.*1875
Produced by William Woollams & Co.
V&A: E.526–1914

Aesthetic Textiles

Sonia Ashmore

EXTILES BECAME a focus of concern about taste in the Victorian industrial age; they were an important aspect of Aesthetic dress and an integral feature of the House Beautiful. While textiles could embody Aesthetic sensibilities, they were also commodities that had to sell in a competitive market, a dichotomy reflected in the rise of the professional designer, the 'art fabric' manufacturer and the artistic retailer.

The mechanization of textile production, particularly cotton, had played a key part in Britain's industrial success, and by the mid-nineteenth century the industry provided livelihoods for several million people. Fortunes were made in the drapery trades as consumption expanded and a constant supply of textile novelties became available both for wearing and furnishing the home. Yet the industrial triumphs of the Great Exhibition were tempered by criticism of design standards. Printed cottons were included in the exhibition of 'False Principles' at the Museum of Ornamental Art in 1852; three-dimensional effects and narrative textiles were particularly reviled. Design reformers looked for practical solutions to the aesthetic and spiritual crisis caused by mechanical production, finding inspiration in Gothic revival patterns, hand-production and the promotion of Asian textiles as models for British manufacturers.

Artists' sensibilities were close to those of design reformers and textiles often featured prominently in their work, with fluid textures, sensual surfaces and saturated but subtle colours. Artists of the Pre-Raphaelite Brotherhood were particularly interested in fabric and dress; designing garments and finding textile props for the paintings was often a cooperative effort between artist, sitter and friends. The artist's studio could also be a showroom, where exotic and other textiles provided a set for the paintings while at the

114
Edward Burne-Jones and John Henry Dearle for Morris & Co.,
Pomona tapestry
Woven wool and silk on a cotton warp, 1900
V&A: T.33–1981

115
Arthur Silver, *Peacock*
Roller printed cotton for Liberty & Co.,
Rossendale Printing Co., 1887
V&A: T.50–1953

116
Bruce Talbert, *Kingfisher*
Woven silk damask for Warner & Ramm, *c.*1875
V&A: Circ.296–1953

same time indicating the artist's breadth of cultural reference and self-appointed role as 'dispenser of beauty'.[1]

As life became an artistic enterprise the boundaries of art, design and architecture were often ignored. E.W. Godwin and Bruce Talbert were architects and furniture designers who turned their hand to textiles; Godwin also became a consultant to Liberty's dress department. Burne-Jones designed hand-worked textiles such as the *Pomona* tapestry (plate 114). Christopher Dresser, Lewis Day, G.C. Haité and Arthur Silver were part of a new generation of professional designers and teachers; the latter's Silver Studio was an independent commercial design studio which sold designs to major manufacturers and retailers; his *Peacock* printed cotton for Liberty & Co. (plate 115) remains a key Aesthetic piece, successfully revived more than a century later.

Like the 'reformers', Aesthetic designers preferred flat pattern and restrained repeats to illusionistic perspective. Aesthetic textiles were characterized by stylized floral, oriental and historically based designs, by favourite motifs such as lilies and sunflowers, peacock feathers symbolizing the rare and exotic, almost anything 'Japanese', and by particular colour palettes. Burne-Jones's *Pomona*, goddess of fruit trees and orchards, is represented in unstructured Aesthetic overdress in a soft material of muted terracotta, like sage green a fashionably Aesthetic colour.

Despite the often self-conscious artifice of Aestheticism, naturalistic imagery was favoured and textile motifs included two-dimensional images of birds, butterflies and flowers, as in Bruce Talbert's *Kingfisher* design (plate 116) and Lewis F. Day's *Narcissi* (plate 117). More populist

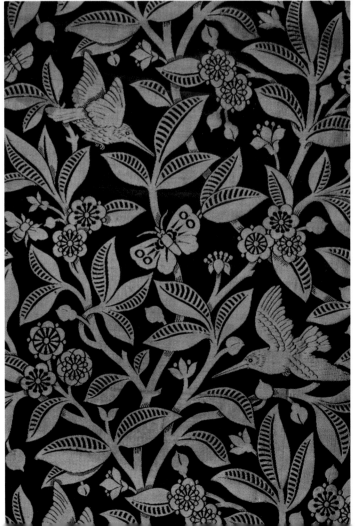

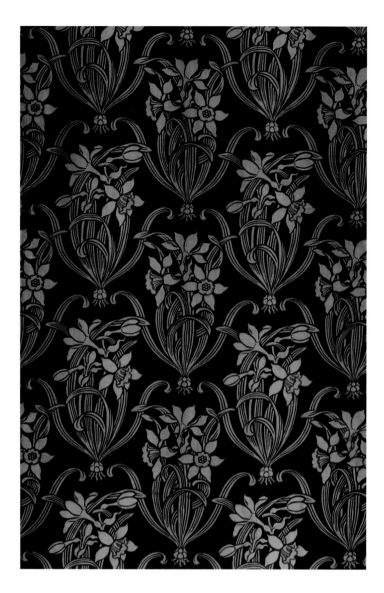

117
Lewis F. Day, *Narcissi*
Printed velveteen for Wardle & Co., 1888
V&A: T.75–1967

and keeping out draughts; others, such as Walter Crane's cartoon for the embroidered hanging *Salve* (plate 10), were simply showpieces for techniques such as tapestry or embroidery. Although specifically associated with Arts and Crafts, embroidery was also promoted as an Aesthetic activity through which women could beautify the home.

Designs were nothing without production, and groups of key textile manufacturers bought work from the leading designers. Among these were Warner & Ramm, later Warner & Sons, high-quality silk weavers who produced a number of Japanese-influenced designs by Owen Jones, Bruce Talbert and others; the dyer and printer Thomas Wardle, who worked with Morris and produced designs for Liberty & Co. using Indian silks; and Turnbull & Stockdale, whose Art Director was Lewis F. Day. Alexander Morton bought textile patterns from contemporary designers, and in the 1890s produced carpets in the Morris manner but with Celtic themes, hand-made in Ireland and sold by Liberty.

Retailers were crucial to the diffusion of Aesthetic artefacts. The most influential was Liberty & Co., founded in 1875, which did a huge trade in soft silks imported from India, suited to unstructured Aesthetic clothing such as the blue silk dress (plate 119), and both dress and furnishing textiles in subtle shades with restrained designs; Liberty even registered 'Art Fabrics' as a trademark. Liberty silks 'found great favour in the households of artists, and the higher class of amateurs of art, on account of these beautiful and rare colourings, and the soft draping qualities of the fabrics … all fast and "warranted to wash"'.[2] Liberty pioneered the idea of the store where the requirements of an Aesthetic lifestyle might be acquired; smaller shops attempted the same thing, although some, such as the Art Furnisher's Alliance in Bond Street, with Dresser as 'Art Manager', were short-lived.

printed cottons were often more pictorial or 'picturesque', in the spirit of Walter Crane or Kate Greenaway, or loosely borrowed from Japanese prints or porcelain. The influence of Japan on Western art and design in the late nineteenth century is strongly evident in textiles, in stylized forms, lack of perspective and the meandering plants and popular 'Japanese patchwork' motif used in Haité's curious *Bat* figured satin (plate 118); several designers used the Japanese *mon* or crest motif, as in Godwin's woven furnishing fabrics (plate 77). Some textiles were designed for use in specific locations, such as portières, fashionable for framing doorways

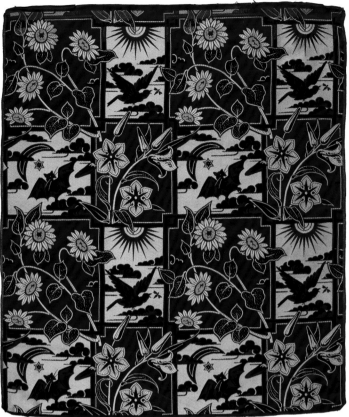

118
George Haité, *Bat*
Figured satin for Daniel Walters & Sons, *c.*1880
V&A: T.168–1972

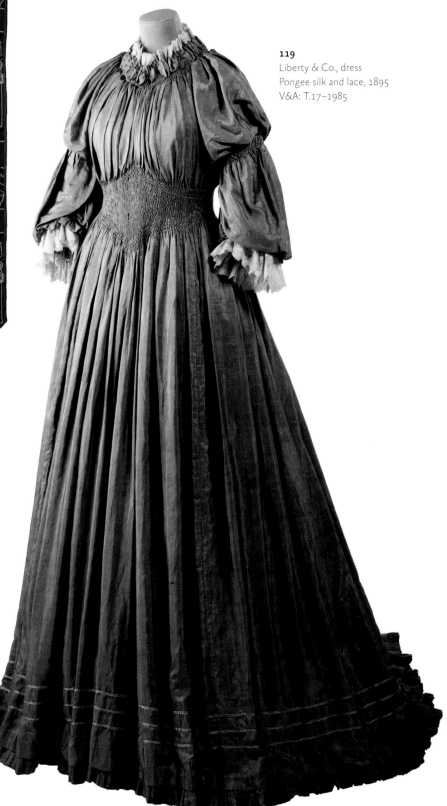

119
Liberty & Co., dress
Pongee silk and lace, 1895
V&A: T.17–1985

New domestic and fashion magazines and design manuals helped consumers to make artistic choices, suggesting alternative Aesthetic colour schemes and materials such as soft silks and muslins instead of window blinds and the use of textiles as wall hangings. *The Artist* reported on fabrics and dress 'as much art as architecture':[3] readers could also find out what fashionable society was wearing; indeed, reporting on art and dress sometimes converged. The dress worn by the Princess of Wales on one occasion was described as having 'a lustrous green ground with gold spots. The harmony of green and gold in tint was exactly that on the wings of a green woodpecker.'[4] The Princess might well have been a Whistler painting.

Art and Utility: Furniture Fit for Purpose

Frances Collard

FROM THE 1860s influential writers, including Charles Eastlake and Robert Edis, and prominent designers such as E.W. Godwin, B.J. Talbert and Christopher Dresser, promoted design reform in furniture for practical as well as artistic reasons. Improvements in construction, in materials and in techniques were as important to them as innovations in design and decoration. Practical considerations of housekeeping as well as flexibility of use led them to favour flat rather than raised decoration, straight or only slightly curved legs, light frames for small tables and chairs, and castors for extra mobility. Both Eastlake and Edis discussed contemporary interest in functionality and in

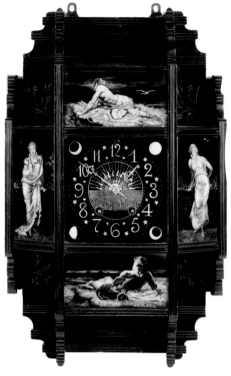

121
Lewis F. Day, wall clock
Mahogany, ebonized
and painted *en grisaille*,
1879
V&A: W. 27–2008

value for money in their publications. In 1872 Eastlake regretted the lack of shops offering consumers a choice of reasonably priced 'art' furniture, as it was commercially known,[1] while by 1881 Edis could recommend the specialist art furniture maker Jackson & Graham for a drawing room cabinet which combined artistic skill and practicality but avoided expensive decoration (plate 120).[2]

The selection and placing of furniture was the most prominent aspect of furnishing an Aesthetic interior.

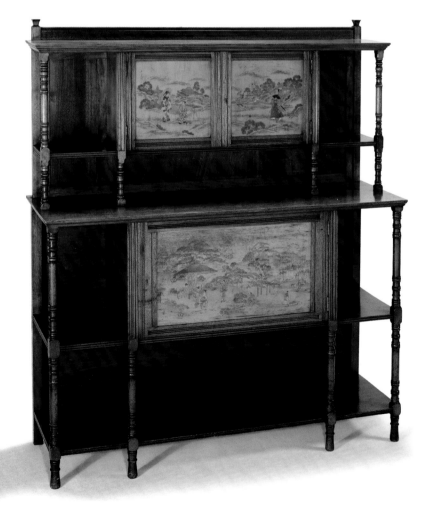

120
Jackson & Graham, drawing-room cabinet
Walnut and metal with painted panels by
Kunihisa Utagawa, c.1881
The Minneapolis Institute of Art

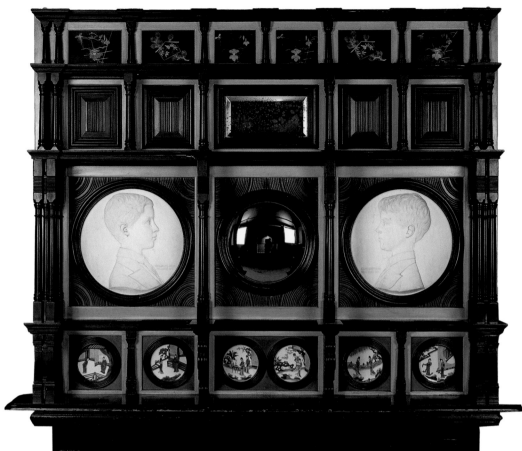

122
Thomas Jeckyll, overmantel made
for Heath Old Hall
Ebonized and green-stained wood,
inset with Japanese lacquer panels,
two mirrors, Chinese blue-and-white
plates and two marble roundels,
*c.*1872–5
Leeds Museums and Galleries
(Lotherton Hall)

Designers and manufacturers quickly developed an almost bewildering range of different types of furniture in appropriate 'Old English', 'Anglo-Japanese' or 'Queen Anne' styles.[3] The revival of eighteenth-century furniture designs, an important feature of Aesthetic furniture, may have encouraged the popularity of hanging wall units with cabinets, shelves, mirrors or clocks (plate 121). Similar hanging cabinets, sets of shelves and brackets were also popular for the corners of rooms, a formerly neglected interior space. Full-height corner cabinets, also a revival of an eighteenth-century furniture design, were another innovation. From 1873 Godwin designed ebonized and painted corner cabinets for Collinson & Lock,[4] and other examples were made by Cottier & Co. and to designs by Rhoda and Agnes Garrett.[5] The corner cupboard by Cottier & Co. was one of several Aesthetic furniture designs by British and American designers and makers recommended by the critic and writer Clarence Cook in 1878.[6]

One of the most distinctive examples of this emphasis on covering all available spaces in a room with decorative and functional furniture was the introduction of the overmantel. These were made of wood, painted or stained, and fitted with shelves and brackets, mirror glass, tiles or ceramics. Early examples included those designed by Thomas Jeckyll for 1 Holland Park, London (*c.*1870–72), and for Heath Old Hall, Yorkshire (*c.*1872–5; plate 122). The originality and variety of British furniture, including overmantels and hanging shelves, was much admired by Continental visitors at the Paris Exposition Universelle in 1878.[7] Overmantels offered useful display spaces for enthusiastic amateur collectors and decorators who were encouraged by writers such as Eastlake and Mrs Haweis to develop their personal aesthetic taste.

Ebonized and coloured finishes, a distinguishing characteristic of 'art' furniture, also indicated an awareness of functionality and hygiene in furniture associated with eating

and drinking (like Godwin's ebonized sideboard or coffee table, plate 124) and in bedroom furniture (like the blue and green suites designed by Robert Edis for Jackson & Graham in 1881).[8] Practical fittings for sideboards included shelves with grooves in which to stand dishes for display, a feature possibly inspired by traditional kitchen dressers. Good housekeeping was encouraged by art furniture makers, such as William Watt, and by large house furnishers like Shoolbred & Co., whose stock of sideboards, wardrobes and cabinets

stood on legs high enough to give access for cleaning floors and carpets.

Upholstery fabrics included both hard-wearing options, such as Utrecht velvet or leather recommended by Dresser,[9] and designs for more delicate embroidered panels, exhibited by the Royal School of Needlework in Philadelphia in 1876 and popular with amateur enthusiasts.[10] Deep buttoned sprung upholstery on armchairs and sofas was replaced by thinner hair stuffing and cushions. Light chairs

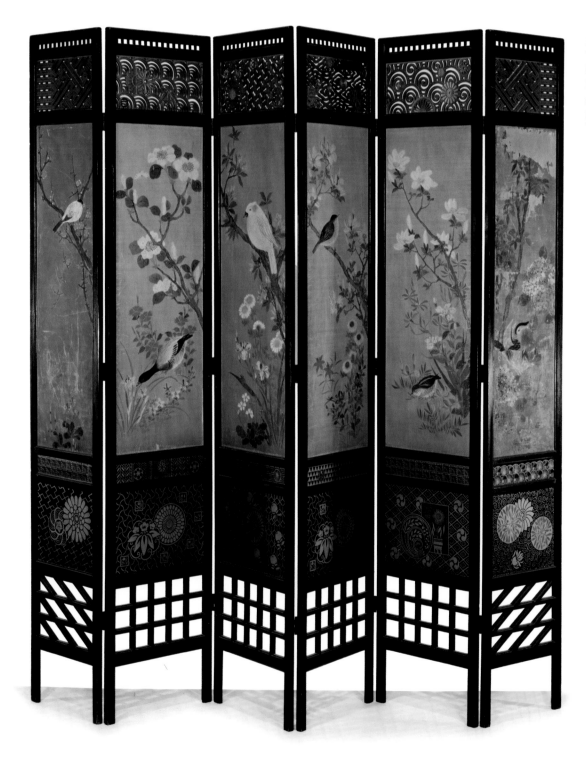

123
W.E. Nesfield / James Forsythe for Richard and Agnes Shaw, screen
Ebonized wood, with fretwork and gilding, and six panels of Japanese paper, 1867
V&A: W. 37–1972

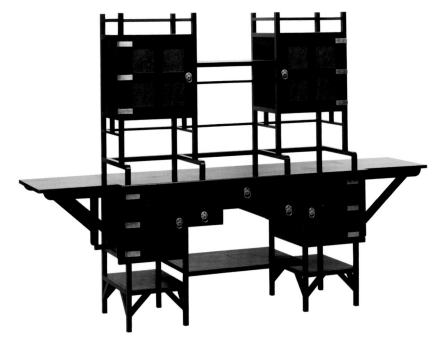

124
Edward William Godwin (possibly
manufactured by William Watt), sideboard
Ebonized mahogany with silver plated handles
and panels of leather paper, 1865–75
V&A: Circ.38–1953

with cane, wicker or upholstered seats were available from
William Watt and Collinson & Lock, and from Gillow & Co.,
a large furniture-making firm. Alternatively, consumers could
choose from the Sussex range of rush-seated furniture by
Morris & Co., recommended by Edis as artistic, reasonably
priced and appropriate for halls or bedrooms.[11]

Combination pieces of bedroom furniture, which
offered multi-purpose functions and space-saving advantages,
were also a feature of Aesthetic furniture from the late 1860s.
Godwin's modular design (c.1868), which combined a
wardrobe with mirrored door, a chest of drawers and a shelf
unit, was originally made for his own home and subsequently
included in William Watt's catalogue of 1877.[12] Large firms
of house furnishers were quick to recognize the attraction of
this compact and space-saving furniture: in their catalogue
of 1876 Shoolbred & Co. illustrated an Aesthetic bedroom
cabinet combining drawers with a vertical cupboard and shelf
unit.[13] These multi-function cabinets or wardrobes became
increasingly popular, with elaborate combinations of full- and
half-length cupboards, mirrored doors and sets of small and
full-width drawers.

Reforms in the design and construction of Aesthetic
bedroom furniture also included practical and hygienic
suggestions for washstands, some inspired by simple

domestic furniture. Eastlake argued that an understanding of
honest furniture construction, as demonstrated in a modest
washstand with a shelf cut out for a bowl and cupboard below,
was essential for the development of artistic furniture, and he
criticized the conventional techniques of grained finishes and
French polish on mahogany as impractical and ridiculous
for washstands. Godwin also recommended more practical
materials, such as deal, birch or ash, the surfaces of which
could be scrubbed like a kitchen table. His washstand,
originally designed for his own use around 1868 and
subsequently sold by William Watt, was multi-purpose, with
a shaped marble shelf for a bowl and ewer, tiled splashback,
a cupboard for a chamber pot, a mirror with adjustable candle
sconces, and a fitted towel rail.[14] The 'Anglo-Japanese' version
of Godwin's washstand retailed by Gillow & Co. in 1880
acknowledged his influence both in the title and the design,
illustrating the importance to commercial enterprises of such
compact and functional ideas for Aesthetic furniture.[15]

125
Christopher Dresser for the Art
Furnishers' Alliance, chair
Ebonized mahogany with incised
and gilt decoration, upholstery
replaced, c.1880
The Birkenhead Collection

Ceramics

Sonia Solicari

FOR THE Aesthetic pioneers Whistler, Rossetti and Wilde, ceramic collecting was obsessively focused upon the antique. This first wave of influential taste-makers elevated Chinese Kangxi porcelain to iconic status, whipping up a 'chinamania' that positioned ceramics as integral to the creation of the artistic home.

Dominated by 'blue-and-white', it is often difficult to place *contemporary* ceramics within the Aesthetic framework. Nonetheless, the late nineteenth century witnessed a dynamic period of production, fuelled by the heightened artistic climate. Experimentation flourished and design adopted a self-conscious humour, the result of a new-found confidence that aimed to raise a smile as well as inspire admiration.

Most notable was the increasing aesthetic fluidity between factory products and the output of the recently established art potteries: small artisan ventures which heralded the return of the designer as potter and defined themselves in opposition to faceless mass production. Both Minton and Doulton, giants of industry, established art pottery departments to meet the growing fashion for 'art' wares, and smaller ventures, such as that of William De Morgan, produced some of the most distinctive works of the age.

By the 1870s so many historic styles had already been revived, so many cultures plundered, that designers could adopt an eclecticism that was as liberating as it was overwhelming. What evolved was a 'motifism' that allowed mass producers to create medleys of popular Aesthetic images, such as owls, fans and sunflowers, but also enabled accomplished designers to take inspiration from different sources and create pieces that appeared fresh and daring (plate 126).

Many high-profile designers worked across different media. This is nowhere better demonstrated than in the

126
Brown-Westhead, Moore & Co., plate
Earthenware, *c.*1875–85
V&A: C.216–1984

127
Edward William Godwin (designer), maker unknown, vases
Slipware, sgraffito-decorated, *c.*1877
V&A: C.1&2–2008

128
W.S. Coleman / Minton, charger
Painted earthenware, *c.*1870
Private collection

129
Harry Barnard / Doulton, Lambeth, vase
Salt-glazed stoneware, 1882
V&A: C.54–1972

work of E.W. Godwin, whose only surviving three-dimensional ceramics are a pair of vases (plate 127), one of which depicts a Godwin-designed side-table, and beside it, in mock-Greek phonetics, the word 'Kawphyrite' (copyright), a reference to the widespread plagiarism of Godwin's furniture.[1] It shows a designer confident enough to make a joke, but also demonstrates the appeal of the ceramic medium: personal, accessible, adaptable.

The tremendous possibilities afforded to designers encouraged a decorative playfulness that was unprecedented. There was a growing demand for the whimsical, which blurred the artistic boundaries between the nursery and the drawing room, as witnessed in the fantastical forms of the Martin Brothers and the work of W.S. Coleman for Minton's Art Pottery, which presented a world inhabited by figures on the brink of adulthood, intensely engaged with their material surroundings, deferring worldly responsibility (plate 128).

Minton's wares were expensive but influential, fuelling a fashion for versatile painted plaques and chargers which, like tiles, could be hung on walls, displayed on dressers or set into furniture. This in turn spawned a 'do-it-yourself' industry that

130
Royal Worcester Porcelain
Company Ltd, *Ars Longa,*
Vita Brevis, vase
Glazed parian, 1883
Private collection

encouraged mainly female amateurs to take up ceramic painting. Indeed, the story of Aesthetic ceramics is also one of the expanding role of women in the ceramic industry. The establishment of Minton's Art Pottery at Kensington Gore provided a critical London base where, away from the conservatism of Staffordshire, women were able to play an active part in the design process and achieve fame and credibility as designers.

Much ceramic production of the period benefited from its association with an established designer or decorator. Doulton in particular was keen to encourage personal creativity at its Lambeth art pottery, an extension of the growing consumer interest in home adornment as an expression of artistic individualism. With a sentiment that could be seen as a mantra for Aesthetic ceramics, Henry Doulton, founder of the firm, declared that 'to distinguish between eccentricity and genius may be difficult, but it is surely better to bear with singularity than to crush originality'.[2] This yearning for the evidence of individuality in ceramics inspired an appreciation of imperfection that freed many to experiment with the ceramic medium and paved the way for more robust styles, such as the revival of stoneware championed at Doulton (see plate 129).

For some, such as the independent artist-potters, their individualism was a constant financial gamble. Some of the big factories, however, were able to support a number of production lines, to offer both experimental and conventional pieces. This allowed firms such as Royal Worcester to produce both its *Ars Longa, Vita Brevis* vase (plate 130), the essence of Aesthetic design, and one of the icons of anti-Aesthetic satire in the Budge/James Hadley teapot (plate 131).

Arguably, the issue of humour gets to the heart of Aesthetic ceramic style. Christopher Dresser's designs for Minton are among the most striking and radical of the period. In contrast to Godwin's more explicit 'joke', Dresser advocated a subtle 'semi-humorous' tone that typified much contemporary ceramic production.[3] Far from satirical, this humour was borne out in an exploration of the commonplace as subject matter for decoration, inspired by the usually

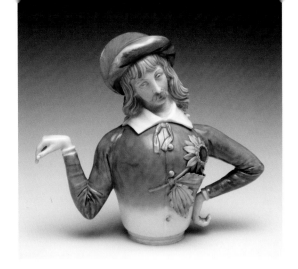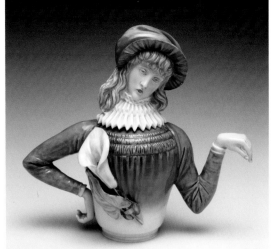

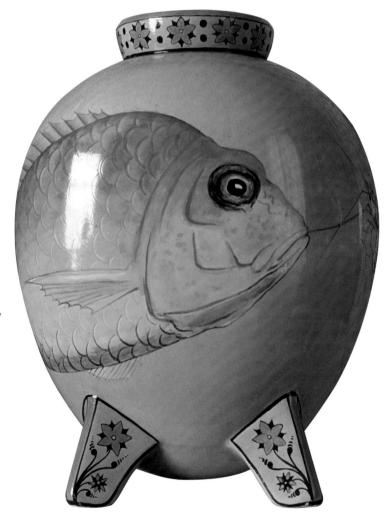

131
'Budge' (designer) / James Hadley
(modeller) / The Worcester Royal
Porcelain Company Ltd, teapot
Glazed parian, 1881
Fine Art Museums of San Francisco

anthropomorphic historic precedents of Japanese prints or delft tiles, the latter copiously used in Aesthetic interiors. Dresser's fish and prawn tug-of-war vase (plate 132) echoes Japanese graphic design in exploiting the blank space to give both the image and the inherent wit room to breathe.

Certainly the comic animal kingdom was plundered time and again by designers and potters keen to capture this lighter mood, and also to produce work that was beautiful as well as narrative. One of the most insightful descriptions of De Morgan's work, written after his death by his business partner Halsey Ricardo, describes:

> This humour, so kindly, so sympathetic, laughs out in his designs: the way he treats his birds, beast and fishes, to obey his spacing and place themselves in almost impossible situations, without protest and with the suspicion of a grin.[4]

The intention of much ceramic work was evidently to make people smile and, coupled with its affordable and practical nature, was the perfect means of expressing personality in the home.

Whatever truly defines an Aesthetic ceramic, contemporary production catered for a growing 'art' consumerism and, in many cases, specialized in the interpretation of elite taste for a mass market. For better or worse, for artistic integrity or maximum profit, Aestheticism contributed to a thriving artistic environment that fuelled creativity and left one of the most ancient art forms with the suspicion of a grin.

132
Christopher Dresser / Minton, vase
Painted earthenware, 1887
Private collection

Aesthetic Metalwork

Eric Turner

AESTHETIC METALWORK was a confluence of disparate influences including Gothic Revival, naturalism and a Western interpretation of the arts of Japan. The following architects, designers and companies were responsible for some of the most innovative metalwork of the Aesthetic Movement.

Philip Webb, closely associated with William Morris for most of his career, designed and supplied many of the furnishings for Morris's 1859 Red House, such as a pair of copper candlesticks manufactured by Morris, Marshall, Faulkner & Co. (plate 133). Whereas Morris is identified with the Arts and Crafts Movement, Webb, a partner in his firm from 1861, bridges Arts and Crafts and Gothic Revival.

The clear geometric, massive quality of their work, characterized as Reform Gothic,[1] distinguished it from the earlier Gothic revivalists and anticipated the new decorative vocabulary of the Aesthetic Movement.

Christopher Dresser, at the peak of his career in the late 1870s, was dealing in Japanese and other oriental imports, while his busy design studio supplied designs for silver and plate manufacturers. The collapse of his company, The Art Furnisher's Alliance, in 1883 was a severe blow from which he never fully recovered, and by the time of his death his influence and reputation were already in decline. It was Nikolaus Pevsner who first rescued Dresser from obscurity in his book *Pioneers of Modern Design* (1936),[2] and in more detail in an article in the *Architectural Review* the following year.[3] Pevsner regarded Dresser as a proto-modernist, with his stark, geometric tableware designs in electroplate and base metals and his advocacy of functionally designed tableware.[4] But functionalism was not the preserve of twentieth-century modernism: Dresser was reflecting principles promoted by Henry Cole and his circle a generation earlier, and absorbed while studying at the South Kensington School of Design. Dresser viewed materials in a hierarchy, as indicated by his admiration for Gilbert Scott's Hereford Screen, a richly polychromatic Gothic confection in wrought and cast iron.[5] In Dresser's view wrought iron could justifiably be richly coloured and decorated because it was crafted by hand: his cast-iron designs for the Coalbrookdale foundry, though decorated, were usually monochrome because he saw cast iron as inferior

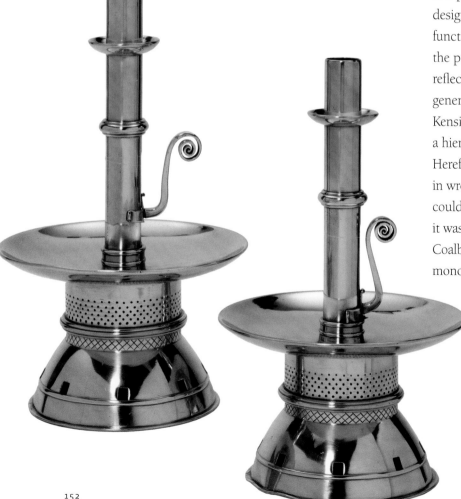

133
Philip Webb, pair of candlesticks
Cast copper, c.1860
V&A: M.1130&A–1926

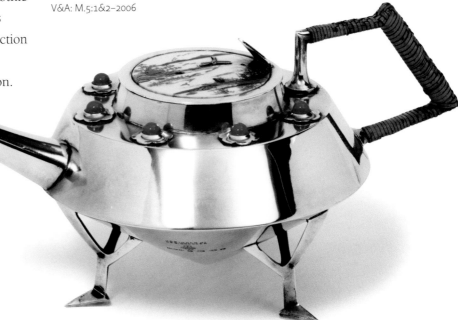

to wrought.[6] Similarly, his electroplate tableware was undecorated while his designs in silver could be richly ornamented, as demonstrated by his teapot of 1878 for Hukin & Heath with its lid incorporating a Japanese inlaid ivory medallion, surrounded by turquoises (plate 135).

Dresser designed for industry but his designs were not generally produced by mechanical means. A Dixon's calculation book of 1879 includes details of a remarkable series of his highly original teapot designs, one of which was acquired by the V&A in 2006 (plate 134). A breakdown of the costs reveals interesting details of the manufacture.[7] The bulk of the work, although increasingly mechanized, was carried out by and reliant upon skilled craftsmen and accounted for the majority of the total production costs, while the materials only accounted for a quarter. Dresser's contribution to the nineteenth-century decorative arts at the peak of his career was truly original and innovative, but he can only be properly understood in the context of the Aesthetic Movement, to which he was a major contributor, not as a coincidental and lone precursor of twentieth-century modernism.

Thomas Jeckyll ran a successful practice in both Norwich and London. His Norfolk architectural design practice was primarily ecclesiastical, and his early work mainly in the Gothic style. It was not until he moved to London in 1858 that his professional career began to flourish artistically. His introduction to the so-called Chelsea Aesthetes, who included Rossetti, Whistler, Nesfield and Godwin, changed his artistic direction.

134
Christopher Dresser / James Dixon & Sons, teapot
Electroplated nickel silver with ebony handle, c.1879
V&A: M.4–2006

135
Christopher Dresser / Hukin & Heath, teapot
Silver, ivory and enamel set with turquoises and
with a rush covered handle, 1878
V&A: M.5:1&2–2006

136
Thomas Jecykll / Barnard, Bishop
& Barnard, sunflower andiron
Brass, *c.*1876
The Birkenhead Collection

137
Thomas Jeckyll / Barnard,
Bishop & Barnard, fireplace
surround
Cast brass, after 1873
V&A: M.49–1972

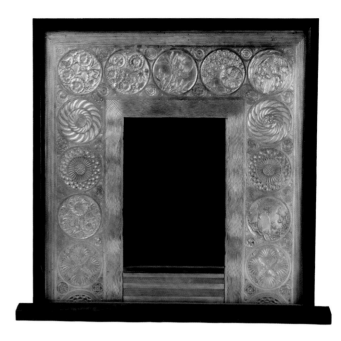

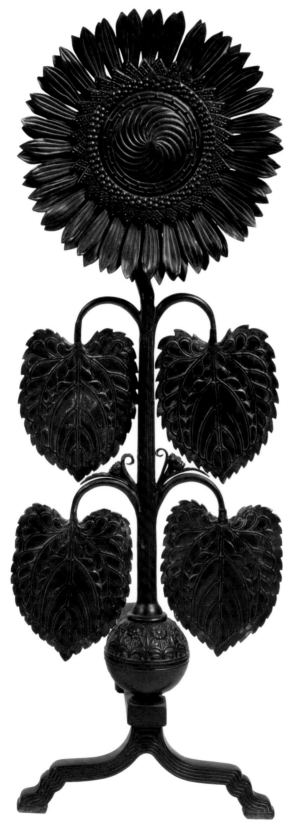

In 1859 he began a long and fruitful association with the
Norwich brass and iron foundry Barnard, Bishop & Barnards.[8]
The critic Gleeson White described him as 'the first to design
original work with Japanese principles assimilated – not
imitated'.[9] His 'Vienna Gates', manufactured by Barnards, were
greatly admired for their combination of naturalistic scrollwork
with Japonisme floral and animal forms at the 1867 Exposition
Universelle in Paris. Jeckyll's Japanese pavilion for the
Philadelphia Centennial Exposition of 1876, subsequently
re-erected at the 1878 Exposition Universelle in Paris, was a
remarkable pagoda-like structure of cast and wrought iron,
the decoration a skilful combination of Japanese ornament with
naturalistic elements from English flora and fauna. One of its
most striking features was the ground-level railing composed
of serried ranks of wrought-iron sunflowers, the upright stems
flanked by stylized leaves directed downwards. This feature
alone helped to confirm the image of the sunflower as one of
the emblems of the Aesthetic Movement (plate 136).

Jeckyll's other major success with Barnards was his range
of designs for the front panels of their revolutionary and hugely
successful slow-burning combustion fireplaces. Production of
these panels, incorporating Japanese ornament, started in
1873, and for the rest of the decade he designed a considerable
variety in all sizes and shapes (plate 137). They proved

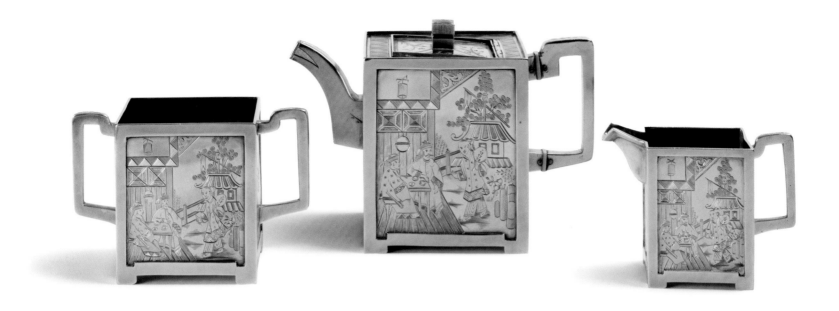

138
Elkington and Co., tea service
Electroplated nickel silver, parcel-gilt, 1878
V&A: M.48,49 & 50–2009

enormously popular, with architects as distinguished as Norman Shaw and Christopher Dresser incorporating them into their buildings. Thus Jeckyll, in association with Barnards, achieved what many notable nineteenth-century design reformers failed to do: they produced a quality product that was accessible to a mass market.

The contributions to international exhibitions by silver and electroplate manufacturers declined after 1862 as the industry sank into recession.[10] Elkingtons of Birmingham were one of the few to experiment with new lines, with a range of enamel wares incorporating the newly fashionable Japanese decoration associated with the Aesthetic Movement. Elkingtons, who pioneered the commercial applications of the electrotyping and electroplating processes, sought to imitate a cloisonné enamelled surface. The results were both accomplished and admired. Examples were on display at the Elkington stand at Philadelphia in 1876, and the V&A acquired three vases for the permanent collections (plate 139). But they proved a commercial failure: the firm simply could not compete with imported Japanese enamels on price and by 1880 had ceased production. Elkingtons enjoyed rather more success with imitation Komai decorative metalwork, including tea sets (plate 138), jugs, beakers and boxes with decoration of birds, ferns and oriental scenes.

139
Elkington & Co., vase
Cloisonné enamel on gilt metal, 1876
V&A: 562–1877

5 The Grosvenor Gallery, Patronage and the Aesthetic Portrait

THE GROSVENOR GALLERY, PATRONAGE AND THE AESTHETIC PORTRAIT

Barbara Bryant

THE CULT OF AESTHETICISM flowered from the 1860s onwards, fostered by a highly individual group of artists, their associates and their patrons. Watts, Rossetti and Whistler occupied a distinctive place in the art world at this time. They sought a status beyond the limits of the establishment Royal Academy of Arts by taking advantage of exhibition opportunities at smaller venues, such as the French Gallery, the Dudley Gallery and culminating in the Grosvenor Gallery in 1877 – or indeed, as in the case of Whistler, by staging his own exhibitions within appropriately designed interiors. Here, in new arenas, the relationship between artist and patron took on a fresh dynamic, where the artist might dictate terms and the patron seek out the work of one who has taken charge of the display of his creative output in the self-conscious knowledge of his status as an artist. Artists cultivated their patrons, with friendship and flattery or simply by tempting them with something special and exclusive. Prices rose, tempers flared, some enduring relationships were forged, others were destroyed. The highly charged interplay between artist and patron is nowhere more manifest than in the portraiture of the period.

PATRONS AND PORTRAITS

Cultivated avant-garde patrons did much to bring about an enhanced awareness of the arts from the 1860s onwards. Given that personalities loomed so large in this period, portraiture in particular offered a fertile area for new trends. Dante Gabriel Rossetti adapted his studies of women against floral backgrounds, such as *Bocca Baciata* (plate 42), in small-scale portraits for some of his favoured private patrons.[1]

In the late 1850s George Frederic Watts returned to the Royal Academy with his portraits and ideal subjects, earning himself a reputation as an artist of poetic sensibilities. Even in a seemingly traditional grand manner portrait such as *Lady Margaret Beaumont and Daughter* (plate 140), a commissioned work intended for a family who inherited a collection of Old Master paintings, the graceful movement of the sitter, not to mention the styling of her gown, suggests the portraiture of Gainsborough as a model. But this updated version of an eighteenth-century type is unmistakably modern in its approach, particularly in its subtly harmonized pale colours and the detail of the flowering azalea, prefiguring concerns with decorative elements in the work of younger artists such as Albert Moore (see plate 159). In a more intensely personal work, *Choosing* (plate 155), exhibited at the Royal Academy in 1864, Watts portrayed his young wife, Ellen Terry, in a marriage portrait for the modern day that epitomized 'the poetry of painting'.[2] Critical reception focused on the artist's 'unusual subtle sense of the harmony of colour'. The sheer beauty of the highly finished surface rendered it an 'idyll which delights the eye'. Such sensual visual qualities entered into the bloodstream of the nascent cult of Aestheticism.

140
G.F. Watts, *Lady Margaret Beaumont and Daughter*
Oil on panel,
exhibited at the Royal Academy in 1862
The Viscount Allendale

During the 1860s, as an awareness of the arts filtered into the lives of new collectors and patrons, they increasingly socialized with artists on an informal footing. The personal contact between patrons and artists led to an increased interest in the lives and lifestyles of artists (see Chapter 3). Whistler turned his life into a theatrical performance, intending his self-portrait with models in *The Artist's Studio* (*c*.1865)[3] to act as a large-scale visual apotheosis of his creative life.

Portraits of artists' muses, often on view in studios, lent further glamour to the personalities of the art world. Whistler's *White Girl* (plate 14), showing his paramour Jo Hiffernan, had created a sensation in 1862; Hiffernan appeared in other works of this period such as *The Little White Girl* (plate 36), confirming the portrayal of women in white garb as one particular feature of innovative portraiture. The fervent relationship between Rossetti

and Jane Morris can be traced in photographs (plate 1) and portraits,[4] especially *The Blue Silk Dress* (plate 141), completed in 1868, in which the intense colour, combined with the darkened interior, conjures up a hothouse atmosphere which betrays the artist's obsession with his sitter. The Latin inscription on the canvas, 'Famous for her poet husband, and most famous for her face, finally let her be famous for my picture!'[5] commemorated her beauty as well as the role of the painted portrait as an evocation of her role in Rossetti's life and art.

The type of painting associated with Rossetti adapted easily to commissioned portraiture as a stylish alternative to more formal portrayals. Younger artists in his circle such as Frederick Sandys painted in a remarkably precise technique which lent a hallucinogenic, hyper-detailed quality to works such as *Grace Rose* of 1866 (plate 142). The sitter, who arranges her namesake flower amid orientalizing accessories and antique-inspired jewellery, was the sister-in-law of Rossetti's lawyer, James Anderson Rose, a collector himself.[6] Sandys also portrayed fringe members of Rossetti's circle in chalk portrait drawings, such as Charles Augustus Howell, go-between for artists and their buyers, and his wife Kitty, seen in a ravishing image with oriental vase and floral decorations (1873; RA 1876; Birmingham Museums). From 1875 Murray Marks's shop on Oxford Street, designed by Richard Norman Shaw, catered for the new craze for oriental blue-and-white porcelain and other decorative items. Sandys's coloured chalk drawing of Louisa Marks (1873; V&A) is a lush image of an individual who disseminated Aesthetic tastes, helpfully marketed by her husband (see plate 85), by virtue of her very existence.

In the wider world of patronage, among the more artistically aware individuals of the 1860s and 1870s, unique collaborations occurred. The Anglo-Greek Ionides family occupied a special position through their friendship with artists such as Watts, Rossetti and Whistler. Cyril Flower (later Lord Battersea) and Madeline and Percy Wyndham[7] were in the vanguard of an elite group of well-informed aristocrats with the funds to pay for their art patronage. Friendly with artists such as Leighton,[8] the Wyndhams commissioned Watts to paint a full-length portrait of Madeline[9] (plate 147). An oil study (*c*.1865–70) shows the sitter posed in the tradition of the eighteenth-century grand manner, updated by dress festooned with massive sunflowers to indicate a patron attuned to current fashions and motifs.[10] Madeline took the lead in collecting contemporary art, buying Watts's *Orpheus and Eurydice* (RA 1869; formerly Forbes Collection) and owning Whistler's *Nocturne: Grey and Gold – Westminster Bridge* (1871–2; Glasgow Museums and Art Gallery). When the Wyndhams redecorated their London townhouse at 44 Belgrave Square they called on George Aitchison, who became the decorator of choice to avant-garde patrons and often collaborated with his artist friends in interiors featuring painted friezes or large paintings set into the walls. At the top of the soaring space of the staircase hall (plate 143) at Belgrave Square, Leighton painted *The Dance of the Cymbalists*, large-scale classical dancing figures on gold backgrounds, conjuring up the musical associations that were so much a part of the Aesthete's world. When this design was exhibited at the Royal Academy in 1870, the taste for such decorations reached wider audiences and also, crucially, advertised the Aesthetic credentials of the patrons.

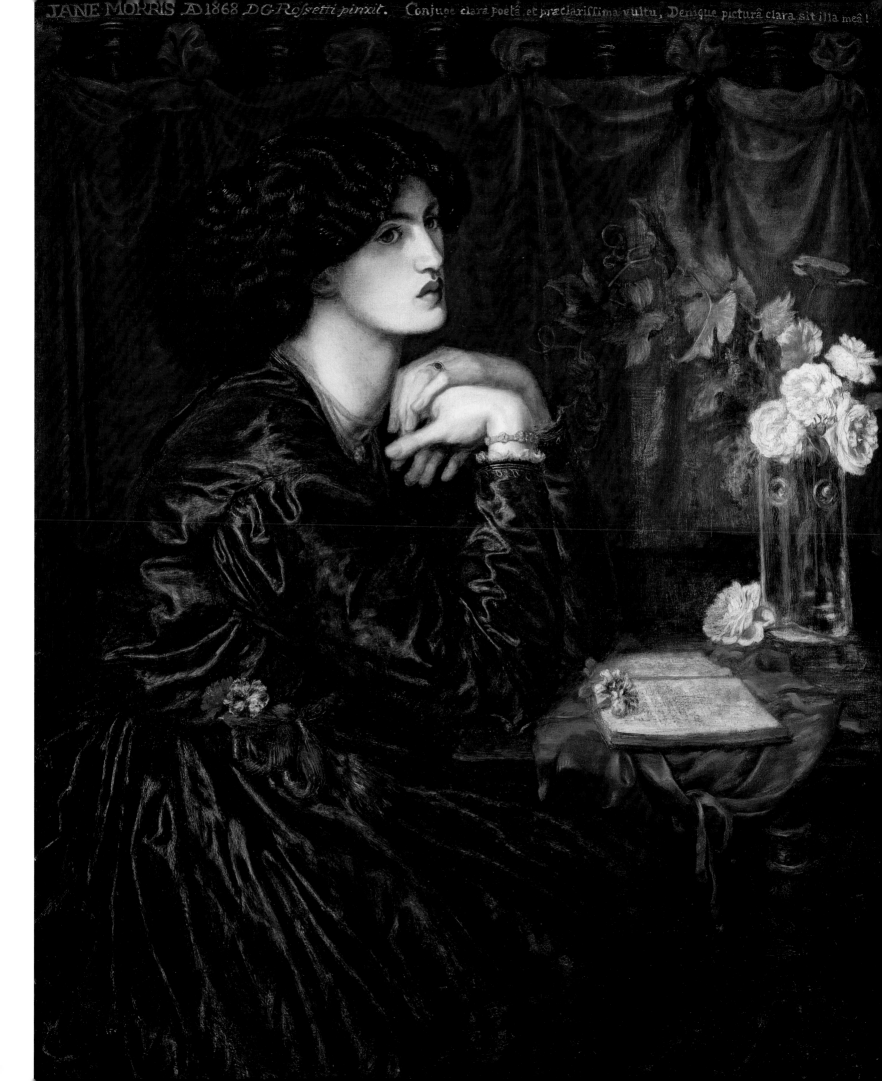

JANE MORRIS AD 1868 D·G·Rossetti pinxit. Conjuge clara poeta et præclarissima vultu, Denique pictura clara sit illa meâ !

Grace Rose. A:D:1866:

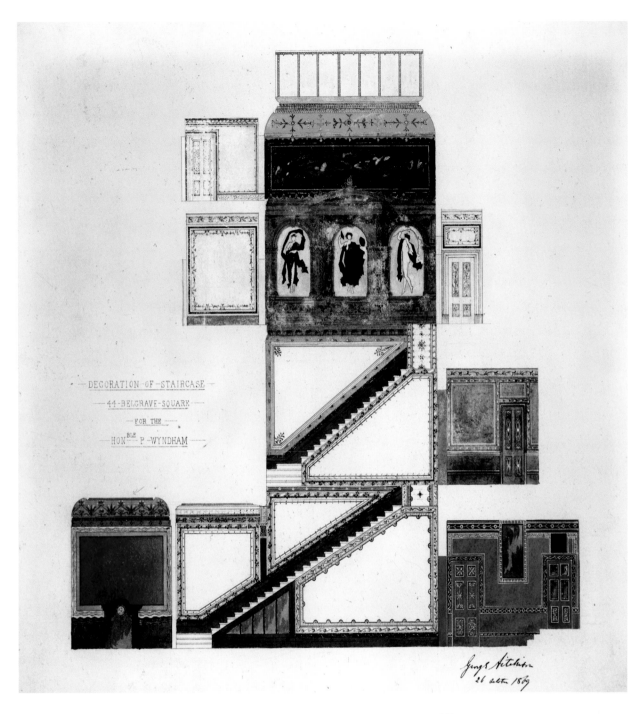

DECORATION·OF·STAIRCASE·

44·BELGRAVE·SQUARE·

FOR·THE·

HON.ᴮᴸᴱ·P·WYNDHAM·

143
George Aitchison, design for the decoration
of the staircase, 44 Belgrave Square
Watercolour on paper, 1869, exhibited at
the Royal Academy of Arts 1870
Royal Institute of British Architects

OPPOSITE
142
Frederick Sandys, *Grace Rose*
Oil on panel, 1866 , exhibited
at the French Gallery 1866
Yale Center for British Art

144
Dante Gabriel Rossetti, *Monna Rosa*
(portrait of Frances Leyland)
Oil on canvas, 1867
Private collection

During this key period other leading patrons keen to assert their claims to advanced taste commissioned portraits from avant-garde artists as a natural extension and adjunct to their modern interiors. From 1873 onward William Cleverly Alexander, a noted collector of Old Master paintings and oriental porcelain,[11] patronized Whistler for both portraits and the interior decorative schemes at Aubrey House in Campden Hill (plate 164).[12] The artist's grandiose plan for a series of full lengths of each of Alexander's six daughters resulted in two completed works, *Harmony in Grey and Green: Miss Cicely Alexander* (1872–4) and *Miss May Alexander* (1875; both Tate Britain),[13] both distinctly unconventional portraits. The collections of Thomas Eustace and Mary Martha ('Eustacia') Smith at 52 Prince's Gate and Frederick Lehmann at 15 Berkeley Square were also displayed in new interiors designed by Aitchison. Lehmann, who earned his fortune in the iron trade, had contacts in the art world

through his brothers Rudolf and Henri, both portrait painters, yet he commissioned Millais to paint his young daughter, Nina. She is dressed completely in white, sitting sulkily atop an outsized green orientalist vase, a pot of camellias and rich hangings in the background (RA 1869; private collection).[14] While the painting recalled Whistler's *White Girl* first and foremost, studies of women in white in the work of Watts, Rossetti and Sandys throughout the 1860s heralded a new aestheticizing mode of portraiture. As in Lehmann's case, a commission for a portrait often preceded the redecoration of the interior as the first step in the patronage process. In the scheme at Berkeley Square from 1872 onward, Aitchison also indicated the placement of paintings within the decorative ensemble; his attractive drawings of the interiors, Aesthetic objects in themselves, appeared at exhibitions of the Royal Academy in 1874 and 1875.

These decorative ventures set the stage for the cult of Aestheticism as collectors created suitable environments for their works of art. Most famously, Liverpool shipping magnate Frederick Leyland called in Whistler to advise on decorations at his new residence at 49 Prince's Gate in London.[15] In 1876, with Thomas Jeckyll's scheme for the display of Chinese porcelain in the dining room left incomplete, Whistler took over to create his own flamboyant statement. The room underwent a complete transformation, becoming 'The Peacock Room: Harmony in Blue and Gold'; but Whistler failed to consult with Leyland about the extent of the work and the payment; the two quarrelled and fell out permanently.

Leyland had already been buying art voraciously since the mid-1860s, and his move from Queen's Gate in South Kensington to the mansion on Hyde Park was as much to gain suitable spaces for his collection of works by Rossetti, Albert Moore, Whistler and Burne-Jones[16] as to acquire a desirable residence in a new, sought-after enclave. His commissions to Rossetti resulted in some of the artist's most beautiful subject pictures as well as several striking chalk studies and the vibrant fancy portrait of his wife, Frances, in *Monna Rosa* (plate 144). Here Rossetti adapted the image of a woman with flowers for a portrait in which key motifs heralded Aesthetic tastes – a blue-and-white Chinese jar and a peacock fan. Later Whistler became all but official painter to the family, with ambitious full-lengths, including that of Frances, *Symphony in Flesh Colour and Pink* (1871–4; Frick Collection, New York).[17] As a member of the Leyland family circle Whistler was allowed a bantering relationship with his patron in which he did not hesitate to ridicule a 'very questionable Japanese … bric à brac stand' presented to him.[18] But the portrait of Leyland himself enveloped in darkness, *Arrangement in Black* (1870–73; Freer Gallery of Art, Washington, DC), suggests a disturbingly sinister side to the patron. As ruthless in his collecting as in his business dealings, Leyland also pruned his collection of unwanted works: in 1872 and again in 1874 when he very publicly sold at auction a group including Leighton's *Syracusan Bride* (plate 50).[19] For Leyland, as for many other collectors, works of art including paintings, had to play a role in conjunction with the interiors – the ensemble reigned supreme (hence his interest in artist-designed frames, see pp.184–6). By 1878 he displayed his collection of works by Rossetti in one section of the main drawing room at Prince's Gate, a space which must have been seen as a tribute to that artist and a particularly telling one given the recent rupture of his relationship with Whistler.

THE GROSVENOR GALLERY OF 1877

The completion of the Peacock Room, and attendant press accounts, occurred shortly before the opening of London's newest exhibition venue on New Bond Street – the Grosvenor Gallery.[20] When the founders, Sir Coutts Lindsay, Bt, and his wife, Blanche, proposed that the works of an individual artist could be best appreciated when grouped together and seen within a designed setting, they were responding to a growing trend that saw the arts, indeed artists themselves, as special and deserving appropriate treatment in their presentation. This notion was in stark contrast to the crowded, populist, highly commercialized spaces of the Royal Academy at Burlington House, with its vast exhibitions of some 1,500 works of art. Coutts and Blanche set out to create an exhibition that complemented the new sense of aesthetic awareness of the decorative environment that could already be found in the London townhouses of a select group of art patrons and, indeed, of artists themselves.

In planning the Grosvenor Gallery the Lindsays had the advice and assistance of young art critic Joseph Comyns Carr and the artist Charles Hallé, both of whom became assistant directors of the gallery. Carr's critical writing in journals such as *The Globe* identified an extraordinary interest in 'new movements in painting', with Watts and Rossetti in the vanguard of the new 'spirit of poetry' in art, and his recommendations for the new venue carried much weight. To exhibit at the Grosvenor was by invitation only, fostering a sense of exclusivity. The Lindsays succeeded in wooing the notoriously reticent Watts and the self-obsessed Whistler. Even if Rossetti's planned inclusion did not materialize, attracting Burne-Jones, who had previously resigned from the Royal Society of Watercolour Painters after a furore in 1870, constituted a real coup for the forthcoming venture.

The Grosvenor Gallery opened amid great fanfare in May 1877, housed in a splendid new building by architect William Thomas Sams. The exterior grandeur of the entrance on New Bond Street, marked by a church portal from Venice said to be by Palladio, led to a staircase adorned with white and gold columns and a display of majolica,[21] suggesting an opulent private mansion rather than an art gallery. On the main floor, after the East Gallery, one arrived at the spacious West Gallery (plate 145), over 100ft long, lit by skylights from above; separate areas existed for the display of watercolours and sculpture. The lavish interiors contained green Genoese marble, deep crimson damask, gilt Florentine console tables and Indian and Persian carpets.[22] By careful placement and spacing of the 160 or so main exhibits, as far as possible grouping the work of each artist together, the organizers created a sense of calm amid the richly decorated spaces,[23] fulfilling their desire 'to make the walls look beautiful'.[24] The Grosvenor was a social destination as well: Lady Lindsay acted as the hostess for Sunday afternoon receptions attended by the Prince and Princess of Wales, the aristocracy and fashionable society as well as, in the words of one observer, 'artists and intellectuals'.[25] When works of art were for sale, a reference in the catalogue noted it, yet a considerable portion of the first exhibition consisted of loans from private collectors,[26] indicating the origins of the Grosvenor in a select circle of friends and associates including the Leylands, the Wyndhams and William Graham.

Thanks to the novelty of the project and extensive press coverage, the first exhibition

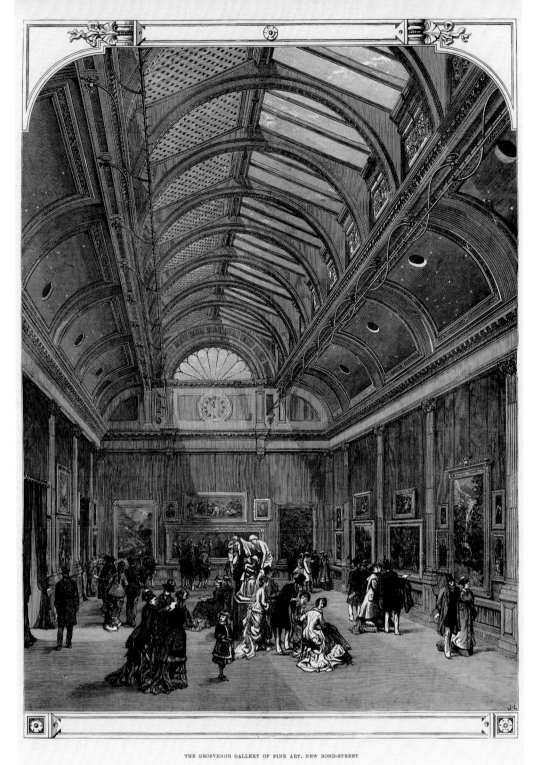

145
'The Grosvenor Gallery of Fine Art,
New Bond Street'
Engraving of the West Gallery, *Illustrated
London News*, 5 May 1877
Stephen Calloway collection

THE GROSVENOR GALLERY OF FINE ART, NEW BOND-STREET

had a huge impact. Here for the first time Burne-Jones and Watts showed in strength, alongside a wide range of artists engaged in newer forms of art, as well as a significant gathering of Continental and European-born artists.[27] The exhibition introduced a cast of characters representing not only the artists themselves, but also the patrons who sought their work (and lent to it) and the individuals whom they painted in portraits, fuelling a growing personality cult centred on the arts. Prominent on entering the East Gallery was Watts's portrait of his friend Lady Lindsay playing her violin (plate 146), planned as a *coup de théâtre* for the inaugural exhibition.[28] Blanche, in her early thirties, wears the colour

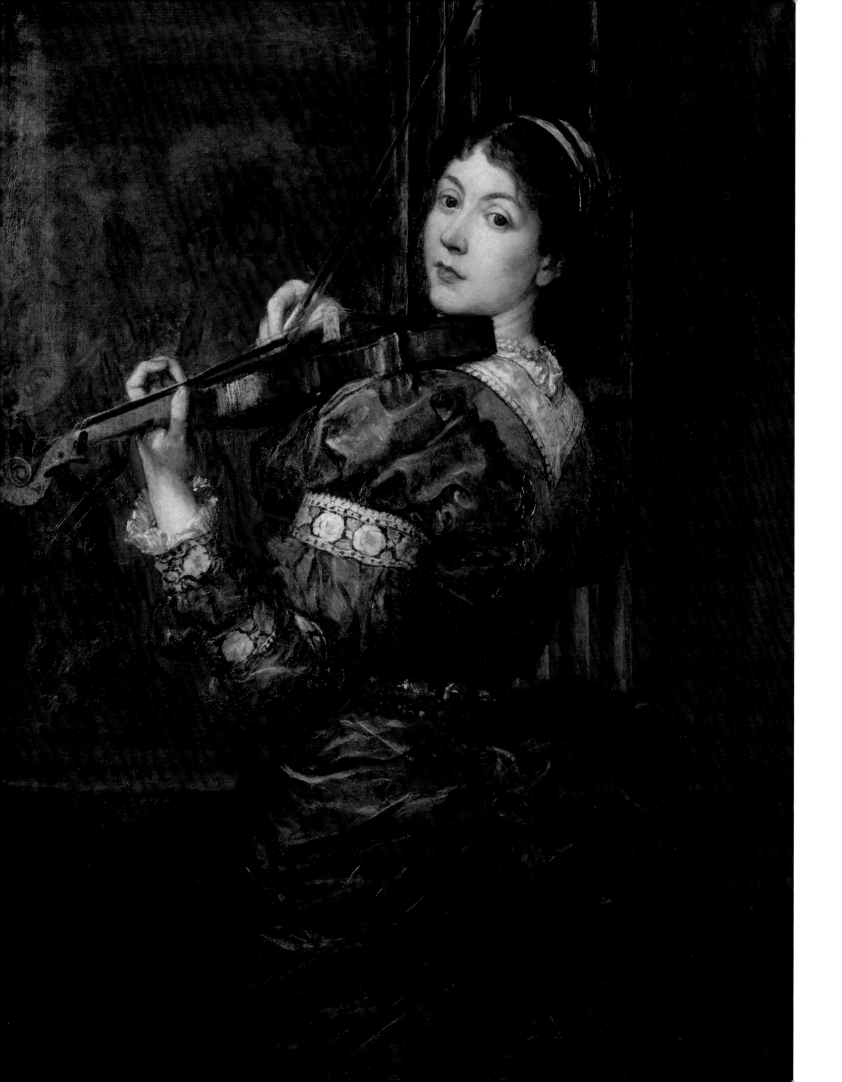

of the moment, olive green, in a gathered silk dress with a bustle at the back, decorative bands of embroidery on puffed sleeves and an ornate jewelled belt. With music essential to Blanche's personal identity,[29] it is not surprising to find her portrayed with her beloved violin as she had appeared in many other portraits.[30] Watts depicts a fleeting moment as she raises her bow, ready to draw it across the strings. The idea of a performance portrait perfectly suited the notion of the Grosvenor Gallery as a kind of theatre itself. With a dramatic turn, Blanche welcomed the elite to the newest exhibition venue in London.

Watts's full-length portrait of Madeline Wyndham (plate 147), loaned by her husband Percy, also made a visual reference to two key patrons of the period. In grand manner format yet a fully modern exercise, Madeline stands on a balustraded terrace with a mass of laurel behind, framing her head, and a vase containing blooming magnolias which act as a foil to the subdued sunflower pattern on her dress. Henry James commented in *The Galaxy*: 'It is what they call a "sumptuous" picture with something admirably large and generous in the whole design of the work'.[31] But more than just a sitter for this magnificent portrait, Madeline also lent one of her own pictures: Whistler's *Nocturne: Grey and Gold – Westminster Bridge*. This interplay between artists and their patrons proved to be a vital element of the Grosvenor Gallery.

The East Gallery contained Watts's third portrait, a haunting portrayal of Burne-Jones (plate 148). Pale, withdrawn, even otherworldly, this image personified Burne-Jones in the same spirit as his art, introducing him as the artistic idol of the Grosvenor: his eight paintings in the West Gallery constituted the grandest display of 1877. Art critic (and Cambridge Slade professor) Sidney Colvin commented that these formed, 'an exhibition in themselves',[32] as indeed the organizers must have planned by turning to private owners for major works: to Leyland for *The Beguiling of Merlin* (plate 161) and *The Mirror of Venus* (Calouste Gulbenkian Foundation) and Graham for *The Days of Creation* (Fogg Art Museum). Those attuned to advanced art of the period, such as Oxford undergraduate Oscar Wilde, characterized the beguiling of Merlin by the sorceress Vivien as a 'picture full of magic' in which the 'delicate tones of grey, and green, and violet seem to convey to us the idea of languid sleep'.[33] Wilde viewed Burne-Jones as 'a dreamer in the land of mythology, a seer of fairy visions'. For other critics, *The Mirror of Venus* established the type of art associated with Burne-Jones in that it was 'entirely free from any appeal to the passions, and only appeals to aesthetic sentiment'.[34] The frequency with which the word 'genius' was applied to Burne-Jones is noteworthy. Colvin wrote that 'we have among us a genius, a poet in design and colour, whose like has never been seen before'.[35] Another art critic, Cosmo Monkhouse, wrote some years later:

> the revelation of Burne-Jones's genius was almost as complete as it was sudden.... The public were, therefore, scarcely prepared for the wonderful apparition which was in store for them when the Grosvenor Gallery opened its doors for the first time in 1877. The imaginative feeling of the strange pictures which met their view, as indeed akin to that of the poems of Rossetti, Morris, and Swinburne, but the presentation of it in pictorial form was comparatively new...[36]

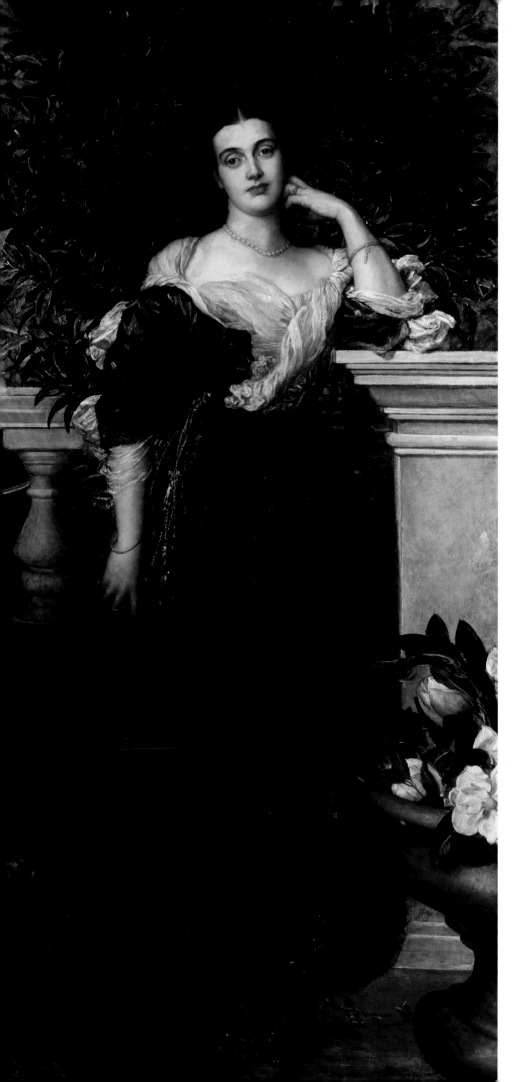

147
G.F. Watts, *Madeline Wyndham*
Oil on canvas, exhibited
at the Grosvenor Gallery 1877
Private collection

148
G.F. Watts, *Edward Burne-Jones*
Oil on canvas, exhibited at the
Royal Academy of Arts 1870 and
the Grosvenor Gallery 1877
Birmingham Museums and Art Gallery

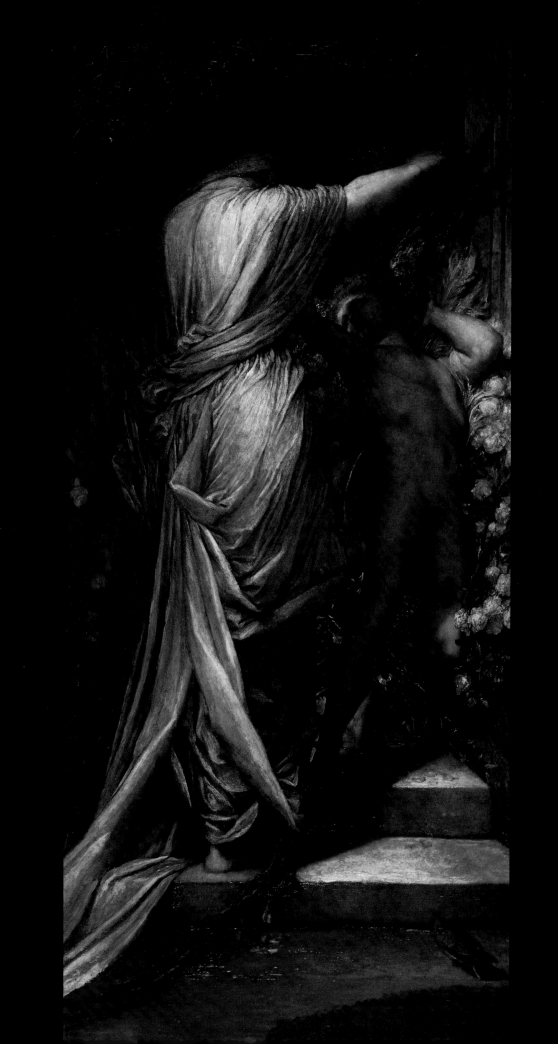

OPPOSITE
149
G.F. Watts, *Love and Death*
Oil on canvas, exhibited at
the Grosvenor Gallery 1877
Whitworth Art Gallery,
University of Manchester

Qualities of poetry and a manner of painting termed 'quattocentist' were unprecedented and baffling, but even Tom Taylor in *The Times* had to acknowledge that these works have 'a decorative beauty and an imaginative delight, which it may require special cultivation to feel, but which really and honestly exists for the initiated'.[37] This comment spelled out the cult aspect of such art. Those observers paying their shilling entrance charge to the Grosvenor may well have felt privileged to be granted access to a select private club. To include a portrait of Burne-Jones fitted neatly into the plan: Watts himself suggested it, commenting that people 'will want to know what sort of men painted all these angels'.[38] Endorsed by portraiture, artists had arrived as fully-fledged personalities in the cultural life of the period.

Love and Death (plate 149), one of Watts's 'symbolical' designs, presented a new type of imaginative subject that embodied universal concepts in a simplified visual language with monumental figures. This 'poem painted on canvas'[39] showed Love, the winged youth, struggling to fend off Death, a powerful female figure, moving forward inexorably to claim her next victim. In a key position in the West Gallery, the organizers located it directly opposite the wall of works by Burne-Jones. The triumphant revelation of *Love and Death*, 'nobly executed and grandly conceived',[40] greatly enhanced Watts's reputation as well as that of the Grosvenor.

Other subject painters in the shadows of Burne-Jones and Watts included Walter Crane, William Blake Richmond and J.R. Spencer Stanhope whose *Love and the Maiden* (plate 49) offered an enigmatic allegory in the spirit of quattrocento art. With its gold paint and gold leaf on the surface, this painting literally took fine art into the realm of the decorative. Crane painted *The Renaissance of Venus* (plate 150), an etherealized goddess in the manner of Botticelli, in tempera, the chalky tones imitating fresco. Richmond's subject, *Electra at the Tomb of Agamemnon* (plate 151), derived from classical tragedy but displayed a stylized vision of death and mourning, avoiding passion and instead aiming for a compositional balance and refined colour harmonies. What Crane and Richmond presented were not history paintings in any traditional moralizing sense but an aestheticizing treatment of such subjects, with an emphasis on colour and composition fully in tune with modern sensibilities.

Whistler made a strong showing in 1877 but polarized opinions and provoked a torrent of abuse. The Lindsays considered him essential to their project as he was represented by eight paintings, all but one of which appeared in a striking grouping in the West Gallery – two full-length portraits (of unnamed female sitters)[41] and the *Arrangement in Black, No.3: Henry Irving as Philip II of Spain*[42] (1876; Metropolitan Museum of Art)[43] hanging up high, with four nocturnes arranged below. The conservative *Saturday Review* felt that Whistler 'has deliberately chosen to affect these monstrous eccentricities, secure of admiration from a clique which prides itself upon possessing artistic perceptions too fine for common understanding'.[44] To the equally conventional *Art Journal*, his works were 'simply conundrums'. While Oscar Wilde hailed the artist as the 'Great Dark Master', John Ruskin's comments in *Fors Clavigera* precipitated the scandal of the year, the famous libel case brought by the artist against the critic.[45]

150
Walter Crane, *The Renaissance of Venus*
Tempera on canvas, slightly touched
with watercolour, exhibited at the
Grosvenor Gallery 1877
Tate, London

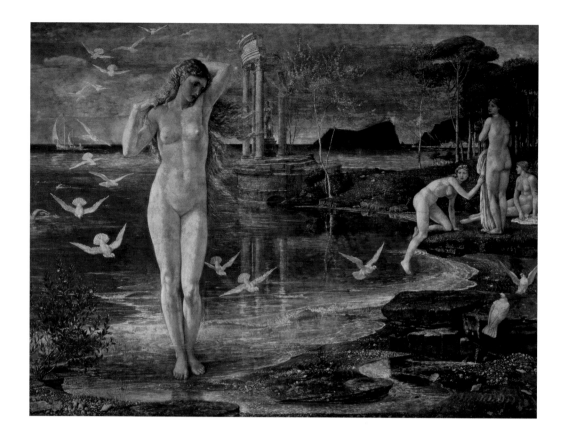

Whistler's portrait of Irving reveals his risk-taking strategies. To show a leading actor
of the day courted comparison with a long line of theatrical portraits in English art; that the
work was sketch-like taunted even a potentially sympathetic critic such as William Michael
Rossetti, who thought it 'exceedingly offhand…. we cannot but regard it as a rather strong
experiment upon public submissiveness'.[46] Thomas Carlyle sat for Whistler's *Arrangement
in Grey and Black No.2* (1872–3; Glasgow Museum and Art Gallery), positioned in the
Grosvenor's entrance hall. This work drew the most approbation for here was a more
finished painting depicting a sage of the era, easily recognizable in a faithful portrait. The
provocative Whistler was himself represented in Joseph Edgar Boehm's animated terracotta
bust (1872; National Portrait Gallery, Smithsonian Institution, Washington, DC) placed in
the Sculpture Gallery. As in the case of Watts's *Burne-Jones*, Whistler, one of the idols of the
exhibition, took centre stage as a personality. This privileging of the image of the artist was
central to the ethos of the Grosvenor.

Whistler's portraits in the inaugural exhibition caused the most controversy and
those by Watts drew the most admiration, with Henry James considering him 'the first
portrait painter in England'. Their sitters included an actor, a writer, and artists; many other
portraits at the first Grosvenor Gallery (and in succeeding years) depicted individuals who
had strong links with the art world. Patrons naturally felt pleased to send portraits of their
family in which their chosen artists offered new approaches. Richmond's portrait of Mrs
Douglas Freshfield (1874–5; private collection), positioned behind a parapet, adopted a
pose from Renaissance portraiture allied with a fresco-like handling.[47] Connoisseur and

collector J.P. Heseltine, for whom Shaw designed a house in the 'Queen Anne' style in South Kensington, lent Edward Poynter's portrait of his wife. Millais's portrait of sculptor Lord Ronald Gower (Royal Shakespeare Company) brought the aristocracy and the arts together, as did his portrayals of members of the Duke of Westminster's family. These were not included solely for the sake of status; the Duke was a keen patron of contemporary sculpture.[48] Millais's bust-length portraits of the Duke's sisters, including the Marchioness of Ormonde (1876; private collection), seemed to one critic 'to convey a challenge to Gainsborough'; but the 'chalkiness of whites' marked these portraits as part of a trend for studies of women in white.

Such forward-thinking patrons featured as part of the Grosvenor's cast of characters in 1877, as did artists themselves. Indeed, artists' wives acquired a new social caché. Poynter's portrait of his wife Agnes (1866; private collection) and her sister Georgiana Burne-Jones (1869; private collection)[49] were not recent works and their inclusion alluded

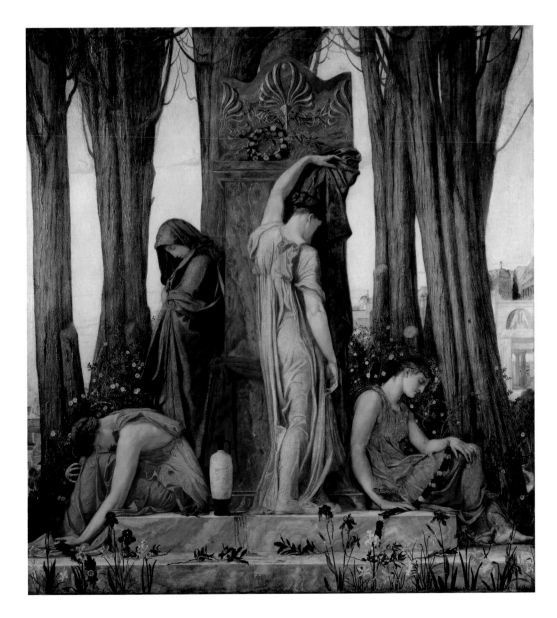

151
William Blake Richmond, *Electra at the Tomb of Agamemnon*
Oil on canvas, exhibited at the Grosvenor Gallery 1877
Art Gallery of Ontario, Toronto, Canada

to the lifestyles of artists and their families. These quiet images show women in artistic dress within settings characterized by contemporary works of art and floral accessories. Georgiana's portrait was commissioned and lent by her close friend Rosalind Howard, wife of aristocratic amateur artist George Howard. That women were lending paintings that they themselves owned was another distinctive feature of the Grosvenor. Women artists such as Louise Jopling, a member of the inner circle, also fared exceptionally well, due in no small measure to the role of Blanche Lindsay, herself an artist, in shaping the direction of the early exhibitions.

It is now possible to identify two other intriguing players in the Grosvenor circle, artist Kate Carr and Katherine Boughton, the subject of Carr's portrait shown in 1877 (plate 152).[50] Carr was the elder sister of Joseph Comyns Carr, co-director of the Gallery and a key figure in its creation. From 1871 until 1874 she studied fine art at the newly opened Slade School of Art where Poynter, its first professor, in a new reforming spirit, introduced academic methods based on the system taught in French ateliers, with an emphasis on sound draughtsmanship and working directly from the living model. Kate belonged to a younger generation of artists coming up in the 1870s for whom the Slade opened its doors to all who were eligible, including women. According to one contemporary writer, some of its students were 'enthusiastically devoted to the Aesthetic Movement'.[51]

Kate Carr might have had the edge in the selection process in 1877 thanks to her brother Joseph; but even without this advantage her portrait of Katherine Boughton would have been an obvious choice as it depicted the wife of artist George Boughton, himself an exhibitor. As one of London's most sociable couples, the Boughtons entertained at their new 'Queen Anne' style residence in Campden Hill designed by Shaw. Decorated in a style worthy of inclusion in Mrs Haweis's *Beautiful Houses* (1882), West House provided the setting for Boughton and 'his audacious little wife' to bring together friends such as Comyns Carr, Whistler and other 'devotees of the *bal masque*'.[52] Kate Carr's portrait shows Katherine Boughton wearing archaeological-style coin-set jewellery: a pendant suspended from a yellow ribbon and earrings of ancient silver coins with the same setting.[53] Dressed in white and set against a white tiled background, the sitter gazes steadily outward, a tangle of thorny rose branches behind her head and spray of forget-me-nots at her neckline. The restricted space enhances this pale and austere portrayal, inviting observers to consider the circle of friends and associates who desired such portraits. Certain traits mark it out as a quintessentially Aesthetic portrait: its contemplative mood, aided by the overall white setting, as well as the accessories that proclaim the interests of the sitter. Like Watts's *Blanche Lindsay* and *Madeline Wyndham*, this portrait highlighted the role of individual style makers of the 1870s.

Portraiture at the Grosvenor continued to be a key part of every exhibition, providing an irresistible insight into the personalities behind paintings as patrons, collectors and artists themselves came into focus as participants in the cult of the moment. It is remarkable how quickly, thanks in part to the Grosvenor, the term 'Aesthetic' slipped into common usage, with the whole phenomenon formally recognized in Walter Hamilton's book, *The Aesthetic Movement in England* (1882). Certainly before 1877 the word had currency in the

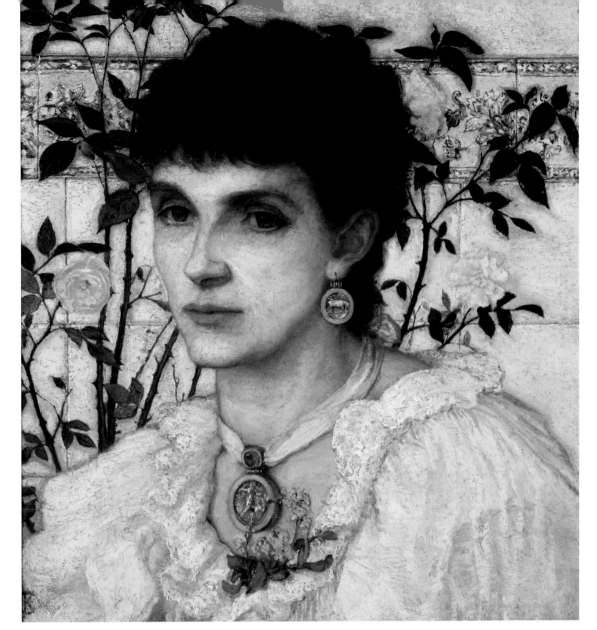

152
Kate Carr, *Katherine Boughton*
Oil on canvas, exhibited at
the Grosvenor Gallery 1877
Private collection

pages of *Punch*, but with the cult publicly revealed, it proliferated. Indeed, the notion of Aestheticism captured the public's imagination, making it ripe for satire. William Powell Frith's group portrait, *Private View at the Royal Academy, 1881* (see plate 191) presents the now instantly identifiable Aesthetes, including Lillie Langtry, along with the acolytes of the cult dressed in the Aesthetic style. Frith's own commentary on the painting made it clear that he disapproved, particularly of the 'eccentric garments', but when he expanded on the topic in his *Autobiography* of 1887, he reserved particular indignation for '… the folly of listening to self-elected critics in matters of taste, whether in dress or art. I therefore planned a group, consisting of a well-known apostle of the beautiful, with a herd of eager worshippers surrounding him'.[54] That 'well-known apostle of the beautiful' was, of course, Oscar Wilde, whose portrait is conspicuous in this work.

By the time Frith's painting appeared at the Royal Academy in 1883 the Aesthetic craze was already on the wane. In retrospect, the opening of the Grosvenor Gallery in 1877 marked a turning point in the fortunes of the cult of Aestheticism as it moved from a matter of elite, private display to a public celebration of the arts.

The 'Aesthetic' Woman

Margaret D. Stetz

IF JOHN RUSKIN'S influential 'Of Queens' Gardens' from *Sesame and Lilies* (1865) served as the guide to a middle-class lady's responsibilities – to be a helpmeet to her husband; to spread piety and calm at home – it also assigned her a further duty: to be beautiful. Unlike her other tasks, which required education and experience, this one depended upon maintaining immaturity, for the 'perfect loveliness of a woman's countenance' had to combine the 'majestic peace' signalling a life well lived with a 'yet more majestic childishness'. Like a flower still in bud, rather than fully in bloom, a woman would have to be 'opening always' with 'change and promise';[1] the Aesthetic woman would have to remain an Aesthetic girl.

Cultivating and (re)producing the image of the Aesthetic girl became an obsession. No one did more to give her a form – slim and physically undeveloped – and a uniform – high-waisted, ankle-revealing Regency dress – or to brand her upon the public imagination than Ruskin's disciple Kate Greenaway, who wrote and illustrated children's books. Greenaway's girls, often posed in garden settings, adorned calendars, greeting cards and decorative tiles (plates 153, 154), while Liberty's, purveyor of all things Aesthetic, sold 'Artistic Dress for Children' mirroring the artist's designs.

153
Kate Greenaway, *Summer*, tile
Earthenware, transfer-printed and hand-coloured,
for T. & R. Boote, 1881–5
V&A: Circ.399–1962

154
Kate Greenaway, *Winter*, tile
Earthenware, transfer-printed and hand-coloured,
for T. & R. Boote, 1881–5
V&A: Circ.398–1962

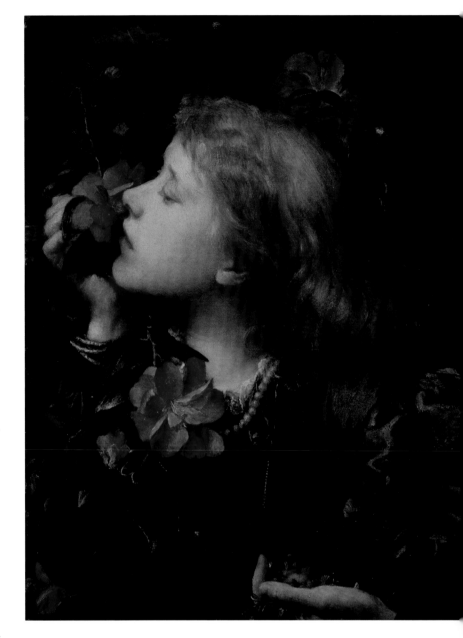

Women illustrators of the 1890s followed her lead in creating graceful, drooping, prettily gowned female figures that seemed coyly poised on the brink of sexual knowledge. In their work for the final numbers of the *Yellow Book*, Ethel Reed, Mabel Dearmer, Nellie Syrett, Georgina Gaskin and Katharine Cameron all depicted the same feminine type – the Ruskinian girlish woman or womanly girl. (Beatrix Potter, of course, parodied this ideal wittily by placing Greenaway-inspired gowns and bonnets on domestic animals.)

For male painters, however, the Aesthetic young woman was not pre-sexual; she was the embodiment of eroticism. To George Frederic Watts, the 16-year-old actress Ellen Terry presented an irresistible vision of beauty and sex, which he annexed through marriage and refashioned through art. In *Choosing* (plate 155), as Wilfrid Blunt notes, Watts painted his adolescent bride in her brown wedding-dress, 'trying to decide between the rival merits of a showy, scentless camellia, and the humble but fragrant violets in her hand'.[2] But this narrative about the subject's choice was superseded by an extra-diegetic one, in which the masculine spectator was choosing to look at and fantasize about the flowerlike Terry. As a painter-figure in Ella Hepworth Dixon's 'New Woman' novel *The Story of a Modern Woman* (1894) would remark cynically about such canvases filled with lovely maidens and blossoms, 'Nothing but girls, and nothing but roses. Lord, you can't give the public enough of either of them. It likes 'em, because they both "go off" so soon'.[3]

This notion of the young woman as a spectacle existing only for a moment and inviting consumption – or, to use Walter Pater's term, *appreciation* – by the sophisticated Aesthetic observer dominated the work of Albert Moore. For Moore, the tension between the evanescent beauty of his models and the timelessness of their classical settings

155
George Frederic Watts, *Choosing: Portrait of Ellen Terry*
Oil on strawboard, 1864
National Portrait Gallery, London

FOLLOWING PAGES
156
Albert Moore, *Reading Aloud*
Oil on canvas, 1883–4
Glasgow Museums

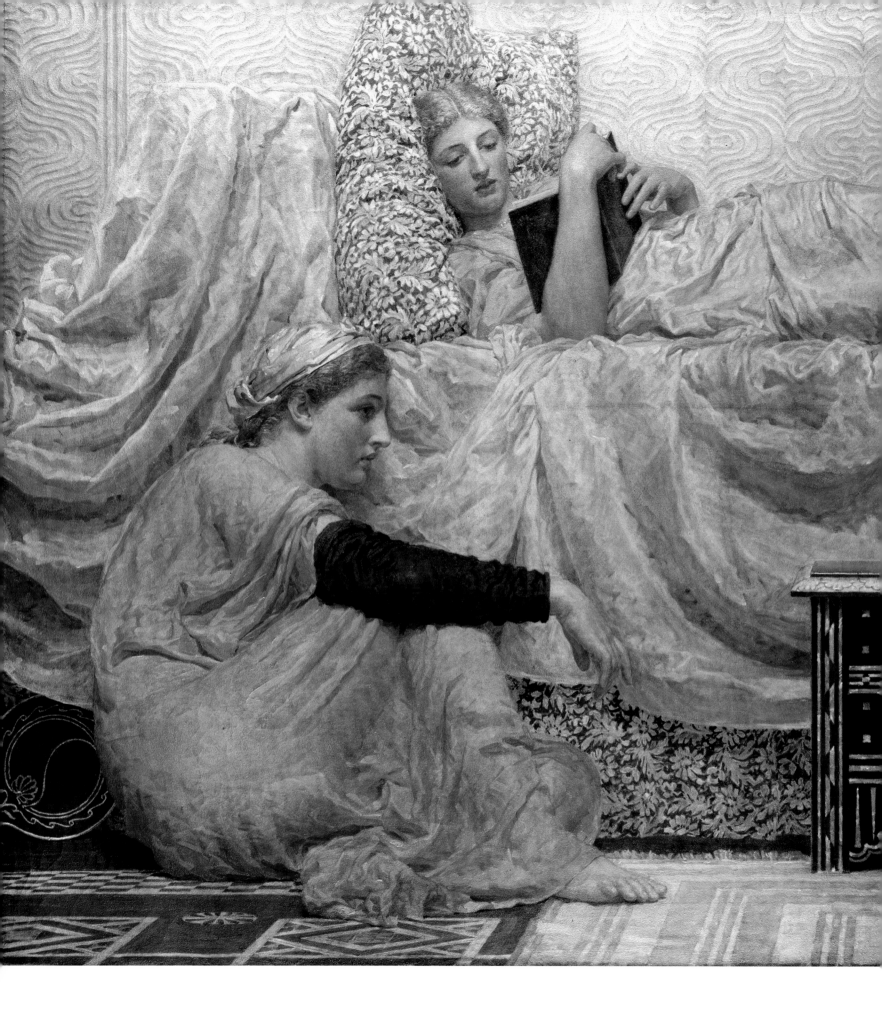

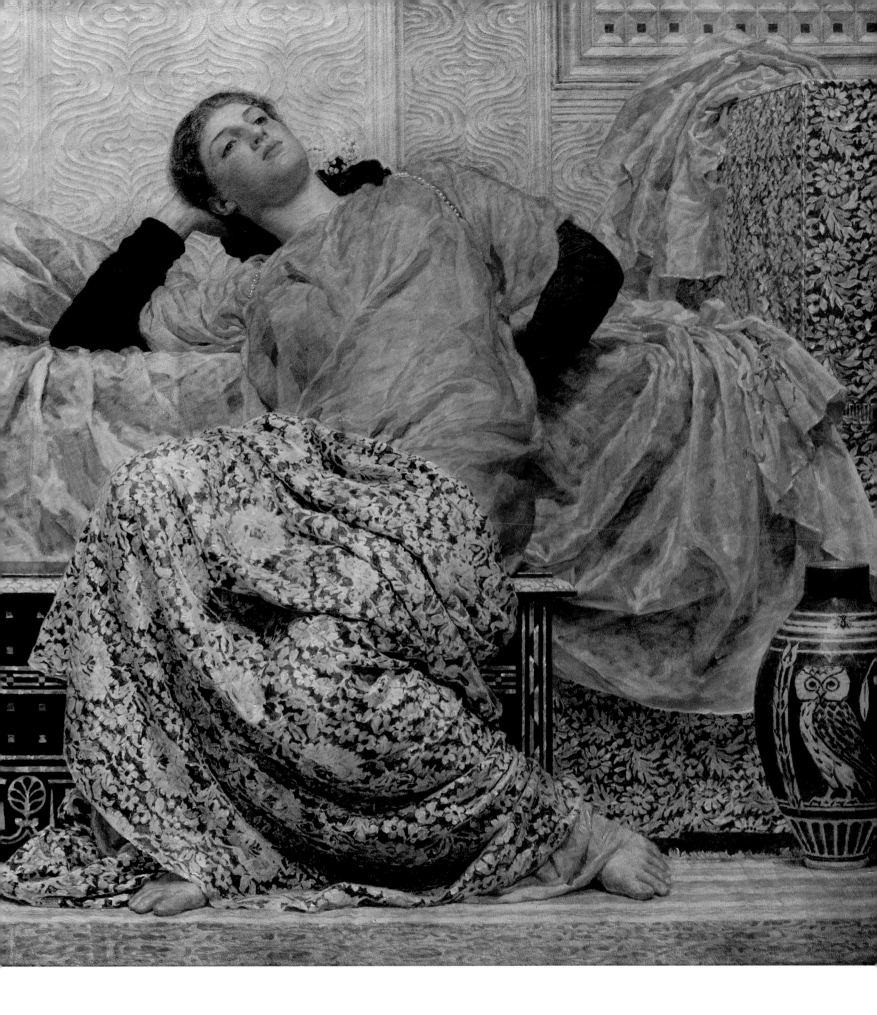

and draperies created a meditation on temporality, as did the contrast between the implied dynamism of their bodies and what Robyn Asleson calls the 'static composition' of 'linear and chromatic arrangements'[4] in paintings such as *Reading Aloud* (plate 156). But for Victorian audiences, of course, his compositions were also exercises in (and excuses for) indulgence in sensual reverie.

In her 1878 *The Art of Beauty*, Mary Eliza Haweis had urged women to take control of their surroundings, develop their own aesthetic judgments, and 'think – think – think'.[5] So established, nonetheless, was the convention of portraying young women as motionless ornaments or as languidly swaying plants that painters continued it, even as Eliza Lynn Linton's 'Girl of the Period' (1868), who was 'fast' in both movement and morals, morphed into the politically aware and rebellious *fin-de-siècle* feminist. Thus for George Francis (Frank) Miles, the unidentified sitter in *Pause in the Match* (plate 157) was less an active sportswoman than another decorative occasion for, as Molly Whittington-Egan, says, 'the fine painting of the dress, and the bamboo theme'.[6] By the time, however, that Albert Morrow designed his poster for Sydney Grundy's satirical play *The New Woman* (1894; plate 158), the central figure – a caricature of 'George Egerton' (Mary Chavelita Dunne), author of *Keynotes* (1893) – could no longer be confused with a budding flower. Dreaming not of camellias and violets, but of a latchkey, the Aesthetic girl had grown up to become a thorn in the sides of men.

157
Frank Miles, *Pause in the Match*
Oil on canvas, 1883
Wimbledon Lawn Tennis Club Museum, London

OPPOSITE
158
Albert George Morrow, *The New Woman*,
poster for the Comedy Theatre
Colour lithograph, 1894
V&A: E.2682–1962

THE NEW WOMAN

By Sydney Grundy.

DAVID ALLEN & SONS·BELFAST·LONDON·MANCHESTER·NEW YORK (Copyright Res.?)

FROM THE COMEDY THEATRE·LONDON·

Artists' Frames

Lynn Roberts

WHEN ROSSETTI and Ford Madox Brown began designing frames together in the early 1850s, they were working in a style very different from the patterns used by academic artists. Most artists exhibiting in the Royal Academy during the first half of the nineteenth century would have chosen industrially produced frames in conservative styles: reproductions of earlier baroque or neoclassical models with deep, sculptural sections and ornaments such as fluting to emphasize pictorial perspective.

Brown's and Rossetti's frames looked further back historically, to early Netherlandish patterns. They preferred flat architrave profiles (Rossetti, *The Blue Closet*, plate 29) in oak, usually gilded directly on to the wood so that the texture was visible through the gilding, and careful arrangements of geometrical ornament, including an arrowhead moulding. Around 1861 Rossetti evolved a setting for his small paintings of women, described by Brown as 'Rossetti's thumb-mark moulding' because of the semicircular indentations carved into its triangular section (*Bocca Baciata*, plate 42; *Fair Rosamund*, plate 34). The effect was decorative and flattening, emphasizing the abstract, ornamental qualities of the painting.

The 1862 International Exhibition, with its impressive Japanese pavilion, provided a rich vein of motifs to be mined by British artists. The architect W.E. Nesfield had begun to introduce Eastern ornaments into the mixture of classical and medieval influences which informed his work, and his protegé Albert Moore was profoundly affected by this creative medley.[1] In 1864, when Moore's friendship with Whistler began, Whistler was using references from his collection of china and Japanese prints to introduce a contemporary gloss into his paintings and early frame designs. *The Lange Leizen of the Six Marks* (plate 84) has

a gilt-oak frame based on Brown's and Rossetti's patterns, including their arrowhead moulding, and covered with incised oriental motifs. One of four almost identical frames, it uses these ornaments in the same unidigested way as Whistler imported oriental props into his paintings.

The first surviving frames by Moore (*The Shulamite*, 1864–6, Walker Art Gallery, Liverpool; *Pomegranates*, 1865–6, Guildhall Art Gallery, London; the latter very similar to that of *Azaleas*, plate 159) reveal a sophisticated grasp of design principles and the ability to synthesize an idiosyncratic style from diverse sources. Brown's and Rossetti's gilt-oak frames supply the basic structure, but the ornament applied to *Pomegranates* and *Azaleas* is a mixture of classical beading, spindle-and-bead and bead-and-reel motifs, organized just as fillets and reeds in various groupings are used to frame compartments on Japanese furniture. As with the Pre-Raphaelite frames, the effect increases the perception of the paintings as flat, decorative panels.

As Whistler and Moore diverged progressively as artists, so did their frames. Moore's 1870s designs introduce ogee mouldings, decorating them with further stylized classical motifs, whilst Whistler's continue to use grouped and spaced reeds, the friezes between being painted with simple japanizing patterns (*Blue and Gold: Old Battersea Bridge*, c.1872–5; Tate, London). The colours of these panels harmonize with the painting inside, just as Moore's mouldings harmonize with the lines of his work, and the

159
Albert Moore, *Azaleas*
Oil on canvas, 1867–8
Hugh Lane Municipal Gallery
of Modern Art, Dublin

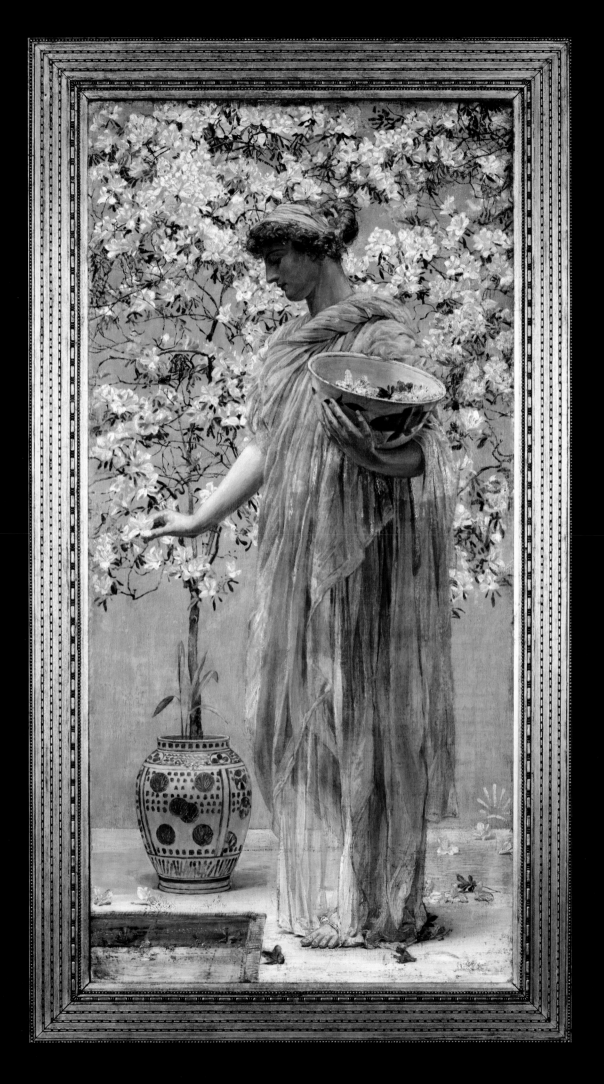

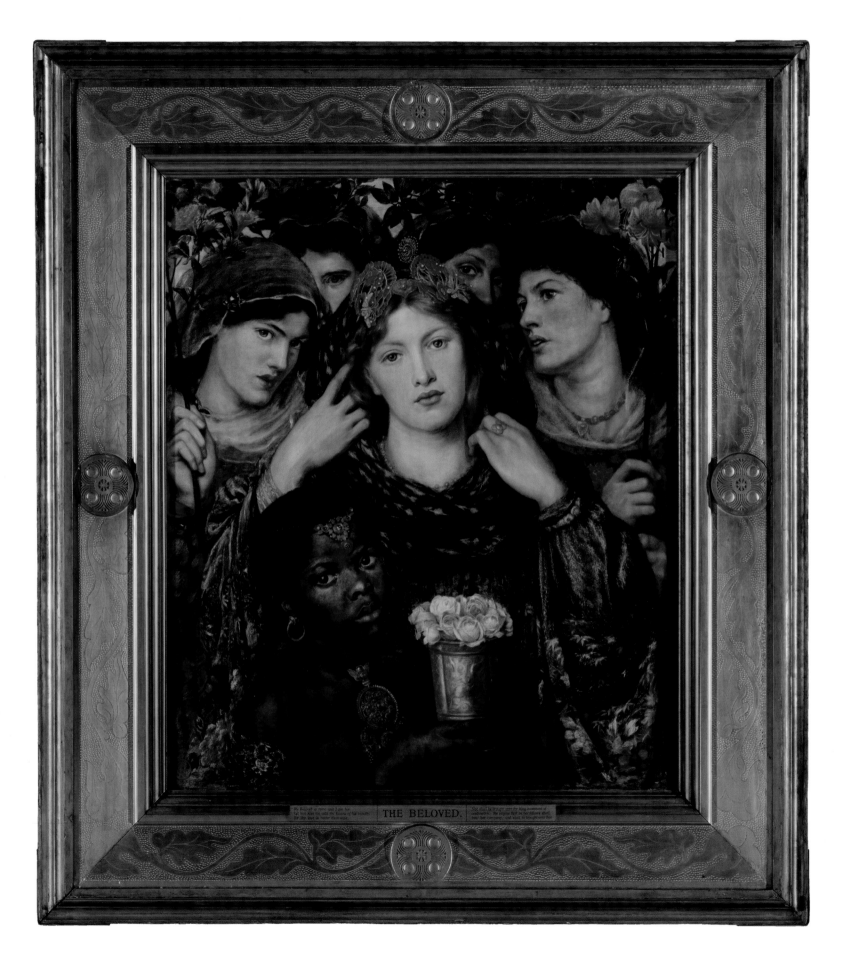

THE BELOVED.

butterfly signature (influenced by Moore's anthemion)
increases the flattening, abstract tendencies of the pictures.

Rossetti had also absorbed oriental motifs into his
frame designs. In about 1868 he designed a carved pattern
combining organic and geometric elements (*The Beloved*,
1865–6, reframed 1873; plate 160). Its construction is
simple and monumental, containing a canted frieze with
a round medallion, its face parallel to the picture plane.
Each medallion is segmented like a half-fruit containing
seeds, the curving lines echoing the female figures in
Rossetti's paintings whilst the seeds hint at mortality and
regrowth. Like Moore's combination of Japanese lines and
classical ornament, Rossetti's design marries a Renaissance
cassetta frame with a motif from Japanese textiles.

Burne-Jones had a close working relationship with
Rossetti and Brown – like Whistler's, his early frames
derived from theirs. Unlike them, he visited Italy, and from
about 1870, as his work began to show the influence of
Michelangelo, he adopted Renaissance-style frames. When
the Grosvenor Gallery opened in 1877 it included many
artists whose similar classicizing bent was expressed
through the use of temple-like frames. Burne-Jones used
these himself, but also produced one of the most attractive
Renaissance Revival designs of the period, the Venetian-style
frame on *The Beguiling of Merlin* (plate 161). It consists of a
pierced torus carved with scrolling foliage and swans' heads,
set over a burnished hollow so that – as the spectator moves
before it – the passage of light through the hollow gives a
shimmering vitality to the painting.

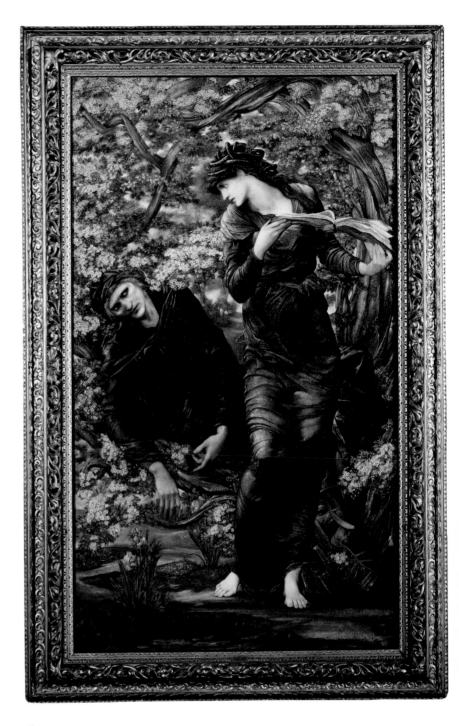

161
Edward Burne-Jones,
The Beguiling of Merlin
Oil on canvas, 1872–7
Lady Lever Art Gallery,
National Museums Liverpool

Much in Little Space: Whistler's White and Yellow Exhibition as an Aesthetic Movement Bell-wether

David Park Curry

Since several of our leading painters have frankly stepped out of the restricted sphere of the painter into decorative arts that belong more to the house-furnishing trade than the exhibition of high art products, it is now in order for the art critic to enlist in the same cause.[1]

New York Times, 1881

CLOSELY ASSOCIATED with 'art for art's sake' by the mid-1860s, Whistler aroused public and critical interest with suggestive images inspired by oriental art. He left much to the imagination when highly finished, often narrative art was the norm.[2] During the 1870s and '80s, trenchant cartoons mocked not only his pictures, but also the affectations of artists and patrons 'living up to their blue china' in interiors where three-dimensional furnishings, flat art, wall treatments and textiles merged to create a harmonious whole.[3] Whistler's paintings were sometimes associated with wallpaper.[4] But living aesthetically became ever less risible as a flood of self-help decorating books inundated eager readers (see pp.126–33).

Pilloried as the 'idle apprentice' in the 1894 bestseller *Trilby*, Whistler was in truth a purposeful Aesthetic strategist.[5] Both George du Maurier's characterization and Aubrey Beardsley's coeval caricature (plate 162) demonstrate how Whistler's carefully constructed yet seemingly offhand public persona invited constant comment, maintaining his visibility in the competitive art marketplace.[6] Although he eventually dismissed the Aesthetic Movement out of hand,[7] Whistler's high profile virtually assured his impact on fashionable interior design (plate 163). Other than the Peacock Room – an elaborate scheme conceived to display blue-and-white china along with his own painting (see p.165) – no Whistler

162
Aubrey Beardsley, *Caricature of J.M. Whistler*
Pen and black ink on wove paper, *c*.1893–4
Rosenwald Collection, National Gallery of Art, Washington, DC

Whistler perches on an attenuated ebonized settee, the type of bitterly uncomfortable Aesthetic Movement furniture that was decried by *Punch* cartoonists in the 1870s and '80s.

interior survives.[8] However, glimpses are to be had in surviving oils, watercolours and drawings (plate 164).

Aesthetes indulged in an eclecticism that might bewilder any taxonomic thinker. E.W. Godwin's design for a wall decoration at a medievalizing Irish castle combines large

163
James McNeill Whistler, *The Yellow Room*
Watercolour on off-white paper laid down on card,
*c.*1883–4
Private collection, Florida

Based on a palette favoured by impressionist
landscape painters, Whistler's interior features a
Japanese umbrella and pieces of blue-and-white
china, accessories that eventually became Aesthetic
Movement decorative clichés.

164
James McNeill Whistler, *Design for wall decoration
at Aubrey House, London*
Charcoal and gouache on brown paper, *c.*1873–4
Hunterian Art Gallery, University of Glasgow,
Birnie Philip Bequest

Again painted in an impressionist palette,
Whistler's drawing reveals how he prepared his
walls as he would a canvas, in layers of colour
that broke through one another to give life and
interest to a seemingly blank expanse.

squares of William Morris's *Trellis* wallpaper – inspired by sixteenth- and seventeenth-century herbals – with a plant in a vaguely neoclassical jar and a graceful female figure in full Japanese dress (plate 165). Reinforced by his ties to Godwin,[9] the equally eclectic Whistler began seeking recognition of his ideas outside the context of commercial decoration just as venues such as the Grosvenor Gallery afforded public access to contemporary works privileging decorative qualities.[10] Among the works shown, Whistler's *Falling Rocket* (1875; Detroit Institute of Arts) precipitated multiple crises. The artist barely survived twin fiscal disasters of the Ruskin libel trial of 1877 (see p.173)[11] and the loss of a major patron over the Peacock Room decoration. He had to sell his beloved Chelsea studio house (1877–8) designed by Godwin, 'the greatest aesthete of them all'.[12]

Retreating to Venice, Whistler refined his mature style. He then reinvented himself, attracting fresh patronage by returning to the British capital and mounting a trio of unconventional one-man shows at the Fine Art Society.

Well documented in the London press,[13] his controversial public exhibition designs blended elements of domestic decoration with avant-garde art. Among them, his 'Arrangement in White and Yellow' (1883) marks a transitional moment as the concerns of the Aesthetic Movement shifted from exclusive circles of artists and collectors to a more general targeting of middle-class domestic markets. Well aware of the power of the press and savvy about changing audiences, Whistler, with Godwin's input, created exhibitions in which his signature elements of decoration became ever more familiar.[14] Resting on calculated theatricality and accumulated notoriety, 'Arrangement in White and Yellow' generated the most far-reaching press.[15] On the heels of Oscar Wilde's tour of America (1881–2), the exhibition travelled straight from London to the United States, delighting or confounding audiences in New York, Baltimore, Boston, Detroit, Chicago, and Philadelphia.[16]

Affirming ideas explored by Whistler and Godwin in their collaboration on the studio-house, the 'White and Yellow' project offers Whistler's clearest link to elegant economy and

165
Edward William Godwin, design for a Japanese-inspired wall decoration at Dromore Castle, County Limerick, Ireland
Watercolour and pencil on paper, *c.*1869
V&A: E.491–1963

Well ahead of their times, both Godwin and Whistler tempered their eclecticism by avoiding clutter.

166
Alexandre Sandier, 'Much in Little Space',
illustration from Clarence Cook,
*The House Beautiful: Essays on Beds and
Tables, Stools and Candlesticks*, London,
1878; New York, 1881. Immediately
pirated as 'A Comfortable Corner'
by Lucy Orrinsmith for *The Drawing
Room: Its Decorations and Furniture*,
London 1878
V&A: NAL

The crowded space includes a hanging
cabinet designed by Sandier for Herter
Brothers, a cast of *Minerva* by Antoine-
Louis Barye, and a Japanese scroll not
unlike those Whistler collected and
pictured (*The Artist in His Studio*, 1865–6,
Art Institute of Chicago).

historically based eclecticism, lynchpins of the Aesthetic
Movement during the 1880s and '90s. Depending on an
abstract colour scheme lifted from Regency decor, Whistler
sidestepped the narrative associations of tiered objects that
crammed 'Much in Little Space' for Clarence Cook's *House
Beautiful* (plate 166). Yet the two intersect on the common
ground of performance, fashion, and display. Cook's crowded
parlour, like Whistler's airy exhibition, captured the ethos of
the Aesthetic Movement interior as a stage for presentation
of an artistic self. Pared-down interiors, also predicted in
Whistler's exhibition designs, did not take hold until the
twentieth century.

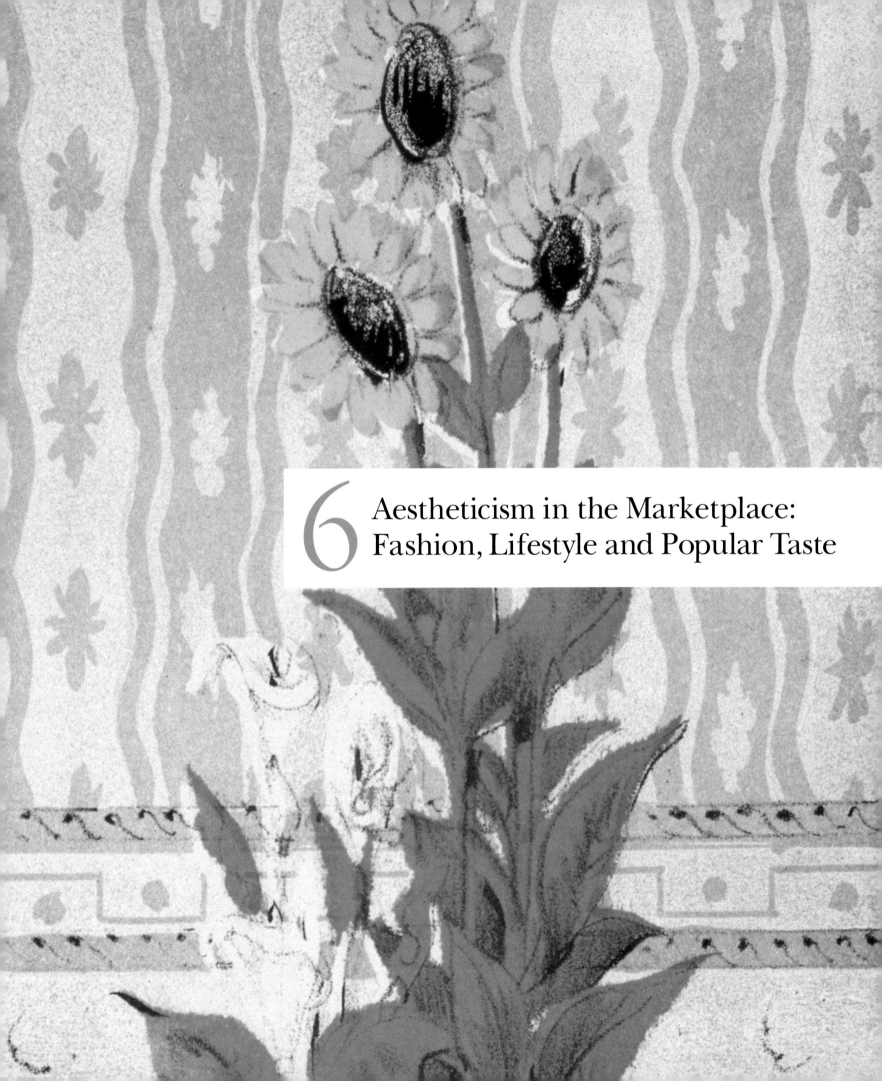

6 Aestheticism in the Marketplace: Fashion, Lifestyle and Popular Taste

AESTHETICISM IN THE MARKETPLACE: FASHION, LIFESTYLE AND POPULAR TASTE

Christopher Breward

> A most remarkable change has of late come over the English mind in respect of art.
> It is not in the Grosvenor Gallery that it has been manifesting itself – certainly not
> in the Royal Academy. It is in our thousand and one shops, and workshops, and
> manufactories … The sense of being, as English people, at least alive to this thing
> called art is immensely exhilarating.[1]
>
> *'The Architect', 1881*

S O NOTED a columnist in the influential trade journal in November, 1881. As Deborah
Cohen argues in her important book on the modern British home, such public de-
bates on the place of 'art' in late nineteenth-century domestic life were all-pervasive
and had the effect of transforming the concerns and pretensions of a metropolitan elite into
a far-reaching transformation of the middle-class way of life. This chapter follows Cohen's
lead in reassessing the impact of Aestheticism on questions of 'taste'. It notes the move-
ment's debt to the moral certainties of the Arts and Crafts pioneers and the reforming zeal
of South Kensington, and enjoys the tensions thrown up by the association of its key pro-
tagonists with an artistic and sexual dissidence that would probably have horrified Ruskin,
Morris and Cole.[2] But, more presciently, it sees in the space that opened up between these
two influences a platform upon which concepts of choice, purchase and possession gained
a new prominence.

In other words, the Aesthetic Movement is interesting not simply because of its
conflicted debt to the philosophies of both Design Reformers and Decadents, nor because
of the sensual attractions of its shimmering peacock surfaces to a gilded 'elect'. It has a
longer-lasting relevance because it ushered into the wider national consciousness a socio-
logical concept that would not be named as such for at least another half century. In its
harnessing of 'art' to the chariot of retail and publicity, its spawning of countless paper
fans, blue-and-white ginger jars and Kate Greenaway-inspired pinafores to an appreciative
suburban and provincial audience, the Aesthetic Movement anticipated and hastened the
consumerist idea of the 'lifestyle'.

Of course the Movement also reflected the increasingly aspirational mores of the
society in which it resided. Cohen cites Mrs Talbot Coke's decorating and household man-
agement guide *The Gentlewoman at Home* of 1892, in which the author suggested that the
question of the day was not 'Who are they?' but 'What *have* they?' Such a question was at
the heart of late Aestheticism's popular success. In a world where materialist middle-class
pretensions were becoming more influential than aristocratic taste-making, 'individuality
had to be earned. As … other signs of belonging diminished, material belongings gained in
significance. An artistically furnished room did not simply express one's status; it conferred

167
Adolf Manfred Trautschold,
The Tower House, Bedford Park
Colour lithograph on paper,
1882
V&A: E.4039–1906

status.'³ This more complex relationship between the worlds of art appreciation, identity formation and commodity culture that seemed so especially suited to Aestheticism's mode of address was necessarily dependent on the existence of new commercial networks, media and outlets in which the pure principles of the Movement risked dilution at best, debasement at worst. But it was, ironically, in this sphere, in the rough and tumble of the late Victorian marketplace, that 'art for art's sake' made its biggest impact.

For Aestheticism to be considered as the prototypical fashionable 'lifestyle' trend, it is necessary to look beyond its manifestation in the relatively rarefied spaces of the Grosvenor Gallery, or even South Kensington and Bedford Park. For the purposes of this study, the 'High Aesthetic' calling is less important than its translation into the ephemeral phenomena of the theatre, the suburban parlour, the shop window and the store catalogue, the nursery book, and the mass-circulation periodical. It is also necessary to consider the ways in which this translation from 'High' to 'Low' resulted in an exposure of the Movement's inherent vulgarity: its broad appeal as a 'craze' of the moment effectively eclipsing its cultish status as a religion for the philosopher/connoisseur. If one could identify the moment in which such a shift took place, one might look to 1881, the year in William Powell Frith chose to set his celebrated painting *A Private View at the Royal Academy* (exhibited 1883; plate 191). Writing in his autobiography of 1887, Frith recalled:

> Seven years ago certain ladies delighted to display themselves at public
> gatherings in what are called aesthetic dresses; in some cases the dresses are
> pretty enough, in others they seem to rival each other in ugliness of form and
> oddity of colour. They were – and still are I believe – preachers of aestheticism

168

WITH · YEARNINGS · FOR · YOUR · INTENSE · JOY ·

169

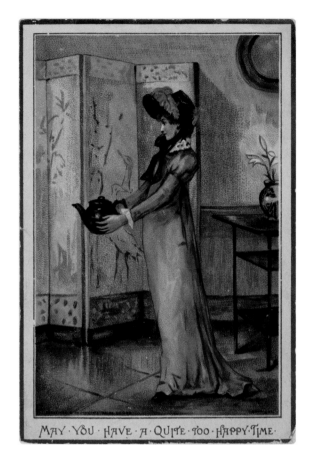

MAY · YOU · HAVE · A · QUITE · TOO · HAPPY · TIME ·

170

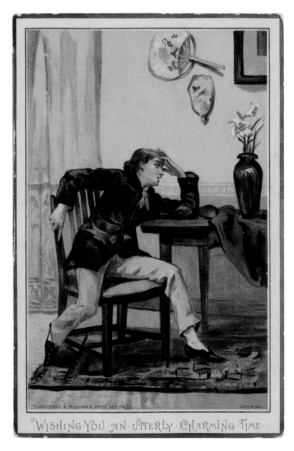

WISHING · YOU · AN · UTTERLY · CHARMING · TIME ·

171

VERY · PRECIOUS · WISHES · FOR · YOU ·

in dress … Beyond the desire of recording for posterity the aesthetic craze
as regards dress, I wished to hit the folly of listening to self-elected critics
in matters of taste whether in dress or art.[4]

OPPOSITE
168–71
Albert Ludovici Jr, four Aesthetic
greetings cards
Colour lithographs on paper, 1882
V&A: E.2413–2416–1953

Pioneering dress historian Stella Mary Newton suggested that 'in Frith's painting, the dress
of the pure aesthetes follows the principles pronounced by Mrs Haweis' (author of the
influential Aesthetic Movement primers *The Art of Dress*, 1878, and *The Art of Decoration* of
1881). Newton sees them reflected in the artist's rendering of

> dresses with folds in the bodice which continue below the waist-belt down the
> skirt … a dress with no folds at all. Its colour is olive green with a yellow trimming,
> and a yellow sunflower … tucked into the front of [the] bodice…. The most
> spectacular … is pink, a long drapery flows down from the neck at the back and
> lies on the ground in an ample train.

Most significantly, she argues that the painting 'makes it clear that there was no social div-
ision between those who wore artistic dresses in the early 'eighties and those who did not.
It also shows that in high society there was a good deal of it about.'[5]

Certainly by 1881 a taste for Aesthetic dressing had permeated fully through the
more arty fringes of metropolitan society, contributing towards the reconciliation of an
escapist sense of creativity, inherited from the Romantics via the Pre-Raphaelites, with the
more commercial prerogatives of an industrialized modernity. Cultural historian Elizabeth
Wilson has identified this marriage of art and commerce as one of the defining characteris-
tics of the bohemian myth.[6] But contemporaries such as Frith were dismissive of what
they saw as a pretentious disjuncture, and the arising cultural clash was a rich source for
satirists. Indeed, in February of the same year F.C. Burnand's Aesthetic farce *The Colonel*
opened at the Prince of Wales Theatre, to be followed in April by W.S. Gilbert and
A. Sullivan's more celebrated *Patience* at the Opera Comique (plate 172). Both productions
went to some lengths to capture an authentic sense of artistic clothing and interiors, which,
while intending to lampoon, did much to circulate and popularize a minority taste. As
editor of *Punch*, Burnand looked to his colleague, the ruthless caricaturist of Aesthetic folly
George Du Maurier, to advise on the set dressing. His instructions come close to a shop-
ping list in their specifics:

> Try and have a room papered with Morris' green daisy, with a dado six feet high
> of green-blue serge in folds – and matting with rugs for floor (Indian red matting
> if possible), spider-legged black tables & sideboard – black rush-bottomed chairs
> and arm chairs; blue china plates on the wall with plenty of space between – here
> and there a blue china vase with an enormous hawthorn or almond blossom sprig
> … Also on mantelpiece pots with lilies and peacock feathers – plain dull yellow
> curtains with dull blue for windows if wanted. Japanese sixpenny fans now & then
> on the walls in picturesque unexpectedness.[7]

For *Patience*, as for *The Colonel*, Liberty fabrics featured prominently in costumes and furnishings, and the store's 'artistic silks' were advertised prominently in the programme. Its much-admired Umritza cashmere, first introduced in 1879, seems almost to have been designed with the production in mind, for as a journalist in the society fashion magazine *The Queen* remarked of the available colour ranges,

> There are tints that call to mind French and English mustards, sage-greens, willow-greens, greens that look like curry, and greens that are remarkable on lichen-coloured walls, and also on marshy vegetation – all of which will be warmly welcomed by those who indulge in artistic dress or in decorative revivals.[8]

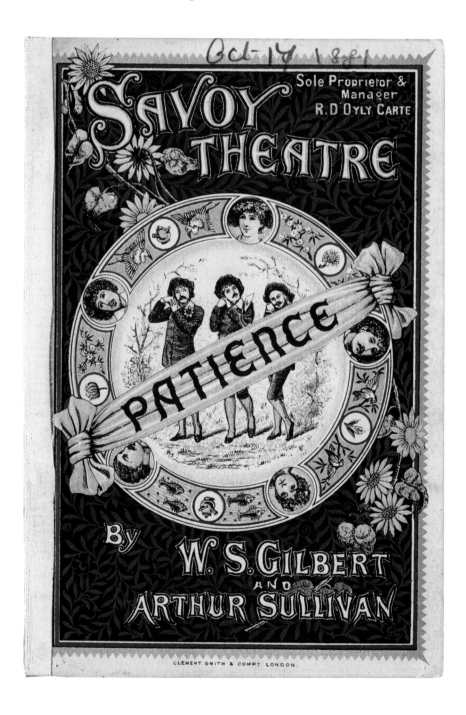

172
Cover of programme for Gilbert and Sullivan's
Patience
Lithograph, 1881
V&A: location unknown

OPPOSITE
173
Liberty & Co. Ltd., dress
Striped washing silk lined with cotton, *c*.1885
V&A: T.171–1973

Liberty's was not the only shop enlightened and commercially savvy enough to engage in Aesthetic promotions, though it was perhaps the most innovative and well-known. Other stores followed its lead in establishing oriental departments, including Whiteley's in Bayswater, Swan & Edgar of Piccadilly and Debenham & Freebody of Oxford Street. Lewis & Allenby of Conduit Street and A. Stephens & Co. of Regent Street were also well regarded for their 'Art' textiles. But it is interesting to note how the terms 'Aesthetic' and 'Liberty' became more widely applied through the 1880s and '90s to denote a rather debased engagement with 'bric-a-brac' and 'gifts' of the sixpenny fan variety. The Aesthetic Gallery of New Bond Street advertised its wares in 1890 as including 'English silks, cashmeres, velveteens, fans, cushions, handkerchiefs, table covers, and other dainty manufactures'. And by 1909 the winter sale catalogue of Cavendish House, Cheltenham, offered a page of 'Liberty Department' goods, including 'Indian printed covers … Liberty lacquer trays, Japanese inlaid tables, draught screens, Liberty garden and summer hats, and imitation panama hats'.[9]

The wider dissemination of Aesthetic values into the marketplace did not always signify crass popularization, however. Deborah Cohen notes the similarity between the missions of the new department store entrepreneurs and the keepers of the South Kensington museums. After visiting Waring & Gillows' luxurious Oxford Street premises in 1903, the editors of *The Connoisseur* observed that 'there are many museums and public galleries far less rich in historic examples and far less important from an artistic and educational point of view'. Indeed, the departmental heads of several stores were sometimes termed 'curators', with access to substantial financial resources and the freedom to pioneer display innovations such as the 'period room set' well before the museum sector arrived at this strategy. At the turn of the century Arthur Lasenby Liberty was even described as

> as much the founder of an artistic school as ever were Velasquez, Rubens or Turner. What is far more important, Liberty has founded a cult that is more wide-reaching than that of any of the men mentioned, for his work … is not devoted, like that of most other founders of artistic schools and systems, solely to the service of the opulent.[10]

The furniture and interior decoration trades were generally enthusiastic about what they viewed as this 'democratization' of good taste. In 1883 *The Furniture Gazette* suggested that 'Decorative Art is really the only art that is within the means of the largest proportion of people … The home is the fit altar at which to offer up our artistic efforts.'[11] Yet the Aesthetic Movement's seeming elevation of dress and decor to the status of a religion also attracted a great deal of criticism, indeed moral outrage, even from those close to the cause. In his 1885 'Ten O'Clock Lecture', the commercially astute and self-promoting Whistler denounced the traducing of art as 'a common topic for the tea-table' by those

174
Alfred Concanen, *Quite Too Utterly Utter*,
paper sheet-music cover
Colour lithograph, *c.*1881
V&A: S.34–1993

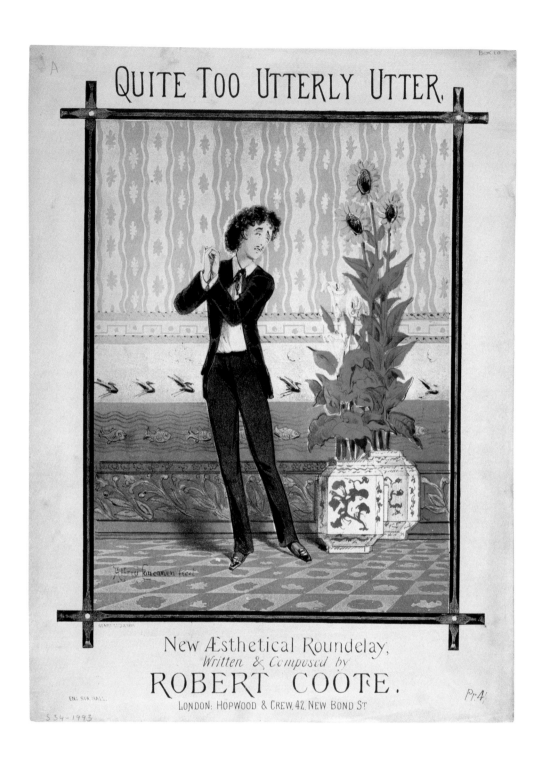

'false prophets who have brought the very name of the beautiful into disrepute'.[12] Certainly Alfred Concanen's popular sheet music covers of the early 1880s, with their quivering swains and maidens swooning before blue china vases, sunflowers and lilies, suggest an ambivalent and mocking attitude towards the reification of 'beauty' (plates 174, 175).[13]

Sitting behind this counter-blast was a discernible horror at the incipient effeminacy suggested by the whole Aesthetic Movement, its inevitable lapse into degeneracy and decadence. Whistler must have had Oscar Wilde in mind when he lambasted the 'false prophets', and Wilde was indeed the most prominent and provocative of Aestheticism's

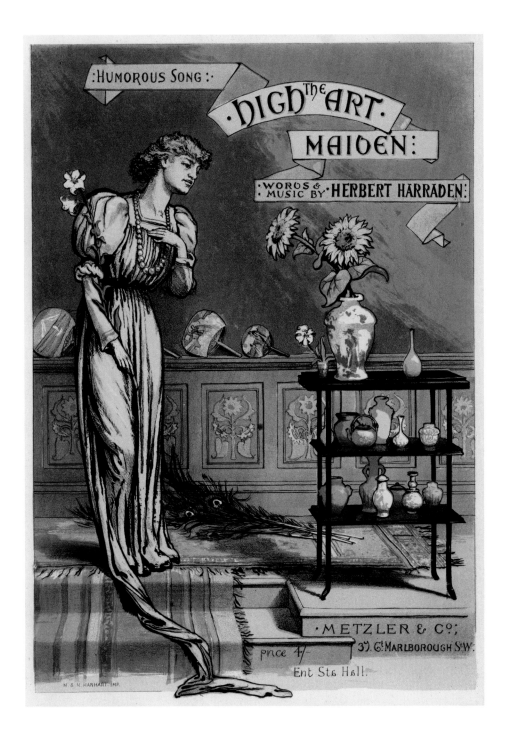

175
Alfred Concanen, *The High Art Maiden*,
paper sheet-music cover
Colour lithograph, *c.*1880
Mary Evans Picture Library, London

apologists. His 1882 promotional lecture tour of North America, sponsored by Richard D'Oyly Carte as a taster for the American run of *Patience*, offered a perfect opportunity for the mannered posturing that so infuriated the critics, not least through Wilde's choice of wardrobe. As Gere and Hoskins record,

> Wilde's clothes mixed the preposterous with the pragmatic, the most outré of
> them being made to his own designs. Whistler begged him to return the befurred,
> full-length overcoat he ordered on the eve of his departure for America to Nathan's,

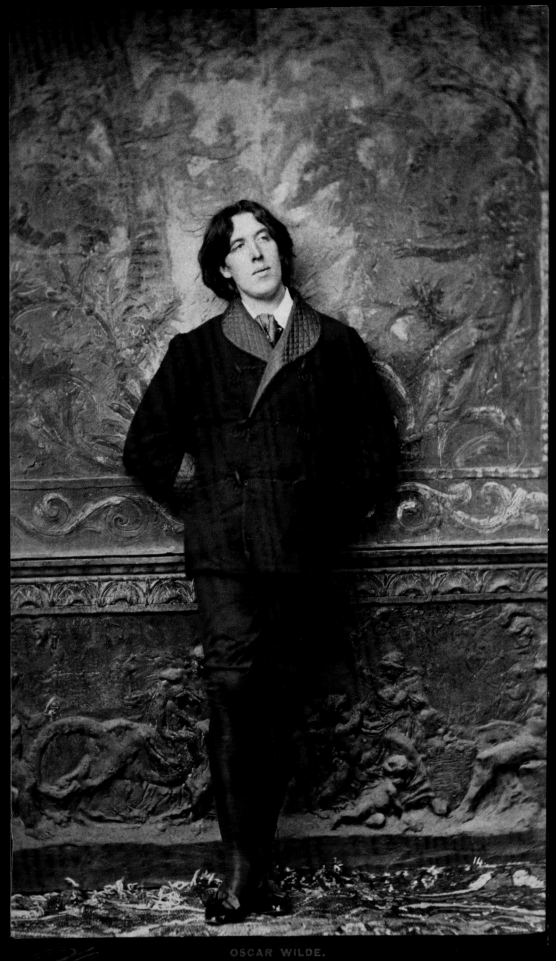

OSCAR WILDE.

Copyright 1882, by N. Sarony. NEW YORK.

the theatrical costumier. The outfit consisting of velvet kneebreeches and silk stockings which caused such a rumpus on his American tour – 'Strange' he was to say later, 'that a pair of silk stockings should so upset a nation' – was merely the uniform of his Masonic Lodge at Oxford. However, it was sufficiently outlandish to provoke widespread ridicule, and most of the pictures of Wilde that adorned the newspapers show him dressed in this way.[14]

OPPOSITE
176
Napoleon Sarony, *Oscar Wilde*
Albumen panel print, 1882
National Portrait Gallery, London

The brown velvet version of the 'Aesthetic Suit' loaned to the V&A (plate 177) suggests that the style did momentarily influence at least one brave wearer not intimidated by the cruel stereotypes of *Punch* or the crude commemorative commercialism of the Royal Worcester Porcelain Company, who in 1881 patented a Janus-faced 'Aesthetic' teapot, decorated by limp-wristed male and female aesthetes, sunflower and lily pinned to their breasts, the base inscribed with the admonitory motto 'Fearful consequences through the laws of natural Selection and Evolution of living up to one's teapot'. Wilde himself, of course, had famously anticipated the rebuke of Royal Worcester in his undergraduate days when in 1876 he announced that 'I find it harder and harder every day to live up to my blue china', goading the Dean of St Mary's Church, Oxford, to sermonize that such subversive views were 'a form of heathenism which it is our bounden duty to fight against and crush out, if possible'.[15] In 1880 Du Maurier reprised the incident in a *Punch* cartoon titled 'The Six-Mark Teapot', where the Wildean 'Aesthetic Bridegroom' presents his 'Intense Bride' with a 'consummate' piece of Japonisme. 'Oh Algernon', she cries, 'Let us live up to it'.

Wilde almost had the last word. In 1890, at the height of his career, he re-emphasized his point in the essay 'The Critic as Artist'. As Cohen notes, his shocking argument was that 'aesthetic discernment was not merely different from morality, it was superior. "Even a colour-sense is more important, in the development of the individual, than a sense of right and wrong"'.[16] Yet by this date the faddish material extremes of Aestheticism had passed and Wilde was turning to fashionable high society as a new source for his writing and plays. As early as March 1883 *Punch* was celebrating his return from America with a comic advertisement offering 'the whole Stock-in-Trade, Appliances and Inventions of a Successful Aesthete, who is retiring from business. This will include a large stock of faded lilies, dilapidated Sunflowers and shabby Peacock's Feathers'.[17]

But despite the mocking and the rather bathetic ending of the Aesthetic craze, the wider influence of the movement was more difficult to cast aside. The Wildean challenge to received understandings of morality via the code of taste was personally and politically dangerous, carrying as it did the taint of 'perversion' and social revolution. It could not help but inspire further aftershocks. In the public view expressed at the time of Wilde's arrest and trial in 1895 for 'acts of gross indecency with other male persons', his radical 'art for art's sake' dandyism seemed evidence enough of moral bankruptcy and sexual disgrace. But it also guaranteed Aestheticism's place at the start of a longer trajectory of artistic provocation. It ushered in a new conception of identity formation, avant-gardism and the commodity value of art that would reverberate through the twentieth century to Warhol and beyond.[18]

177
Man's Aesthetic suit
Cotton velvet, 1880–5
Private collection on loan to V&A

OPPOSITE
178
Kate Greenaway, 'The Bubble',
illustration for *Rhymes for the Young Folk*
by William Allingham, published by
Cassell & Co., 1887
Colour wood engraving
V&A: E.1390–1936

In the less controversial spheres of everyday life, the Aesthetic Movement also left a longer imprint on British and North American domestic and popular culture. In the world of fashion, as noted above, Aesthetic notions of individualistic, beautiful and rational clothing provided a powerful prototype for the bohemian, the healthy and the eccentric registers of dress that were to become associated with social groups as diverse as Bloomsbury artists, demi-monde actresses and aristos, inter-war hikers and vegetarians, and even the sub-cultural teenage sects of the late twentieth century.[19] The widely reproduced and republished work of Walter Crane and Kate Greenaway similarly helped to promote an ideal of childhood that was instantly nostalgic, free from trauma and imbued with a sweet, graphic simplicity that would endure in the middle-class imagination well beyond the end of the nineteenth century (plate 178).[20]

Crane, along with social reformers including Octavia Hill, Samuel Barnett and Henrietta Barnett, was active in translating such utopian visions into a living campaign for better standards of design and access to inspirational art in the soulless working-class environments of the modern industrial city. Aestheticism thus also left a legacy in the philanthropy of a burgeoning labour movement. Its relationship to the capitalist marketplace was not all one way.[21]

Most importantly, the efforts of popularizers such as Mrs Haweis, and the vehicle which Aestheticism provided them, offered a radical template for self-expression through the fashionable commodity that was almost entirely unprecedented, at least in its demographic and geographical reach. This was particularly true in terms of the freedom implied in the exhortations of Aesthetic Movement supporters to ordinary consumers to 'do-it-themselves', to make informed and creative decisions about the decoration of their homes and the dressing of their bodies. As Cohen concludes,

> those who cared how their walls were covered struck a blow for the 'right of
> individual thought and action.' They withstood the tyranny of the upholsterer
> and the rules of design reform. An artistic home, no less than a successful
> business, provided a way for a man to distinguish himself from the crowd and to
> improve the nation.[22]

This was a powerful and wide-reaching impact indeed for a style that originated in the idiosyncratic, anti-materialistic decorating choices of a select coterie of artists and intellectuals in 1860s Oxford and Chelsea.

Women's Dress

Edwina Ehrman

HOW WOMEN should dress and what constituted female beauty were questions that had long preoccupied Victorian society. Was fashion a tyrant or the mark of a civilized society and a consequence of modernity? The pace of industrialization and the continuing expansion of the fashion and clothing industries were both causes for concern. Women's fashions, which took their lead from Paris, were expensive and elaborate, requiring corsetry and supporting garments to create the fashionable silhouette which emphasized a suppressed waist.

Those who criticized fashion cited moral, economic, hygienic and aesthetic reasons. Many commentators were involved with the visual arts, including some at the heart of the Aesthetic Movement. Edward Godwin, William Morris, Walter Crane and Oscar Wilde wrote and lectured about dress, and Godwin and Morris were knowledgeable about textiles.[1] They all argued for the beauty of the natural body and that a woman's clothes should reflect her form and respect its physiology. Rejecting the uniformity, artifice and materialism of high fashion, they encouraged individuality and the use of richly coloured draped fabric to attract and please the eye.

Very few garments that can be described as Aesthetic survive from the 1860s, when the Aesthetic Movement took root in Britain, but images of women in avant-garde circles, such as Jane Morris and the Pattle sisters, show them wearing simple dresses in plain fabrics draped from the shoulders, with unconstricted waists and sleeves that did not inhibit movement. In the 1870s women wishing to dress artistically were recommended to look for inspiration in paintings, particularly those by the Pre-Raphaelite artists, and in books about period costume where they would find attractive sleeve details and decorative combinations of colours and fabrics.[2]

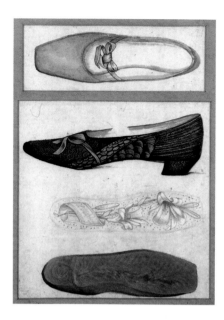

179
Edward Burne-Jones, design for shoes
Watercolour, 1877
Private collection

Burne-Jones created this design at the instigation of Frances Horner, the daughter of his patron William Graham, who acted as a model and muse for the artist in the last twenty years of his life. The inner soles are decorated with lilies and the inscription 'ne oublies'. The embroidery was to be carried out by Frances's sister, Agnes Jeckyll.

Appropriate materials could be bought at the Royal School of Art Needlework, and at Lewis & Allenby and Liberty's in London's Regent Street, who sold velvets and lightweight undressed silks, coloured by natural dyes, which could be gently shaped to the body's contours with gathering and shirring (plate 181). In 1884 Liberty's opened a dress department, with Godwin as consultant and designer, offering historically inspired styles made in their fabrics. Most extant Aesthetic dresses have boned under-bodices, but some women wore bone-free corsets or none at all. For outer wear, cloaks were popular.

As well as rejecting mainstream fashion, some Aesthetes flouted conventional standards of female deportment and the etiquette governing dress worn in public. Their behaviour was parodied in *Punch* by George Du Maurier, whose cartoons emphasized the escapist, faddish traits of the Aesthetic Movement. Other women were more measured, displaying 'originality' while keeping 'within certain discreet bounds of loyalty to the prevailing fashions'.[3] The eclectic and individual approach to dress promoted by the Aesthetic Movement manifested itself in the twentieth century in the dress of women moving in artistic and bohemian circles; today it is considered one of the key characteristics of British style.

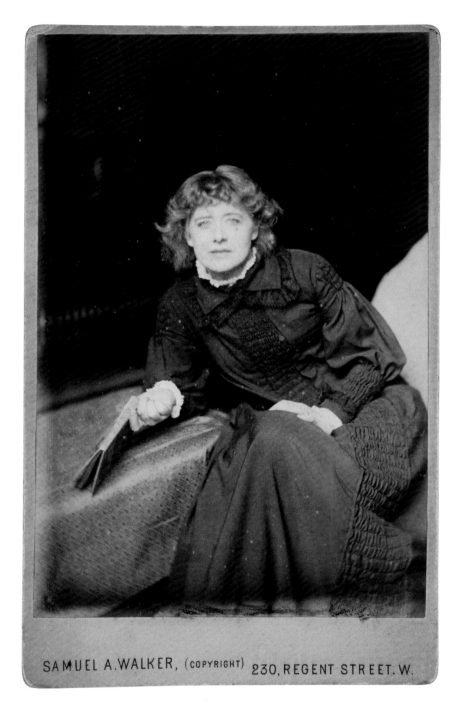

180

Samuel A. Walker, *Ellen Terry*, carte-de-visite
Albumen print, 1873
Smallhythe, National Trust

Ellen Terry, who was a universally admired celebrity, was a living example of how to dress aesthetically. Her stage costumes and clothes were reported in the press and carte-de-visite photographs brought her image to a wide audience. Here her dress has been shaped with shirring, which was a popular method of softly controlling the volume of Aesthetic dresses.

181

Dress, consisting of a bodice, skirt and overdress
Silk trimmed with silk braid, 1878–80
Gallery of English Costume, Manchester

This was worn by the artist Madame Canziani, née Louisa Starr, who dressed herself and her daughter Estella in artistic styles. Of their surviving clothes many are home-made or purchased from Liberty's.

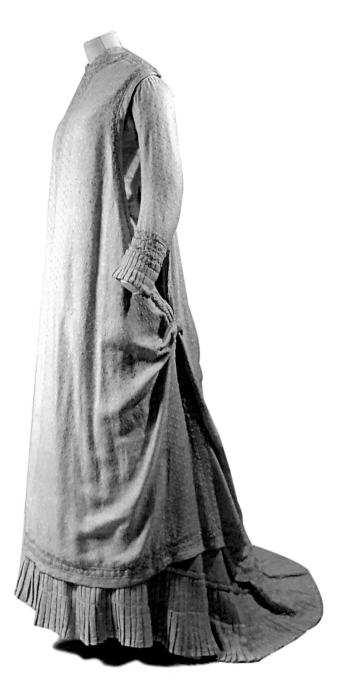

207

Jewellery
Clare Phillips

ON A LECTURE TOUR of the United States in 1882 Oscar Wilde declared there to be 'nothing to my mind more coarse in conception and more vulgar in execution than modern jewellery'.[1] The broad sweep of his condemnation echoed the writings of many influential theorists before him, and also anticipated the sentiments of the Arts and Crafts Movement. The Aesthetic Movement was part of this continuum, contributing to the debate for design reform. Particularly lamented were an absence of artistic creativity in jewellery design and the increasing mechanization within the trade. Perhaps as keenly felt but less clearly expressed was a weariness among many women over the correlation between financial value and gem-set jewellery, and a yearning for less ostentatious jewellery that expressed more subtly their own interests and taste.

The archaeological discoveries of the nineteenth century had provided a welcome new resource for jewellery design. According to William Burges, 'Until the late revival of Etruscan work it was positively dangerous to one's artistic feelings to look in at a jeweller's window'.[2] Connecting with an idealized classical past, such jewels had a historical fascination and were exemplars of fine metalworking rather than vehicles for the display of massed gemstones. This style of jewellery had been sufficiently prominent for *Punch* to

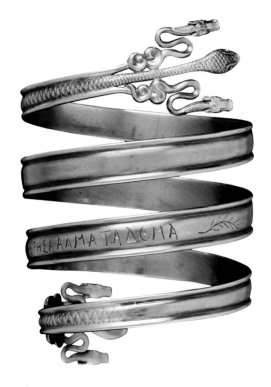

182
J.S. & A.B. Wyon, serpent armlet
Gold, *c.*1870
Private collection, London

Inscribed 'Laura Theresa Alma Tadema' in Greek characters, it was worn by her in classical scenes painted by her husband.

183
Castellani, wreath
Gold and pearls mounted on velvet, 1860–9
V&A: M.63–1921

Copies or adaptations of archaeological finds were considered more artistic than conventional gem-set jewellery. This wreath was a wedding gift to the future Countess of Crawford in 1869.

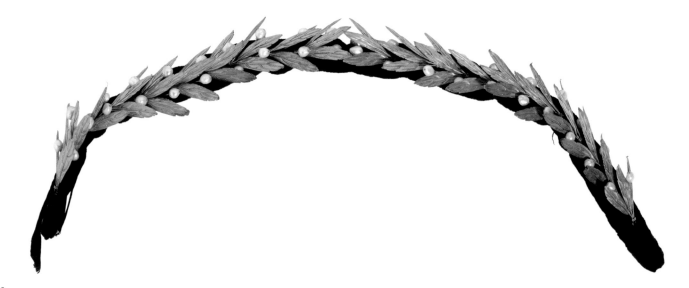

lampoon it as early as 1859,[3] and it became a key element of Aesthetic jewellery. Castellani of Rome remained the most prestigious maker in this style (plate 183), although there were also many London jewellers. Burges himself recommended Richard Green of The Strand,[4] while the Alma Tademas turned to J.S. & A.B. Wyon of Regent Street for an engraved serpent armlet (plate 182).[5] Performances of Greek plays and *tableaux vivants*, which enjoyed a particular vogue in the first half of the 1880s, kept such jewellery to the fore, as did events such as the Royal Academy's Grecian reception of 1885 and the Alma Tademas' classical costume ball of 1886.[6]

The London jeweller Giuliano achieved a rare degree of approval in artistic circles (plate 184), entrusted by Burne-Jones, Poynter and Ricketts with realizing their own designs. Known for his gold jewellery in the archaeological taste and for delicate combinations of enamels and coloured stones, he also found inspiration in traditional Indian jewellery, including plaque necklaces from Gujarat and Sind.[7] Mrs Haweis singled out Giuliano, with Robert Phillips, for especial praise for their 'artistic appreciation of good forms', offering him what was perhaps her ultimate accolade – that one of his necklaces was 'worthy, for its beauty, of a place in a museum of art'.[8] Greatly to her liking was their utilizing museum collections, which they 'ransacked for devices of necklaces, earrings, and pendants'.[9] Less celebrated but also patronized by Burne-Jones was the South Kensington firm Child & Child, whose trademark sunflower may still be seen above the window at 35 Thurloe Street.

Just as Pre-Raphaelite paintings had inspired ideas of Aesthetic dress, the jewellery they depicted was also to have an effect. Rossetti's paintings of the 1860s, with their rich

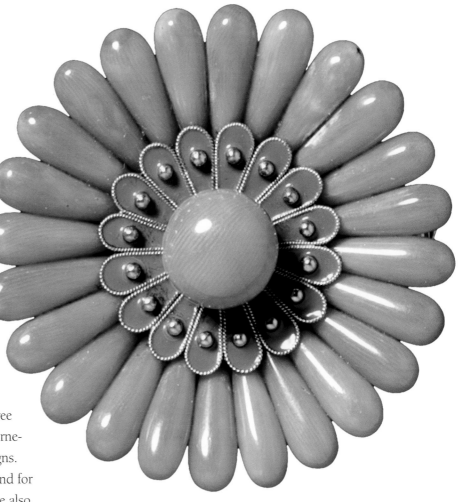

184
Carlo Giuliano, brooch
Coral and enamelled gold, 1875–95
V&A: M.13.1-2011

The brooch, with a pair of matching hair ornaments, belonged originally to Edith Holman Hunt.

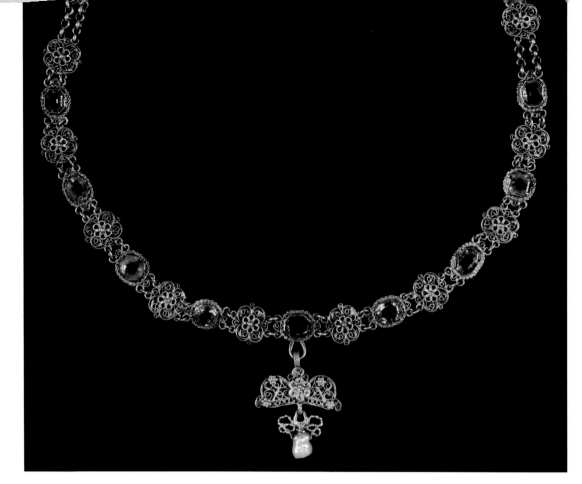

185

Necklace
Silver-gilt, amethysts and a pearl,
c.1877
V&A: M.230–1925

Bought in Nuremberg by the
engraver Thomas Oldham Barlow
RA for his daughter, this is recorded
as having been used by Millais in
The Princes in the Tower (1878;
Royal Holloway College, University
of London).

depictions of exotic jewellery, are particularly notable and must have fostered an interest in the jewellery of other cultures and encouraged the idea of its wearability. These jewels were painted from life, and a number of them survive in the V&A's collection, the gifts of May Morris and her companion Vivian Lobb. That Rossetti's collection encompassed both oriental work and the folk traditions of Europe is significant in terms of the jewellery that became popular in Aesthetic circles.

The fascination with international folk or, as it was then termed, 'peasant' jewellery reflected a yearning for pre-industrial craftsmanship and honest labour as yet untainted by commercialism. Burges had commented in the 1860s that 'in the more remote villages of Europe, we still see elegant ornaments of filigree in far better taste than the modern French jewellery which is gradually supplanting them'.[10] This appreciation was furthered by the extensive jewellery acquisitions made by the V&A in the 1860s and '70s.[11] Whereas Rossetti had combed the curiosity shops around

Leicester Square and Hammersmith to find pieces, by the 1880s there was a much easier availability of both peasant and exotic jewellery. By 1883, when Liberty's opened its Eastern Jewellery department, stocked principally with work from Syria and Egypt, *The Queen* magazine was able to write of 'the many items of Moorish jewellery, which we see displayed in the show windows of the now numerous Eastern shops of London'.[12] Indian jewellery also was greatly admired, praised by Mrs Haweis for its 'natural, spontaneous variety'.[13] Doubtless she continued to prefer the unpredictable cuts of their gemstones above the 'carefully-matched and recklessly-paired sets of stones' used by conventional European jewellers.[14]

Japanese metalworking techniques had no European parallels, and these exotic pieces, which disregarded conventional Western notions of the precious, had an immediate fascination. The Parisian jeweller Falize was among the first to design work in the Japanese style (plate 186). Tiffany & Co. of New York achieved rare success in imitating

the complex contrasting effects of Japanese alloys, while in England jewellers satisfied the hallmarking regulations by incorporating coloured gold or silver-gilt (rather than authentic base metal) details. Pieces were imported from Japan, but alongside this the fashion for Japanese-style jewellery spread widely, thanks to the relative cheapness of silver and the efficiency of machine production.

The emphasis on originality and individual taste makes the Aesthetic in jewellery terms difficult to define. In addition to the distinctive styles already discussed, adornment included natural flowers: Beatrix Potter commented of Oscar Wilde in 1884 that 'He was not wearing a lily in his button hole, but to make up for it, his wife had her front covered in great water-lilies'.[15] Henry James in 1869 described Janey Morris 'wearing some dozen strings of outlandish beads';[16] certainly beads, particularly amber ones, featured prominently in Aesthetic circles. Perhaps the eccentric orthodoxy of the style was best expressed by Mrs Haweis when she approved 'family relics (not objecting to Oriental-cut stones and foreign settings, with all their irregularities) *cinquecento* or Battersea enamels, and offenceless ropes of pearls, because mechanical work does not enter in … copies of Greek work … or fine traditional patterns … carried out by expert native workmen'.[17] Her view that 'The real "jewel" brings [the wearer] an intellectual tribute'[18] was also a key element in the success of this alternative approach to jewellery.

186
Alexis Falize and the enameller
Antoine Tard, necklace
Cloisonné enamel and gold.
French *c*.1867
V&A: 1043–1871

The motifs were probably
derived from enamelled
copper vases.

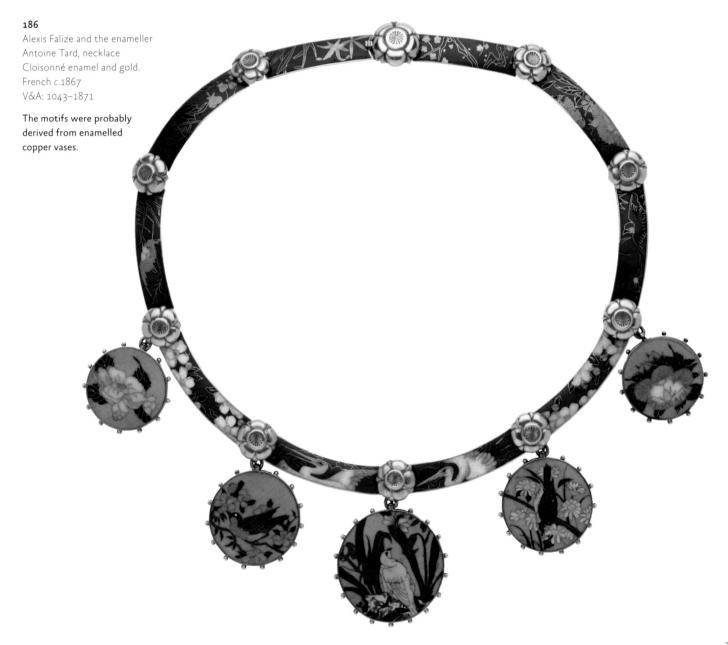

'Punch' and Satire

Leonee Ormond

MANY PEOPLE learnt about Aestheticism from *Punch*, and the social cartoonist George Du Maurier was a significant and influential commentator on the movement. He contributed his first Aesthetic cartoon to *Punch* on 8 March 1873 and his last on 21 May 1881.

Du Maurier's cartoons record his impression of the icons, taste, costume, language and behaviour of the 'Aesthetes' (plate 187). In his 'Intellectual Epicures' of 1876 De Tomkyns wears a velvet jacket and knee breeches, typifying the popular impression of male Aesthetes as unmanly. The caption lists some of the elements of an

187
George Du Maurier, original drawing for 'Frustrated Social Ambition', illustrated in *Punch*, 21 May 1881
Pen and ink, 1881
V&A: E.146–2009

Aesthetic interior: 'artistic wall-papers, blue china, Japanese fans'. These items feature in many of the cartoons. One group, published at intervals between 1874 and 1877, satirizes what Du Maurier describes as 'chinamania', the craze for blue-and-white Chinese porcelain (see pp.114–17). In 'Aptly Quoted from the Advertisement Column' of 1877 (plate 188) the 'Amiable Chinamaniac' husband returns home with two enormous vases, to the dismay of his 'Thrifty Wife' whose house is already full of 'useless china'. The voice of common sense, often provided by the character of 'our friend the Colonel', provides a chilly commentary on the Aesthetic lifestyle.

Du Maurier invented a number of recurring 'Aesthetic' characters, among them the Cimabue Brown family. Mrs Cimabue Brown first appeared in 1877. Her idiosyncratic dress defied contemporary fashion and her wild curly hair recalled Rossetti's model, Jane Morris. Mrs Cimabue Brown's name, absurdly combining an early Italian painter admired by the Aesthetes with one of the most common English surnames, became a byword for the movement.

188
George Du Maurier, 'Aptly Quoted from the Advertisement Column', illlustrated in *Punch*, 15 December 1877
V&A: NAL

APTLY QUOTED FROM THE ADVERTISEMENT COLUMN.

Thrifty Wife. "OH, ALGERNON! MORE USELESS CHINA! MORE MONEY THROWN AWAY WHEN WE HAVE SO LITTLE TO SPARE!"
Amiable Chinamaniac. "POOH! POOH! MY LOVE! 'MONEY NOT SO MUCH AN OBJECT AS A COMFORTABLE HOME,' YOU KNOW!"

189
George Du Maurier, 'Ye Aesthetic
Young Geniuses', from 'The Rise
and Fall of the Jack Spratts, Part III',
Punch, 21 September 1878
V&A: NAL

OPPOSITE
190
Linley Sambourne, 'Fancy Portrait
no.37: Oscar Wilde', illustrated in
Punch, 25 June 1881
British Library, London

In February 1880 she acquired two companions, the poet Jellaby Postlethwaite and the painter Maudle. Du Maurier said that Postlethwaite was: 'the aesthetic character out of whom I got some fun. Postlethwaite was said to be Mr Oscar Wilde, but the character was founded not on one person at all, but a whole school'. There is no reason to disbelieve Du Maurier here, but other characters from his Aesthetic cartoons do occasionally resemble Wilde.

Du Maurier's 'The Rise and Fall of the Jack Spratts', an extended piece commenting on social mores and snobberies, was published over several weeks in 1878. The Jack Spratts, as their name implies, are nonentities who practice a ridiculously archaic lifestyle. The success of a painting of Mrs Spratt, wearing medieval dress and darning a stocking, suddenly renders her a sought-after celebrity. Du

Maurier's illustration 'Ye Aesthetic Young Geniuses' shows the Spratts' friends drooping gloomily, the central figure dressed in an open jacket, round-brimmed hat and cutaway jacket. Mrs Spratt eventually rejects the Aesthetes and begins to admire the upright and top-hatted 'Gorgeous Young Swells' with whom Du Maurier contrasts them (plate 189).

Du Maurier was not the only *Punch* artist to publish 'Aesthetic' cartoons. Charles Keene, Harry Furniss and Linley Sambourne all joined the fun; Sambourne's 'Fancy Portrait' of Oscar Wilde of 1881 (plate 190) is a frequently reproduced image. Like Du Maurier, the *Punch* writers contributed mocking verses and parodies. These are unsigned, but some at least can be attributed to *Punch*'s editor from 1880, Francis Burnand, whose satire *The Colonel* was launched in 1881.

PUNCH'S FANCY PORTRAITS.—No. 37.

"O. W."

"O, I eel just as happy as a bright Sunflower
Lays of Christy Minstrelsy

Æsthete of Æsthetes!
What's in a name?
The poet is WILDE,
But his poetry's tame.

215

Oscar Wilde

Susan Owens

In fact, Beauty had existed long before 1880. It was Mr. Oscar Wilde who managed her debut.[1]
Max Beerbohm, 1894

THESE WORDS of Max Beerbohm capture two important truths about Wilde: his self-appointed role as Aesthetic impresario and his sheer audacity. Written in a witty essay summing up the Aesthetic Movement from the point of view of a future historian looking back at a distant period of scarcely credible folly, they nonetheless astutely credit Wilde with the vital role he played in shaping perceptions of Aestheticism.

His association with Aestheticism began when he was still an undergraduate at Magdalen College, Oxford, when he reviewed the inaugural Grosvenor Gallery exhibition (1877). Already marking out territory as spokesman for the movement, Wilde wrote knowledgeably of Burne-Jones, Watts, Millais, Alma Tadema, Albert Moore and Whistler, regretted the absence of works by Simeon Solomon and Rossetti, and quoted Walter Pater. He took possession in 1882, when he undertook an extensive lecture tour of the USA and Canada (plate 193), funded by D'Oyly Carte, the producer of the Gilbert and Sullivan comic opera *Patience*. For more than a decade Aestheticism had been developing along various disparate lines. The lecture tour acted as a catalyst, giving Wilde the opportunity to create a cogent picture of what he termed the 'English Renaissance' in which he synthesized – sometimes outrageously plagiarized – the ideas and words of Ruskin, Pater, Morris and Whistler.[2]

Wilde's achievement at this time was to give Aestheticism a focus, even a new lease of life, which without his energy and wit it would have lacked. By the time Wilde came of age, Rossetti, the principal painter of the movement, had retreated to what Pater termed 'mystic isolation', and died the same year as Wilde's American tour.[3] In 1879 Swinburne, its principal poet, largely retired from the world having for the sake of his health submitted to a closely monitored existence in Putney, where he was carefully guarded by his friend Theodore Watts-Dunton. Pater himself had since the publication of the conclusion to *Studies in the*

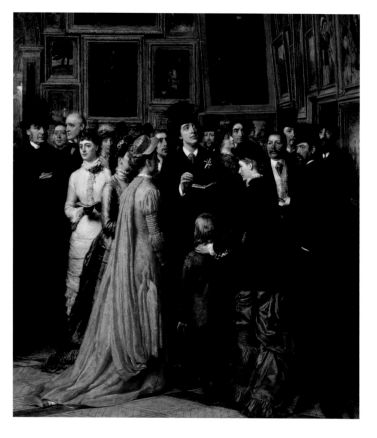

191
W.P. Frith, *Private View at the Royal Academy,*
detail showing Oscar Wilde
Oil on canvas, 1881
Private collection

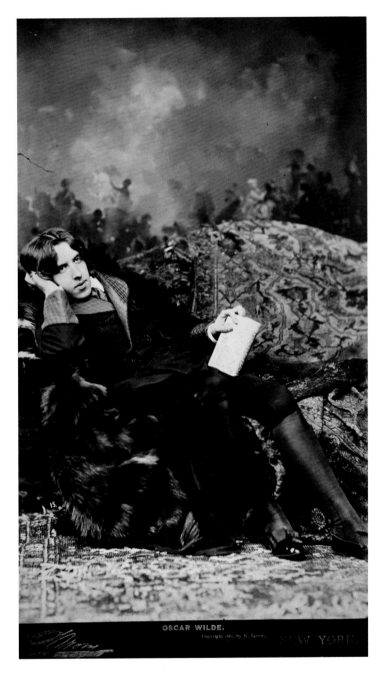

History of the Renaissance in 1873 been attempting to live down the controversy it had caused. So from the point of Wilde's arrival in London in 1879, his ostentatiously Aesthetic pose in dress, manner and talk immediately made him the new symbol of Aestheticism. While much attention focused on his appearance, the message of his lectures was also broadcast. During his year in America the British press continued to report his activities and, remarkably, the first book on the Aesthetic Movement, by Walter Hamilton, published the same year, devoted an entire chapter to Wilde.

But Wilde was more than a popularizer, and he engaged with and advanced Aesthetic ideas in important ways. His mature ideas found their fullest expression in the

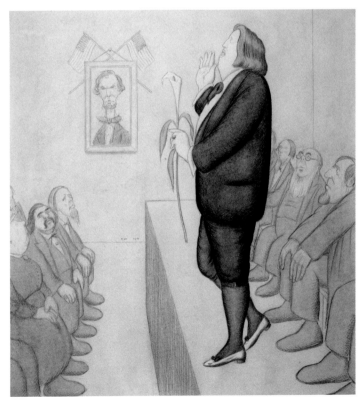

192
Napoleon Sarony, *Oscar Wilde*
Albumen print, 1882
National Portrait Gallery, London

193
Max Beerbohm, *The name of Rossetti is heard for the first time in the USA*, caricature of Oscar Wilde lecturing in 1882
Pencil and watercolour on paper, 1916
Tate, London

194
Charles Ricketts, cover
design for Oscar Wilde,
Intentions
Published by Osgood
McIlvaine, 1891
Stephen Calloway collection

Pater's ostensible agreement with Arnold here is disingenuous. While seeing the object as 'it really is' is cited as the ultimate aim, Pater has shifted attention from the object to the perceiver. Knowing 'one's own impression' of it – and knowing it in nuanced and profound ways – is offered as the actual goal. When Wilde comes to the debate he takes up and modifies this passage. Rejecting Pater's careful manoeuvring in favour of a head-on confrontation, Wilde's paradoxical claim is that 'the primary aim of the critic is to see the object as in itself it really is not'. The object, having made its impression, becomes redundant, as the nature of this impression on the self is more compelling:

> That is what the highest criticism really is, the record of one's own soul. It is more fascinating than history, as it is concerned simply with oneself. It is more delightful than philosophy, as its subject is concrete and not abstract, real and not vague. It is the only civilized form of biography, as it deals not with the events, but with the thoughts of one's life; not with life's physical accidents of deed or circumstance, but with the spiritual moods and imaginative passions of the mind.[6]

Criticism is thus radically recast as potent aesthetic/psychological contemplation. To see the object as it really is *not* is to see it richly transformed by one's own perception, memory and creative powers. Wilde's statement lays the theoretical foundations, albeit retrospectively in Pater's case, for ekphrastic prose-poems that are free to range far from the original object. What Wilde so extravagantly argues for here, of course, is the absolute independence of art: the central tenet of art for art's sake which had reverberated for half a century.

Other exponents of Aestheticism had tended to be overtly combative – most notably Gautier, Swinburne and Whistler – or, like Rossetti, rarely spoke publicly. Paradoxically, Wilde's triumph was that although he was profoundly disdainful of philistine, bourgeois society, he was hugely successful in entertaining and engaging that society. And, through the enduring popularity of his plays, stories and much-quoted epigrams, he remains Beauty's most persuasive and eloquent champion.

late 1880s in a group of essays and dialogues published in 1891 as *Intentions* (plate 194). The dialogue proved Wilde's ideal medium; here his outstanding skill as a conversationalist was deployed in brilliant flights of repartee. Deliberately provocative and subversive, these works were the vehicle by which he attacked his favourite targets, such as conventional morality and literary realism.

Among Wilde's most profound contributions to Aesthetic thought, the dialogue 'The Critic as Artist' examines the theory of art and literary criticism and contains an important statement about creativity. In a key passage he refers back to Pater, who in his preface to *Studies in the History of the Renaissance* (an exceptionally important book for Wilde) had quoted Matthew Arnold's dictum that the 'aim of criticism is to see the object as in itself it really is':[4]

> 'To see the object as in itself it really is,' has been justly said to be the aim of all true criticism whatever; and in aesthetic criticism the first step towards seeing one's object as it really is, is to know one's own impression as it really is, to discriminate it, to realise it distinctly.[5]

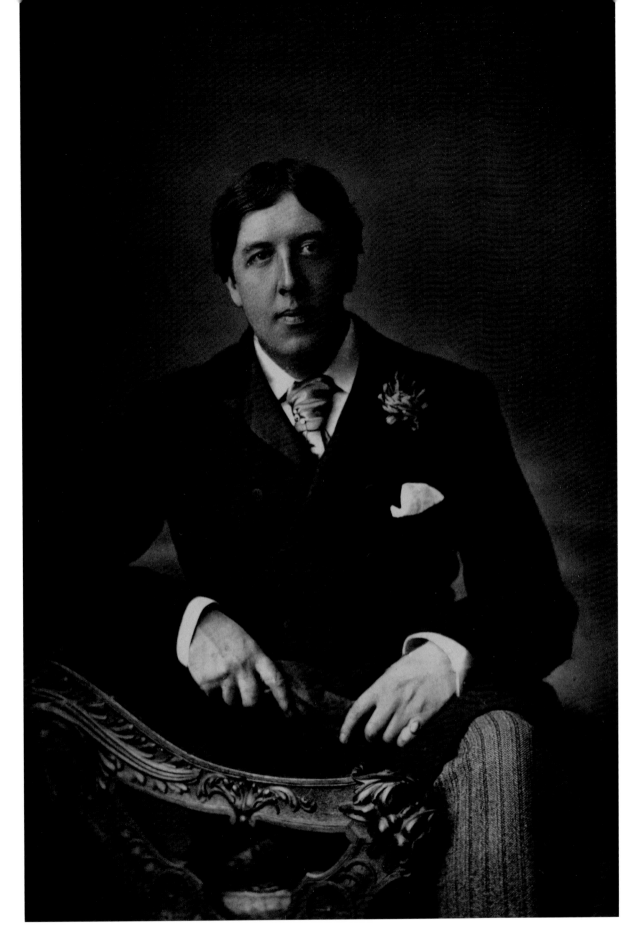

195
W. & D. Downey,
Oscar Wilde
Photograph, 1889
Stephen Calloway
collection

'Patience' and the Theatre

Catherine Haill

WHEN W.S. GILBERT read reviews of *Where's The Cat?*,[1] which opened at London's Criterion Theatre on 20 November 1880, he was not amused. It was a nonsensical farce about the bequest of a dead cat, but Gilbert was dismayed that the character Scott Ramsay was played brilliantly by Herbert Beerbohm Tree (plate 196) as a caricature of Oscar Wilde. As a reviewer noted: '… there could be no mistaking the portraiture. The "society poet" putting himself into classical attitudes and sighing over a sunflower was comical in the extreme.'[2]

A play on the London stage lampooning Aestheticism was hardly overdue.[3] Topical plays were speedily produced in the nineteenth century, and Aestheticism had long been the target of Du Maurier's *Punch* cartoons (see pp.212–15). What irked Gilbert was that *Where's The Cat?* had beaten him to it. He had been working on a successor to *The Pirates of Penzance* since May[4] and by November was finishing the libretto of *Patience*, his comic opera on Aestheticism. He wrote to the play's author, James Albery, immediately, explaining the situation to avoid accusations of plagiarism.[5]

Gilbert originally conceived *Patience* as a satire of 'the aesthetic school of poets' but changed his mind, perhaps because an American opening was proposed and he doubted that British Aestheticism would be understood,[6] or because of difficulties 'in getting the chorus to dress and make up aesthetically'.[7] Instead he chose rival curates, the subject of one of his *Bab Ballads*;[8] an early draft of *Patience*[9] includes the Reverend Lawn Tennison and a cohort of lovesick ladies.[10] When the American opening was abandoned, Gilbert returned to Aestheticism. Tennison became the 'fleshly' poet Reginald Bunthorne (plate 197) and the rival cleric became Algernon Grosvenor, named after the gallery.[11] Gilbert even suggested Du Maurier as the designer.[12]

196
Two images of Herbert Beerbohm Tree as Scott Ramsay in *Where's The Cat?*, *Illustrated Sporting and Dramatic News*, 4 December 1880
V&A: NAL

197
George Grossmith as Reginald Bunthorne in *Patience* at the Opera Comique
Photograph, 1881
V&A: S.146:180–2007

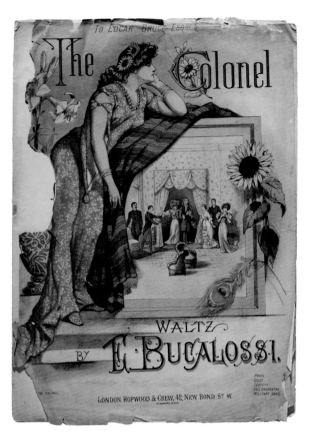

198
Illustrated sheet-music cover for *The Colonel Waltz*
by Ernest Bucalossi, conductor of the incidental
music played on the opening night of the farce
The Colonel by F.C. Burnand
Colour lithograph by Stannard & Son, published
by Hopwood & Crew, 1881
V&A: S.631–2010

199
Illustrated sheet-music cover for *The Patience
Quadrille* by Eugene D'Albert, based on the score
by Arthur Sullivan of the comic opera *Patience*
by W.S. Gilbert and Arthur Sullivan
Colour lithograph by M. & N. Hanhart, possibly
from a design by H.G. Banks, published by
Chappell & Co., 1881
V&A: S.632–2010

The success of *The Pirates of Penzance* meant that its replacement was not scheduled until April. Gilbert's irascible temper was doubtless sorely tested when on 2 February another Aesthetic satire, *The Colonel* by Francis Burnand,[13] opened at the Prince of Wales Theatre (plate 198). The play's duplicitous Professor of Aesthetics, Lambert Streyke, and his supposed painter nephew, Basil Giorgione, were thinly disguised caricatures of Wilde and Whistler. Du Maurier advised Burnand on the design,[14] and the resulting drawing-room set,[15] with Morris wallpaper, a dado, blue china, lilies, peacock feathers and Japanese fans, proved so attractive that several critics considered *The Colonel* a good advertisement for the style it intended to mock.

Despite its favourable reception, Oscar Wilde declared The Colonel 'a dull farce'[16] when writing to George Grossmith[17] asking him to reserve a box for the opening night of *Patience* at the Opera Comique on 23 April. Wilde was 'looking forward to being greatly amused'; he was not disappointed. With Sullivan's sparkling music, Gilbert's witty libretto, a talented cast and brilliant stage pictures contrasting the primary-bright Hussars' uniforms with the 'greenery-yallery' lovesick maidens' robes and the simple milkmaid's dress worn by Patience,[18] *Patience* was the most sparkling, ingenious and enduring Aesthetic satire of them all (plate 199).

7 'Tired Hedonists': The Decadence of the Aesthetic Movement

'TIRED HEDONISTS': THE DECADENCE OF THE AESTHETIC MOVEMENT

Stephen Calloway

OVER A PERIOD of eight weeks in the autumn of 1878 *Punch* serialized an extended satire of the Aesthetic Movement, 'The Rise and Fall of the Jack Spratts'.[1] Written and illustrated by George Du Maurier, it revealed considerable inside knowledge, but offered a view of the movement and its cast of characters intriguingly different from that of the suave world of 'artistic' society portrayed in Du Maurier's series of individual *Punch* cartoons of the Aesthetes Maudle, Postlethwaite and the Cimabue Browns. The story centres on an aspiring but untalented painter, Spratt, and his wife, a beauty whose looks alone gain them recognition and success in Aesthetic circles: 'so beautiful a woman as Mrs John Spratt had not been seen for four hundred years'.[2] The Spratts' friends are all 'Aesthetic young geniuses', intense but down-at-heel young men, clearly cast in the mould of the ragged Parisian bohemians of the 1840s in Mürger's *Scènes de la Vie de Bohème* (1849). Prominent among them is Peter Leonardo Pye, 'quite the greatest poet that had sung since Milton', but one whose 'burning thoughts, fiery though Platonic passions, and a habit of too recklessly burning the midnight oil had wasted his once comely cheeks, contracted his chest and made his shoulders round and sloping'.[3] His aspirations, we are told, are 'so high … that he passionately longed not to be recognised by the world for many generations to come, and lived in constant dread of sudden popularity'. Pye is the author of *Dank Kisses from Mildewed Lips*.

At this date perhaps no more than a small number of *Punch* readers could have made the connection between the fictitious title of Pye's book and the dangerous, decadent world of Baudelaire's poetry; some might astutely have associated the deliberate note of morbid sentiment with Edgar Allan Poe. Many, however, would have readily identified Pye with Dante Gabriel Rossetti and *Dank Kisses* with the real book of verse Rossetti published in 1870 following the exhumation of the only manuscript copy which, in a grand romantic gesture, he had buried in the coffin of his wife Elizabeth Siddal eight years earlier.[4] Though every attempt had been made by Rossetti and his circle to play down the *grand guignol* aspect of this retrieval, the story inevitably became known and was well on the way to becoming legendary when Robert Buchanan made his infamous attack on the Aesthetes in his article 'The Fleshly School of Poetry'.[5] Buchanan aimed at nothing less than a sensational revelation of a dark, immoral side to Aestheticism, imputing to the verses of Swinburne, Rossetti and even the robust Morris a 'morbid deviation from healthy forms of life … [a] sense of weary, wasting, yet exquisite sensuality; nothing virile, nothing tender, nothing completely sane'.[6] His accusations, coded but essentially scattershot, that these poets, and so by implication the entire Aesthetic Movement, had succumbed to a decadence in which sensuality and vice were compounded with ugliness and unhealthiness gained some lasting currency. Indeed, curiously, it would be in those very same terms that, twenty years on, the Decadents of the 1890s were most routinely attacked.

In the immediate aftermath of the 'Fleshly School' controversy and throughout the 1870s, the crucial years in which Aesthetic ideas became more widely known and gained a considerable following, it is also possible to trace a growing antagonism towards the movement that ranged in mood and intensity from indulgent amusement and benign satire to serious ideological criticism and vociferous moral outrage. A sequence of essentially unconnected events in the 1870s served to some degree to unite the Aesthetes, but also to mobilize and consolidate public and even official objection to what was increasingly perceived as a general decadence among artists and writers. That this decadence was held to take such widely various forms, ranging from the iniquities of unconcealed homosexuality ('unmanliness') to challenges to the conventional work ethic, from lack of patriotism to irreligion or deliberate paganism, served only to make it seem the more dangerous.

The arrest in 1873 of Simeon Solomon (then an intimate of Swinburne, Rossetti, Burne-Jones and Pater) on charges of actual homosexual activity, and the perhaps more vaguely preventative dismissal from Eton of the schoolmasters William Cory and Oscar Browning in 1872 and 1875, were probably viewed as isolated incidents of little importance in themselves, but nevertheless indicative, to those in search of such evidence, of the loosening of moral codes.[7] However, viewed in the light of broader concern about artistic and literary decadence, we can see that two other vitally significant events of the decade also have at their heart issues that placed Aesthetic ideals on trial, pointing up their oppositional stance to conventional morality. The first of these was the brouhaha surrounding the publication in book form of Pater's *Studies in the History of the Renaissance* in 1873, denounced as immoral by the Bishop of Oxford; the second was the celebrated Whistler v. Ruskin court case prompted by Ruskin's intemperate attack on Whistler's pictures at the 1877 Grosvenor show, a battle which effectively hinged on the litigants' rival claims for the primacy of moral intent and conscientious labour or inspiration, and bravura in the creation of works of art.

The immediate impact and wider outcomes of these tribulations of the 1870s on the protagonists were as various as their characters. The long-term effect of Buchanan's hostile critique was disastrous for Rossetti, who suffered a protracted crisis or breakdown; for the remaining years of his life he shunned all criticism, avoided as far as possible any public contact, and ultimately withdrew into almost total seclusion. Similarly Swinburne, already shaken by the outcry which had greeted the publication of his *Poems and Ballads* in 1866, sank lower into the problems with drink which had already been the dismay of his friends for some time. Eventually, towards the end of the decade he was 'rescued' by Theodore Watts-Dunton who carried him off to live out long years of productive, blameless boredom in semi-captivity in a suburban villa, The Pines at Putney. Whistler, although he won his libel action against Ruskin, was ruined by the costs of the trial when he was awarded only a farthing damages. Bankrupted, he was obliged to sell his newly built studio, The White House; but, making light of misfortune, he decamped to make etchings of Venice and soon bounced back with triumphant exhibitions of new work. Pater, forced by the Oxford establishment to recant, agreed to suppress certain notorious passages of his 'Conclusion' to *The Renaissance*. He admitted that his book, with its defence of 'passionate attitudes' and provocative advocacy

200
George Du Maurier, 'Intellectual Epicures',
Punch, 5 February 1876
V&A: NAL

of sensuous Aesthetic response in all aspects of life, 'might possibly mislead some of those young men into whose hands it might fall'; in the event Pater weathered the storm, though not without some setback to his otherwise uneventful academic career.[8]

By the 1880s we can sense a distinct polarizing of ideas and attitudes to the Aesthetic Movement. On one hand a number of the major figures most closely associated in the public mind with Art for Art's Sake – and in particular those painters, such as Watts, Leighton and Burne-Jones, who had triumphed at the first shows of the Grosvenor Gallery – were becoming securely established in the regard of grand London society. In the same way, architects and decorators such as Morris who catered to this influential clientele also crossed over to the mainstream. In contrast to this Olympian world, the more subversive writers and artists fell increasingly under suspicion from press and public of harbouring ideals that could undermine not just art and literature but the whole moral fibre of the country. As a result of such feelings, the Aesthete of the 1880s oscillates in the popular perception between being an ineffectual and often effeminate figure of harmless fun (as in many of Du Maurier's funnier cartoons or in Gilbert and Sullivan's portrayal of Bunthorne in *Patience*) and something darker, less healthy and more threatening to the common good. A subtle reading of this period of uneasy truce was offered by W.G. Blaikie Murdoch in his 1911 study *The Renaissance of the Nineties*, where he observed that 'the eighties, if they have a distinct character, were a time of transition, a period of simmering for revolt'.[9]

One very specific aspect of anxiety about the supposedly decadent core of the 'artistic' temperament centred on the Aesthete's lack of engagement with 'the real world' and his utter disregard for 'ordinary' values expressed in a self-obsessed fastidiousness of taste. Du Maurier's *Punch* cartoon 'Intellectual Epicures' (plate 200), published as early as 5 February 1876, captures precisely this concern:

> Steeped in aesthetic culture, and surrounded by artistic wall-papers, blue china, Japanese fans, mediaeval snuff-boxes, and his favourite periodicals of the eighteenth century, the dilettante De Tomkyns complacently boasts that he never reads a newspaper, and that the events of the outer world possess no interest for him whatever.[10]

In a similar vein, Whistler's old adversary the art critic Harry Quilter (the 'Arry of Whistler's many altercations) wrote two articles in *The Spectator*, 'The Palace of Art' in 1880 and 'Fashion and Art, or Spots on the Sunflower' the following year, in which he attacked the 'sham sentiment and fashionable foolishness, which as it were, armour plated the Aesthetic movement'.[11] Full of self-righteous truculence, Quilter imagines visiting the house of an Aesthete and viewing his exquisite collections. The critic finds himself seized by

an unholy desire … to make a row, after all this gasping and guggling about
Cinquecento and Greek coins, and the 'philosophy of line' and the spirit of beauty
… I want to take hold of my little friend … and give him a good shake, and make
him do his hair like other men. I should like to let a little fresh air into that house
of his, metaphorically as well as literally, and make him see the futile absurdities
of which he and the others of his set are guilty.[12]

This is the same bullying bluster displayed by the varsity hearties who in the 1870s sacked
Wilde's Oxford rooms, breaking his blue china; and it differs little from the means by
which the establishment sought to deal with the decadence of the Aesthetes of the 1890s.

Much has been written about the 1890s stressing its uniqueness as a decade when
considered in terms of its prevailing ideals, attitudes and intellectual sensibilities or when
judged by its artistic and literary output. Often to the exclusion of many significant charac-
ters and traits, attention has to a very great extent been focused upon notions of decadence
and in particular on the lives and, sometimes it seems almost incidentally, the actual
achievements of a relatively small coterie of London-based artists, poets and men of let-
ters. Few decades have attracted so rich a set of epithets to characterize the tenor of the
times: the 'naughty nineties', the 'purple' or 'mauve decade', the 'yellow nineties' – in
reference to that almost totemic periodical *The Yellow Book* – and, of course, '*fin-de-siècle*'
and 'the Decadence', both of which theoretically general terms have now come to sound
oddly misapplied when used to describe the last years of any century but the nineteenth.
An equally strong case can, however, be advanced for considering the 1890s not as an era
distinct and *sui generis*, but rather as one in which so many of the artistic, poetic, intel-
lectual and 'lifestyle' preoccupations of the previous twenty or thirty years reached their
natural conclusion, albeit with a startling intensity. According to such an interpretation,
'The Decadence' of the 1890s should therefore properly and precisely be seen as the deca-
dence of the Aesthetic Movement in its end-phase. Attempting a definition, the poet and
critic Arthur Symons, a central figure of 'the Beardsley Period' and the principal apologist
of the Decadence of the Nineties, wrote:

After a fashion it is no doubt a decadence; it has all the qualities that mark the
end of great periods, the qualities that we find in the Greek, the Latin decadence;
an intense self-consciousness, a restless curiosity in research, an over-subtilising
refinement upon refinement, a spiritual and moral perversity.[13]

In fact, the mythologizing of 'the nineties' began early and continues even now to some
extent to obscure the essential continuity of thought and often of theme which links the
work of the younger generation with the key Aesthetes, including Swinburne and Rossetti,
Simeon Solomon and Burne-Jones, whose experiments in the 1860s and '70s remained
of crucial importance. W.B. Yeats, who shared rooms with Symons in Fountain Court in
the Temple in the early 1890s, gave to the most important section of his memoirs of those
years the title 'The Tragic Generation'.[14] He thereby quite consciously initiated a reading

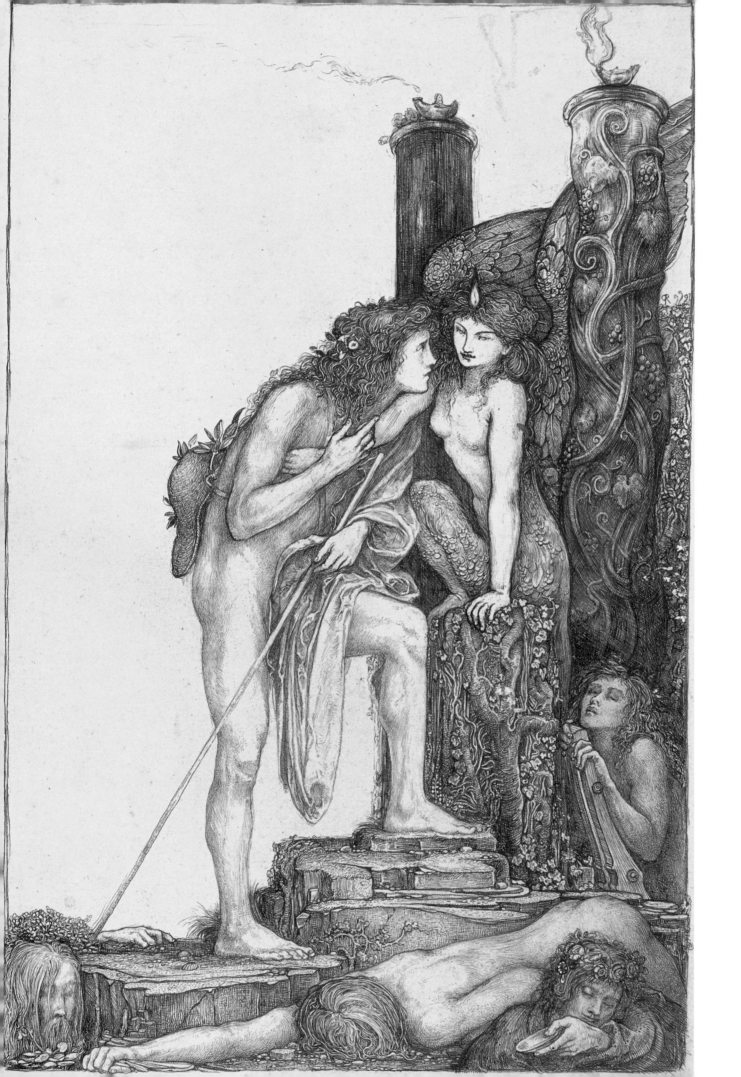

of the decade that traced the dramatic trajectories of those, such as Aubrey Beardsley or the poet Ernest Dowson, who lived fast and died young, succumbing to consumption, drink and drugs, or poverty and despair. Significantly, in this light Yeats chose to make an explicit connection with Rossetti, whom he cited as 'a subconscious influence, and perhaps the most powerful of all'.[15] Later, Richard Le Gallienne, minor poet and sometime protégé of the Wilde set, recalled in his tellingly titled reminiscence *The Romantic Nineties* that for the men of his generation 'of all the great figures … but recently departed' the most numinous was Rossetti, who had 'dwelt in mysterious sacrosanct seclusion like some high priest behind the veil in his old romantic house in Chelsea'.[16]

Adulation of Rossetti as both painter and poet had grown to an extraordinary degree in the years since his death in 1882 at the relatively early age of 54. From the at first highly guarded biographical books and articles which began to appear at that time, and as gossip embellished the story of Rossetti's latter years, the picture of the young poet and eager Pre-Raphaelite was transmuted into the darker image of the tormented insomniac, fatally addicted to the opiate chloral, the too-readily available substitute for the laudanum that had caused the death of his wife, Elizabeth Siddal. As a result, Rossetti became a prototype for romanticized decadence. His obsession with themes of Love and Death, shared with others including Swinburne in particular, and his eroticized fascination with the historical and legendary femmes fatales that form the subject of his late works, became deeply woven into the fabric of artistic culture of the 1890s.

The strain of morbid sensuality that pervades much of the art and literature of the period has been extensively studied by many scholars from Mario Praz onwards.[17] The remarkable thing to note in this respect, perhaps, is the extent to which such sensibilities pervade the work of so many artists and writers of the period, and not merely those of the younger generation. Even the grand figures among the old men, Leighton, Watts and to a degree also Burne-Jones, seem to have spent their final years producing huge canvases based on mythological subjects drawn from their own reveries, and displaying, by almost any meaningful definition, a high degree of decadence. It is interesting to observe that the criticism frequently levelled at Aubrey Beardsley's drawings, that his figures are over-languid, effeminate and etiolated, might very well be applied to the drawings of Charles Ricketts and Laurence Housman, or with equal justification to Burne-Jones's late pictures. Yeats, indeed, made such a neat coupling when he wrote of the rarefied unwordliness of Burne-Jones and Ricketts, observing that 'they have so little interest in the common thoughts and emotions of life, that their images of life have delicate and languid limbs that could lift no burdens, and souls vaguer than a sigh' (plates 201, 202).[18] Even the bronzes of the New Sculpture, for all their glorious delight in the male or female

202
Edward Burne-Jones, *Fantasy*
Black chalk, bodycolour and gold on prepared purple ground, 1897
Cecil French Bequest, London Borough of Hammersmith and Fulham

OPPOSITE
201
Charles Ricketts, *Oedipus and the Sphinx*
Pen and ink on paper, 1891
Tullie House City Museum and Art Gallery, Carlisle

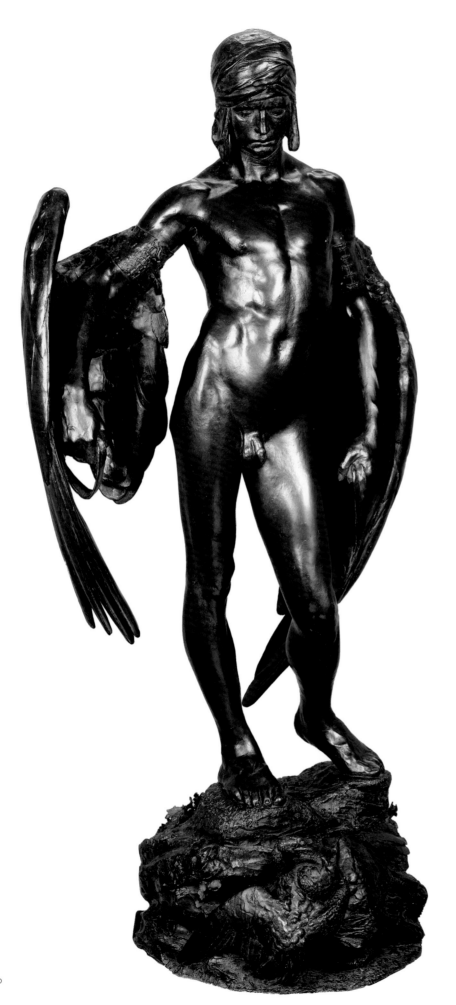

204
Charles Ricketts, *Silence*
(figure for the tomb of Oscar Wilde)
Bronze, 1905
Private collection, courtesy of
The Fine Art Society, London

203
Alfred Gilbert, *Icarus*
Bronze, 1884
National Museums and
Galleries of Wales, Cardiff

205
Aubrey Beardsley, *Siegfried, Act II*
Pen and ink and washes, 1893
V&A: E.578–1932

Beardsley considered this the finest
of his early drawings and presented
it to Edward Burne-Jones.

form, are not without some strong suggestion of languid and pagan eroticism verging on decadence (plates 203, 204).

The idea of a last, glorious swan-song of an essentially pagan culture does emerge as a haunting preoccupation of the era. Pater set his late book *Marius the Epicurean* (1885) in the decaying years of the Roman Empire, reworking in symbolic, philosophical fictional terms the Aesthetic ideals that he had first adumbrated in his *Renaissance* essays. '… that old pagan world', he wrote, 'had reached its perfection in the things of poetry and art – a perfection which indicated only too surely the eve of decline.'[19] Wilde as a great admirer of Pater also shared this love of a romanticized pagan decadence suggestive, as he saw it, of strange sins. But he could not resist the chance of also sending up such attitudes in his dialogue 'The Decay of Lying', in which he almost self-parodyingly invents a society called

'the Tired Hedonists … it is a club to which I belong. We are supposed to wear faded roses in our buttonholes when we meet, and to have a sort of cult for Domitian. I am afraid you are not eligible. You are too fond of simple pleasures'.[20] A taste embraced by Wilde and the younger Aesthetes for collecting late works by Simeon Solomon seems also to connect with this pose of cultish paganism. Solomon, disgraced following his arrest in 1873 and dropped by friends such as Burne-Jones and Pater, continued to subsist for many years making drawings of hazily symbolic profile heads and figures (plate 206); often tragically repetitive and frequently homoerotic, they necessarily attracted the same somewhat specific following as the Baron von Gloeden's 'classicizing' photographs of Sicilian youths (plate 207).

The discreet pursuit of such 'artistic' tastes had in all probability troubled the establishment very little over the years, and writers and artists had for the most part been left alone to follow their own predilections. By the beginning of the 1890s, however, the atmosphere of amused tolerance was distinctly shifting. Wilde was no longer perceived as the harmless and entertaining 'professor of aesthetics' advocating Beauty in literature, art and house-decoration, but rather as a dangerously persuasive spokesman for an altogether more subversive philosophy. This philosophy was composed not merely of suspect, if already familiar, Aesthetic ideals, but also of French claims deriving from Gautier, Baudelaire and more recently Huysmans, for which Wilde was a conduit, that all good art is essentially amoral. Acting with growing recklessness socially and with his profile as a writer enhanced by the sudden extraordinary success of his plays, Wilde increasingly acted as a focus for the forces of reaction. Two publications in 1894, Wilde's *Salome*, with striking illustrations by Beardsley that in fact satirize Wilde, and a few months later *The Yellow Book* – for which Beardsley drew the memorable cover and most of the best illustrations, but to which Wilde actually made no contribution – gave the public a precise visual image of what had previously been a nebulous idea of decadence (plates 208, 209).[21] On the appearance of the first number of *The Yellow Book* a now forgotten writer, J.A. Spender, thundered that nothing less than 'a short act of parliament to make this kind of thing illegal would meet the case'.[22] Battle lines were being drawn.

The precise events surrounding Wilde's failed libel action against the Marquess of Queensberry and his own subsequent trials and imprisonment have been written about at inordinate length and need no further discussion here.[23] Significantly, Wilde, who had been an early proselytizing disciple of Pater in Oxford at the beginning of the 1870s, continued to declare that allegiance. He had also, though no longer on friendly terms with Whistler, absorbed a good deal of the painter's egotistic artistic credo and, perhaps fatally, sought to emulate the example of the Butterfly's courtroom repartee. These disastrous trials, in which Wilde rehearsed in brilliant dialogue his now fully evolved ideas concerning art and the artist but was led on to damn himself as he spoke of 'the love that dare not speak its name', can be seen as a *caesura* that divides the Decadence of the first half of the 1890s from the years of reaction that followed. In some ways Wilde's heroic stand can be recognized also as a final, defining moment of the overarching trajectory of the Aesthetic Movement itself. To give the always perceptive Bernard Muddiman the final laconic word, 'the fall of Wilde killed the age'.[24]

209
Max Beerbohm, *Caricature of Aubrey Beardsley*
Pen, ink and wash, c.1894
V&A: E.1379–1931

OPPOSITE
208
Aubrey Beardsley, *The Toilet of Salome*
Line block print, 1894
V&A: E.433–1972

Religion and Sexuality

Colin Cruise

THE RISE OF Aestheticism in mid-nineteenth-century Britain coincided with an urgent, sometimes violent debate on religious belief. The revival of church rituals, altar furniture and vestments was seen by many as a return to a Roman Catholic dominance of British culture. Ritualism, however, was a manifestation of a wider cultural concern with architecture, design and painting as a response to the Great Exhibition of 1851. Some observers thought that both phenomena – excessive interest in both the visual arts and religion – betrayed the state of contemporary morals. Max Nordau, for example, surveying the origins of a putative national degeneration in British religious practices, observed: 'The first result of the epidemic of degeneration and hysteria was the Oxford Movement in the thirties and forties. Wiseman turned all the weaker heads. Newman went over to Catholicism. Pusey clothed the entire Established Church in Romish garb.'[1] Furthermore, he claimed, 'in the world of art … the religious enthusiasm of degenerate and hysterical Englishmen sought its expression in Pre-Raphaelitism'.[2]

When *Punch* expressed its opinion that Aestheticism was a reaction to an 'exaggerated Muscular Christianity' it brought together two quite different phenomena. The mid-century church movement Muscular Christianity, *Punch* argued,

> trampled on the Christian Lily, emblem of perfect purity; and what Athleticism trod underfoot, Aestheticism picked up, cherished, and then, taking the sign for the reality, paid to it the extravagant honours of a Pagan devotion; and the worship of the Lily was substituted for the veneration paid to the sacred character, in whose hand Christian Art had originally placed it.[3]

210
Simeon Solomon, *The Bride, The Bridegroom, and Sad Love*
Pen and ink on paper, 1865
V&A: E.1367–1910

However, *Punch* argued, this was 'false Aestheticism', noting that 'it has come in a slang sort of way to stand for an effeminate, invertebrate, sensuous, sentimentally-Christian, but thoroughly pagan taste in literature and art…'.[4] Religion was often linked to the feminine, effeminacy and dubious sexual preferences. Certainly, in addition to Christian ritual,

an interest in exotic religious practices, including Paganism and ancient Mystery Religions, was among the most suspect elements of Aestheticism. Wilde's interest in a variety of religious belief systems informs his poem *The Sphinx* (1893). There, a poet imagines a journey, full of religious and sexual varieties and sexual perversity; eventually he finds rest in front of a crucifix 'whose pallid burden, sick with pain, watches the world with wearied eyes, / And weeps for every soul that dies, and weeps for every soul in vain.'[5]

Contemporary observers drew parallels between Aesthetes 'worshipping' beauty and the new constituency of worshippers at Ritualist churches.[6] Both were highly suspect in constructions of normative masculinity. 'Effeminate' – the perceived opposite to 'muscular' – was consistently used to describe both Aesthetes and Ritualists. Decoration and devotion were activities associated with femininity, separate from the physical and intellectual toil associated with masculinity. Both Aesthetes and Ritualists were involved with 'worship', either of the abstract concept of beauty or the rare object of craftsmanship. We can see a nexus of concerns with art, religion and sexuality in Simeon Solomon's works which illustrate the dilemma of same-sex desire, such as *The Bride, The Bridegroom and Sad Love* (plate 210), as well as in his ritual paintings, such as *The Mystery of Faith* (plate 211)[7]. If we compare the latter to the famous *Punch* cartoon by Du Maurier, 'The Six-Mark Tea Pot' (plate 87), we see the same reverence lampooned. For the Aesthete and the Ritualist alike, rare and beautiful objects demanded intense concentration, deep engagement and even worship.

Many writers and artists associated with Aestheticism were converted to Catholicism in the 1890s, among them Wilde, Beardsley, Lionel Johnson, Robert Ross, John Gray and the two poets known as 'Michael Field';[8] it is significant that many of these were homosexual or of ambiguous sexuality. A sense of shame and sin dominated the religious imagination of these converts. They could be absolved from sin and released from their burden through the sacraments of Penance and Eucharist. The ritual of the Mass was the central dramatic element of an alien religion which British

211
Simeon Solomon, *The Mystery of Faith*
Watercolour on paper, 1870
Lady Lever Art Gallery, National Museums Liverpool

Protestants identified with Italy, Ireland or France. It had negative connotations, too: ignorance, indolence and duplicity. Yet it could be simultaneously transgressive and reactionary at the same time.

The excessive concern of Aestheticism for the beautiful objects of material culture, personality, sensuality and experience had parallels with the quest for the spiritual. The Catholic Church was a place in which outsiders could find solace as well as beauty, yet remain outsiders in the mainstream culture of their homeland.

Late Paintings

Elizabeth Prettejohn

AESTHETICISM, its painters, and the century grew old together: at the Exposition Universelle held in Paris to celebrate the turn of the century in 1900, such artists as Leighton and Burne-Jones were represented by paintings that fell within the Exposition's chronological purview (works created since 1889) but the artists had already died, in 1896 and 1898 respectively. The tendency in recent literature on British painting of the *fin de siècle* has been to speak of it in terms of international Symbolism, and there is some cogency to this view. A painting such as Rossetti's *The Day Dream* (plate 30), one of the last he made before his death in 1882, has clear affinities with Symbolist works that show women in trees, recalling the mythological metamorphoses of Daphne into a laurel, or Phyllis into an almond tree (a subject painted by Burne-Jones in 1870), or the biblical Eve with the Tree of Knowledge.[1] Moore's *Midsummer* (plate 212) and Leighton's *Flaming June* (plate 213), again among the last works of their painters, may be related to the Symbolist fascination with sleep and dreams.

Such works can also be interpreted as expressions of the individual artists' 'late styles': culminating masterpieces, summing up the experimentation of a lifetime and hinting at mortality.[2] Thus sleep becomes an analogue for death, and Moore's and Leighton's paintings may be seen to make poignantly beautiful the idea of oblivion. But is it possible to identify a 'late style' for Aestheticism as a collective artistic enterprise, one which accumulates knowledge and experience over the decades? From the beginning Aesthetic art had gathered to itself a panoply of allusions to the art of the past, and this aspect of artistic practice was bound to grow in complexity and scope as the disciplines of art history and museology, assisted by new techniques of photographic reproduction, augmented the repertoire of artistic precedents available for emulation or transformation. At both the Grosvenor Gallery and the Royal Academy there was a notable increase in the scale of important paintings in the later decades of the century. The art of beauty expanded its dimensions, physically as well as imaginatively, to become what might more properly be called an art of magnificence.

A work by Burne-Jones at the Grosvenor exhibition of 1880, *The Golden Stairs* (plate 214), is a case in point. At over 2.5m high it towers over its viewers like the grandest of Renaissance altarpieces. Its cyclical movement is a double one: as the figures wind their way down the staircase the viewer's eyes are drawn in a corresponding spiral up to the roof, where there perches a flock of birds reminiscent of the figures peeping through the opening to the sky in Andrea Mantegna's great ceiling fresco of the Camera degli Sposi in Mantua. The painting combines memories of a variety of fifteenth-century prototypes: the altarpieces of Carlo Crivelli in the intricate patterning of detail; the angels of Piero della Francesca's *Nativity* (acquired by the National Gallery in 1874) in the repetition of figure and face, and the beautiful bare feet; Luca Signorelli in the abundance of figures, each with its freshly invented pose; and Botticelli, as always with Burne-Jones, in the rhythmic folds of the drapery. The later fifteenth century had been Burne-Jones's special love since his journeys to Italy in the early 1870s; by 1880 he was able to blend reminiscences of the styles of his favourite masters into a coherent whole, harmonized around a colour chord of silvery and golden shades. The figures are poised to

212
Albert Moore, *Midsummer*
Oil on canvas, 1887
Russell-Cotes Art Gallery, Bournemouth

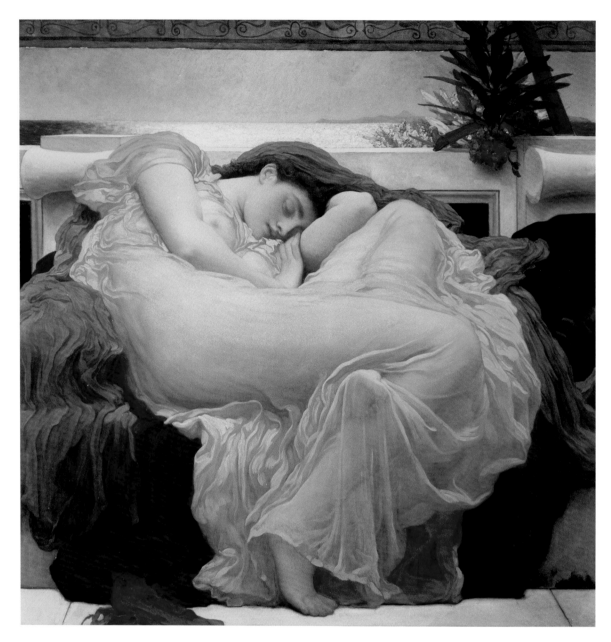

213
Frederic Leighton,
Flaming June
Oil on canvas, 1895
Museo de Arte de Ponce

play their instruments rather than sounding them, and the harmony is seen rather than heard. A viewer might recall the lines from Keats's 'Ode on a Grecian Urn': 'Heard melodies are sweet, but those unheard / Are sweeter'. Like the figures circling a Greek vase, the draped maidens move in concert, yet the spiralling forms suggest repose. Somehow the painting manages to make its representation of music and movement evoke silence and stillness.

In one sense Aestheticism invoked memories of an artistic tradition stretching all the way back to classical antiquity. The intimations of mortality in Moore's *Midsummer* draw on ancient Greek grave *stelai*, with seated figures flanked by standing mourners, while the striations of the background marble relief borrow a standard pattern from ancient sarcophagi.[3] Titianesque colour gives way to the powerful anatomy of Michelangelo's figures in many of

214
Edward Burne-Jones, *The Golden Stairs*
Oil on canvas, 1880
Tate, London

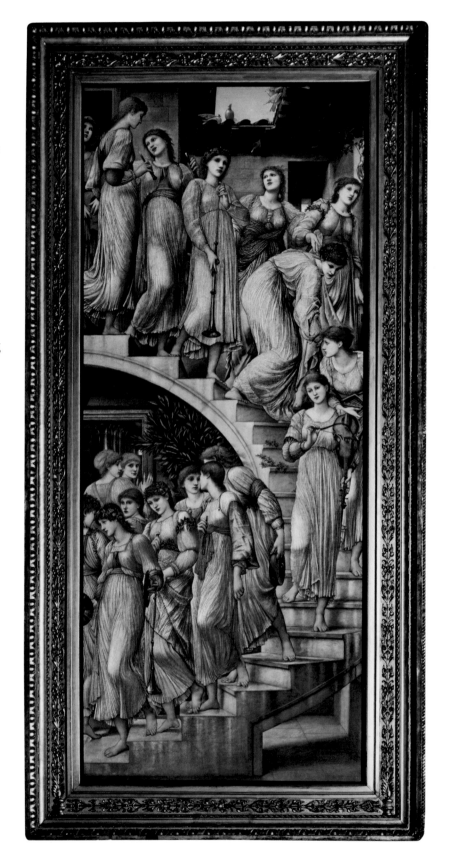

the late paintings, notably *Flaming June*, as magnificence joins beauty among the expressive resources of Aestheticism.[4] Yet the favourite masters of the fifteenth century, rediscoveries of the early days of Aestheticism, are never forgotten. Botticelli, creator of *La Primavera* and *The Birth of Venus*, was the artist of spring, birth and the dawn, which in Pater's landmark essay of 1870 came to correspond with the reawakening of the arts in the earlier Renaissance.[5] In its espousal of Botticelli Aestheticism proposed a second reawakening, the freshness of spring ripening into the fullness of summer. That was literally the case for the painting on which Rossetti spent the last of his strength. At first he planned a spring subject, to be entitled *Monna Primavera* (*My Lady of Spring*), but as he worked the sycamore tree grew into summer plenitude; the spring flowers (snowdrop and primrose) he had planned to place in the figure's hand appeared too delicate for his Michelangelesque figure and for his own late style. In the final painting, retitled *The Day Dream*, the figure holds a honeysuckle, already beginning to wilt, and Rossetti's sonnet for the picture dwells on the 'thronged boughs' of summer foliage: 'Dreams even may spring till autumn'.[6]

The characteristic season of late Aestheticism, though, is not autumn or the waning year. Rather it is the height of summer, with the full richness of mature greens in *The Day Dream* or the magnificence of orange in *Midsummer* and *Flaming June*. Summer slumber – the title of another late painting by Leighton[7] – may adumbrate the oblivion of death as Aestheticism nears its end. But as an impulse or power in human experience it does not countenance its own demise any more than it suffers the Old Masters to pass into oblivion. For all their intimations of mortality, the late paintings of Aestheticism are more majestic in scale, more commanding in visual address than those that had gone before.

The New Sculpture

Robert Upstone

AFTER DECADES of dull and unoriginal work, the 1880s and 1890s witnessed a dramatic revival in British sculpture. Classical prototypes which had been endlessly imitated through the century were now abandoned by innovative young sculptors such as Alfred Gilbert, Edward Onslow Ford, Harry Bates and George Frampton. Instead, what was termed 'The New Sculpture'[1] now utilized both explicit symbols and subtle suggestion to express intangible themes of love, death or the eternal. The origins of the New Sculptors' interest in communicating abstract emotion were a direct inheritance from Aestheticism, translating into three dimensions the suppression of narrative or moral directive in favour of mood or atmosphere found in paintings by Whistler, Leighton and Albert Moore. Pieces such as Gilbert's *Icarus* (plate 203), *The Virgin* (1884) or Onslow Ford's *A Study* (plate 215) essentially depict contemplative states which both reflect and recreate the action of abstract emotion on the senses, while any 'meaning' remains elusive and complex.

A profound stillness and sense of introspective self-absorption is a recurrent leitmotif in much of the New Sculpture. There is little movement or drama, but instead a pervasive melancholy, suggesting the psychological dimensions of the self that dictate fate or future action. If classical subjects are depicted – as in Gilbert's *Icarus* or Bates's *Pandora* (plate 216) – the figures are frozen at the moment before they fulfil their destiny, becoming archetypes for human frailty and the complexities of the psyche that dictate behaviour. Gilbert even encoded his own character and emotions into his early sculpture, later revealing his series of early male nudes were 'writing my history by symbol'.[2] Shown at the Grosvenor Gallery in 1882, *Perseus Arming* represented the sculptor as a mortal on the brink of heroic success, he explained, while *Icarus* acknowledged the fatal rashness in his character which would later bring financial disgrace – 'I was very ambitious: why not "Icarus" with his desire for flight?'[3]

215
Edward Onslow Ford, *A Study*
Bronze, 1886
Aberdeen Art Gallery & Museums Collections

Leighton had partly heralded this British sculpture revival with his dramatic life-size *Athlete Wrestling with a Python* (*c*.1874–7; see plate 217), which demonstrated the potential of revitalized modelling and casting. But by the time he exhibited its sequel, *The Sluggard* (plate 218), in 1885 a new generation of young sculptors had emerged, among whom the most brilliant was Alfred Gilbert. Leighton's *Sluggard* was partly based on Gilbert's *Perseus Arming*, and he greatly encouraged Gilbert by commissioning *Icarus* and obtaining for him a position teaching at the Royal Academy. Leighton mentored other young sculptors too, including Thomas Brock and Hamo Thornycroft, and exhibited them in the prestigious Royal Academy exhibitions. British sculptural teaching was largely outdated, most of the New Sculptors receiving a more enlightened modern training in Paris, or else learning more virile French methods from the French sculptor Jules Dalou, who came to teach sculpture at the South Kensington School. By 1901 the influential critic M.H. Spielmann was able to describe this sculpture renaissance as 'a change so revolutionary that it has given new direction to the aims and ambitions of the artist and raised the British school to a height unhoped for'.[4]

A significant feature of the New Sculpture was its fine modelling, unusual decoration and use of new or exotic materials. Enamel, ivory, mother of pearl, gold, silver, semiprecious

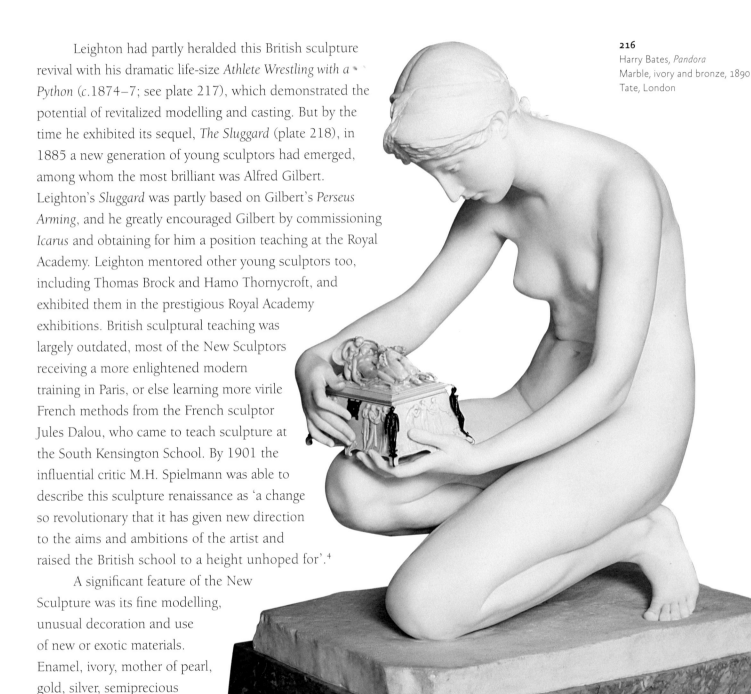

216
Harry Bates, *Pandora*
Marble, ivory and bronze, 1890
Tate, London

217
Photograph of Lord Leighton handling *Athlete Wrestling with a Python* in Frederic Stephens, *Artists at Home*, London 1884
V&A: NAL

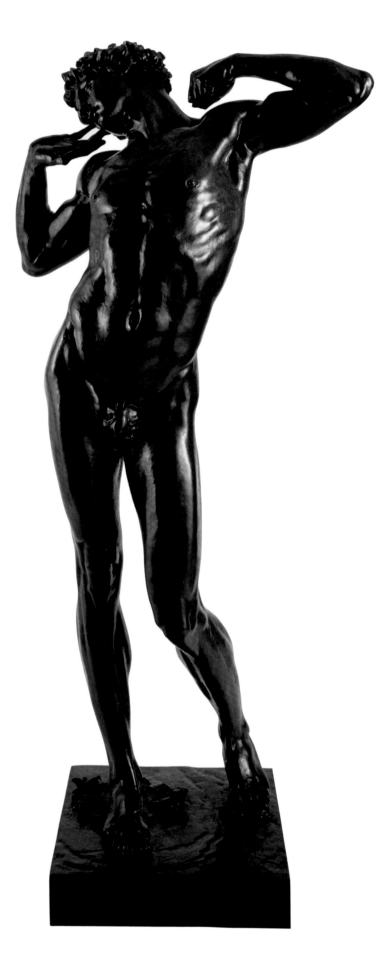

stones and modern materials such as aluminium all found their way into use. A revival of 'lost-wax' bronze casting allowed the creation of a sensuously expressive surface, itself capable of communicating subtle emotion, especially in its treatment of the body. Gilbert learnt the lost-wax technique in Italy, where he lived between 1878 and 1882, and triumphantly reintroduced it to England in a cycle of three major nude figures (*Perseus Arming*, *Icarus* and *Comedy and Tragedy*) which recalled the Renaissance bronzes of Cellini and Donatello. Gilbert presented the male body as a source of sensual interest and emotive expression rather than as an athletic or masculine ideal. Gone was the epic muscularity of such sculptural precedents as Leighton's *Athlete*, replaced by a suggestive mixture of introspection, sadness

218
Frederic Leighton, *The Sluggard*
Bronze, 1882–5
Tate, London

219
Photograph of drawing room with
William Hamo Thornycroft's, *The Mower,*
from *Magazine of Art,* 18, 1895

and eroticism. In its soft sensuality and vulnerability here was a changed attitude to manly stereotypes wholly in tune with Aesthetic circle beliefs.[5] Moreover, the temperament of Gilbert's nude figures could be read as transparently homoerotic.

This focus on the male body as an object of sexual desire was presented in other pieces such as Thornycroft's *The Mower* (1884; see plate 219), inspired partly by Matthew Arnold's reverie on a young farm labourer in his poem 'Thyrsis' (1867). Thornycroft based his figure, originally conceived as naked, on a muscular mower he saw by the Thames.

Part of the New Sculpture phenomenon was the 'cult of the statuette', which had links to concepts of the House Beautiful and the home as a place where art could give

expression to an Aesthetic ideal. Until the 1860s the production of reduced bronze casts was almost unknown in England, but in the 1880s and 1890s it became a major new business and an important method by which the New Sculpture was disseminated. Journals such as *The Magazine of Art* promoted domestic-sized sculpture as part of an integrated decorative scheme, alongside other items of fine and decorative art.[6] The main subject for British sculpture had hitherto been the portrait bust or large classical figure, so the idea of subject sculpture in the home was itself almost wholly new. For the buyer, statuettes suggested a link to the artist's studio, associated with freedom from conventional thought, decoration and codes of behaviour. By buying a statuette, buyers were making a statement.

Although they were expensive and issued only in small editions to ensure some exclusivity, statuettes held an advantage in that they were multiples and, like etchings, could be sold to more than one buyer. Different sizes could be produced according to limitations of budget and space: Gilbert's *Perseus Arming*, for instance, was cast in a number of editions of varying size. Essentially the creation of a new, specialized commerce, statuettes had the potential to be a substantial source of revenue for both sculptors and dealers.

While the statuette market endured, the New Sculpture did not. After the South African War the temper of Edwardian Britain's new century followed a more nationalistic path which had little time for the introspective or ambiguous. With the beginnings of modern art in Britain after 1910, the New Sculpture became part of a history that was already gone.

'The Cult of Indistinctness': Art Photography in the 1890s

Hope Kingsley

Once upon a time photography … was to a large degree an art, and to a considerable extent a science … Not so now … If the resulting negative is not sharp, print it on dirty, brown, rough paper, and you have a fashionable print. Only contrive to give it a 'greenery-yallery' look and it will pass. Some one will say it has 'soul' and 'poetry' in it. If it has a dim and distant look, a faded, far, far away appearance, so much more readily will the soul and the poetry be discernible.[1]
The Globe, 1890

THIS REVIEW of the Photographic Society's 1890 exhibition announced a change in photographic aesthetics, and ascribed blame. The fashion for murky images – borrowed here from the halls of the Grosvenor Gallery – was a convenient camouflage for poor photography. This mode departed from photography's tradition of legible representations, to works communicating an idea, an atmosphere, a 'soul'. Early examples of that shift occur in *Wild Life on a Tidal Water*, a volume of text and photogravures published by the photographer P.H. Emerson in collaboration with the New English Art Club painter T.F. Goodall (plate 221). The photographs were made while Goodall was working on a substantial painting destined for the Royal Academy. *The Last of the Ebb* (plate 222), like the direct photographs in *Wild Life*, shows a world of water and old ships that recalls James McNeill Whistler's *Thames Set* plates. The subtle, schematized tones of the photogravures emphasize atmosphere over description, an approach extended by Emerson in the minimalist photographic notations of his last book, *Marsh Leaves* (plate 220). Those images dated from 1890–91, when Emerson was taking an interest in Chinese and

220
P.H. Emerson, *The Misty River*
Photogravure, image dated c.1890–91,
published as plate VIII in *Marsh Leaves*, 1895
The Wilson Centre for Photography, London

Japanese art through coincident exhibitions at the British Museum and the Fine Art Society.

Photogravures were photomechanical prints resembling aquatints or etchings. Gravure gave substantial control over tonal values and image resolution, and as such was seen as an artistic process. The finest of the photographic 'artist-etchers' was James Craig Annan, whose photogravure sets such as *Venice and Lombardy* (1896) came from travels with a fellow Glaswegian, the painter-etcher D.Y. Cameron. Annan's *Venice from the Lido* (plate 223) is very like a view in Whistler's *First Venice Set*. Annan inscribed marks and lines on the plate that quoted Cameron's drypoint etching of the same scene

221
P.H. Emerson and
T.F. Goodall,
Low Water on Breydon
Photogravure, image
dated 1887, published
as plate II in *Wild Life
on a Tidal Water*, 1890
The Wilson Centre
for Photography, London

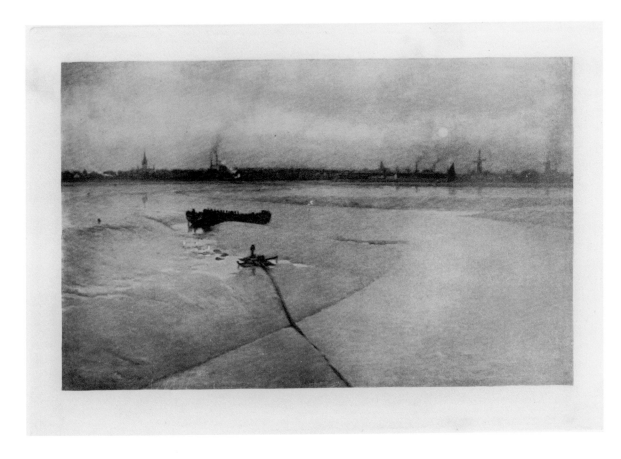

222
Thomas Frederick Goodall,
*The Last of the Ebb – Great
Yarmouth from Breydon*
Photogravure, image dated
1887, reproducing painting
exhibited at the Royal
Academy in 1888, plate XXX
(30) in *Wild Life on a Tidal
Water*, 1890
The Wilson Centre
for Photography, London

and signalled a process 'made' by hand rather than mechanically 'taken' by a camera. This agenda was shared by Annan's peers in the Brotherhood of the Linked Ring, a progressive London-based exhibiting society founded in 1892. The Links promoted the artistic seriousness of their practice through experimental lens optics and new processes that produced grainy and diffused images (plate 224). The results failed to impress all, and the photographers were chided as 'The Cult of Indistinctness'.[2] Whistler was again an inspiration, as satirized in a letter to *The Amateur Photographer*: 'I purpose [sic] sending for your inspection some photographic nocturnes, rondos, concertos, sonatas, overtures, and symphonies. I am particularly strong in nocturnes'.[3]

The Links were also attentive to contemporary aesthetics of presentation; their first Photographic Salon replaced traditional gilt frames and bright, Bristol board mounts with plain, dark frames surrounding mounts in

hand-made crayon papers of muted grey, brown and green. The effect suited the ethereally dim pictures but proved a gloomy combination with the Dudley Gallery's maroon walls. In 1897 Annan engaged a Glasgow designer to reconsider the Salon; George Walton's installation featured brown, green and unbleached canvas as background echoes of the exhibits. There were obvious Aesthetic markers, including pastel stencils of leaves, lotuses and lilies and, as a dado, a shelf displaying glass vases filled with sprigs of dried flowers. The scheme got mixed reviews; even admirers judged it reminiscent of other influential shows, including 'Mr. Whistler's "Mustard Pot"' at the Fine Art Society in 1883.[4]

223
James Craig Annan, *Venice from The Lido*
Photogravure, image dated *c*.1896, published as
no. 1 in the folio *Venice and Lombardy*, 1896
The Royal Photographic Society Collection,
National Media Museum, Bradford

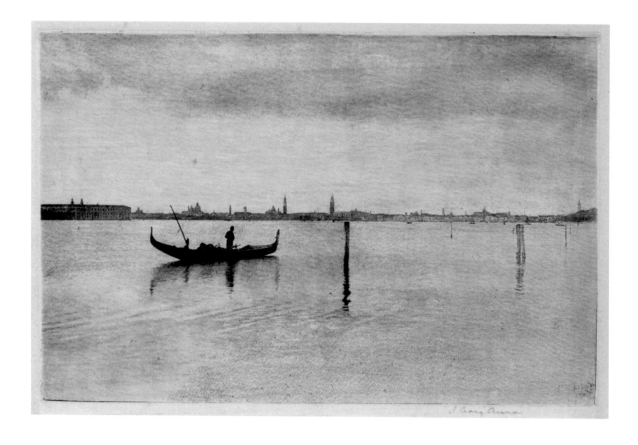

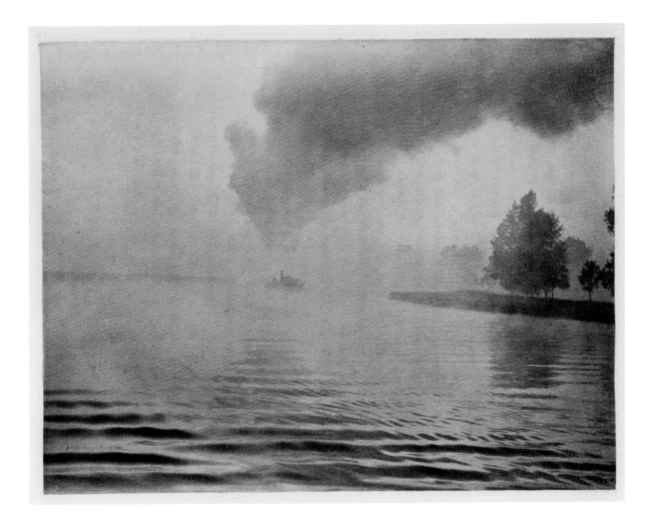

224
Alfred Maskell, *Landscape*
Gum bichromate print, *c.*1896
The Royal Photographic Society Collection,
National Media Museum, Bradford

Three weeks later another Link, George Davison,
opened a large exhibition for the Eastman Photographic
Materials Company, of which he was assistant manager.
He booked the New Gallery on Regent Street, and
commissioned Walton to produce elaborately draped rooms
decorated with heliotrope-coloured 'Kodak' stencils. The
Eastman International Photographic Exhibition presented the
company as a high-status concern (plate 226). Davison
persuaded fellow Links like Annan to show photographs
made with a Kodak snapshot camera (plate 227), using the
Ring as an aspirational blandishment to Eastman customers.
Amateur photographers were increasingly cultivated in
fashionably styled advertisements, publications (plate 225)
and retail outlets, of which Walton designed several for

ABOVE

226

Central foyer of the New Gallery, Regent Street,
showing stands in the Eastman International Exhibition, 1897
Gelatin silver photograph, 1897
Kodak Collection, National Media Museum, Bradford

LEFT

225

Cecil Aldrin, cover design for *The Kodak News*,
vol.1, no.1, May 1895
Letterpress on paper, bound within volume
Kodak Collection, National Media Museum, Bradford

Eastman, integrating furniture, cabinetry, fabrics and wall coverings into a 'house style' that persisted into the early twentieth century.

In art photography, material qualities expressed an aesthetically engaged artistic production. Yet there was also a sense that materiality mattered less than intentionality, as Alfred Maskell argued in 1891:

> We are told that the photographer uses an unintelligent machine. Well – the brush and the palette, are they intelligent? … in both cases, the intelligence is, or should be, in the user … We cannot say, let your artistically-educated eye select the subject, the machine will do the rest; if it were so, half our position … would have to be surrendered.[5]

Maskell echoed a well-known advertisement: the Eastman Company promoted their 1890 Kodak hand camera with the words 'You press the button, we do the rest'.[6] His warning was prescient; Eastman and other manufacturers might emulate the trappings of elite camera work, but snapshot photography represented a quite opposite impulse. For Maskell and his fellow members of the Linked Ring, the emphasis on connoisseurship and aesthetics would become a rearguard against mass production and modernity.

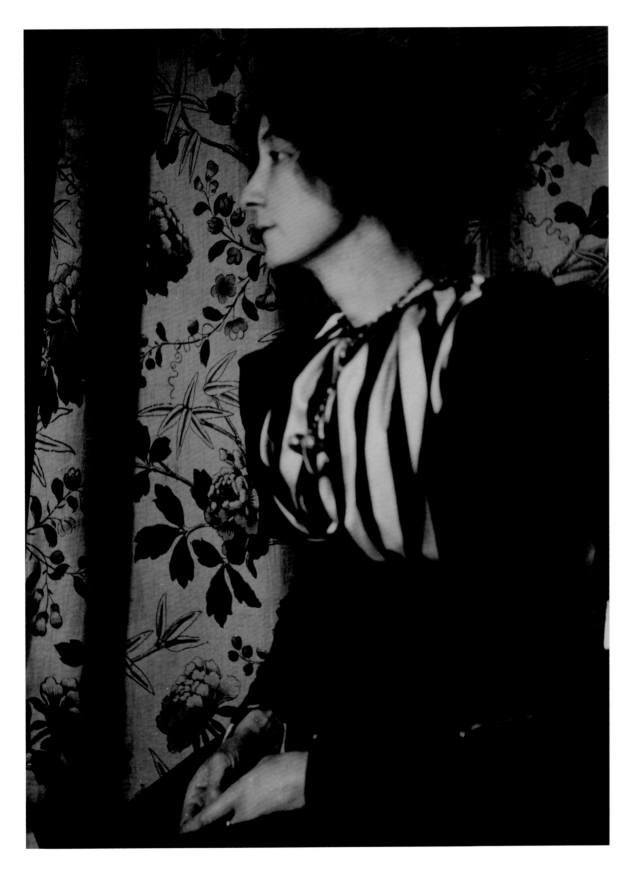

227
James Craig Annan,
Portrait of a Lady
(Mrs Grosvenor Thomas
in interior designed by
George Walton),
produced for Eastman
International Exhibition,
1897
Gelatin silver citrate
(POP) photograph from
snapshot negative, 1897
Kodak Collection, National
Media Museum, Bradford

The Book Beautiful

Stephen Calloway

THE ONCE widely held idea that the decorative arts in England suffered a disastrous collapse around the year 1830, recovered to some degree as a result of the design reform movements of the middle years and flourished again only in the final decades of the century, lingers long in studies of the book as artefact. Whilst the almost overwhelming inventiveness of the binders of mid-Victorian 'gift-books' and the prolific charms of the woodblock illustrators of the 1860s have been justly celebrated, these achievements stand out against a background of lamentable mediocrity in terms of type design and layout, choice and quality of materials, and sensibility to the 'feel' of the book.[1]

Many of the attempts to improve individual aspects of book production, whether cover design, type and typography, paper and presswork or quality of illustration and its relation to the page, originated with figures closely associated with the Aesthetic Movement. Indeed, it is within the wider context of Aestheticism as much as that of the Arts and Crafts Movement that the ideal of 'the book beautiful' first arose and can be said with some justification to have been achieved by the end of the century.

Although many talented artists contributed to the great flowering of wood-engraved illustration in the 1860s, the mere handful of designs made by Rossetti in the 1850s gave the greatest impetus to imaginative illustration as an independent art. One, for Allingham's ballad 'The Maids of Elfen-Mere', first won Burne-Jones and William Morris to the artistic cause.[2] Rossetti's five designs for the celebrated 1857 edition of Tennyson's poems published by Moxon changed the direction of illustration, revealing – though Tennyson himself could not recognize it – the extent to which the Pre-Raphaelite artists had outdone the older established illustrators in expressive intensity, beauty of drawing and awareness of decorative effect.[3]

It was perhaps natural that Rossetti, defining himself as 'poet-painter', but also increasingly interested in design, should have take a generalized interest in the appearance of books. But around 1861–2, newly involved through his friendship with William Morris in the practicalities of design, he began to think seriously about the arrangement of illustrations and type on the page and, most notably, to consider cover designs and the physical qualities of binding cloths. Beginning with his sister Christina's poem *Goblin Market* (1862), he placed woodblocks and lettering with conspicuous care to create a highly novel title opening, and devised a strikingly pure, asymmetric, Japanese-inspired cover design to be blocked in gold on plain blue publishers' book-cloth. Perceiving the 'artistic' possibilities of ordinary materials, Rossetti seems to have consciously sought to establish a 'livery' of blue, blue-green or blackish cloth bindings, exquisitely gilt-stamped, to unite visually the books of his immediate circle. His own *Poems* (1870) and Swinburne's *Songs Before Sunrise* (1873), both with highly influential designs by Rossetti himself, together with Morris's *The Story of the Volsungs and Nibelungs* (1870; designed by Philip Webb) and *Love is Enough* (1873; with ornament derived from Morris's own manuscript illuminations), all conformed to this subtle Aesthetic 'branding' (plates 228–31).

A potent source of inspiration for members of the group came from their collections of old, rare or curious books,

228–31
Four bookbindings in Rossetti's 'livery' for works by members of his circle, each blocked in gold on blue-green publisher's cloth.
TOP LEFT Dante Gabriel Rossetti, *Poems*, 1870 (design by Rossetti);
TOP RIGHT Algernon Swinburne, *Songs Before Sunrise*, 1873 (design by Rossetti);
BOTTOM LEFT William Morris, *Love is Enough*, 1873 (design by Morris);
BOTTOM RIGHT William Morris, *Volsunga Saga: The Story of the Volsungs and Niblungs*, 1870 (design by Philip Webb)
Stephen Calloway collection

228

229

230

231

233
William Morris, Edward Burne-Jones and
Charles Fairfax Murray, *The Aeneids of Virgil*
Body colour, black ink and burnished gold
on vellum, 1874–5, completed by
Louise Powell and Graily Hewitt 1904–10
Private collection

232
Photograph of Morris's library, Kelmscott House,
Hammersmith
Private collection

gathered either opportunistically from junk shops in the case of Rossetti, or with more focused intent by Morris, who began to purchase in earnest manuscripts and early printed volumes as exemplars for his own work (plate 232). Rossetti, Burne-Jones, Morris and Walter Crane all owned copies of that most celebrated of bibliophile's treasures, Francesco Colonna's Renaissance fantasy *Hypnerotomachia Poliphili* printed by Aldus in Venice.[4]

Morris, initially seeking to create the 'book beautiful' by the most demanding ancient methods, experimented in the 1860s and '70s with calligraphy and illumination, concocting inks, writing with quills on vellum and decorating his pages

with leafy ornament heightened with gold.[5] Many of these manuscripts remained unfinished, but a few volumes of his of his own poems and romances or favourite texts such as the *Rubáiyát of Omar Khayyám* (the best of them completed as gifts to Georgiana Burne-Jones) reveal an exquisite sense of balance between lettering and ornamentation.[6] Planned on the most lavish scale, a monumental manuscript of Virgil's *Aeneid* written out by Morris and with illustrations designed by Burne-Jones remains one of their greatest collaborative achievements (plate 233).[7]

Around this time Morris also tried to use commercial printers to create editions of his texts, and went so far as to

master the difficult process of wood engraving with the aim of emulating the tough integrity of his admired fifteenth- and sixteenth-century models. Though good in effect – by comparison with normal trade-work – these forays all failed to please the exacting Morris, largely because of the weakness of modern types and the impoverished materials currently available. It was not until the beginning of the 1890s that he found time to turn again to the question of how to create the book beautiful; this time he realized that, as with his reform of fabric-printing or tapestry-weaving, it would be necessary to return to basics and master each of the trades concerned. Accordingly, he began to design types of a distinctly Gothic 'blackness', formulated dense red and black inks and commissioned rough and heavy, antique-style, watermarked papers, enlisting the know-how of dedicated old press-men and incorporating borders and initials of his own designing often with illustrations by Burne-Jones. The 53 titles issued by the Kelmscott Press stand as the high-water-mark of both Aesthetic idealism and Arts and Crafts endeavour. The books

are magnificent but, as has often been observed, not entirely comfortable to hold in the hand and read.

Morris's Kelmscott books had an immense influence and stand at the head of a private press movement which flourished until 1914. However, the finest achievements of the presses such as the Ashendene, the Doves and, most notably Charles Ricketts's Vale Press look not to the weighty, Germanic styling of Morris's books but to the lighter effects of Italian Renaissance printing. This lightness and delicacy is also to be seen in the best of the volumes designed for trade publication by Ricketts and others, which take as their starting point Rossetti's stylish and intelligent use of ordinary materials to create commercial editions of singular beauty.[8] Typical of Ricketts at his best are two slim, self-consciously precious volumes of decadent poetry, John Gray's *Silverpoints* (1893) and Oscar Wilde's *The Sphinx* (1894; plates 234–5); these, rather than Morris's culminating achievement, the magisterial Kelmscott Chaucer, remain the quintessential books of the Aesthetic 1890s.

234–5
Bookbindings designed by Charles Ricketts.
LEFT Oscar Wilde, *The Sphinx*, 1894, vellum blocked in gold;
RIGHT John Gray, *Silverpoints*, 1893, green cloth blocked in gold
Stephen Calloway collection

BIBLIOGRAPHY

Adburgham, Alison, *Liberty's: A Biography of a Shop* (London 1975)

Adburgham, Alison, *Shops and Shopping 1800–1914* (London 1989)

Anderson, Anne, '"Doing As We Like": Grant Allen, Harry Quilter and Aesthetic Dogma', *Journal of Design History*, 18 (2005), pp.335–55

Anderson, Anne, '"Fearful consequences of living up to one's teapot": Men, women and "cultchah" in the English Aesthetic Movement *c*.1870–1900', *Victorian Literature and Culture*, 37 (2009), pp.219–54

Angeli, Helen Rossetti, *Pre-Raphaelite Twilight: The Story of Charles Augustus Howell* (London 1954)

Anon., 'English Furniture at The Exhibition', *The American Architect and Building News*, 6, no.155 (14 December 1878), pp.198–9

Anon., 'An Illustrated Guide to the First Annual Trades' Exhibition, August 4th to 15th, 1881', *The Cabinet-Maker and Art Furnisher*, 2 (July 1881–June 1882), supplement p.6

Anon., 'The Eastman Photographic Exhibition', *The Practical Photographer*, 8 (January 1897), pp.368–9

Arbuthnott, Catherine, 'E.W. Godwin and Ceramics', in *E.W. Godwin: Aesthetic Movement Architect and Designer* (New Haven 1999), pp.299–300

Armstrong, Isobel, *Victorian Glassworks: Glass Culture and the Imagination 1830–1880* (Oxford 2008)

Arnold, Matthew, *Culture and Anarchy* (London 1869)

Ashmore, Sonia, 'Liberty and Lifestyle; shopping for art and luxury in nineteenth-century London', in *Buying for the Home: Domestic Consumption from the Seventeenth to the Twentieth Century*, eds D. Hussey and M. Ponsonby (Aldershot 2008), pp.73–90

Asleson, Robin, *Albert Moore* (London 2000)

Aslin, Elizabeth, *The Aesthetic Movement: Prelude to Art Nouveau* (London 1981)

Atterbury, P., and M. Batkin, *The Dictionary of Minton* (Woodbridge 1990)

Barber, Giles, 'Rossetti, Ricketts and some English publishers' bindings of the 'nineties', *The Library*, 5th series, 25, no.4 (December 1970), pp.314–30

Barringer, Tim, and Elizabeth Prettejohn (eds), *Frederic Leighton: Antiquity, Renaissance, Modernity* (New Haven and London 1999)

Bartram, Michael, *The Pre-Raphaelite Camera: Aspects of Victorian Photography* (London 1985)

Baudelaire, Charles, 'The Painter of Modern Life', repr. in *The Painter of Modern Life and Other Essays*, ed. and trans. J. Mayne (New York 1969)

Beerbohm, Max, *The Works of Max Beerbohm* (London 1896)

Bell, Clive, *Art* (1914; rev. edn London 1927)

Bendix, Deanna Marohn, *Diabolical Designs: Paintings, Interiors and Exhibitions of James McNeill Whistler* (Washington, DC, and London 1995)

Bizup, Joseph, *Manufacturing Culture: Vindications of Early Victorian Industry* (Charlottesville and London 2003)

Blaikie, W.G., *The Renaissance of the Nineties* (London 1911)

Blanchard, Mary W., 'Oscar Wilde's Legacy: Women, Aesthetic Style and Twentieth-Century Art', in *The Importance of Being Misunderstood: Homage to Oscar Wilde*, eds Giovanna Franci and Giovanna Silvani (Bologna 2003), pp.253–67

Blunt, Wilfrid, *'England's Michelangelo': A Biography of George Frederic Watts, O.M., R.A.* (London 1975)

Brake, Laurel, Lesley Higgins and Carolyn Williams, *Walter Pater: Transparencies of Desire* (Greensboro, NC, 2002)

Breward, Christopher, *Fashion* (Oxford 2005)

Bryant, Barbara, *G.F. Watts Portraits: Fame and Beauty in Victorian Society*, exh. cat., National Portrait Gallery (London 2004)

Bryant, Barbara, 'An Artist Collects: Leighton as a collector of paintings and drawings', in *Closer to Home: The restoration of Leighton House*, ed. D. Robbins (London 2010), pp.22–9

Buchanan, Robert (as 'Thomas Maitland'), 'The Fleshly School of Poetry: Mr. D.G. Rossetti', in *Contemporary Review*, 18 (October 1871), pp.334–50

Buchanan, William, *The Art of the Photographer J. Craig Annan*, exh. cat., National Galleries of Scotland (Edinburgh 1992)

Burges, William, *Art Applied to Industry: A series of lectures* (Oxford and London 1865)

Burne-Jones, Georgiana, *Memorials of Edward Burne-Jones* (London 1904)

Burns, Sarah, *Inventing the Modern Artist: Art and Culture in Gilded Age America* (New Haven and London 1996)

Bury, Shirley, 'Rossetti and his Jewellery', *Burlington Magazine*, 118, no.875 (February 1976), pp.94–102

Bury, Shirley, *Jewellery. The International Era, 1789–1910* (Woodbridge 1991)

Cachin, Françoise, Charles S. Moffett, and Michel Melot, *Manet 1832–1883* (New York 1983)

Carr, Alice, *Mrs. J. Comyns Carr's Reminiscences*, ed. E. Adam (London 1926)

Casteras, Susan P., and Colleen Denney (eds), *The Grosvenor Gallery: A Palace of Art in Victorian England* (New Haven and London 1996)

Clements, Patricia, *Baudelaire and the English Tradition* (Princeton 1985)

Cohen, Deborah, *Household Gods: The British and their Possessions* (New Haven and London 2006)

Colvin, Sidney, *Notes on the Exhibitions of the Royal Academy and Old Water-Colour Society, reprinted, with corrections and additions, from 'The Globe'* (London 1869)

Colvin, Sidney, 'The Grosvenor Gallery', *Fortnightly Review*, n.s. 21 (1 June 1877)

Conforti, Michael, 'Orientalism on the Upper Mississippi: the Work of John S. Bradstreet', *The Minneapolis Institute of Arts Bulletin*, 65 (1986), pp.2–35

Conway, Moncure D., *Travels in South Kensington with Notes on Decorative Art and Architecture in England* (London 1882)

Cook, Clarence, *The House Beautiful: Essays on Beds and Tables, Stools and Candlesticks* (1878; rev. edn New York 1881)

Corbett, David Peters, *The World in Paint: Modern Art and Visuality in England, 1848–1914* (Manchester 2004)

Corbett, David Peters, and Lara Perry, *English Art 1860–1914: Modern Artists and Identity* (Manchester 2000)

Cox, Julian, and Colin Ford, *Julia Margaret Cameron: The Complete Photographs* (London 2003)

Crane, Walter, *An Artist's Reminiscences* (London 1907)

Cruise, Colin, *Love Revealed: Simeon Solomon and the Pre-Raphaelites* (London 2005)

Culme, John, *Nineteenth-Century Silver* (London 1977)

Cunningham, Patricia C., *Reforming Women's Fashion 1850–1920: Politics, Health and Art* (Kent, OH, 2003)

Curry, David Park, *James McNeill Whistler: Uneasy Pieces* (New York 2004)

Dakers, Caroline, *Clouds: The biography of a house* (New Haven and London 1993)

Dakers, Caroline, *The Holland Park Circle: Artists and Victorian Society* (New Haven 1999)

Day, Lewis Foreman, *Art in Needlework* (London 1901)

Debenham, W.E., 'The Cult of Indistinctness', *Photography*, 3 (16 July 1891)

De la Haye, Amy, Lou Taylor and Eleanor Thompson, *A Family of Fashion, The Messels: Six Generations of Dress* (London 2005)

Delaney, J.G.P., *Charles Ricketts* (Oxford 1990)

Dellamora, Richard (ed.), *Victorian Sexual Dissidence* (Chicago 1999)

Denney, Colleen, *At the Temple of Art: The Grosvenor Gallery, 1877–1890* (Cranbury, NJ, and London 2000)

Dickens, Charles, *Household Words*, 19 vols (London 1850–59)

Dixon, Ella Hepworth, *The Story of a Modern Woman*, ed. S. Farmer (1894; rev. edn Peterborough, CA, 2004)

Donald, Diana, and Jane Munro, *Endless Forms: Charles Darwin, Natural Science and the Visual Arts*, exh. cat., Fitzwilliam Museum, Cambridge, and Yale Center for British Art, New Haven (New Haven and London 2009)

Donnelly, Max, 'Cottier and Company, Art Furniture Makers', *Antiques*, 159 (June 2001), pp.916–25

Dorment, Richard, and Margaret F. Macdonald, *James McNeill Whistler*, exh. cat., Tate, London, Musée d'Orsay, Paris, and National Gallery of Art, Washington, DC (London 1994)

Dresser, Christopher, *Principles of Victorian Decorative Design* (1873; repr. New York 1995)

Dunlap, Joseph, 'William Morris: Calligrapher', in *William Morris and the Art of the Book*, ed. C. Ryskamp (New York 1976)

Dunn, Henry Treffry, *Recollections of Dante Gabriel Rossetti and his Circle; or Cheyne Walk Life* (1904; repr. Westerham 1984)

Eastlake, Charles L., *Hints on Household Taste in Furniture, Upholstery and other details* (1868; 1872; 1878; rev. edn New York 1969)

Edis, Robert W., *Decoration and Furniture of Town Houses: A Series of Cantor Lectures Delivered Before the Society of Arts, 1880* (London and New York 1881)

Edis, Robert W., *Healthy Furniture and Decoration* (London 1884)

Edwards, Clive, *Turning Houses into Homes* (London 2005)

Edwards, Jason, *Alfred Gilbert's Aestheticism* (Aldershot 2006)

Ehrman, Edwina, 'Frith and Fashion', in *William Powell Frith: Painting the Victorian Age*, eds M. Bills and V. Knight (New Haven and London 2006)

Eisenman, Stephen F., with Corinne Granof, *Design in the Age of Darwin: From William Morris to Frank Lloyd Wright*, exh. cat., Mary and Leigh Bloch Museum of Art, Northwestern University (Evanston, IL, 2008)

Elzea, Betty, *Frederick Sandys 1829–1904: A Catalogue Raisonné* (Woodbridge 2001)

Erlich, Cyril, *The Piano: A History* (rev. edn Oxford 1990)

Eyles, Desmond, *The Doulton Lambeth Wares*, rev. L. Irvine (Shepton Beauchamp 2002)

Fennell, Francis (ed.), *The Rossetti-Leyland Letters: The Correspondence of an Artist and his Patron* (Athens, OH, 1978)

Ferry, Emma, '"Decorators May be Compared to Doctors": An Analysis of Rhoda and Agnes Garrett's *Suggestions for House Decoration in Painting Woodwork and Furniture* (1876)', *Journal of Design History*, 16, no.1 (2003), pp.15–33

Ferry, Emma, *Advice, Authorship and the Domestic Interior: An interdisciplinary study of Macmillan's "Art at Home" Series (1876–1883)*, Ph.D. thesis, Kingston University (2004)

Fine Art Society, The, *The Aesthetic Movement and the Cult of Japan* (London 1972)

Fine, Ruth E., *James McNeill Whistler: A Reexamination*, *Studies in the History of Art*, vol.19 (Washington, DC, 1987)

Flanders, Judith, *A Circle of Sisters* (London 2001)

Flanders, Judith, *The Victorian House* (London 2003)

Frith, William Powell, *My Autobiography and Reminiscences*, vol.2 (London 1887)

Garrard, Garry, *A Book of Verse: the Biography of the Rubáiyát of Omar Khayyám* (Stroud 2007)

Garrett, Agnes and Rhoda, *Suggestions for House Decoration in Painting, Woodwork and Furniture*, 'Art at Home' series, ed. W.J. Loftie (London 1876)

Gere, Charlotte, *Artistic Circles: Design and Decoration in the Aesthetic Movement* (London 2010)

Gere, Charlotte, and Judy Rudoe, *The Art of the Jeweller: A Catalogue of the Hull Grundy Gift to the British Museum* (London 1984)

Gere, Charlotte, and Geoffrey Munn, *Artists' Jewellery: Pre-Raphaelite to Arts and Crafts* (Woodbridge 1989)

Gere, Charlotte, and Lesley Hoskins, *The House Beautiful: Oscar Wilde and the Aesthetic Interior* (London 2000)

Gere, Charlotte, and Judy Rudoe, *Jewellery in the Age of Queen Victoria: A Mirror to the World* (London 2010)

Girouard, Mark, *Sweeetness and Light: the Queen Anne Movement, 1860–1900* (Oxford 1977)

Gosse, Edmund, 'The New Sculpture', *Art Journal*, 56 (1894), pp.138–42

Gosse, Edmund, 'Sculpture in the House', *Magazine of Art*, 18 (1895), pp.368–72

Greenacombe, John (ed.), *Survey of London*, vol.45: *Knightsbridge* (London 2000)

Greenwood, Martin, *The Designs of William De Morgan* (Shepton Beauchamp 1989)

Hacking, Juliet, *Princes of Victorian Bohemia: Photographs by David Wilkie Wynfield*, exh. cat., National Portrait Gallery (London 2000)

Halle, Charles, *Notes from a Painter's Life* (London 1909)

Hamerton, Philip Gilbert, 'The Relation between Painting and Photography' (1860), in *Thoughts About Art* (1871; rev. edn London 1889)

Hamilton, Mark, *Rare Spirit: A Life of William De Morgan, 1839–1911* (London 1997)

Hamilton, Walter, *The Aesthetic Movement in England* (London 1882)

Hansen, Joan Maria, *Lewis Foreman Day (1845–1910): Unity in design and industry* (Woodbridge 2007)

Hanson, Ellis, *Decadence and Catholicism* (Cambridge, MA, and London 1997)

Harding, Colin, 'The History of Kodak in Britain: Part 2 – Expansion and a Limited Company 1893–1898', *Photographica World*, 67 (December 1993)

Harker, Margaret F., *The Linked Ring: The Secession Movement in Photography in Britain, 1892–1910* (London 1979)

Haskell, Frances, *Rediscoveries in Art: Some Aspects of Taste, Fashion and Collecting in England and France* (Ithaca, NY, 1976)

Haslam, Malcolm, *English Art Pottery* (Woodbridge 1975)

Haslam, Malcolm, *The Martin Brothers Potters* (London 1978)

Hatton, Joseph, 'The Life and Work of Alfred Gilbert, R.A.', *Easter Art Annual* (London 1903)

Haweis, Hugh Reginald, *Music and Morals* (London 1871)

Haweis, Mrs [Mary Eliza], *The Art of Beauty* (1878; repr. Chestnut Hill, MA, 2004)

Haweis, Mrs [Mary Eliza], *The Art of Dress* (London 1879)

Haweis, Mrs [Mary Eliza], *The Art of Decoration* (London 1881)

Haweis, Mrs [Mary Eliza], *Beautiful Houses: Being a description of certain well-known artistic houses* (London 1882)

Henderson, Philip, *Swinburne: the Portrait of a Poet* (London 1974)

Henrey, Robert, *A Century Between* (London and Toronto 1937)

Hilliard, David 'UnEnglish and unmanly: Anglo-Catholicism and homosexuality', *Victorian Studies*, 25, no.2 (winter 1982), pp.181–210

Hinton, A. Horsley, 'The Photographic Salon', *Photograms of the Year* (1897)

Holland, Merlin, *Irish Peacock and Scarlet Marquess* (London 2003)

Howard, Jeremy, *The Whisper of the Muse: The World of Julia Margaret Cameron* (London 1990)

Howe, Bea, *Arbiter of Elegance* (London 1967)

Hugo, Victor, *Les Orientales. Les Feuilles d'automne*, ed. P. Albouy (Paris 1966)

Hyde, H. Montgomery, *The Trials of Oscar Wilde* (London 1948)

Hyder, Clyde K. (ed.), *Swinburne as Critic* (London and Boston 1972)

James, Henry, *The Painter's Eye: Notes and Essays on the Pictorial Arts*, ed. J.L. Sweeney (London 1956)

Jefferies, Richard, *The Life of the Fields* (London 1884)

Jervis, Simon, *High Victorian Design* (London 1983)

Jones, Edgar Yoxall, *Father of Photography: O.G. Rejlander, 1813–1875* (Newton Abbot 1973)

Jones, Joan, *Minton: The First Two Hundred Years of Design and Production* (Shrewsbury 1993)

Kelly, Linda, *The Young Romantics* (London 1976)

Kelly, Philip, and Betty A. Colley, *The Browning Collections: A Reconstruction with other Memorabilia* (Winfield, KS, 1984)

Kinchin, Juliet, and Paul Stirton, 'Is Mr Ruskin Living Too Long? Selected Writings of E.W. Godwin on Victorian Architecture', *Design and Culture* (Dorchester 2005)

King, Brenda, *Dye, Print, Stitch: Textiles by Thomas and Elizabeth Wardle* (Macclesfield 2009)

Klein, Dan, *Aspects of the Aesthetic Movement* (London, 1978)

Kramer, Elizabeth, 'From Luxury to mania: A Case Study of Anglo-Japanese Textile production at Warner & Ramm, 1870–1890', *Textile History*, 38, no.2, pp.151–64

Lambourne, Lionel, *The Aesthetic Movement* (London 1996)

Lang, Cecil Y. (ed.), *The Swinburne Letters*, vol.1: *1854–1869* (New Haven 1959)

Layard, George Somes, *Tennyson and his Pre-Raphaelite Illustrators: a book about a book* (London 1894)

Le Gallienne, Richard. *The Romantic Nineties* (London 1926)

Leighton, Frederic, *Addresses, Delivered to Students at the Royal Academy* (London 1896)

Lovell, Margaretta. *Venice: The American View, 1860–1920*, exh. cat., The Fine Arts Museums of San Francisco and The Cleveland Museum of Art (Washington 1984)

Lubbock, Jules, *The Tyranny of Taste: Politics of Architecture and Design in Britain, 1550–1960* (New Haven and London 1995)

McAllister, Isabel, *Alfred Gilbert* (London 1929)

MacDonald, Margaret, Patricia de Montfort and Nigel Thorp (eds), *The Correspondence of James McNeill Whistler, 1855–1903*, on-line edition, University of Glasgow, http://www.whistler.arts.gla. ac.uk/correspondence

MacDonald, Margaret, Susan Grace Galassi and Aileen Ribeiro, *Whistler, Women and Fashion*, exh. cat., Frick Collection, New York (New Haven and London 2003)

McLean, Ruari, *Victorian Book Design* (1963; rev. edn London 1972)

Macleod, Dianne Sachko, *Art and the Victorian Middle Class* (Cambridge 1996)

McWilliam, Neil, and Veronica Sekules, *Life and Landscape: P.H. Emerson, Art and Photography in East Anglia 1885–1900* (Norwich 1986)

Mallock, W.H., *The New Republic* (London 1878; repr. Leicester 1975)

Maltz, Diana, *British Aestheticism and the Urban Working Classes, 1870–1900* (Basingstoke 2006)

Marillier, H.C., *Dante Gabriel Rossetti: An Illustrated Memorial of his Life and Art* (London 1899)

Marks, Murray, *A Catalogue of Blue and White Nankin Porcelain forming the Collection of Sir Henry Thompson* (London 1878)

Marsh, Jan, *Dante Gabriel Rossetti: Painter and Poet* (London 1999)

Maskell, Alfred, 'The Claims of Photography to Recognition as Art', *Journal of the Camera Club*, 5 (July 1891)

Maxwell, Catherine, *Swinburne* (Horndon 2006)

Merrill, Linda, *A Pot of Paint: Aesthetics on Trial in Whistler v. Ruskin* (Washington, DC, and London 1992)

Merrill, Linda, *The Peacock Room, A Cultural Biography* (Washington, DC, New Haven and London 1998)

Metcalf, Simon, and Eric Turner, 'The conservation of a *c.*1867 cast iron hat stand: a Dresser design and original Coalbrookdale paint scheme revealed', *The Decorative Arts Society, 1850 to the Present*, 26 (2002), pp.26–39

Moon, Karen, *George Walton, Designer and Architect* (Oxford 1993)

Morris, Edward, *French Art in Nineteenth-Century Britain* (New Haven and London 2005)

Morris, May (ed.), *Collected Works of William Morris*, 24 vols (London 1910–15)

Morris, William, *The Defence of Guinevere and Other Poems* (London 1858)

Morris, William, *Hopes and Fears for Art* (London 1882)

Morris, William, *The Collected Letters of William Morris*, ed. N. Kelvin, 2 vols (Princeton 1987)

Muddiman, Bernard, *The Men of the Nineties* (London 1920)

Munn, Geoffrey, *Castellani and Giuliano: Revivalist Jewellers of the Nineteenth Century* (London 1984)

Muthesius, Stefan, *The Poetic Home. Designing the 19th-Century Interior* (London 2009)

Newall, Christopher, *The Grosvenor Gallery Exhibitions* (Cambridge 1995)

Newton, Stella Mary, *Health, Art and Reason: Dress Reformers of the Nineteenth Century* (London 1974)

Nieswander, J.A., *The Cosmopolitan Interior: Liberalism and the British Home, 1870–1914* (New Haven and London 2008)

Nordau, Max, *Degeneration* (London 1895)

O'Brien, Kevin H.F., '"The House Beautiful": A Reconstruction of Oscar Wilde's American Lecture', *Victorian Studies*, 17, no.4 (June 1974), pp.395–418

O'Malley, Patrick, *Catholicism, Sexual Deviance and Victorian Gothic Culture* (Cambridge 2006)

Oman, C.C. and Jean Hamilton, *Wallpapers: A History and Illustrated Catalogue of the Collection of the Victoria and Albert Museum* (London 1982)

Orrinsmith, Lucy, *The Drawing Room* (London 1878)

Østermark-Johansen, Lene, *Sweetness and Strength: The Reception of Michelangelo in Late Victorian England* (Aldershot and Brookfield, VT, 1998)

Owens, Susan, 'Aubrey Beardsley, *Salome* and Satire', unpublished Ph.D. thesis, University College, London, 2002, pp.136–54

Panton, Jane Ellen, *From Kitchen to Garret: Hints for Young Householders* (London 1888)

Parris, Leslie, *The Pre-Raphaelites*, exh. cat., Tate (London 1984)

Parry, Linda, *Textiles of the Arts and Crafts Movement* (London 1988)

Parry, Linda (ed.), *William Morris* (London and New York 1996)

Parry, Linda, *The Victoria and Albert Museum's Textile Collection: British Textiles from 1850 to 1900* (London 2002)

Pater, Walter, *Studies in the History of the Renaissance* (London 1873)

Pater, Walter, *Marius the Epicurean* (London 1885), vol.1

Pater, Walter, *The Renaissance* (New York 1877)

Pater, Walter, *The Renaissance: Studies in Art and Poetry*, ed. D.L. Hill (1888; Berkeley, CA, 1980)

Pater, Walter, *Appreciations: with an Essay on Style* (London and New York 1889)

Pater, Walter, *Appreciations* (London 1890)

Pearsall, Ronald, *Victorian Sheet Music Covers* (Newton Abbot 1972)

Pearson, Fiona, 'The Correspondence between P. H. Emerson and J. Havard Thomas', *British Photography in the Nineteenth Century*, ed. M. Weaver (Cambridge 1989)

Pennell, Joseph and Elizabeth, *The Life of James McNeill Whistler*, 2 vols (London 1908)

Pennell, Joseph and Elizabeth, *The Whistler Journal* (Philadelphia 1921)

Pevsner, Nikolaus, 'Christopher Dresser, Industrial Designer', *Architectural Review*, 81 (1937), pp.183–6

Pevsner, Nikolaus, *Pioneers of Modern Design, from William Morris to Walter Gropius* (London 1960)

Pevsner, Nikolaus, *Studies in Art, Architecture and Design*, vol.2: *Victorian and After* (New York 1968)

Praz, Mario, *The Romantic Agony*, trans. A. Davidson (1933; rev. edn London 1970)

Prettejohn, Elizabeth, 'Moral versus aesthetics in critical interpretations of Frederic Leighton, 1855–75', *Burlington Magazine*, 138, no. 1115 (February 1996), pp.79–86

Prettejohn, Elizabeth, *Rossetti and His Circle* (London 1997)

Prettejohn, Elizabeth, *Dante Gabriel Rossetti* (London and New York 2003)

Prettejohn, Elizabeth, 'From Aestheticism to Modernism, and Back Again', *Interdisciplinary Studies in the Long Nineteenth Century*, issue 2 (May 2006)

Prettejohn, Elizabeth, *Art for Art's Sake: Aestheticism in Victorian Painting* (New Haven and London 2007)

Prettejohn, Elizabeth, *Beauty and Art, 1750–2000* (Oxford 2009)

Quilter, Harry, *Opinions on Men, Women and Things* (London 1909)

Reade, Brian, *Sexual Heretics* (London 1970)

Reynolds, Simon, *William Blake Richmond: An Artist's Life 1842–1921* (Norwich 1995)

Rhead, G.W. and F.A., *Staffordshire Pots and Potters* (London 1906)

Richardson, Joanna, *The Bohemians: La vie de Bohème in Paris, 1830–1914* (London 1969)

Rossetti, Dante Gabriel, *Poems* (London 1870)

Rossetti, Dante Gabriel, *The Collected Works* (London 1888)

Rossetti, Dante Gabriel, *The Correspondence of Dante Gabriel Rossetti*, ed. W. E. Fredeman, 4 vols (Woodbridge 2004)

Rossetti Sale 1882: T.G.Wharton, Martin & Co.,*16 Cheyne Walk, Chelsea, Catalogue of the Household and Decorative Effects … to be sold … July 5ᵗʰ 1882 and two following days* (London 1882)

Rossetti, William Michael, 'Fine Art. The Grosvenor Gallery', *Academy*, 11 (5 May 1877), p.396

Rossetti, William Michael, and Algernon C. Swinburne, *Notes on the Royal Academy Exhibition, 1868* (London 1868)

Rudoe, Judy, 'Design and Manufacture, Evidence from the Dixon & Sons Calculation Books', *The Decorative Arts Society, 1850 to the Present*, 29 (2005), pp.66–83

Ruskin, John, 'Modern Manufacture and Design', in *The Two Paths* (London 1859)

Ruskin, John, *Sesame and Lilies*, ed. D. Epstein Nord (1865; rev. edn New Haven 2002)

Ruskin, John, *The Works of John Ruskin*, eds E.T. Cook and A. Wedderburn, 39 vols (1903; reissued Cambridge 2010)

Saint, Andrew, *Richard Norman Shaw* (New Haven and London 1976)

Saunders, Gill, *Wallpaper in Interior Decoration* (London 2001)

Shoolbred & Co., James, *Designs of Furniture illustrative of Cabinet Furniture and Interior Decoration* (London 1876)

Smith, Walter, *Masterpieces of the Centennial International Exhibition*, vol.2: *The Industrial Art of the Exhibition* (Philadelphia 1876)

Soros, Susan, *The Secular Furniture of E.W. Godwin* (New Haven 1999)

Soros, Susan Weber, and Catherine Arbuthnott, 'A Union of Art and Industry', in *Thomas Jeckyll: Architect and Designer, 1827–1881* (New York, New Haven and London 2003), pp.200–239

Sparke, Penny, *As Long as It's Pink: The Sexual Politics of Taste* (London 1995)

Spencer, Robin, *The Aesthetic Movement* (London 1972)

Spencer, Robin, 'Whistler's *The White Girl*: Painting, Poetry and Meaning', *Burlington Magazine*, 140, no.1142 (May 1998), pp.300–311

Spencer, Stephanie, 'O.G. Rejlander: Art Studies', *British Photography in the Nineteenth Century: The Fine Art Tradition*, ed. M. Weaver (Cambridge 1989)

Spielmann, M.H., *British Sculpture and Sculptors of Today* (London 1901)

Staley, Allen, 'The Pre-Raphaelites in the 1860s: III, Millais', *British Art Journal*, 5, no.2 (2004)

Stange, G. Robert, 'Art Criticism as a Prose Genre', *The Art of Victorian Prose*, eds G. Levine and W. Madden (New York and London 1968)

Stein, Richard L., *The Ritual of Interpretation: The Fine Arts as Literature in Ruskin, Rossetti, and Pater* (Cambridge, MA, 1975)

Stern, Radu, *Against Fashion Clothing as Art, 1850–1930* (Cambridge, MA, 2004)

Stetz, Margaret D., *Facing the Late Victorians: Portraits of Writers and Artists from the Mark Samuels Lasner Collection* (Cranbury, NJ, 2007)

Surtees, Virginia, *The Paintings and Drawings of Dante Gabriel Rossetti (1828–1882): A Catalogue Raisonné* (Oxford 1971)

Surtees, Virginia, *Coutts Lindsay: 1824–1913* (Norwich 1993)

Swinburne, Algernon Charles, *William Blake: A Critical Essay* (London 1868)

Swinburne, Algernon Charles, 'The Poems of Dante Gabriel Rossetti', *Fortnightly Review* (1 May 1870), pp.551–79

Swinburne, Algernon Charles, 'Mr. Whistler's Lecture on Art', *Fortnightly Review* (June 1888), p.746

Swinburne, Algernon Charles, *Poems and Ballads & Atalanta in Calydon*, ed. K. Haynes (London 2000)

Swinburne, Algernon Charles, *Major Poems and Selected Prose*, eds J. McGann and C.L. Sligh (New Haven 2004)

Symons Arthur. 'The Decadent Movement in Literature', in *Harper's New Monthly Magazine* (European edn; November 1893), pp.858–67

Symons, Arthur, *Studies in Prose and Verse* (London 1904)

Tennyson, Alfred, *Poems* (London 1857)

Tennyson, Alfred, *The Poetic and dramatic works of Alfred, Lord Tennyson*, ed. W.J. Rolfe (Boston and New York 1898)

Teukolsky, Rachel, *The Literate Eye: Victorian Art Writing and Modernist Aesthetics* (Oxford 2009)

Treuherz, Julian, Elizabeth Prettejohn and Edwin Becker, *Dante Gabriel Rossetti*, exh. cat., Van Gogh Museum, Amsterdam, and Walker Art Gallery, Liverpool (Zwolle 2003)

Turner, Mark, and Lesley Hoskins, *Silver Studio of Design* (London 1988)

Walkley, Giles, *Artists' Houses in London, 1764–1914* (London 1994)

Ward, Martha, 'Impressionist installations and Private Exhibitions', *The Art Bulletin,* 73 (December 1991), pp.599–622

Warner, Eric, and Graham Hough (eds), *Strangeness and Beauty: an Anthology of Aesthetic Criticism 1840–1910* (Cambridge 1983)

Warner, Malcolm, *The Victorians*, exh. cat., National Gallery of Art (Washington, DC, 1995)

Waterfield, Giles (ed.), *The Artists' Studio*, exh. cat., Compton Verney (London 2009)

Whistler, James McNeill, *Whistler v. Ruskin, Art and Art Critics* (London 1878)

Whittaker, Esmé, 'Creating Coherence: George Aitchison and the Aesthetic Interior', MA dissertation, Courtauld Institute of Art, University of London (2005)

Whittington-Egan, Molly, *Frank Miles and Oscar Wilde: 'such white lilies'* (High Wycombe 2008)

Wilde, Oscar, *The Portrait of Dorian Gray* (London 1890)

Wilde, Oscar, 'The Decay of Lying', in *Intentions* (London 1891)

Wilde, Oscar, 'House Decoration', *Essays and Lectures* (London 1928)

Wilde, Oscar, *The Complete Works of Oscar Wilde*, intro. V. Holland (1966; rev. edn 1989)

Wilde, Oscar, *The Complete Letters of Oscar Wilde*, eds M. Holland and R. Hart-Davis (London 2000a)

Wilde, Oscar, *The Complete Works of Oscar Wilde*, vol.1: *Poems and Poems in Prose*, eds B. Fong and K. Beckson (Oxford 2000b)

Wildman, Stephen, and John Christian, *Edward Burne-Jones: Victorian Artist-Dreamer*, exh. cat., The Metropolitan Museum of Art (New York 1998)

Williams, Carolyn, *Transfigured World: Walter Pater's Aesthetic Criticism* (Ithaca, NY, 1989)

Williamson, G.C., *Murray Marks and His Friends* (London 1919)

Wilson, Elizabeth, *Bohemians: The Glamorous Outcasts* (London 2000)

Wilton, Andrew, and Robert Upstone (eds), *The Age of Rossetti, Burne-Jones and Watts: Symbolism in Britain 1860–1910*, exh. cat., Tate (London 1997)

Wolohojian, Stephen, *A Private Passion: 19th-Century Paintings and Drawings from the Grenville L. Winthrop Collection, Harvard University*, exh. cat., Musee des Beaux-Arts, Lyon, National Gallery, London, and Metropolitan Museum of Art, New (New Haven and London 2003)

Yeats, William Butler, 'A Symbolic Artist and the Coming of Symbolic Art', in *The Dome*, n.s. vol.1 (December 1898)

Yeats, William Butler, 'The Trembling of the Veil', in *Autobiographies* (London 1955)

Young, Andrew McLaren, et al., *The Paintings of James McNeill Whistler*, 2 vols (New Haven and London 1980)

Zukowski, Karen, *Creating the Artful Home: The Aesthetic Movement* (Salt Lake City, UT, 2006)

GLOSSARY OF NAMES

Esmé Whittaker

George Aitchison (1825–1910) Architect and interior designer, Aitchison was commissioned by Frederic Leighton to design a studio-house at 2 Holland Park Road (Leighton House). His friendship with Leighton led to a series of commissions to design interior schemes for the homes of the leading patrons of Aesthetic art.

William Cleverly Alexander (1840–1916) Wealthy banker and avid collector of blue-and-white china, Alexander commissioned James McNeill Whistler to paint portraits of his children and to decorate the interior of his home, Aubrey House, Campden Hill, London.

William Allingham (1824–89) Irish poet who wrote the ballad 'The Maids of Elfin-Mere', illustrated by Dante Gabriel Rossetti and published in *The Music Master* (London 1855). He was editor of *Frazer's Magazine* 1874–9 and was married to the watercolour artist **Helen Allingham (1848–1926)**.

Sir Lawrence Alma-Tadema (1836–1912) Dutch painter who, inspired by the excavations at Pompeii and with an enthusiasm for classical archaeology, painted everyday scenes from Roman life. His homes, Townsend House near Regent's Park and then Grove End Road, St John's Wood, were decorated in an array of historical styles and contained his large collection of oriental textiles and furniture. His second wife, artist **Laura Theresa Epps (1852–1909)**, created paintings influenced by seventeenth-century Dutch genre scenes.

James Craig Annan (1864–1946) Scottish photographer and master of the photogravure process. He joined his father, Thomas Annan, in business in Glasgow, became a member of the progressive exhibiting society The Linked Ring and was the first president of the International Society of Pictorial Photographers.

Thomas Armstrong (1832–1911) Painter who trained in Paris where he became a close friend of George Du Maurier, Edward John Poynter and James McNeill Whistler. In 1881 he was appointed director of the Art Division of the Department of Science and Art based at the South Kensington museum.

Harry Bates (1850–99) Sculptor central to the New Sculpture movement. His output ranged from a monumental equestrian statue to relief panels inspired by classical mythology. He also carried out architectural decoration working with architects such as Alfred Waterhouse and J.D. Sedding.

Aubrey Beardsley (1872–98) Illustrator influenced by Morris's Kelmscott Press when undertaking his first major commission, illustrations for Malory's *Morte d'Arthur*. He soon developed his own distinctive black-and-white linear style and his work was promoted in the first issue of the *Studio* magazine in 1893. In 1894 he illustrated Oscar Wilde's play *Salomé* and became art editor for the periodical the *Yellow Book*, a position from which he was dismissed when he was mistakenly associated with Wilde's controversial arrest. He went on to establish a new publication, *The Savoy*, in 1896.

Sir Max Beerbohm (1872–1956) Caricaturist and writer who took over from George Bernard Shaw as drama critic for the *Saturday Review*. Beerbohm parodied fashionable society, caricaturing the leading figures of the Aesthetic movement such as Oscar Wilde and James McNeill Whistler.

Sir Thomas Brock (1847–1922) Sculptor of public monuments and portrait busts. Close friend of Frederic Leighton and was responsible for both a bronze bust of Leighton and Leighton's tomb in St Paul's Cathedral, London. Brock was first president of the Royal Society of British Sculptors. His most famous work is the Queen Victoria Memorial outside Buckingham Palace.

Robert Buchanan (1841–1901) Poet and novelist who published an article entitled 'The Fleshly School of Poetry' in *The Contemporary Review* under the pseudonym Thomas Maitland. The article, subsequently republished as a pamphlet, criticized the poetry of Dante Gabriel Rossetti and Algernon Charles Swinburne for its sensuality and morbidity.

William Burges (1827–81) Gothic Revival architect and designer who laid out the Medieval Court at the International Exhibition of 1862 in London. He created architectonic and elaborately painted furniture in collaboration with painters such as E.J. Poynter and Simeon Solomon. His architectural achievements included work at Cardiff Castle for the 3rd Marquess of Bute and his own home, Tower House, on Melbury Road, London.

Sir Edward Burne-Jones (1833–98) 1st Bt, painter, illustrator and designer. Alongside his friend William Morris, he was inspired by the writings of Ruskin and the paintings of Rossetti to leave Oxford University and become an artist in London. In 1861 he helped to found Morris, Marshall, Faulkner & Co., for whom he designed stained glass, tiles and tapestries. He also provided illustrations for the Kelmscott Press, which Morris founded in 1891. His paintings, inspired by legend, myth and the art of the Italian Renaissance, brought him great acclaim. In 1860 he married **Georgiana Macdonald (1840–1920)** and in the late 1860s he had an affair with the sculptor **Marie Zambaco (née Cassavetti) (1843–1914)**.

Lindsay Butterfield (1869–1948) Wallpaper and textile designer who worked with firms such as Alexander Morton, G.P. & J. Baker and the retailer Liberty & Co.

Julia Margaret Cameron (née Pattle) (1815–79). Photographer who was given her first camera at the age of 48. Her circle of friends, which centred around her sister's home at Little Holland House in Kensington, included G.F. Watts and Alfred Tennyson. Inspired by literature and Old Master paintings, she produced photographs which had a soft focus and were dramatically lit.

Joseph Comyns Carr (1849–1916) Art critic and gallery director. Together with Sir Coutts Lindsay and C.E. Hallé he was a director of the Grosvenor Gallery and, with Hallé as his partner, went on to found the New Gallery, Regent Street. His sister, **Kate Comyns Carr**, was a portrait painter.

Sir Henry Cole (1808–82) Civil servant Cole helped to promote and organize The Great Exhibition in 1851. He became secretary in the Department of Practical Art based at Marlborough House, London, which moved to South Kensington along with its museum in 1856. Cole was the first director of the newly named South Kensington Museum, renamed the Victoria and Albert Museum in 1899.

William Stephen Coleman (1829–1904) Book illustrator, painter and designer. Coleman worked at Copeland's then the Minton Ceramic factory, painting china plaques and designing table services which drew upon his skills as an illustrator of natural history books. He became head of Minton's Art Pottery Studio in Kensington Gore, London.

Sir Sidney Colvin (1845–1927) Art critic who contributed to the *Pall Mall Gazette*, the *Fortnightly Review* and the *Portfolio*. He was Slade Professor of Fine Art at Cambridge University and Director of the Fitzwilliam Museum, Cambridge. In 1884 he became Keeper of the Department of Prints and Drawings at the British Museum.

Alfred Concanen (1835–86) Lithographer who specialized in producing illustrated sheet music covers. Concanen's lithographs captured the leading personalities of the nineteenth-century music halls.

Revd Moncure Daniel Conway (1832–1907) American Unitarian minister and social reformer, Conway moved to London in 1863 where he became minister at South Place Chapel. He became a friend of Aesthetic artists and writers, offering spiritual advice and exchanging ideas. He lived in the Aesthetic London suburb of Bedford Park

Clarence Cook (1828–1900) American art critic. Inspired by the writings of John Ruskin, he helped to found The Society for the Advancement of Truth in Art, a group also known as the American Pre-Raphaelites. Between 1875 and 1877 he published a series of articles about home furnishings in *Scribner's Monthly* which helped to promote the Queen Anne Revival. These were reprinted in *The House Beautiful* in 1878.

Fanny Cornforth (born Sarah Cox) (1835–1906) Artist's model who posed for Dante Gabriel Rossetti, Edward Burne-Jones and J.R. Spencer Stanhope. She first met Rossetti in the late 1850s and modelled for some of his most important paintings over the next decade such as *Bocca Baciata* (1859) and *The Blue Bower* (1865). Believed to have been Rossetti's mistress, in 1862 she became his housekeeper at Tudor House, Chelsea, after the death of his wife, Elizabeth Siddal.

Lucy Crane (1842–82) Writer who collaborated with her brother, Walter Crane, on a number of illustrated children's books. She wrote and delivered a series of lectures on art published posthumously as *Art and the Formation of Taste* (1882).

Walter Crane (1845–1915) Illustrator, designer and painter, Crane established his reputation as an illustrator of children's books ('Toy Books') for the printer Edmund Evans. This led to a commission to design nursery wallpapers for Jeffrey & Co.; subsequently his career as a designer of wallpapers, textiles and ceramics flourished, overshadowing his allegorical paintings.

Lewis F. Day (1845–1910) Designer and writer who worked closely with industry in order to raise the standards of manufacturing. He produced designs for textiles, wallpapers, 'art' pottery, stained glass, clocks and furniture and wrote a number of instructive texts such as *Textbooks of Ornamental Design: The Anatomy of Pattern* (1887).

William Frend De Morgan (1839–1917) Potter and novelist, De Morgan was interested in ceramic production as both an art and a science. He experimented widely with glazes producing pieces with a distinctive 'lustre'. He was a close friend of William Morris, with whom he collaborated. In 1887 he married **Evelyn Pickering (1855–1919)** a successful painter trained at the Slade School of Fine Art.

Sir Henry Doulton (1820–97) Pottery manufacturer who joined the family business in 1835. In the 1860s, under his influence, the firm began to produce 'art pottery' – salt-glazed stoneware with decorations by students from Lambeth School of Art.

Christopher Dresser (1834–1904) Influential industrial designer who embraced new materials and machine production. He worked with a wide range of manufacturers, such as Coalbrookdale and James Dixon & Sons, and produced designs for metalwork, wallpapers, textiles, furniture and ceramics. His designs were influenced by his extensive knowledge of botany and his travels in Japan, where he represented the British Government.

George Du Maurier (1834–96) Illustrator and novelist, Du Maurier trained in Paris in the same studio as Thomas Armstrong and Edward Poynter. This Paris group, with Whistler, became the subject of his successful novel *Trilby* (1894). As well as illustrating novels by authors such as Elizabeth Gaskell and Wilkie Collins, Du Maurier was a social cartoonist at *Punch*, satirizing fashionable society and the Aesthetes were a popular target.

Henry Treffry Dunn (1838–99) Studio assistant and close friend of Dante Gabriel Rossetti. Dunn captured Rossetti's life at Tudor House, Chelsea, London, in a series of watercolours painted after Rossetti's death and in his 'Recollections of Dante Gabriel Rossetti and His Circle'.

Charles Locke Eastlake (1833–1906) Writer and museum keeper, Eastlake studied architecture, painting and sculpture before writing *Hints on Household Taste, in Furniture, Upholstery and Other Details* (1869), which was widely read in both Britain and America. This was followed by *A History of the Gothic Revival in England* (1872). In 1878 he was appointed keeper and secretary at the National Gallery, London.

Sir Robert Edis (1839–1927) Architect and writer who, through his designs and publications, promoted the Queen Anne style. In 1880 he delivered a series of lectures at the Royal Society of Arts, published the following year as *Decoration and Furniture of Town Houses*.

Peter Henry Emerson (1856–1936) Photographer who pioneered 'naturalistic' photography, blurring the periphery of the photograph to imitate human vision. After a brief career in medicine, Emerson began to publish albums of platinotype prints and photogravures such as *Life and Landscape on the Norfolk Broads* (1886) and *Marsh Leaves* (1895). In 1895 he was awarded the Progress Medal by The Royal Photographic Society.

Katherine (Kate) Faulkner (1841–98) Designer and craftswoman, Kate Faulkner was the sister of **Charles Joseph Faulkner (1833–92)**, an associate of William Morris who helped to form the decorating company Morris, Marshall, Faulkner & Co. Along with her sister Lucy she painted tiles for the company, decorated furniture and designed wallpaper and textiles. She also designed wallpapers independently which were manufactured by Jeffrey & Co.

Edward Onslow Ford (1852–1901) Sculptor specializing in portraiture and small-scale statuettes. He was influenced by the work of Alfred Gilbert and, like Gilbert, utilized the lost-wax casting process. Ford also produced mixed media sculptures using enamels and precious metals.

Sir George Frampton (1860–1928) Sculptor and decorative artist who produced memorials, portrait busts, architectural decorations and enamelled jewellery. A key figure in the Arts and Crafts movement, becoming Master of the Art Worker's Guild in 1902 and contributing articles to *The Studio* magazine. He sculpted the statue of *Peter Pan* (1912) for Kensington Gardens, London.

Harry Furniss (1854–1925) Caricaturist and illustrator whose works appeared in a wide range of periodicals such as the *Illustrated Sporting and Dramatic News*, the *Illustrated London News* and *The Graphic*. He spent fourteen years producing illustrations for *Punch*, specializing in sketches of politicians. Furniss also illustrated novels by authors such as Charles Dickens and collaborated with Lewis Carroll.

Ernest Gambart (1814–1902) Belgian-born print publisher and art dealer. From 1840 he settled in London where he imported and exported prints and published engravings after the work of the leading artists such as Alma-Tadema and Millais. He also opened a commercial gallery, the French Gallery, at 120/121 Pall Mall.

Agnes Garrett (1845–1935) and **Rhoda Garrett (1841–82)** The Garrett cousins, having worked as apprentices for the architect J.M. Brydon, established their own 'Art Decoration' business. They were influential promoters of the Queen Anne style and in 1876 published *Suggestions for House Decoration in Painting, Woodwork and Furniture*.

Georgina Gaskin (née France) (1866–1934) Designer and illustrator, trained at Birmingham School of Art where she met her husband and collaborator, **Arthur Joseph Gaskin (1862–1928)**. Together they specialized in the design and production of jewellery using semiprecious stones and enamelwork.

Sir Alfred Gilbert (1854–1934) Sculptor, goldsmith and the leading figure of the New Sculpture movement. Having learnt the lost-wax process in Italy, he was one of the first to re-introduce it to Britain. His best-known work is *Eros* (1885–93) in London's Piccadilly Circus.

Edward William Godwin (1833–86) Architect and designer, and a central figure in Aesthetic circles. He had an affair with the actress Ellen Terry, wife of the painter G.F. Watts, and was a friend of Whistler for whom he designed a house in Chelsea. The first architect of the Aesthetic London suburb, Bedford Park, Godwin also designed striking rectilinear Anglo-Japanese furniture.

Lord Ronald Gower (1845–1916) Sculptor and writer. Having relinquished his role as a Liberal politician, Gower created sculptures, such as the Shakespeare monument in Stratford upon Avon (1888), inspired by his passion for historical research. He also wrote popular historical texts.

Kate Greenaway (1846–1901) Illustrator and writer who created idyllic rural scenes of children in eighteenth-century-style dress. Her books, first published by Frederick Warne and subsequently by Edmund Evans, were a great commercial success and won the admiration of Ruskin, who was to form a close friendship with Greenaway.

John Atkinson Grimshaw (1836–93) Painter whose early work was influenced by the Pre-Raphaelite landscape paintings of fellow Leeds artist **John William Inchbold (1830–88)**. He went on to specialize in townscapes with a concentration on lighting effects, particularly moonlight, and created detailed paintings of figures in domestic interiors with Aesthetic furnishings.

Charles Edward Hallé (1846–1914) Painter and gallery director who founded the Grosvenor Gallery in 1877 with Sir Coutts Lindsay and Joseph Comyns Carr. After the Grosvenor suffered financial problems he and Carr established The New Gallery, Regent Street, with the support of painters such as Edward Burne-Jones.

Walter Hamilton (1844–99) Critic and bibliophile who wrote the first history of the Aesthetic movement, *The Aesthetic Movement in England*, in 1882.

Mary Eliza Haweis (née Joy) (1848–98) Author and illustrator of a series of manuals on the art of decoration and dress. In *Beautiful Houses* (1882) she described examples of well-known 'artistic' houses such as Leighton's at 2 Holland Park Road. In 1883 she bought Rossetti's former home, Tudor House, and renamed it 'Queen's House'.

Sir Hubert von Herkomer (1849–1914) Painter and illustrator whose illustrations appeared in periodicals such as the *Cornhill Magazine* and *The Graphic*. His oil paintings were predominantly scenes of poverty and Bavarian peasant life. He was also a successful portraitist: among his subjects was Ruskin, whom he succeeded as Slade Professor of Art at Oxford University in 1885.

John Postle Heseltine (1843–1929) Collector, etcher and Trustee of the National Gallery, Heseltine had a large collection of Italian bronzes and Old Master drawings. He was a friend of Edward Poynter and Charles Keene.

Joanna (Jo) Hiffernan (born *c*.1843) Artists' model Hiffernan had a six-year relationship with James McNeill Whistler and posed for many of his most important paintings, such as *Symphony in White No. 1: The White Girl* (1862). She acted as an agent for Whistler in the sale of some of his works.

Charles Holme (1848–1923) Magazine editor whose career began with importing Asian art and a partnership with Christopher Dresser, as Dresser & Holme (from 1879–82). In 1893 he founded *The Studio: An Illustrated Magazine of Fine and Applied Arts*, the first issue having a cover designed by Aubrey Beardsley.

Laurence Housman (1865–1959) Writer and artist, Housman contributed to Harry Quilter's *Universal Review*, the *Yellow Book* and was an art critic for the *Manchester Guardian*. He published poetry, novels and a number of plays. He was a friend of Charles Ricketts and Oscar Wilde and an ardent supporter of women's suffrage.

George Howard (1843–1911) 9th Earl of Carlisle, liberal politician, painter and patron, Howard was part of the 'Etruscan' school of painting producing landscape paintings inspired by Italy. Together with his wife **Rosalind (née Stanley) (1845–1921)** he moved in Aesthetic circles, forming close friendships with artists such as Burne-Jones. He commissioned Philip Webb to design his home at 1 Palace Green, Kensington, which had interiors decorated by Morris & Co.

Charles Augustus Howell (1840?–90) Artist's agent who worked for Ruskin, Rossetti, Burne-Jones and Whistler. He helped to handle debts, negotiations and lawsuits and was involved in some of the most controversial moments of their careers. He was an influential dealer of art and home decorations but he was also known for his double-dealing, alleged blackmail and art forgery. In1867 he married his cousin **Frances Kate (Kitty) Howell (died 1888)**.

William Holman Hunt (1827–1910) One of the founders of the Pre-Raphaelite Brotherhood. Influenced by Ruskin's book *Modern Painters* (1847), Hunt's paintings combined a belief in 'truth to nature' with religious symbolism. Many of his landscapes were painted out of doors and he travelled extensively in the Near East. His painting *The Light of the World* (1851–3) was frequently reproduced in editions of the Book of Common Prayer. His first wife, **Fanny Waugh (1833–66)**, died after only a year of marriage; Hunt, controversially, went on to marry her younger sister **Edith Waugh (1846–1931)**, who posed for many of his paintings.

Alexander Constantine Ionides (1810–90) Head of a Greek mercantile family who were avid art collectors. From 1864 their family home was at 1 Holland Park, where they employed Thomas Jeckyll to construct a new wing. Ionides and his wife **Euterpe Sgouta (1816–92)** had three sons and two daughters, who also mixed in artistic circles: **Constantine Alexander (1833–1900)** amassed a large collection of Old Masters and nineteenth-century French and British works of art which he left to the South Kensington Museum (now the V&A). 'Alecco' **Alexander (1840–98)** became a friend of Whistler, Poynter, Armstrong and Du Maurier while in Paris, and when he took ownership of the family home he employed Morris & Co. to redecorate the interiors. **Luke (1837–1924)** also formed a close friendship with Whistler, while **Aglaia (1834–1906)**, who married Greek businessman Theodore Coronio, was a close friend of Rossetti and Morris and also an embroiderer and bookbinder in her own right. The youngest daughter, **Chariclea (1844–1923)**, married the musician and conductor Edward Dannreuther.

Thomas Jeckyll (1827–81) Architect and designer, Jeckyll was a proponent of the Anglo-Japanese style. He designed interiors and furniture for 1 Holland Park, home of the Ionides family, and for 49 Princess Gate, owned by Frederick Leyland. He worked closely with the iron and brass foundry Barnard, Bishop & Barnard, designing garden furniture, fireplace surrounds, and their cast- and wrought-iron pavilion for the Centennial Exhibition, Philadelphia, in 1876.

Owen Jones (1809–74) Architect and designer responsible for the interior decoration of Joseph Paxton's Crystal Palace for the Great Exhibition of 1851. His work was influenced by Islamic art and architecture; he spent six months studying the Alhambra, and published *Plans, Elevations, Sections and Details of the Alhambra* (1842–5) on his own press. He worked with manufacturers to produce tiles, wallpapers and textiles but he exerted his greatest influence on the design world through his publication *The Grammar of Ornament* (1856).

Louise Jopling (née Goode) (1843–1933) Painter specializing in portraits of fashionable women such as Ellen Terry, Jopling exhibited at both the Royal Academy and the Grosvenor Gallery. She was a friend of Leighton and Tissot, and had her own portrait painted by Whistler and Millais. In 1888 she set up an art school for women at Clareville Grove, Kensington, and in 1890 published *Hints for Amateurs*.

Charles Keene (1823–91) Illustrator, chief social cartoonist for *Punch* and contributor to *Once A Week*. He also produced book illustrations, such as those for *The Life and Surprising Adventures of Robinson Crusoe* (1847), and etchings for which he received a gold medal at the Paris Exhibition in 1889.

Frederick Lehmann (1826–91) Businessman, musical connoisseur and art patron, and husband of the pianist **Nina Chambers (1830–1902)**. In 1872 they commissioned George Aitchison to decorate the interiors of their home at 15 Berkeley Square where they displayed their collection of watercolours by J.M.W. Turner and the portrait of their daughter, Nina Lehmann (1868–9) by Millais.

Sir Frederic Leighton (1830–96) 1st Bt, painter and sculptor who caused a sensation in 1855 when his first painting to be exhibited at the Royal Academy, *Cimabue's Madonna*, was purchased by Queen Victoria. Having travelled widely on the Continent, Leighton settled in London in 1859. Five years later he comissioned Aitchison to design a studio-house for him at 2 Holland Park Road, to reflect his increasing status. In 1878 he was elected President of the Royal Academy.

Frederick Richards Leyland (1831–92) Shipping magnate and art patron who founded the Leyland Shipping Line and used his wealth to collect Aesthetic paintings. He owned Speke Hall, a Tudor house outside Liverpool, and 23 Queen's Gate, London, where his art collection was carefully arranged in interiors decorated by Morris & Co. In order to house his growing collection he moved to 49 Princes Gate, refurbished by Morris & Co., Richard Norman Shaw and Thomas Jeckyll. Famously, Whistler transformed the dining room into the 'Peacock Room' without Leyland's full permission.

Sir Arthur Lasenby Liberty (1843–1917) Retailer who, having managed Farmer & Roger's Oriental Warehouse, set up East India House in Regent Street in 1875. This later became the Liberty department store which remains in business today. Liberty specialized in the importation of coloured Eastern silks, which inspired the production of Liberty fabrics, and worked closely with leading designers such as Christopher Dresser and Archibald Knox to develop a wide range of home furnishings.

Sir Coutts Lindsay (1824–1913) 2nd Bt, painter, gallery owner and co-founder of the Grosvenor Gallery at 135–7 New Bond Street, London, in 1877. This became the leading venue for the exhibition of Aesthetic works of art. It was supported financially by his wife, painter, musician and writer **Blanche Fitzroy (1844–1912)**. It was largely the collapse of their marriage that led to the gallery's financial problems and eventual closure in 1890.

Murray Marks (1840?–1918) Art dealer who specialized in the importation of Chinese blue-and-white porcelain. His London shop became a centre for collectors including Whistler and Rossetti. Marks was responsible for forming the porcelain collection of Sir Henry Thomson, illustrated by Whistler in *A Catalogue of Blue and White Nankin Porcelain* (1878). Marks supplied Frederick Leyland with the porcelain to display in the 'Peacock Room' and the antique Spanish leather that covered the walls.

George Francis (Frank) Miles (1852–91) Painter of portraits of fashionable members of society for *Life* magazine. In 1879 he commissioned the architect E.W. Godwin to design a house at 44 Tite Street, Chelsea, where he lived with Oscar Wilde.

Sir John Everett Millais (1829–96) 1st Bt, painter and the youngest student ever admitted to the Royal Academy Schools. It was here that he met Holman Hunt with whom he went on to form the Pre-Raphaelite Brotherhood. Putting their belief in 'truth to nature' into practice, Millais created controversial works such as *Christ in the Carpenter's Shop* (1850). As his career progressed his painting style changed to emphasize mood rather than narrative, with paintings of bleak Scottish landscapes, and he also painted a large number of portraits. In 1876 his palatial home at 2 Palace Gate, London, was completed, reflecting his growing wealth and status. In 1896 he became President of the Royal Academy.

William Cosmo Monkhouse (1840–1901) Poet and art critic, Monkhouse was a frequent contributor to *The Academy*, the *Magazine of Art* and the *Saturday Review*. He wrote a number of art historical publications such as *Masterpieces of English Art* (1869), *British Contemporary Artists* (1899) and *A History of Chinese Porcelain* (1901).

Albert Joseph Moore (1841–93) Painter of decorative murals in the early 1860s, often working in collaboration with the architect William Eden Nesfield. This decorative quality was transferred to his easel paintings, which depict classically draped figures in repetitive poses. In these paintings, such as *Azaleas* (1868), Moore concentrated on the formal qualities of line, colour and pattern rather than narrative content.

Mary (May) Morris (1862–1938) Designer and craftswoman, she was the second daughter of William Morris and Jane Morris (née Burden) and an important member of Morris & Co. where, from 1885, she managed the embroidery section. She specialized in needlework and published the book *Decorative Needlework* in 1893, but also mastered a range of crafts including jewellery making and bookbinding. In 1897–1910 she taught at the Central School of Arts and Crafts and in 1907 founded the Women's Guild of Arts.

William Morris (1834–96) Designer, writer and socialist, Morris trained as an architect, in the offices of G.E. Street, and as a painter, with the guidance of Rossetti, before beginning his prolific career as a designer of decorative furnishings. His only oil painting, *La Belle Iseult*, featured **Jane Burden (1839–1914)** whom he married in 1859. In 1861 he founded Morris, Marshall, Faulkner & Co. (later known as Morris & Co.), which produced a wide range of furnishings. Inspired by the writings of Ruskin and the art of the Middle Ages, Morris aimed to reunite the roles of designer and craftsman, reviving traditional skills and becoming an expert in designing patterns for textiles and wallpaper. He also had a successful career as a writer, was a key figure in the Socialist League, and founded the Kelmscott Press in 1891.

Albert George Morrow (1863–1927) Illustrator and cartoonist who specialized in the design of theatre posters. He also submitted illustrations to periodicals including *Good Words* and *Punch*.

William Eden Nesfield (1835–88) Architect, designer, and promoter of the Old English and Queen Anne Revival styles of architecture. He utilized these styles to create estate buildings, such as the lodge at the Royal Botanic Gardens, Kew (1866), and country houses. His early enthusiasm for the Gothic Revival and Continental travels informed his publication *Specimens of Medieval Architecture* (1862). He often collaborated with the artist Albert Moore and in 1863–76 shared offices with the architect Richard Norman Shaw.

Jane Ellen Panton (née Frith) (1847–1923) Writer and daughter of the painter **William Powell Frith (1819–1909)**, for whom she modelled, appearing in paintings such as *The Railway Station* (1861). She provided advice on domestic interior decoration and published instructive texts such as *From Kitchen to Garret* (1887) and *Homes of Taste* (1890).

Walter Pater (1839–94) Writer and tutor at Brasenose College Oxford, in 1868 he published an essay on 'The Poetry of William Morris' for the *Westminster Review*. The conclusion, which stated that the aim of life should be 'to burn always with this hard, gem-like flame', was reprinted in his *Studies in the History of the Renaissance* in 1873. This hedonistic lifestyle was adopted by the Aesthetes; Oscar Wilde referred to *Studies* as his 'golden book'.

Joseph Pennell (1857–1926) American illustrator, printmaker and writer who often collaborated on publications with his wife, **Elizabeth Pennell (née Robins) (1855–1936)**. While living in London they became friends of Whistler, and with his permission they wrote his biography, *The Life of James McNeill Whistler*, published in 1908 after the artist's death.

Sir Edward Poynter (1836–1919) Designer, educator and painter of scenes from ancient history rich in archaeological details. He also designed stained glass, tiles and mosaics, including the tiled Grill Room for the South Kensington Museum (now the V&A). He had numerous educational and administrative appointments, including Director and Principal of the National Art Training School in South Kensington, Director of the National Gallery in London and President of the Royal Academy. In 1866 he married **Agnes Macdonald (1843–1906)**.

(Henry) Thoby Prinsep (1792–1878) Member of the East India Co. and writer who married **Sara Pattle (1816–87)** in 1835. She was one of the seven Pattle sisters, who included the photographer Julia Margaret Cameron and Virginia, Countess Somers. They lived at Little Holland House, Kensington, where G.F. Watts stayed as a house guest for more than twenty years. Here Sara established a salon where guests included Robert Browning, Alfred Tennyson, Rossetti and Whistler.

Valentine Cameron Prinsep (1838–1904) Painter and son of Thoby Prinsep and Sara Prinsep (née Pattle), Val Prinsep benefited from the guidance of the artist G.F. Watts while he was a house guest at the Prinsep family home. He established friendships with George Du Maurier (who used him as the basis for a character in his novel *Trilby*, 1894), Edward Burne-Jones and Frederic Leighton, and commissioned Philip Webb to design his studio-house on Holland Park Road. He married Florence Leyland, daughter of the art patron Frederick Richard Leyland.

Harry Quilter (1851–1907) Art critic and opponent of the Aesthetic movement, Quilter contributed articles to a wide range of newspapers and periodicals, including *The Spectator*, *The Times*, and the *Cornhill Magazine*. He also founded his own periodical, *The Universal Review*. In articles such as 'The New Renaissance or Gospel of Intensity', which appeared in *MacMillan's Magazine* in 1880, he criticized the Aesthetic movement for being 'unhealthy'. He supported Ruskin in the 1878 Whistler v. Ruskin trial, and subsequently purchased and considerably altered Whistler's home, the White House in Chelsea.

Halsey Ricardo (1854–1928) Architect and designer, mainly of domestic buildings in the Arts and Crafts manner, and partner in William de Morgan's pottery from 1888 to 1898. His appreciation of glazed ceramics was evident in his architectural designs, such as 8 Addison Road, Holland Park, London (built 1905–7 for Ernest Ridley Debenham), where he used glazed bricks and tiles to produce a distinctive blue and green exterior.

Charles de Sousy Ricketts (1866–1931) Book illustrator, painter, sculptor and theatre designer who with his partner **Charles Haslewood Shannon (1863–1937)** founded the art journal *The Dial* featuring their own wood engravings; they went on to set up the Vale Press in 1894. Ricketts produced symbolist paintings and sculpture and designed extensively for the theatre.

Walford Graham Robertson (1866–1948) Dandy, gentleman-amateur and sometime pupil of Albert Moore, Robertson was at various times painter, stage designer and writer of children's books; he formed significant collections of Rossetti's late paintings and a major group of works by William Blake. His memoir, *Time Was*, remains one of the key documents of the 1890s.

James Anderson Rose (1819–90) Solicitor and art collector, Rose mixed in artistic circles, was solicitor for Rossetti and Whistler, and formed a collection of prints including a large number of Whistler's etchings. His sister-in-law, Grace Rose, was painted by Frederick Sandys (plate 142).

Dante Gabriel Rossetti (1828–82) Painter and poet, Rossetti was one of the founders of the Pre-Raphaelite Brotherhood; his painting *Girlhood of Mary Virgin* (1849) was the first he signed with the initials 'P.R.B.'. His early paintings, inspired by medieval art and legend, attracted the attention of Ruskin, who was to provide financial support for both Rossetti and his model and wife Elizabeth Siddal. Inspired by the paintings of Renaissance Venice and the model Fanny Cornforth, Rossetti adopted a more sensuous approach to painting and Ruskin's support waned. The sensuality of Rossetti's poetry also came under attack and, suffering from a breakdown, he retreated to the house he rented with Morris, Kelmscott in Oxfordshire. Here he resumed an affair with Jane Morris who forms the subject of his late paintings.

William Michael Rossetti (1829–1919) Art critic, brother of Dante Gabriel Rossetti and secretary of the Pre-Raphaelite Brotherhood, he edited the Pre-Raphaelite magazine *The Germ* and promoted their work, and paintings by avant-garde artists such as Whistler. He contributed articles to a wide range of periodicals such as *The Spectator*, *The Academy* and the *Saturday Review*. He was a close friend of Swinburne, with whom he wrote *Royal Academy Notes* (1868).

John Ruskin (1819–1900) Art and social critic whose writings, lectures and patronage informed the development of art and architecture in the second half of the nineteenth century. His publication *Modern Painters* (completed 1860), with its concept of truth to nature, influenced the Pre-Raphaelite painters, while *The Stones of Venice* (1851–3), with its celebration of the medieval craftsman, inspired Morris and Burne-Jones. Ruskin promoted the Pre-Raphaelite Brotherhood in the press and through patronage. He acted first as a promoter of Millais, who went on to have an affair with his own wife, **Euphemia (Effie) Chalmers Gray (1828–97)**, and then supported Rossetti and Elizabeth Siddal. His support was not, however, felt by all contemporary artists and he was sued for making disparaging comments about Whistler's 'Nocturnes'.

Edward Linley Sambourne (1844–1910) Illustrator and cartoonist for *Punch* for almost 43 years. He also illustrated books such as *Water Babies* by Charles Kingsley (1885). He decorated his home 18 Stafford Terrace, Kensington, now known as Linley Sambourne House (and open to the public), with Aesthetic furnishings.

Frederick Augustus Sandys (1829–1904) Painter and illustrator who was highly influenced by the work of Millais and Rossetti, to the extent that the latter accused him of plagiarism. He specialized in a new type of portraiture, crayon and ink drawings originally begun as preparatory sketches for oil paintings but quickly valued in their own right. Sandys also produced illustrations for periodicals such as the *Cornhill Magazine*.

John Pollard Seddon (1827–1909) Gothic Revival architect and furniture designer and intimate of the Rossetti circle, Seddon was an enthusiastic advocate of painted art-furniture.

Richard Norman Shaw (1831–1912) A pupil of G.E. Street, Shaw evolved from Gothic Revival beginnings to become the leading exponent of the 'Sweetness and Light' architecture of the Queen Anne Revival. His vast red-brick town houses in Hampstead, the elaborate terraces of London's Cadogan Estate and several large country house projects including Cragside for Lord Armstrong, represent the high-point of fashionable Aesthetic domestic architecture.

Elizabeth Siddal (1829–62) Painter and artists' model, Siddal sat to Walter Deverell, Holman Hunt and Millias. From 1852 she modelled exclusively for Rossetti, whom she married in 1860. Encouraged by Rossetti and Ford Madox Brown, and with the patronage of Ruskin, she began to produce her own drawings and watercolours. She died of an overdose of laudanum in 1862.

Arthur Silver (1853–96) Designer who set up a commercial design studio, the Silver Studio, in 1880. The studio produced pattern designs for wallpapers, textiles, carpets and book jackets in a wide range of styles for some of the leading manufacturers and retailers of the period such as Jeffrey & Co., Warner & Sons and Liberty & Co. The designs included Aesthetic patterns inspired by Japanese art.

Thomas Eustace Smith (1831–1903) Wealthy Newcastle shipping magante who married **Martha Mary Dalrymple (1835–1919)** in 1855. Known as 'Eustacia', she was the driving force behind their collection of Aesthetic art which included G.F. Watt's *Choosing* (1865) and Albert Moore's *A Garden* (1870). Eustacia was a friend of Leighton and chose his architect, George Aitchison, to decorate the interiors of their home at 52 Prince's Gate, London.

Simeon Solomon (1840–1905) Painter and close friend of Rossetti, Burne-Jones and Swinburne. His paintings and drawings explored the relationship between art and music, mysticism and sexuality, through the depiction of religious rituals and androgenous classical figures. With his arrest in 1873 for gross indecency, Solomon's reputation was ruined and he spent his final years in the workhouse.

Marie Spartali (later Stillman) (1844–1927) Painter and artist's model, Spartali came from a wealthy Greek family who mixed in artistic circles. She trained with the painter Ford Madox Brown and went on to specialize in watercolours inspired by the work of Rossetti and Burne-Jones. She also posed for these artists and for the photographer Julia Margaret Cameron. In 1871 she married the journalist and painter **William James Stillman (1828/9–1901)**.

John Roddam Spencer Stanhope (1829–1908) Painter who trained with G.F. Watts and quickly became part of the Pre-Raphaelite circle of artists. His work was influenced by his friendship with Rossetti and Burne-Jones as well as his increasing appreciation of Italian Renaissance art. In 1860 he commissioned the architect Philip Webb to design his home, Sandroyd in Surrey.

Marcus Stone (1840–1901) Painter of historic costume-pieces and genre scenes. His often saccharine and much-reproduced depictions of Regency beaux and belles, often erroneously classed as 'Queen Anne', enjoyed considerable popularity in suburban Aesthetic circles.

George Edmund Street (1824–81) Leading architect and influential theorist of the Gothic Revival, his buildings include the Law Courts in the Strand, London, and numerous churches. Philip Webb and William Morris first met whilst working in Street's office in 1856–7; John Pollard Seddon and Richard Norman Shaw were also pupils.

Algernon Charles Swinburne (1837–1909) Poet who was introduced to the Pre-Raphaelite artists while he was a student at Balliol College, Oxford, and they were painting the Oxford Union murals. When he moved to London Swinburne became part of their artistic circle, living with Rossetti at Tudor House, Chelsea, in 1862–4. He wrote poems to accompany paintings such as 'Before the Mirror' written for Whistler's *Symphony in White No. 2: The Little White Girl* (1864) and 'Laus Veneris' which inspired Burne-Jones's painting of the same name. The latter appeared in *Poems and Ballads* (1866), which caused great controversy due to its 'decadent' themes.

John Addington Symonds (1840–93) Writer who struggled with ill-health throughout his life and used his writings to campaign for a greater acceptance and understanding of homosexuality. His publications included *A Problem in Greek Ethics* (1873, published 1883), *A Problem in Modern Ethics* (1891) and a controversial translation of Michelangelo's sonnets.

Bruce James Talbert (1838–81) Architect and commercial designer who set up a design studio and employed assistants such as **George C. Haité (1855–1924)** and **Henry W. Batley (active 1872–1908)**. Talbert designed furniture, wallpapers, textiles and metalwork for the leading manufacturers such as Jackson and Graham, Jeffrey & Co., Brintons of Kidderminster and the Coalbrookdale Company. He also wrote decorating manuals such as *Gothic Forms Applied to Furniture, Metalwork and Decorating for Domestic Purposes* (1867).

Sir William Hamo Thornycroft (1850–1925) Sculptor who was part of the New Sculpture movement and a founder of the Art Workers' Guild. Thornycroft's approach ranged from classicism to realism. He created works on a monumental scale, sculptures which were intended as public memorials, and intimate pieces, bronze reductions of larger sculptures made for the domestic interior.

James Jacques Joseph Tissot (1836–1902) French-born painter and etcher who came to London during the Franco-Prussian war. From 1876 many of his elegant costume pieces and fashionable genre scenes featured his mistress Kathleen Newton, a consumptive whose suicide in 1882 led Tissot to abandon 'society' subjects in favour of laboured religious themes.

Frederick Walker (1840–75), Illustrator, wood engraver and painter of social realist scenes. Walker was a prolific contributor to the illustrated Gift Books of the 1860s and black-and-white journals such as *Once a Week* and the *Cornhill Magazine*. Best remembered for his graphic work, his pictorial advertisement for *The Woman in White* (1871) is considered one of the first 'artistic' posters.

George Frederic Watts (1817–1904) Painter and sculptor whose wide-ranging career included portrait paintings, social realist paintings, dynamic sculptures, mural paintings and 'symbolical paintings'. His success as an artist was supported by patrons such the Ionides family and Sara and Thoby Prinsep, with whom he stayed at Little Holland House. He would later commission the architect Frederick Cockerell (1833–78) to design his own studio-house in the grounds of this property. In 1864 he married the young actress **Dame Ellen Alice Terry (1847–1928)**, but the marriage was brief; in 1886 he married **Mary Seton Fraser-Tytler (1859–1938)**.

Theodore Watts-Dunton (1832–1914) Writer and poet who gave up his career as a solicitor to write literary criticism for *The Examiner* and *The Athenaeum*. He was a close friend of Rossetti and, in particular, of Swinburne, with whom he lived from 1879.

Philip Webb (1831–1915) Architect who looked to local vernacular traditions for inspiration and designed houses that influenced the development of the Arts and Crafts movement. Having met Morris while they both worked in the offices of G.E. Street, Webb went on to design Morris's home, Red House at Bexleyheath, Kent (1859–70). He designed furniture and stained glass for Morris, Marshall, Faulkner & Co., the company he founded with Morris; he was also founder of The Society for the Protection of Ancient Buildings.

James Abbott McNeill Whistler (1834–1903) American painter, printmaker and designer whose career was characterized by controversy. His emphasis on mood and colour harmonies rather than narrative content, reinforced by his use of musical titles such as 'Symphony' and 'Nocturne', was widely misunderstood by critics. In 1877 Ruskin accused Whistler of 'flinging a pot of paint in the public's face'. Whistler sued Ruskin for libel and won, but the cost of the court case, combined with Frederick Leyland's refusal to pay Whistler fully for his decorations of 'The Peacock Room' at 49 Princes Gate, left him in financial ruin.

Oscar Wilde (1854–1900) Writer who helped to popularize the Aesthetic movement. As early as 1877, while at Oxford University, Wilde wrote a review of the first exhibition at the Grosvenor Gallery for the *Dublin University Magazine*. In 1882 he carried out a lecture tour in the US and Britain, with papers on 'The Decorative Arts', 'The House Beautiful' and 'The English Renaissance'. He employed the leading Aesthetic artists such as Walter Crane and Aubrey Beardsley to illustrate his publications. In 1895 he was accused of sodomy by Archibald William Douglas, 8th Marquess of Queensberry, and was sentenced to two years' hard labour.

Honourable Percy Wyndham (1835–1911) Art patron with his wife, **Madeline Wyndham (née Campbell) (died 1920)**, and youngest son of Colonel George Wyndham, 1st Baron Leconfield of Petworth, Sussex. The Wyndhams were members of the circle of aristocratic art enthusiasts, The Souls. They commissioned the architect George Aitchison to decorate their home at 44 Belgrave Square, a scheme which included paintings by Leighton. Philip Webb designed their country house, Clouds in Wiltshire. Madeline Wyndham helped to found the School of Art Needlework.

David Wilkie Wynfield (1837–87) Painter and photographer, Wynfield was part of the St John's Wood Clique of painters who specialized in historical genre paintings. He took a series of photographs of artists, such as Burne-Jones, Watts and Leighton, dressed in medieval and Renaissance costumes; some of these photographs were published in *The Studio: a Collection of Photographic Portraits of Living Artists, Taken in the Style of the Old Masters, by an Amateur*.

NOTES

THE SEARCH FOR A NEW BEAUTY
Stephen Calloway

1 Morris and Burne-Jones took Rossetti's old rooms at 17 Red Lion Square in November 1856. A sketch by Burne-Jones (plate 69) shows their decorative effects, including hanging brass rubbings and some of their earliest attempts at painted furniture. The decoration and furnishings of Red House, Bexleyheath (Morris's home 1859–65) were markedly more sophisticated. Rossetti designed decorative schemes for his Chatham Place rooms in 1860, but elaborated his distinctive style of interiors following the move to Tudor House, Cheyne Walk, in 1862.
2 Hamilton 1882.
3 See Conway 1882. Conway's book, *Travels in South Kensington*, subtitled *Notes on Decorative Art and Architecture in England,* is, significantly, divided into two main sections on the South Kensington Museum and on the new decorative arts, followed by a short account of Bedford Park
4 For the Prinsep – Watts – Leighton set see Dakers 1999, esp. pp.19–40, 188–205, and Gere 2010, pp.137–57.
5 Cimabue's *Celebrated Madonna is Carried in Procession through the Streets of Florence [etc]*, oil on canvas, painted 1854–5; exhibited Royal Academy 1855; purchased by Queen Victoria for 600 guineas (collection HM The Queen).
6 On the 'Battle of *Hernani*' see Richardson 1969, pp.14, 15, 24, 27; Kelly 1976, pp.36–40.
7 For Swinburne and Baudelaire see Henderson 1974, pp.63–4; Swinburne's review of Baudelaire's *Les Fleurs du Mal* appeared in the *Spectator*, September 1862.
8 For a discussion of the intellectual origins of the Aesthetic Movement see Prettejohn 2007, and of Aestheticism in general, Prettejohn 2009.
9 In the section in *Modern Painters*, 1843–60, vol.2, on 'Ideas of Beauty', Ruskin described *Aesthesis* as 'the mere animal consciousness of pleasantness' (Ruskin 2010 edn, vol.4, p.47).
10 Buchanan 1871.
11 Pater 1873.
12 Ibid., p.viii.
13 John Ruskin, 'Letter 79: Life Guards of New Life', in *Fors Clavigera*, 7, July 1877 (Ruskin 2010 edn, vol.29, p.160).
14 See Whistler 1878.
15 Whistler's pamphlet war on the philistines ranged from the eloquent lecture *Mr.Whistler's 'Ten o'clock'* (privately printed 1885, published 1888) to catalogues of the works in his exhibitions in which the artist combatively quoted his critics against themselves; these included *Etchings and Dry points, Venice, Second Series*, 1883, and *Nocturnes, Marines and Chevalet Pieces*, 1891. The most substantial of his publications was *The Gentle Art of Making Enemies*, 1890.
16 The first Kelmscott volume was *The Story of the Glittering Plain*, 1891; the *Works of Geoffrey Chaucer*, the culmination of Morris and Burne-Jones's efforts, was finished only shortly before Morris's death in 1896.
17 In recognition of this encouragement, Beardsley presented to Burne-Jones the finest of his early drawings, *Siegfried, Act II*, 1893, pen and ink, with ink washes (V&A).
18 Charles Ricketts, *Oedipus and the Sphinx*, 1891, pen and ink (Tullie House Museum, Carlisle, Bottomley). When Ricketts delivered the commissioned drawing, Leighton showed him his studio, remarking 'I'm afraid you won't care for my work, but I am interested in yours' (quoted in Delaney 1990, p.46).
19 Alfred Gilbert, *Icarus*, 1884, bronze, exhibited Royal Acadeny, 1884 (The National Museum of Wales, Cardiff). Leighton, having seen Gilbert's earlier bronze *Perseus Arming*, offered him a £100 commission for a figure of any subject and treatment of his choice.
20 Baudelaire 1969 edn, p.29.

THE CULT OF BEAUTY: THE VICTORIAN AVANT-GARDE IN CONTEXT
Lynn Federle Orr

1 From *The Life of the Fields*, Jefferies 1884, p.13.
2 From 'The Critic as Artist' (1890), Wilde 1966 edn, p.1030.
3 Rossetti and Swinburne 1868, p.32.
4 Major publications on the Aesthetic Movement include: Aslin 1981; Spencer 1972; Lambourne 1996; Gere and Hoskins 2000; Prettejohn 2007; Teukolsky 2009; Gere 2010.
5 For a reassessment of the links between Aesthetic formalism and the canons of Modernism, see Teukolsky 2009.
6 In 1848 revolts shook Paris, Vienna, Berlin, Venice, Milan, and Rome.
7 A.W.N. Pugin, *True Principles of Pointed Architecture*, London 1853, p.34; quoted in Lubbock 1995, p.246.
8 Milner Gibson reported to the 1849 Parliamentary Select Committee on the School of Design, 'Upon the advantages of cultivating the taste of the people … and the moral and elevating influence of taste in legitimately attracting them from degrading objects and pursuits, it must be superfluous to dilate', *Journal of Design and Manufactures*, 2, p.33, quoted in Bizup 2003, p.117.
9 Matthew Digby Wyatt (1849), quoted in Pevsner 1968, vol.2, p.107.
10 *The Times*, 15 January 1851, quoted in Armstrong 2008, p.142.
11 Arnold 1869.
12 Rossetti and Swinburne 1868, p.32.
13 Pater 1877, *School of Giorgione*, p.111.
14 William Morris, 1880 lecture, 'The Beauty of Life', Morris 1910–15, vol.22, p.76.
15 Rossetti 2004 edn, p.26.
16 Muthesius 2009, p.245.
17 Morris 1987 edn, vol.2, p.227.
18 Quoted in Pevsner 1968, p.120.
19 More modest and cluttered, yet evocative of Aesthetic taste, is the Stafford Terrace, Kensington, home of cartoonist Edward Linley Sambourne, decorated in 1874 and newly renovated and reopened to the public.

20 Oscar Wilde, 1883 lecture: 'The Value of Art in Modern Life'.

21 Garrett 1876; Panton 1888.

22 For a reconstruction of Wilde's American tour lecture, see O'Brien 1974.

23 Ibid., p.409.

24 Morris 1882 lecture, 'The Lesser Arts of Life', in Morris 1910–15, vol.22, p.262.

25 O'Brien 1974, p.406.

26 Aslin 1969, p. 128.

27 Leighton *Addresses* 9, 10, quoted in Corbett 2004, p.90.

28 Wilson 2000, p.3.

29 Ibid., p.6.

30 Gere 2000 and Hoskins, p.28.

31 Wilde, 'The Critic as Artist' (1890), Wilde 1966 edn, p.1030.

32 Ibid., p.1058. On the impact of Darwin on the arts, see Eisenman 2008, and Donald and Munro 2009.

33 Wilde 1966 edn, p.1058. Darwin and others, including geologist Charles Lyell (1797–1875), challenged the biblical theories of divine creation and recast the Earth's age in terms of geological not biblical time. French historian and critic Ernest Renan (1823–92) took a historical rather than theological approach to *The History of the Origins of Christianity*; his widely read first volume, *The Life of Jesus*, portrayed Jesus as a man of gifted oratory but not divine origin. Renan followed German literary scholars, subjecting the Bible to structural and syntactical analysis, and concluding that it was a compilation of texts disparate in time, style, and voice, not a received text of divine origin. The Bible was also re-translated at this time, challenging the tenet of one authoritative version.

34 Bell 1914, p.177.

35 Prettejohn 2006, p.7.

36 On the critical legacy of Aestheticism, see Prettejohn 2006; Teukolsky 2009, pp.192–201.

37 Jefferies 1884, p.13.

1 LITERATURE AND THE AESTHETIC MOVEMENT
Susan Owens

1 Henry James, 'On Some Pictures Lately Exhibited', originally published in the *Galaxy*, July 1875, repr. in James 1956 edn, p.90.

2 Morris's poems 'A Tune of Seven Towers' and 'The Blue Closet' were published the following year in his 1858 collection, *The Defence of Guenevere and Other Poems*, which was dedicated 'to my friend, Dante Gabriel Rossetti, painter'. Swinburne's 'A Christmas Carol' was eventually published in *Poems and Ballads* in 1866.

3 Morris 1992 edn, p.72.

4 Quoted in Layard 1894, p.55.

5 Rossetti 1888, vol.1, p.304.

6 Swinburne 1870, p.577.

7 Burne-Jones 1904, vol.1, pp.234–5; Garrard 2007, p.81.

8 Wildman and Christian 1998, pp.162–3.

9 Marsh 1999, p.249.

10 Burne-Jones 1904, vol.2, p.135.

11 Wildman and Christian 1998, pp.162–4.

12 John Christian, cat. entry on *Laus Veneris* in Parris 1984, p.230.

13 Ibid.; Wildman and Christian 1998, pp.166–9 (p.168). The Venus and Tannhäuser legend was also explored by Morris, who included 'The Hill of Venus' in his cycle of narrative poems *The Earthly Paradise* (1868–70).

14 Henderson (1974) notes how Swinburne's descriptions of Rosamond could be applied to one of Rossetti's paintings of women: 'how she went / Holding her throat up, with her round neck out / Curdwise, no clot in it not smooth to stroke – / All night I shook in sleep for that one thing' (p.50). The story of Rosamond was also used at around this time as the subject of a watercolour by Burne-Jones: *Fair Rosamund* (1863; private collection).

15 Surtees 1971, no.48, p.15.

16 Letter from Swinburne to Pauline, Lady Trevelyan, 19 January 1861, in Lang 1959, pp.38–9. A fragment of the projected story exists.

17 See note by Kenneth Haynes in Swinburne 2000 edn, p.324; Surtees 1971, no.48, pp.15–16.

18 From 'A Ballad of Life', Swinburne 2000, p.3.

19 Théophile Gautier, preface (1834) to *Mademoiselle de Maupin* (1835), here quoted from Warner and Hough 1983, vol.1, p.164.

20 Swinburne did not see the original unexpurgated version until 1864, when his friend William Michael Rossetti gave him a copy.

21 Hyder 1972, p.30.

22 Ibid., p.28.

23 Clements 1985, p.55.

24 See Cachin, Moffett and Melot 1983, pp.146–50; Spencer 1998, pp.310–11.

25 Spencer 1998, pp.310–11.

26 When Whistler had the painting reframed in 1892 the verses were discarded.

27 Swinburne 2000, p.104.

28 Ibid., p.105.

29 Ibid., pp.251–2.

30 Here quoted from Warner and Hough 1983, vol.2, p.28.

31 'Dedication, 1865', in Swinburne 2000, pp.234–7 (p.236).

32 Kenneth Haynes, preface to Swinburne 2000, p.xv.

33 See Maxwell 2006, pp.29–30.

34 Edgar Allen Poe, 'The Philosophy of Composition', first published in *Graham's Magazine*, April 1846; here quoted from Warner and Hough 1983, vol.1, p.156.

35 Swinburne 2000 edn, p.162.

36 Ibid., p.57. 'Thou hast conquered, Galilean' were the legendary dying words of Julian the Apostate, nephew of Constantine I, the first Christian Roman emperor.

37 Ibid., p.48.

38 Ibid., p.122.

39 Quoted in Swinburne 2004 edn, p.xvi.

40 This deal was brokered by Swinburne's friend Charles Augustus Howell, the agent who also arranged the exhumation of Rossetti's manuscript poems from Lizzie Siddal's grave. Hotten shared Swinburne's interest in the literature of flagellation.

41 From a pamplet published in October 1866; here quoted from Warner and Hough 1983, vol.1, p.231.

42 Swinburne 1868, p.90.

43 Rossetti 1870, p.109.

44 Ibid., p.193.

45 From 'Dante Gabriel Rossetti', written in 1883, published in Pater 1889, p.215.

46 Buchanan 1871, 336–7.

47 Quoted in Warner and Hough 1983, vol.1, p.247.

48 G. Robert Stange uses the phrase 'expressive imitations' for these kinds of prose descriptions of the experience produced by a work of art, in Stange

1968, p.51; Richard L. Stein refers to the 'almost magical power' which this kind of ritualistic writing seems to confer upon the contemplation of a work of art; Stein 1975, p.12.

49 Quoted in Warner and Hough 1983, vol.2, p.59

50 Pater 1873, p.viii

51 Symons 1904, p.65.

52 From 'Leonardo da Vinci' in Pater 1873, pp.118–19. This sentence literally became poetry when W.B. Yeats chose to include it, arranged in *vers libre* with the lines broken at each anaphoric 'and', at the beginning of the 1936 edition of the *Oxford Book of Modern Verse*.

53 From 'The School of Giorgione', in Pater 1888, p.160.

54 The essay which became the 'conclusion' was first published, rather incongruously, as the end of Pater's review of three volumes of poetry by William Morris in the *Westminster Review* of October 1868.

55 Pater 1873, p.211.

56 From 'De Profundis', letter to Lord Alfred Douglas, January to March 1897, in Wilde 2000 edn, p.735.

57 Wilde 1966 edn, pp.1026–7.

Walter Pater (1839–1894)
Colin Cruise

1 Several of the chapters of the book had appeared previously as essays in periodicals such as the *Fortnightly Review*. The 2nd edn of 1877 omitted the controversial concluding chapter which was restored in the 3rd edn of 1888. For the development of the text see Donald L. Hill's edn of *The Renaissance* (1980), pp.207–76, quoted elsewhere in this piece. It reprints the 4th edn of 1893, noting textual variations from earlier editions.

2 Yeats 1955, p.130.

3 Pater 1980 edn, p.xxi.

4 Ibid., p.44.

5 Ibid., p.106.

6 Ibid., p.189

7 Mallock 1975, p.262.

2 AESTHETICISM IN PAINTING
Elizabeth Prettejohn

1 Pater 1980 edn, p.xx.

2 For further information on the picture and its title, from Boccaccio's *Decameron*, see Prettejohn 2007, pp.208–11.

3 'The Royal Academy', *Art Journal* (1 July 1869), p.198.

4 Colvin 1869, p.42.

5 Ibid., p.43.

6 Colvin 1877, p.829.

7 For further detail, see Elizabeth Prettejohn, 'Aestheticising History Painting', in Barringer and Prettejohn 1999, pp. 95–9.

Early Aesthetic Photography: Julia Margaret Cameron and David Wilkie Wynfield
Hope Kingsley

1 Editorial, 'The Late Exhibition of the Photographic Society', *British Journal of Photography*, 11 (19 August 1864), p.301.

2 'Photography and Fine Art', *Illustrated London News*, in *Photographic Notes*, 9 (1 April 1864), p.97; excerpt in Hacking 2000, p.16.

3 Hamerton [1860] 1889, pp.64–5, in Bartram 1985, p.132.

4 Editorial, *Photographic News*, 30 (13 August 1886), p.520.

The Musical Ideal in Aesthetic Art
Suzanne Fagence Cooper

1 Edward Dannreuther, *Macmillan's Magazine* (July 1876), p.193.

2 It is clear from Rossetti's use of the two different types of organs in other pictures that he was aware of the contrasting symbolism. For example, he included a small portative organ in his early work *The Girlhood of Mary Virgin* (1849; Tate Britain) as a sign of her sanctity. This instrument was drawn from Fra Angelico's *Linaiouli Tabernacle* (1433; Museo di San Marco, Florence). However, in his image of *Music* for *King René's Honeymoon* (c.1863, stained glass made by Morris and Company, V&A), Rossetti showed the newly-weds embracing across a larger positive organ, with the King working the bellows. The connection between portative organs and eroticism can be traced back to Titian's series of *Venus with a Musician*, (c.1550; Museo Nacional del Prado, Madrid).

3 H.R. Haweis, quoted in Ehrlich 1990, p.92.

4 Edward Burne-Jones to Kate Faulkner in Burne-Jones 1904, vol.2, p.112.

5 Haweis 1871, p.19. H.R. Haweis was an accomplished musician, who 'helped to introduce Wagner's music to English audiences' (*New DNB*). After D.G. Rossetti's death in 1882 he and his family moved into the artist's house in Cheyne Walk, Chelsea.

3 'THE PALACE OF ART': ARTISTS, COLLECTORS AND THEIR HOUSES
Stephen Calloway

1 'The Palace of Art', in Tennyson 1857, p.113.

2 Ruskin 1859, p.121.

3 'Style', in Pater 1890, p.14.

4 Tennyson 1857, p.113. Swinburne's dedication of *Poems and Ballads* (1866) to his friend Burne-Jones included the phrase '… receive in your palace of painting / this revel of rhymes'.

5 For a discussion of the history of artists' studios see Giles Waterfield, 'The Artists' Studio', in Waterfield 2009.

6 For an account of the development of studios and studio houses in Kensington and Chelsea see Walkley 1994, pp.58–97.

7 Quoted in Pennell 1908, vol.1, p.106.

8 Haweis 1882, p.iv.

9 Ibid., p.11.

10 On Leighton as a collector, see Bryant 2010.

11 Pennell 1908, vol.1, p.106.

12 Ibid., p.116.

13 Unidentified, anonymous press cutting, 19 September 1878. Quoted in Bendix 1995, p.155.

14 Letter to William Allingham, January 1861, in Fredeman 2002, letter 61.5

15 C.L. Cline (ed.), *Letters of George Meredith*, vol.1 (London 1970), no.16.

16 Rossetti Sale 1882:
Lot 100: 'A 6ft. couch with 2 loose squabs, upholstered in sage green stamped velvet and three panels at the back, "Amor", "Amas", "Amata" these figures and the other ornamental details were painted by Dante G. Rossetti'.
Lot 104: 'A curiously carved mahogany frame chair with cane seat, formerly belonging to the Chinese Giant "Chang"' Originally part of the stage-set of the Chinese giant exhibited in London by Barnhum, these chairs were acquired by Rossetti duing his phase of enthusiasm for oriental furniture. They are probably the only objects to have passed through the hands of all three chief members of the Pre-Raphaelite Brotherhood.

Lot 381: 'A very fine Japanese bronze of a bull'.
17 Dunn 1904, pp.35–7; for Mrs Haweis, see Howe 1967, pp.167–202.
18 Pennell 1908, vol.1, p.13.
19 Ibid.
20 Marillier 1899, pp.121–2.

Japonisme
Christine M.E. Guth
1 Swinburne 1888, p.746.
2 Wilde 2000a edn, p.173.

Blue-and-White China
Stephen Calloway
1 European connoisseurship developed slowly and until relatively recent times made insufficient and uncertain distinction between pieces of Chinese, Japanese (Arita) or other Asian origins. Consequently the naming of the various wares remained indiscriminate.
2 The extent of this trade can be gauged from the scale of the so-called Vung-Tau cargo, salvaged in 1993 from the wreck of a trading ship sunk off Batavia in 1690, which contained some hundreds of blanc-de-chine figures and dishes, but over 28,000 pieces of blue-and-white.
3 Queen Mary's blue-and-white included both true oriental wares, European-made imitations and pieces in baroque style, such as monumental tulip-pyramids from the Delft factory of Adrianus Kocks.
4 Apart from the royal palaces, English houses with significant early collections still extant include Dyrham and, most notably, Burghley.
5 'Long Elizas' derives from '*Lange Leizen*' (tall young women), the Dutch traders' name for the typical elongated straight-sided vases often decorated with female figures.
6 Most of Rossetti's collection was sold towards the end of his life in order to defray debts incurred during his lengthy illness. A number of pieces with identifiable Rossetti provenance are preserved in the V&A, Fitzwilliam Museum, Lady Lever Art Gallery, Port Sunlight, and at Wightwick Manor. In financial crises Whistler also sold numerous pieces at various times: an important lidded jar belonging to him is in the V&A, whilst the collection that remained in his possession at his death is preserved in the Hunterian Museum.
7 For Howell, see Angeli 1954; for Marks, see Williamson 1919. An unidentified newspaper obituary notice of Marks in 1918 (Cuttings File, Brighton History Centre) states that 'It was entirely due to the influence of Mr Marks that the cult of blue and white Chinese porcelain was established'.
8 Marks 1878.
9 See Anderson 2009, pp.219–54.
10 George Du Maurier, 'The Six-mark Teapot', in *Punch* (30 October 1880).

Leighton and Aitchison
Esmé Whittaker
1 'Obituary: Mr George Aitchison, R.A.', *The Times* (17 May 1910), p.10.
2 For a wider discussion of Aitchison's decorative schemes see Dakers 1999.
3 'House and Studio of F. Leighton, Esq., A.R.A., Kensington', *Building News*, 13 (1866), p.747.
4 Julian Hawthorne, *Shapes That Pass: Memories of the Old Days* (London 1928), p.135.
5 These ideas have been developed in Whittaker 2005.
6 Conway 1882, p.159.

The Aesthetic Movement and Architecture
Stefan Muthesius
1 Saint 1976; Girouard 1977; for Old English and Neo-Georgian elements in the interior see Muthesius 2009.
2 Morris 1882, p.214.

4 FURNISHING THE AESTHETIC INTERIOR: MANUALS AND THEORIES
Penny Sparke

1 Haweis 1889, p.2.
2 Nieswander 2008, p.2.
3 For a fuller account of the Design Reform Movement see Lubbock 1995, and of the Aesthetic Movement see Lambourne 1996.
4 For an overview of some of thee mediating forces see Edwards 2005.
5 See Felski 1995, and Bronner 1990.
6 Muthesius 2009, p.41; Ferry 2003, p.21.
7 Arguably it finds its most recent manifestation on our television screens in the form of 'makeover' programmes.
8 See, for example, Rev. J.P. Faunthorpe, *Household Science: Readings in Necessary Knowledge for Girls and Young Women* (London 1895) and L. Sutcliffe, *The Principles and Practices of Modern House-Construction* (London, Glasgow, Edinburgh and Dublin 1899).
9 Women's growing responsibility in this is described in Davidoff and Hall 1992.
10 See Hatt 2007.
11 Ibid.
12 See John Gloag's introduction to 1969 edition of *Hints on Household Taste*, p.v.
13 Eastlake is clearly addressing a female audience, evidenced by, for example, his reference to 'your boudoir' Eastlake 1969 edn, p.68.
14 For more detail on the misogynistic attitudes of several of the prominent design reformers, see 'Part One' in Sparke 1995.
15 Eastlake 1969 edn, p.vi.
16 Ibid., p.91.
17 Ibid., pp.84, p.123.
18 The 'Art at Home' series consisted of 12 volumes published by Macmillan between 1876 and 1883.
19 See Ferry 2003, p.27.
20 Ibid..
21 Ibid., p.26.
22 Ferry 2004.
23 Ferry 2003 p.24.
24 Haweis 1889, p.52.
25 Haweis 1882, p.iii.
26 Haweis 1878, p.225.
27 Edis 1881, p.15.
28 Ibid., p.1.
29 Ibid., p.21.
30 Ibid., p.14.
31 Ibid., p.24.
32 H.J. Cooper, *The Art of Furnishing on Rational and Aesthetic Principles* (London 1879), frontispiece.

Wallpapers
Gill Saunders
1 William Morris, 'Some Hints on Pattern-Designing' (1881), in Morris 1910–15 edn, 22, pp.195–6.

2 Described in a lighthearted summary of the style (1879, quoted by Lesley Hoskins in *The House Beautiful*, p.129) as follows: '...all the colours were in a low key – the wallpapers are more or less green...' and later dismissively characterized in E.M. Forster's *Howard's End* (1910; Penguin edn, 1969) as 'self-colour and self-denial' (p.153).

3 Metford Warner, lecture to the Art Workers Guild in 1896.

4 Mrs Humphrey Ward, *A Writer's Recollections (1865–1900)* (London 1918), pp.123–4; p.119.

5 Quoted in Lambourne 1996, p.121.

6 George Wardle, Morris's business manager, in his pamphlet *The Morris Exhibit at the Foreign Fair, Boston 1883–4*, pp.20–21, explained the Morris & Co. philosophy which asserted that 'panels formed by stripes or cuttings of wallpaper are futile decorations, as such, and they are ridiculous as architecture ... Our wallpapers therefore are simple fillings; they imitate no architectural features, neither dados, friezes, nor panellings.'

7 A total of 14, by Bruce James Talbert, Andrew Fingar Brophy, Brightwen Binyon and possibly other artists. Produced by Jeffrey & Co., *c.*1877–80. See V&A: E.652 to 665-1953 (cat. no.700 in Oman and Hamilton 1992). Several were exhibited by Jeffrey & Co. at the Exposition Universelle in Paris in 1878; V&A: E.657 (with a filling of bay leaves by A.F. Brophy) was awarded a gold medal at this exhibition.

Aesthetic Textiles
Sonia Ashmore

1 Macleod 1996, p.298.

2 *The Artist and Journal of Home Culture*, 1 (1880), p.275.

3 *The Artist and Journal of Home Culture*, 3 (1883), p.250.

4 *The Artist and Journal of Home Culture*, 1 (1880), p.244.

Art and Utility: Furniture Fit for Purpose
Frances Collard

1 Eastlake 1872, Preface, pp.viii–ix. The influence of his book, which ran into several edns, including the first American edn in 1872, encouraged British and American manufacturers to develop their own versions of the Eastlake style. In 1875 *The Furniture Gazette* commented on commercial confusion over 'Eastlake Furniture', American versions of which Eastlake repudiated in his Preface to the 4th edn of his book, 1878, p.viii.

2 Edis 1881, pp.103–4, pl.7. Jackson and Graham, praised for their economic artistic furniture by *The Cabinet Maker* in 1881, were also the cabinet makers responsible for the Juno Cabinet, designed by B.J. Talbert for the Exposition Universelle in Paris in 1878.

3 E.W. Godwin used these three titles for his designs in *Art Furniture* (1877). James Shoolbred & Co., a firm of house furnishers who quickly recognized the commercial potential of these new ideas for furniture, described their designs as 'Medieval', 'Old English' and 'Japanese' in their catalogue, *Designs of Furniture* (1876).

4 Soros 1999, pp.206–8, nos 330–32.

5 Donnelly 2001, p.919, pl.1. The corner cabinet, and other pieces of furniture, designed by Rhoda and Agnes Garrett for the Beale family in the late 1870s, are now at Standen, East Grinstead, Sussex. For an analysis of the importance of these pioneering lady decorators, see Ferry 2003.

6 Cook 1878, p.105, fig.39. His book was based on earlier articles published in *Scribner's Illustrated Monthly*, 1875–7. The same illustration of the corner cabinet by Cottier & Co. was included by Mrs Orrinsmith in *The Drawing Room* (1878), p.103.

7 *The American Architect and Building News* (1878), pp.198–9.

8 *The Cabinet-Maker* (1881), supplement, p.6.

9 Dresser 1873, p.72. Utrecht velvet, an embossed mohair plush which was very popular for upholstery, was probably supplied by Heaton & Co. of Manchester and sold by Morris, Marshall Faulkner & Co. from about 1871.

10 Smith 1876, pp.94–5, 129.

11 Edis 1881, pp.28–9, 156–7.

12 Soros 1999, p.186, no.307.

13 Shoolbred 1876, p.57, no.332.

14 Soros 1999, p.197, no.317.

15 Gillow & Co., Estimate Sketch Book, April 1880, no.10809 (City of Westminster Archives Centre, London). The artistic and healthy character of compact multi-functional and built-in furniture for bedrooms and dressing rooms, particularly that available in the showrooms of Jackson & Graham, was one of Edis's themes in his book, *Healthy Furniture and Decoration*, chap.3, p.67.

Ceramics
Sonia Solicari

1 Probably exhibited at the International Electric Exhibition at Crystal Palace London, 1881–2, in the 'Early English Reception Room' furnished by William Watt & Co. for the Domestic Lighting Company Ltd. See Arbuthnott 1999, p.300.

2 Eyles 2002, p.82.

3 Rhead 1906, p.60. See also Dunn 1984, p.14, for reference to Rossetti's taste for delft tiles in the 'serious comic' manner.

4 Hamilton 1997, p.70.

Aesthetic Metalwork
Eric Turner

1 Jervis 1983, pp.102, 169–70.

2 Pevsner 1960, pp.54–5.

3 Pevsner 1937, pp.183–6.

4 Dresser 1995, pp.138–42.

5 Ibid., p.151.

6 For a detailed discussion of this aspect of Dresser's design philosophy, see Metcalf and Turner 2002.

7 For a detailed analysis, see Rudoe 2005.

8 Soros and Arbuthnott 2003.

9 Merrill 1998, p.161.

10 Culme 1977, p.206.

5 THE GROSVENOR GALLERY, PATRONAGE AND THE AESTHETIC PORTRAIT
Barbara Bryant

1 Rossetti's *Bocca Baciata* (Museum of Fine Arts, Boston), exhibited at the Hogarth Club in 1860, heralded new directions in contemporary art; works such as the portrait of Maria Leathart (1862; private collection), the wife a Newcastle collector, adopted the same format.

2 See my discussion of this key work in Bryant 2004, no.44 and the essay 'Subtle Alchemy: The Portrait Painter as Poet' in the same catalogue, pp.27ff.

3 Whistler never completed the work on large scale; versions are at The Hugh Lane, Dublin, and The Art Institute of Chicago.

4 A drawing of 1865 is in the Fogg Art Museum, see Wolohojian 2003, no.185.

5 The version of this quotation given in Prettejohn 2003, pp.200–201 seems the closest to the intended meaning.

6 Elzea 2001, p.184. Sandys also painted the portrait of the mother of James and William Rose, Susanna Rose (1862; RA 1863; Cleveland Museum of Art) and drew William's portrait (1875; Ackland Art Museum, Chapel Hill, North Carolina). On the jewellery worn by Grace Rose, see Gere and Rudoe 2010, pp.184–5.

7 Percy was the second son of Baron Leconfield of Petworth and Madeline was the daughter of an Irish baronet.

8 See Dakers 1993, pp.23ff., for a detailed account of the Wyndhams and their early patronage, much influenced by Madeline's friends, the Earl and Countess of Airlie and the Howards.

9 See my discussion in Bryant 2004, no.54.

10 Madeline's artistic interests included needlework: she commissioned designs from Aitchinson and Burne-Jones and was one of the founders of The School (later Royal School) of Art Needlework in 1872; see Dakers 1993, pp.39–40.

11 He began his collecting of oriental ceramics in 1867; one famous Chinese blue-and-white double gourd vase of the Yuan dynasty (fourteenth century) acquired much later is still known as the Alexander Vase.

12 For this scheme, see Dorment and Macdonald 1994, pp.162–3.

13 See Merrill 1998, pp.151–3.

14 Illustrated in colour and discussed in Staley 2004, p.8, pl.10 and p.9.

15 Merrill 1998 provides a comprehensive discussion of this project; see also Richard Dorment's review, 'Contretemps at Prince's Gate', New York Review of Books (10 June 1999), and Greenacombe 2000, pp.198–204. For a contemporary reaction see E.W. Godwin's article in The Architect, partly reprinted in Kinchin and Stirton 2005, pp.244–7.

16 Leyland had a considerable collection of works by Burne-Jones, including The Wine of Circe, Phyllis and Demophoön, the set of the four seasons, and Night and Day; see Wildman and Christian 1998, pp.108–9.

17 MacDonald, Galassi and Ribeiro 2003, pp.95–115.

18 The Correspondence of James McNeill Whistler, online edn, University of Glasgow no.02568.

19 Thus prompting Rossetti's mischievous remark on 22 June 1874: '… WHAT a haul you did make with that blessed Leighton, the frame did it! You must feel rather tempted to give up buying other pictures to keep, & buy nothing but Leightons to sell' (Fennell 1978, p.66). It sold for £2677. The comment also indicates the nature of the rivalries among contemporary artists at this time, as does his further jibe, '…the thing [Syracusan Bride] is really bad even of its own kind' (Fenell 1978, p.105).

20 The secondary sources on the Grosvenor Gallery include Newall 1995 (with lists of exhibitors); Casteras and Denney 1996, in particular (for the purposes of this study) the essays by Paula Gillett, John Siewert and Barbara Bryant; Denney 2000; Merrill 1992.

21 The columns came from the foyer of the old Opera Comique in Paris. See Tom Taylor's review in The Times (1 May 1877), p.10; see also Casteras and Denney 1996, p.17, and Surtees 1993, p.220 n.44, in which J.G. Links proposed that the portal came from another church by Palladio.

22 From a journal with a wider remit than simply the art at the exhibition, the writer for The Builder (28 April 1877, p.424) readily enumerated the sums involved: the building cost £30,000; the total outlay inclusive of decoration was £120,000 with the Lyons silk on the walls alone costing £1,000.

23 The crimson colour on the walls was widely seen as too strong for many of the paintings; it suited Watts's dark, glowing images but works by Burne-Jones and Whistler suffered. The next year the organizers adjusted it to sage green; see Newall 1995, p.15.

24 Halle 1909, p.110.

25 Crane 1907, p.176.

26 The practice of including lenders' names in the catalogue was employed only for the first year.

27 James Tissot exhibited 10 works, Ferdinand Heilbuth 12, others included Giovanni Costa, Otto Weber, Alphonse Legros, Gustave Moreau and naturalized foreigners such as Whistler and Alma-Tadema; on the international character of the exhibition see my discussion, 'G.F. Watts at the Grosvenor Gallery: "Poems Painted on Canvas" and the New Internationalism', in Casteras and Denney 1996, pp.117–21.

28 Bryant 2004, no.55 for a full discussion of the creation of the work. Watts retained it for his own collection and displayed it prominently in his gallery at Little Holland House until c.1890, when he gave it to Blanche.

29 Blanche's poetry, published after the Grosvenor years, contains one example, 'The Violinist's Farewell' (The King's Last Vigil and Other Poems, London 1895), with an elegiac recollection of performances in the past. My thanks to Stephen Calloway for drawing my attention to this poem and to Edwina Ehrman for her comments on Blanche's dress.

30 Coutts's portrait of Blanche is now unlocated, although it may well be the one illustrated in Henrey 1937, opp. p.184. Joseph Jopling's portrait of 1874, a watercolour, is in the National Portrait Gallery, London; for Howard's portrait drawing of Blanche posing with her violin see Stetz 2007, pp.74–5. These all show her posed with rather than playing her violin.

31 As he also noted, his companion commented 'The lady looks as if she had thirty thousand pounds a year'. James's article was originally published in The Galaxy, August 1877, repr. in James 1956 edn, pp.142–3.

32 Colvin, who was also Director of the Fitzwilliam Museum, Cambridge, discussed Burne-Jones in 'The Grosvenor Gallery', Fortnightly Review, 27 (1877), p.826.

33 See Oscar Wilde on Burne-Jones in 'The Grosvenor Gallery', Dublin University Magazine (July 1877), pp.122–3.

34 George Fraser, Architectural Review, 10 (August–September 1877), p.150.

35 Fortnightly Review, 27 (1877), p.826.

36 Cosmo Monkhouse, 'Edward Burne-Jones', Scribner's Magazine, 15 (1894), p.143.

37 The Times (1 May 1877), p.10.

38 Henrey 1937, p.201.

39 For Watt's phrase 'poems painted on canvas', originally used in his article 'The Present Conditions of Art' of 1880, see my essay in Casteras and Denney, pp.109ff.

40 The Times (1 May 1877), p.10; The Builder (5 May 1877), p.440.

41 One, Harmony in Amber and Black, evolved into Arrangement in Black and Brown: The Fur Jacket (1876; Worcester Art Museum) and the other, Harmony in Amber and Black (c.1876; Portland Museum of Art) has been identified as the work later titled Portrait of Miss Florence Leyland.

42 The character appeared in Tennyson's verse play, Queen Mary Tudor, which ran over April and May 1876, see Dorment and Macdonald 1994, no.64.

43 Dorment and Macdonald 1994, p.149.

44 Saturday Review (12 May 1877), p.581.

45 See Merrill 1992 for the definitive account of the Whistler v. Ruskin trial which took place in November 1878.

46 The Academy (26 May 1877), p.467.

47 Douglas Freshfield, better known for his later mountaineering exploits, collected widely, acquiring Whistler's self-portrait in his studio in the 1890s. Richmond's portrait of Mrs Freshfeld is illustrated in colour in Reynolds 1995, pl.XI.

48 In 1870 the Marquess of Westminster, who inherited the Dukedom in 1874, commissioned Watts's colossal equestrian sculpture of his Norman ancestor, Hugh Lupus, for Eaton Hall and also commissioned sculpture from Jules Dalou.

49 These works, including the portrait of the third sister, Louisa Baldwin (1868; private collection) are illustrated in Flanders 2001, following p.104; the portrait of Georgiana is well known, illustrated in Wildman and Christian 1998, p.193.

50 It is now possible to identify Kate Carr as the Slade-educated sister of Joseph Comyns Carr. That he had a sister is mentioned in his wife's memoirs (Carr 1926, p.28). My thanks to Lord Vinson and Pip Witheridge for providing me with photographs of the portrait.

51 Hamilton 1882, p.30.

52 Crane described one such fancy dress ball in their new house, which he attended dressed as Cimabue and Whistler as a Spanish cavalier in black, sporting a large sombrero (Crane 1907, p.200).

53 Gere and Rudoe 1984, vol.1, p.141 and vol.2, p.241; see also Munn 1984, pl.6, p.19, for the demi-parure of ancient silver coins in gold mounts in archaeological taste. The pendant would normally be suspended from a gold chain, so the use of the yellow ribbon was the sitter's own choice. See also Gere and Rudoe 2010, p.428.

54 Frith 1887, vol.2, p.256.

The 'Aesthetic' Woman
Margaret D. Stetz

1 Ruskin 2002 edn, p.80.
2 Blunt 1975, p.110.
3 Dixon 2004 edn, pp.102–3.
4 Asleson 2000, p.166.
5 Haweis 2004 edn, p.225.
6 Whittington-Egan 2008, p.103.

Artists' Frames
Lynn Roberts

1 See Asleson 2000, pp.45, 51 and 58.

Much in Little Space: Whistler's White and Yellow Exhibition as an Aesthetic Movement Bell-wether
David Park Curry

1 *New York Times,* 25 April 1881. The unsigned article reviews Clarence Cook's book, *What Shall We Do With Our Walls?* published that year by Warren Fuller & Co., a New York wallpaper manufacturer.

2 Using his own Asian objects as props Whistler began making flatly designed figure paintings in 1863. They overlap more abstract 'moonlights' (later called 'nocturnes') of the 1870s, in which he gradually incorporated principles of Japanese art.

3 For a discussion of the cartoons and their meaning, see 'Punch and Jimmy', in Curry 2004, pp.220–61.

4 Victorian journalists were well aware that notoriety sells. In one cartoon, the unctuous retailer of 'The Newest Thing in Wall-Papers' informs potential customers: 'This is artistic, sir. A nocturne in blue and silver. Starlight at Stepney, treated decoratively. P'raps you read what Mr. Frith said about our goods at the Whistler trial, sir? Awfully down on Whistler. Brought us a lot of custom' (*Judy,* 11 December 1878).

5 Whistler and Du Maurier shared a studio at 70 Newman Street, London, in 1860.

6 Burns 1996.

7 Particularly in the 'Ten O'Clock' lecture of 1885. For discussion, see 'A Little White Paper', in Curry 2004, pp.262–315.

8 Merrill 1998.

9 Godwin and Whistler probably met in 1863. Young 1980, vol.1, p.lx.

10 Denny 2000.

11 Merrill 1992.

12 See 'Houses Beautiful', in Curry 2004, pp.114–63.

13 The shows took place in 1880, 1881, and 1883. See 'Coda', in Curry 2004, pp.316–87. See also Curry, 'Total Control: Whistler at an Exhibition', in Fine 1987, pp.67–82.

14 For similarly decorated Impressionist exhibitions in France, see Ward 1991. Unlike the French shows, Whistler's work had almost immediate impact, doubtless because of the international publicity generated as well as the new ideas showcased.

15 The theatrical design included white felt walls picked out with stencilled yellow lines and butterflies, canary-yellow ledge and skirting board, 'perilous little cane bottom chairs' on straw-coloured matting, various potted yellow flowers, including, appropriately for Whistler, narcissi – not to mention the 'poached egg', an attendant clad in a rented yellow and white costume derived from Regency clothing.

16 Conforti 1986, pp.2–35. A co-founder of what is now the Minneapolis Institute of Arts, Bradley insisted that one of the galleries be decorated in the Whistlerian yellow he had seen in London. Isabella Stewart Gardener's Whistlerian yellow room at Fenway Court is still extant.

6 AESTHETICISM IN THE MARKETPLACE: FASHION, LIFESTYLE AND POPULAR TASTE
Christopher Breward

1 Cohen 2006, p.68.
2 Dellamora 1999.
3 Cohen 2006, p.86.
4 Frith 1887, p.256.
5 Newton 1974, pp.87–8. See also Cunningham 2003 and Ehrman 2006, pp.127–9, for more recent discussions of Aesthetic dress.
6 Wilson 2000.
7 Gere and Hoskins 2000, pp.26–7.
8 Adburgham 1975, p.31.
9 Adburgham 1989, pp.177–83.
10 Ibid., pp.69–70.
11 Ibid., p.74.
12 Ibid., p.75.
13 Pearsall 1972, p.54.
14 Gere and Hoskins 2000, p.88.
15 Cohen 2006, p.79.
16 Ibid., p.80.
17 Gere and Hoskins 2000, p.95.
18 Blanchard 2003.
19 De la Haye, Taylor and Thompson 2005. See also Breward 2005, pp.159–67 and 217–28.
20 Flanders 2003, pp.28–62.
21 Maltz 2006.
22 Cohen 2006 pp.83–4.

Women's Dress

Edwina Ehrman

1 For a selection of writing on dress by these authors, see Stern 2004.

2 See, for instance, Haweis 1879, p.97.

3 'Dress at the Private View of the Grosvenor Gallery', *The Queen* (7 May 1881), p.466.

Jewellery

Clare Phillips

1 Wilde 1928, p.169.

2 Burges 1865, p.64.

3 'A Young Lady on the High Classical School of Ornament', *Punch* (16 July 1859), illustrated in Bury 1991, vol.2, pl.233.

4 Burges 1865, p.66. Jewellery shown by Green at the International Exhibition of 1862 featured in the *Art Journal Illustrated Catalogue*, where it was praised for its 'good taste and artistic workmanship' and for its bringing 'grace and beauty within the reach of ordinary purchasers'. See Bury 1991, p.455.

5 The armlet appears in Sir Lawrence Alma Tadema's paintings *The Sculpture Gallery* of 1874 (Hood Museum of Art, Dartmouth College, NH), and *The Frigidarium* (private collection) of 1890. I am indebted to Jeff Cadby for sharing his research on this piece.

6 My thanks to Charlotte Gere, whose unpublished lecture 'Jewels for Helen of Troy: Victorian *Femme Fatale*' details these events and provides fascinating context to the archaeological jewellery of the late nineteenth century.

7 I would like to acknowledge Judy Rudoe's identification of the Indian rather than classical origin of the necklace plaques in the Giuliano necklace similar to that worn by Poynter's *Helen of Troy*.

8 Haweis 1878, p.104.

9 Ibid., p.104.

10 Burges 1865, p.58.

11 Acquisition of the Castellani collection of Italian regional jewellery from the Paris Exposition of 1867 and of extensive displays of traditional jewellery from the International Exhibition, London, in 1872.

12 *The Queen* (29 September 1883). I am most grateful to Jane Perry for allowing me to consult her forthcoming article, 'Wanted, real silver bangles, must be foreign ones, Egyptian especially wanted: The Victorian passion for peasant jewellery', to be published in *Jewellery Studies*.

13 Haweis 1879, p.97.

14 Haweis 1879, p.83.

15 Gere and Munn 1989, p.61.

16 Bury 1991, p.471.

17 Haweis 1879, p.97.

18 Ibid., p.95.

Oscar Wilde

Susan Owens

1 From '1880', in Beerbohm 1896, p.46.

2 Wilde's lecture 'The English Renaissance' was divided *en route* into two lectures, 'The Decorative Arts' and 'The House Beautiful'.

3 Pater 1889, p.213.

4 From a lecture given by Matthew Arnold in 1864, as Oxford University's Professor of Poetry, on 'The Function of Criticism at the Present Time'.

5 Pater 1873, p.viii.

6 Wilde 1966 edn, p.1027.

***Patience* and the Theatre**

Catherine Haill

1 Adapted by James Albery from a German play by Herr Sonthan.

2 *The Era*, 28 November 1880.

3 Whistler had already featured as Pygmalion Flippit in John Hollingshead's play *The Grasshopper*, Gaiety Theatre, 10 December 1877, adapted from *La Cigale* by Meilhac and Halévy. Whistler came to rehearsals and approved the dialogue.

4 D'Oyly Carte had entered into an agreement with Henry Abbey of Booth's Theatre for Gilbert and Sullivan to write their next piece for an American opening at Booth's Theatre New York on 29 November 1880.

5 'Dear Albery, I gather from the notices of your new piece, produced at the Criterion last night, and called *Where's The Cat?*, that you have made good capital out of the eccentricities of the modern school of lily-bearing poets. By an odd coincidence, I have completed the greater part of a libretto of a two-act opera (designed six months ago) in which this preposterous school plays a very prominent part. I mention this as, otherwise, you might reasonably suppose, when the piece comes to be played, that it was in some way suggested by a successful character in your comedy' (Sunday 22 November 1880).

6 When *Patience* eventually opened in America, its producer D'Oyly Carte employed Oscar Wilde for a year-long series of lectures in the United States; see pp.216–17.

7 Letter, Gilbert to Sullivan, 1 November 1880.

8 'The Rival Curates', published in *Fun*, 19 October 1867.

9 The Gilbert Papers, British Library.

10 'The Ladies of the Lea', another *Bab Ballad*, features a female chorus of adulation.

11 Gilbert later changed Grosvenor's name to Archibald.

12 Letter, Gilbert to Sullivan 1 November 1880.

13 Editor of *Punch* and a former librettist of Sullivan. He based his play on the French play *Le Mari à la Compagne* by M. Bayard and Jules de Vailly, previously seen on the London stage as *The Serious Family*, another version by M. Barnett.

14 The evident influence of *Punch* prompted the magazine *Fun* to suggest acknowledging Du Maurier as co-author.

15 For Mr Forrester's house, Acts 1 and 3. Described in the stage directions as being 'in the severest aesthetic taste'.

16 Letter, Wilde to Grossmith, April 1881.

17 George Grossmith created the role of Archibald Grosvenor.

18 Based on the milkmaid's costume in Luke Fildes's painting *Where Are You Going To, My Pretty Maid?*

7 'TIRED HEDONISTS': THE DECADENCE OF THE AESTHETIC MOVEMENT

Stephen Calloway

1 Anon. [George Du Maurier], 'The rise and fall of the Jack Spratts. A tale of modern art and fashion', part I, in *Punch*, 75 (7 September 1878), pp.98–100; part II (14 September 1878), pp. 110–12; part III (21 September 1878), pp.122–4; part IV (28 September 1878), pp.134–5; part V (5 October 1878), pp.154–5; part VI (12 October 1878), pp.159–60; part VII (19 October 1878), pp.178–9; part VIII (26 October 1878), pp.183–4. Du Maurier's authorship is confirmed by the appearance of the series in the 'collected edition' of his satires, *A Legend of Camelot: Pictures and Poems,* London, 1898; I am grateful to Leonee Ormond for this reference.

2 *Punch*, 75 (7 September 1878), p.122.

3 Ibid., p.123.

4 Rossetti 1870.

5 Buchanan 1871.

6 Ibid., pp.336–7.

7 For Solomon, Cory and Browning, see Reade 1970, esp. pp.10–18.

8 Pater 1873 (3rd edn 1888). Pater's explanation of the changes made to his text for the 2nd edn (1877) is appended as a note to the 3rd edn, published as *The Renaissance, Studies in Art and Poetry* (London 1888), p.232.

9 W.G. Blaikie Murdoch, *The Renaissance of the Nineties* (London 1911); here quoted from Muddiman 1920, p.2.

10 *Punch*, 70 (5 February 1876).

11 Harry Quilter, 'The Palace of Art', *Spectator* (6 March 1880); 'Fashion and Art, or Spots on the Sunflower' in *Spectator* (1881); both articles were reprinted in Quilter 1909; for a discussion of these articles see Anderson 2005, pp. 335–55.

12 Quilter 1909, p.57.

13 Symons 1893.

14 William Butler Yeats, 'The Tragic Generation', in *The Trembling of the Vale* (London 1922); repr. in Yeats 1955 (new edn 1961).

15 Ibid., p.302.

16 Le Gallienne 1926, pp.142–3.

17 Praz 1970.

18 Yeats 1898, p.234.

19 Pater 1885, vol.1, p.172.

20 Wilde 1891, p.7.

21 In the two 'Toilette of Salome' illustrations in *Salome*, Beardsley specifically satirized Wilde's outdated taste for Godwin-style black furniture. On this point and on the relationship of Beardsley and Wilde's as illustrator and author in general, see Owens 2002, pp.136–54 and *passim*.

22 *Westminster Gazette* (18 April 1894), p.3.

23 The standard account of the Wilde trials is to be found in Hyde 1948; a fuller and more accurate transcript of Wilde v. Queensbury is reprinted in Holland 2003.

24 Muddiman, 1920, p.35.

Religion and Sexuality
Colin Cruise

1 Nordau 1895, p.77.

2 Ibid.

3 'In Earnest', *Punch*, 32 (7 January 1882), p.12.

4 Ibid.

5 Text as printed in Fong and Beckson 2000, p.194.

6 For an account of the connections made between Ritualism and homosexuality, see Hilliard 1982.

7 For a discussion of Solomon's works and their religious context see Cruise 2005, pp.57–63.

8 For a discussion of the notion of sin for British Aesthetes, see Hanson 1997, chap.1, pp.27–107. For an account sexual of difference and Catholicism in nineteenth-century English literature, see O'Malley 2006.

Late Paintings
Elizabeth Prettejohn

1 See Andrew Wilton, 'Symbolism in Britain', in Wilton and Upstone 1997, p.11.

2 I owe this insight to Sam Smiles, whose forthcoming book *Turner's Last Paintings: The Artist in Old Age and the Idea of Late Style* shows that the concept of 'late style' became important in art-historical scholarship at around this date.

3 These allusions were first suggested by Robyn Asleson (Asleson 2000, pp.180–82).

4 See Østermark-Johansen 1998.

5 Walter Pater, 'A Fragment on Sandro Botticelli', *Fortnightly Review*, n.s. 8 (1 August 1870), pp.155–60, repr. in Pater 1980 edn, pp.39–48.

6 For further details see Treuherz et al. 2003, p.216.

7 *Summer Slumber*, exhibited Royal Academy 1894, private collection; the pose of *Flaming June* is adumbrated in a figure represented as a relief sculpture in this painting.

The New Sculpture
Robert Upstone

1 Gosse 1894.

2 Hatton 1903, p.10.

3 McAllister 1929, p.145.

4 Spielmann 1901, p.1.

5 See Edwards 2006.

6 Gosse 1895.

'The Cult of Indistinctness': Art Photography in the 1890s
Hope Kingsley

1 *The Globe*, 'The Future of Amateur Photography', *British Journal of Photography*, 37 (31 October 1890), p.696.

2 Debenham 1891, p.8.

3 'A Befogged Dry Plate Spoiler and Developer Waster', *Amateur Photographer*, 10 (27 September 1889), p.202.

4 Hinton 1897, p.94.

5 Maskell 1891, p.142.

6 Eastman Company advertisement, 'Kodak No. 2' camera, 1890–91.

The Book Beautiful
Stephen Calloway

1 For gift-books and the design of Victorian books in general, see McLean 1972.

2 Rossetti's illustration first appeared in William Allingham's *The Music Master, A Love Song and Two Series of Day and Night Songs* (London 1855); the book was reprinted as *Day and Night Songs* (1860).

3 See Layard 1894.

4 The *Hypnerotomachia* was first published by Aldus Manutius in Venice in 1499 and reprinted by his heirs in 1545. Inferior French editions appeared in 1546, 1554 and 1600. Rossetti's sale catalogue in 1882 lists only an imperfect copy of the second Aldine edition, Rossetti having presented his complete copy to Robert Browning in 1855 (see Kelly and Colley 1984, Section A: The Library, no.689, p.61).

5 See Dunlap 1976.

6 The manuscript of Morris's *A Book of Verse*, dated 26 August 1870, is in the National Art Library, V&A (L.131-1953); the manuscript of *The Rubaiyat of Omar Khayyam*, dated 10 October 1872 is in the British Library (Add. Ms. 37832).

7 The manuscript (now in the collection of Lord Lloyd-Webber) was begun in 1874. Morris wrote out most of the text (177 pages) and drew the floriated initials; the illustrations were painted by Charles Fairfax Murray following designs by Burne-Jones. Unfinished at the time of Morris's death the volumes passed into the possession of Fairfax Murray, who had the text and illuminations completed by Graily Hewitt and Louise Powell.

8 See Barber 1970.

OBJECT LIST

NOTE: This list documents the exhibition as presented at the Legion of Honor, San Francisco. The objects are arranged alphabetically by artist and/or designer names. Key to the abbreviations of museums is as follows: National Art Library (NAL), Royal Institute of British Architects (RIBA) and Victoria and Albert Museum (V&A). For works on paper, measurements for prints are of image size and dimensions for drawings are of sheet size, unless noted otherwise. Excepting those titles marked with asterisks, all objects on this list were presented in the full exhibition tour; single asterisks denote artworks shown exclusively in the San Francisco presentation of *The Cult of Beauty* and double asterisks indicate those pieces shown in Paris and San Francisco only. The list is correct at the time of going to press.

George Aitchison
Design for decorative scheme of Front Drawing Room, 15 Berkeley Square, London, 1873
Watercolour and oil on paper
19 3/8 x 26 7/8 in. (49.3 x 68.2 cm)
RIBA Library Drawings & Archives Collections: SB 93/3 (5)
Plate 90

Design for decoration of Green Drawing Room, 15 Berkeley Square, London, 1874
Watercolour on paper, heightened with gold
30 3/8 x 23 1/4 x 1 5/8 in. (77 x 59 x 4 cm) (framed)
RIBA Library Drawings & Archives Collections: SC 124/2 (2)

*Design for ceiling of Green Dining Room, 15 Berkeley Square, London, c.1874
Watercolour on paper
23 5/8 x 30 3/8 in. (60 x 77 cm)
RIBA Library Drawings & Archives Collections: SC 124/2 (1)

Design for decoration of Dressing Room, 15 Berkeley Square, London, c.1874
Watercolour on paper
23 5/8 x 30 3/8 x 1 5/8 in. (60 x 77 x 4 cm) (framed)
RIBA Library Drawings & Archives Collections: SC 124/2 (3)

Anna Alma-Tadema
The Drawing Room, Townshend House, 10th September 1885, 1885
Watercolour over pencil and pen and ink on card
10 3/4 x 7 3/8 in. (27.2 x 18.7 cm)
Royal Academy of Arts, London: 08/3530
Plate 74

Lawrence Alma-Tadema
Portrait of Miss Alice Lewis, 1884
Oil on canvas
33 x 21 1/2 in. (84 x 54.6 cm)
Zanesville Art Center, Ohio: 11535

Armchair, 1884–6
Mahogany with cedar and ebony veneer; carving and inlay of several woods, ivory and abalone shell
35 1/2 x 27 x 26 3/8 in. (90.2 x 68.5 x 67 cm)
Made by Johnstone, Norman & Co., London
V&A: W.25:1–1980

Couch, 1893
Mahogany and other woods, carved, turned and inlaid, with mother-of-pearl inlay; brass mounts and leather straps; and modern silk upholstery
14 x 64 x 28 in. (35.5 x 162.5 x 71.1 cm)
Possibly made by Johnstone, Norman & Co., London
V&A: W.3–1971

James Craig Annan
Mrs. D.Y. Cameron, c.1897
Photogravure
8 1/2 x 4 7/8 in. (21.6 x 12.3 cm)
Private collection

Thomas Armstrong
The Hay Field, 1869
Oil on canvas
44 3/4 x 61 7/8 in. (113.7 x 157.2 cm)
Bequeathed by Mrs. Ellen Coltart
V&A: P.9–1917
Plate 43

Edward, John and William Barnard
*Tea service (teapot, sugar bowl and creamer), 1876–7
Parcel-gilt silver; on teapot: raised silver with applied cast spout and handle, protective ivory strips on handle, cast finial attached to hinged lid
Teapot: 5 1/2 x 6 1/8 x 3 5/8 in. (14 x 15.5 x 9.2 cm); sugar bowl: 3 3/8 x 4 3/4 x 3 1/4 in. (8.6 x 12 x 8.3 cm); creamer: 3 7/8 x 2 5/8 x 2 1/8 in. (9.8 x 6.8 x 5.3 cm)
Made by Edward, John and William Barnard, London
V&A: M.26–1981, M.26A–1981, M.26B–1981

Harry Barnard
Vase, 1882
Salt-glazed stoneware with incised,
applied and painted decoration
Height: 10 1/4 in. (26 cm)
Made by Doulton & Co., Lambeth Art Pottery,
London
V&A: C.54–1972
Plate 129

Aubrey Beardsley
Siegfried, 1892–3
Pen, ink and wash on paper
16 1/4 x 11 7/8 in. (41.4 x 30.1 cm)
V&A: E.578–1932
Plate 205

*Cover of *Le Morte Darthur* by Sir Thomas
Malory, 1893–4
Book with one etching, 19 reproductions of
drawings and reproductive ornamental borders
and chapter ornaments (second edition)
10 1/4 x 8 1/4 x 2 3/8 in. (26.2 x 21 x 6.2 cm)
First published 1893–4, reprinted by E.P.
Dutton, New York, 1909
Achenbach Foundation for Graphic Arts
Fine Arts Museums of San Francisco:
1963.30.38650.1–497

The Climax, 1894
Line block and halftone print on Japanese vellum
13 1/2 x 10 5/8 in. (34.3 x 27.1 cm)
From the second issue of *A Portfolio of Aubrey
Beardsley's Drawings Illustrating Oscar Wilde's
Salome*
Published by John Lane, London, 1907
Gift of Michael Harari in memory of his father,
Ralph A. Harari
V&A: E.436–1972

Cover of *The Yellow Book* vol. 1 (April 1894)
Illustrated magazine
8 1/4 x 6 3/4 in. (21 x 17 cm)
Published by Elkin Mathews & John Lane,
London
V&A: NAL: SO.95.0011

The Toilet of Salome, 1894
Design in pen and ink
9 x 6 3/8 in. (22.7 x 16.2 cm)
From a series of drawings illustrating Oscar
Wilde's *Salome*
Presented by the National Art Collections Fund
in memory of Robert Ross
The British Museum: PD 1919-4-12-1
(See plate 208 for print after the drawing)

The Abbé, 1896
Pen, ink and wash on paper
12 1/2 x 10 1/8 in. (31.9 x 25.8 cm)
Illustration to 'Under the Hill' by Aubrey
Beardsley, published in *The Savoy*, no. 1,
January 1896
Purchased with the assistance of The Art Fund
V&A: E.305–1972

D'Albert in Search of His Ideals, 1897
Photogravure plate
9 1/16 x 7 1/2 in. (23 x 19.1 cm)
From six drawings illustrating Théophile
Gautier's *Mademoiselle de Maupin*
Gift of Michael Harari in memory of his father,
Ralph A. Harari
V&A: E.418–1972

*Cover of *Salome* by Oscar Wilde, 1920
Book with reproductions of 16 drawings
10 1/4 x 7 15/16 x 3/4 in. (26 x 20.1 x 1.9 cm)
Published by John Lane, The Bodley Head,
London and New York, 1920
Achenbach Foundation for Graphic Arts
Fine Arts Museums of San Francisco:
1963.30.36851

Max Beerbohm
Caricature of Aubrey Beardsley, c.1894
Pen, ink and wash
12 1/2 x 10 1/8 in. (31.9 x 25.8 cm)
Reproduced in the *Pall Mall Budget*, June 7, 1894
Gift of Mrs. G.R. Halkett
V&A: E.1379–1931
Plate 209

Edward Burne-Jones
Ladies and Animals sideboard, 1860
Pine, painted with oil, with gold and silver leaf
46 x 60 x 29 in. (116.8 x 152.4 x 73.7 cm)
Gift of Mrs. J.W. Mackail, daughter of the artist
V&A: W.10–1953

Merchant's Daughter, c.1860
Stained and painted glass panel
13 1/4 x 7 1/4 in. (33.6 x 18.5 cm)
Made by Morris, Marshall, Faulkner & Co.
Bequeathed by J.R. Holliday
V&A: C.323A–1927

**Le Chant d'Amour*, 1865
Transparent and opaque watercolour on paper
21 5/8 x 30 9/16 in. (54.9 x 77.7 cm)
Bequest of Martin Brimmer, 1906
Museum of Fine Arts, Boston: 06.243

*Saint George, 1873–7
Oil on canvas
61 3/4 x 22 1/4 in. (155 x 57 cm)
The Ella Gallup Sumner and Mary Catlin Sumner
Collection Fund
Wadsworth Atheneum, Hartford, CT: 1961.448

Laus Veneris, 1873–8
Oil with gold paint on canvas
60 5/8 x 85 in. (154 x 216 cm)
Laing Art Gallery, Tyne & Wear Archives &
Museums, Newcastle upon Tyne: TWCMS: B8145
Plate 33

Design for slippers, 1877
Watercolour
19 1/8 x 12 1/8 in. (48.5 x 30.9 cm)
Private collection
Plate 179

Orpheus and the Muses dish, c.1880
Earthenware with lustre decoration
Diameter: 11 13/16 in. (30 cm)
Decorated by William De Morgan at the
De Morgan Pottery, Chelsea, London
Bequeathed by Miss K. Lewis
V&A: Circ.363–1961

**The Tree of Forgiveness–A Mosaic in Rome*
(design for *The Tree of Life* mosaic in the American
Church, Rome), 1891
Black, blue, grey and white chalk with metallic
paint on green wove paper
Left panel: 15 7/8 x 8 in. (41.5 x 20.3 cm);
middle panel: 17 7/8 x 12 1/4 in.
(45.3 x 31.1 cm); right panel: 16 1/2 x 8 1/8 in.
(42 x 20.6 cm)
Memorial gift from Dr. T. Edward and Tullah
Hanley, Bradford, Pennsylvania
Fine Arts Museums of San Francisco:
69.30.18a–c

Fantasy, 1897
Black chalk, body colour and gold on prepared
purple ground
21 1/8 x 16 1/8 in. (53.7 x 41 cm)
Cecil French Bequest
London Borough of Hammersmith and Fulham
Plate 202

*Saint Peter, c.1894–5
Stained glass panel
39 1/2 x 14 1/2 in. (100.3 x 36.8 cm)
Made by Morris & Co., London
Collection of Shelley Perelmuter

**Edward Burne-Jones and
John Henry Dearle**
Flora tapestry, 1883–5 (designed); 1920
(woven)
Wool, silk, and cotton; tapestry weave
69 5/16 x 40 3/16 in. (176 x 102 cm)
Made by Morris & Co.
Museum purchase, Dorothy Spreckels Munn
Bequest Fund
Fine Arts Museums of San Francisco:
2001.120.1

Pomona tapestry, 1883–5 (designed); 1920
(woven)
Wool, silk, and cotton; tapestry weave
70 7/8 x 39 3/8 in. (180 x 100 cm)
Made by Morris & Co.
Museum purchase, Dorothy Spreckels Munn
Bequest Fund
Fine Arts Museums of San Francisco:
2001.120.2

Edward Burne-Jones and William Morris
*The Story of Sigurd the Volsung and the Fall
of the Niblungs*, 1898
Book with two woodcut illustrations designed
by Edward Burne-Jones and woodcut initials
and borders designed by William Morris
13 1/16 x 9 7/16 in. (33.2 x 24 cm)
Printed by William Harcourt Hooper in Chaucer
and Troy type, designed by William Morris
Published by Kelmscott Press, Hammersmith
Gift of the Reva and David Logan Foundation
Fine Arts Museums of San Francisco:
1998.40.109.1

Julia Margaret Cameron
After the Manner of the Elgin Marbles, 1867
Albumen print from wet collodion-on-glass
negative
22 7/8 x 18 1/4 in. (58.2 x 46.5 cm)
The Nevison Bequest
V&A: E.2745–1990

Call, I Follow, I Follow, Let Me Die!, portrait of
Mary Hillier, 1867
Carbon print from copy negative
13 3/4 x 10 1/2 in. (35 x 26.7 cm)
Gift of Mrs. Perrin
V&A: 15–1939

Zöe, 1870
Albumen silver photograph
13 1/4 x 10 3/8 in. (33.7 x 26.4 cm)
Wilson Centre for Photography, London:
84:1003
Plate 54

Chipperfield and Butler, Brighton
Teagown, *c.*1880s
Printed satin and lace
Museum of London: 55.85

Thomas Edward Collcutt
*Cabinet, 1871
Mahogany, ebonized and painted, with metal
fittings
89 5/8 x 57 1/2 x 23 1/4 in. (227.7 x
146 x 59 cm)
Made by Collinson & Lock, London
V&A: Misc.127–1921

Alfred Concanen
Quite Too Utterly Utter paper sheet-music cover,
*c.*1881
Colour lithograph
14 1/8 x 10 1/4 in. (36 x 26 cm)
Printed by Stannard & Sons, published by
Hopwood & Crew, London
V&A: S.34–1993
Plate 174

Walter Crane
At Home – A Portrait, 1872
Tempera on paper
28 x 16 in. (71 x 40.7 cm)
Leeds Museums and Galleries: LEEAG.
PA.1932.0009.0003

Design for *Swan, Rush and Iris* dado paper, 1875
Body colour on paper
20 7/8 x 20 7/8 in. (53.1 x 53 cm)
Gift of Mrs. Margaret Warner
V&A: E.17–1945

Alcestis wallpaper frieze, 1876
Colour woodblock print on paper
27 1/2 x 19 7/8 in. (70 x 50.5 cm)
Produced by Jeffrey & Co., London
Given by Mr. Emslie John Horniman
V&A: E.4034–1915

**Walter Crane and friends
(39 artists, musicians, writers)**
Fan, 1895
Ink, watercolour and gouache on sandalwood
fan elements
11 1/4 x 20 5/8 in. (28.5 x 52.5 cm)
Steve Banks Fine Arts, Inc.

Lewis F. Day
Mantel clock, *c.*1878
Ebonized wood, blue-and-white china panels
22 1/4 x 16 7/8 x 10 1/4 in.
(56.6 x 43 x 26 cm)
Baltimore Museum of Art: BMA.2009.134

Wall clock, 1879
Mahogany, ebonized and painted *en grisaille*
23 5/8 x 15 x 5 7/8 in. (60 x 38 x 15 cm)
V&A: W.27–2008
Plate 121

Narcissi fabric, *c.*1888
Block-printed velveteen
42 7/8 x 63 3/4 in. (109 x 162 cm)
Made by Wardle & Co.
V&A: T.75–1967
Plate 117

Lewis F. Day and Martin Brothers
Clock, 1880
Ceramic case, enamel dial
7 1/2 x 6 1/4 x 3 3/4 in. (19 x 16 x 9.5 cm)
Made by the Martin Brothers, London and
Southall (Middlesex); dial-plate designed by
Lewis F. Day
The Birkenhead Collection

William De Morgan
Charger, *c.*1888
Earthenware, lead glaze
Diameter: 16 3/8 in. (41.5 cm)
Gift of Mr. Archibald Anderson
V&A: C.261–1915

Vase, *c.*1890
Earthenware with lustre glaze
11 7/8 x 7 3/4 in. (30.1 x 19.6 cm)
Made at the De Morgan Pottery, Sands End,
Fulham, London
Bequeathed by Mrs. William De Morgan
V&A: C.414–1919

F. De Valeriola
Bat fan, *c*.1880
Gauze
14 3/4 x 24 3/8 x 2 3/8 in. (37.5 x 62 x 6 cm)
Museum of London: NN8138

Christopher Dresser
Chair, 1870
Cast iron with original colour patination and
gilding; oak seat
52 3/4 x 18 3/4 x 17 1/2 in. (134 x 47.5 x
44.4 cm)
Made by Coalbrookdale, Shropshire; central
panel probably drawn by J. Moyr Smith
V&A: W.11–2010

Jardinière, *c*.1870
Porcelain
Height: 11 1/8 in. (28.4 cm); diameter:
3 7/8 in. (9.8 cm)
Made by Minton & Co., Stoke-on-Trent
Baltimore Museum of Art: BMA 2006.101

Teapot, 1878
Silver, ivory and enamel set with turquoises;
rush-covered handle; lid made of a Japanese
ivory medallion embellished with lacquer and
enamel
4 1/8 x 9 x 5 3/8 in. (10.5 x 23 x 13.6 cm)
Made by Hukin and Heath, Birmingham
Purchased with the generous support of the
National Heritage Memorial Fund, the Art
Fund, the American Friends of the V&A
and an anonymous donor, the Friends of the
V&A, the J. Paul Getty, Jr., Charitable Trust
and a private consortium led by John S.M. Scott
V&A: M.5:1–2006
Plate 135

Claret jug, 1879
Silver and glass
9 1/2 x 6 1/2 x 4 1/2 in. (24 x 16.5 x
11.4 cm)
Made by Hukin & Heath, Birmingham
Gift of Mr. and Mrs. Robert A. Magowan
Fine Arts Museums of San Francisco: 73.14

Teapot, *c*.1879
Electroplated nickel silver with ebony handle
9 7/8 x 6 3/4 x 1 7/8 in. (25 x 17 x 5 cm)
Made by James Dixon & Sons, Sheffield
Purchased with the generous support of the
National Heritage Memorial Fund, the Art
Fund, the American Friends of the V&A and
an anonymous donor, the Friends of the V&A,
the J. Paul Getty, Jr., Charitable Trust and a
private consortium led by John S.M. Scott
V&A: M.4–2006
Plate 134

*Tea service (teapot, sugar bowl, and milk jug),
1880
Silver plate with ebony handles
Teapot: 5 1/4 x 8 x 4 in. (13.3 x 20.3 x 10.2 cm);
sugar bowl: 3 3/8 x 3 3/8 x 3 3/8 in.
(8.6 x 8.6 x 8.6 cm); milk jug: 3 x 2 3/8 x
4 3/8 in. (7.6 x 6 x 11.1 cm)
Made by James Dixon and Sons, Sheffield
Museum purchase, European Art Trust Fund
Fine Arts Museums of San Francisco:
2005.62.3

Chair, *c*.1880
Ebonized mahogany with gold panels, incised
and gilt decoration, modern upholstery
33 1/2 x 24 x 23 5/8 in. (85 x 61 x 60 cm)
Made for the Art Furnishers' Alliance, London
The Birkenhead Collection
Plate 125

Moon Flasks (pair), *c*.1880
Glazed earthenware with gilding
Each 12 1/2 x 10 1/4 x 5 1/8 in. (32 x 26 x 13
cm)
Made by Minton & Co., Stoke-on-Trent
The Birkenhead Collection

Table with inset *Flying Crane* tiles, *c*.1880
Bamboo and glazed earthenware
Tiles: 7 7/8 x 7 7/8 in (20 x 20 cm); table:
29 1/2 x 13 3/4 x 13 3/4 in. (75 x 35 x 35 cm)
Tiles made by Minton & Co., Stoke-on-Trent
The Birkenhead Collection

George Du Maurier
Pet and Hobby, c.1876
Pen drawing
10 x 9 3/8 in. (25.5 x 23.8 cm)
Bequeathed by H.H. Harrod
V&A: E.399–1948

*Frustrated Social Ambition; Collapse of
Postlethwaithe, Maudle and Mrs. Cimabue Brown,*
1881
Pen and brown ink drawing
Published in *Punch*, May 21, 1881
10 x 14 in. (25.4 x 35.7 cm)
Purchased with support from the American
Friends of the V&A thanks to the generosity
of Mr. and Mrs. M.D. Moross
V&A: E.146–2009
Plate 187

Henry Treffry Dunn
*Dante Gabriel Rossetti and Theodore Watts-Dunton
in the Sitting Room at Tudor House, Cheyne Walk,*
1882
Gouache on paper
21 1/4 x 32 1/4 in. (54 x 81.9 cm)
National Portrait Gallery, London: NPG 3022
Plate 71

Rossetti's Bedroom at Tudor House, Cheyne Walk,
c.1874–5
Watercolour on paper
Diameter: 13 in. (33 cm)
Wightwick Manor (The National Trust):
WIG/D/112
Plate 72

Charles L. Eastlake
*Hints on Household Taste in Furniture, Upholstery
and Other Details,* 1872
Book
8 x 5 1/2 in. (20.2 x 14 cm)
Published by Longmans, Green & Co., London
Private collection
Plate 100

Robert Edis
*Decoration and Furniture of Town Houses: A Series
of Cantor Lectures Delivered before the Society of
Arts, 1880,* 1881
Book
8 1/8 x 5 3/4 in. (20.5 x 14.5 cm)
Published by C.K. Paul & Co., London
Private collection
Plate 101

Elkington & Co.
Tea service (teapot, milk jug, and sugar basin),
1878
Electroplated nickel silver, partially gilded and
engraved; ivory insulators
Teapot: 4 1/8 x 5 7/8 x 3 1/8 in. (10.5 x 15
x 7.8 cm); milk jug: 2 5/8 x 3 3/8 x 1 7/8 in.
(6.6 x 8.6 x 4.8 cm); sugar basin: 2 3/4 x
4 3/8 x 2 1/2 in. (7.1 x 11 x 6.5 cm)
Made by Elkington & Co., Birmingham
V&A: M.48–2009, M.49–2009, M.50–2009
Plate 138

Frederick Evans
Aubrey Beardsley, c.1893
Albumen print
5 7/8 x 4 1/4 in. (14.9 x 10.8 cm)
National Media Museum, Bradford

The Sea of Steps, 1903
Photogravure
8 5/8 x 7 1/2 in. (22 x 19.1 cm)
Given by Mark Haworth-Booth
V&A: E.92–1994

Alfred Gilbert
Perseus Arming, 1882
Bronze
Height: 29 in. (73.7 cm)
Leeds Museums and Galleries (Lotherton Hall):
LEEAG.SC.1925.0334.0001

**Comedy and Tragedy: 'Sic Vita,'* 1902/1905
Bronze
Height: 26 1/2 in. (67.3 cm); base: 6 5/8 x
3 1/2 in. (16.8 x 8.9 cm)
Acquired with support from the Parnassus
Foundation/Jane and Raphael Bernstein
Sterling and Francine Clark Art Institute,
Williamstown, Massachusetts: 2004.14

Eros, 1893
Modern aluminium cast
94 1/2 x 66 7/8 x 59 in. (240 x 170 x 150 cm)
Fine Art Society, London

Carlo Giuliano
Brooch and pair of hair ornaments, 1875–95
Carved coral and enamelled gold
Brooch and hair ornaments diameters:
1 3/4 in. (4.6 cm); depth: 3/4 in. (1.8 cm)
Given by the American Friends of the V&A
through the generosity of Judith H. Siegel
V&A: M.13.1–2011, M.13.2–2011, M.13.3–
2011. Plate 184

Edward William Godwin
Sideboard, 1865–75
Ebonized mahogany with silver plated handles
and inset panels of embossed leather paper
71 1/4 x 100 3/4 x 22 in. (181 x 256 x 56 cm)
Probably made by William Watt & Co., London
V&A: Circ.38–1953
Plate 124

Side table, 1867–8
Turned and joined mahogany
27 1/2 x 15 3/4 x 15 3/4 in. (70 x 40 x 40 cm)
Probably made by William Watt & Co., London
V&A: W.71–1981

Design for wall decoration, Dromore Castle,
County Limerick, Ireland, c.1869
Pencil and watercolour on paper
5 5/16 x 7 1/2 in. (13.5 x 19.2 cm)
Gift of Mr. Edward Godwin, son of the artist
V&A: E.491–1963
Plate 165

Fabric swatch book, c.1870–75
Woven silk, wool and cotton furnishing fabrics
8 3/16 x 5 5/8 in. (20.8 x 14.4 cm)
Made by J.W. & C. Ward, Halifax, Yorkshire
V&A: T.97–1953
Plate 77

Design for *Bamboo* wallpaper, 1872
Watercolour on tracing paper
21 1/4 x 22 1/2 in. (53.9 x 57.3 cm)
Printed by Jeffrey & Co., London
Gift of Mr. Edward Godwin, son of the artist
V&A: E.515–1963
Plate 112

Anglo-Japanese furniture design, c.1875
Pen, ink and watercolour on paper
7 7/8 x 11 3/4 in. (20 x 29.8 cm)
V&A: E.482–1963
Plate 76

Design for The White House, 35 Tite Street,
Chelsea, London, 1877
Pen and ink, ink wash, pencil and watercolour
15 1/4 x 21 7/8 in. (38.6 x 55.5 cm)
Gift of Mr. Edward Godwin, son of the artist
V&A: E.540–1963

The Seasons Cabinet, c.1877
Mahogany carcase with satinwood veneer, brass
mounts and epoxy resin handles (replacement
of originals in ivory); upper doors decorated
with four painted and gilt panels
70 3/4 x 16 1/4 x 50 1/2 in. (179.7 x 41.3 x
128.3 cm)
Made by William Watt & Co., London
V&A: W.15:1–1972

Vases with sgraffito decoration (pair), c.1877
Slipware, sgraffito decoration
7 7/8 x 7 1/2 in. (20 x 19 cm), 8 1/8 x
7 1/2 in. (20.7 x 19 cm)
Probably made by William Watt & Co., London
Purchased with the assistance of The Art Fund
V&A: C.1–2008, C.2–2008
Plate 127

Design for front elevation, 44 Tite Street,
Chelsea, London, 1878
Pen, ink, pencil and watercolour
15 3/8 x 11 1/2 in. (39 x 29.2 cm)
Gift of Mr. Edward Godwin, son of the artist
V&A: E.556–1963

Design for The White House, 35 Tite Street,
Chelsea, London, 1878
Pen and ink, ink wash, pencil and watercolour
15 1/4 x 21 7/8 in. (38.6 x 55.5 cm)
Gift of Mr. Edward Godwin, son of the artist
V&A: E.544–1963
Plate 67

Figure in an Anglo-Japanese Room, probably late
1860s
Watercolour and pencil
7 1/2 x 6 5/8 in. (19.1 x 16.8 cm)
V&A: E.286:29–1963
Plate 26

**Edward William Godwin and
James McNeill Whistler**
*Harmony in Yellow and Gold: The Butterfly
Cabinet*, 1877–8
Mahogany painted with oil, with yellow tiling,
brass mouldings and glass
119 5/16 x 74 3/4 x 18 3/4 in. (303 x 190 x
47.6 cm)
Made by William Watt, London
Hunterian Art Gallery, University of Glasgow:
GLAHA 46396

**James Hadley (modelling) and
R.W. Binns (design)**
Teapot, mark for 1882
Glazed parian
6 x 7 x 3 1/8 in. (15.2 x 17.8 x 7.9 cm)
Made by the Worcester Royal Porcelain Works,
Worcester
Museum purchase, European Art Trust Fund
Fine Arts Museums of San Francisco:
2004.113a–b
Plate 131

George C. Haité
Bat fabric, *c.*1880
Figured satin
24 7/8 x 21 1/2 in. (63.3 x 54.5 cm)
Made by Daniel Walters & Sons
V&A: T.168–1972
Plate 118

Frederick Hollyer
*Flower Study, Lilies, c.*1890
Platinum print
41 x 20 1/4 in. (104 x 51.5 cm)
Gift of Hans P. Kraus, Jr.
V&A: E.411–1998

Woman in a Doorway, portrait of Miss Laura
Tennant, *c.*1885–90
Platinum print
6 1/8 x 3 7/8 in. (15.5 x 9.7 cm)
V&A: 7808–1938

William Holman Hunt
**Il Dolce Far Niente*, 1866
Oil on canvas
39 3/4 x 32 in. (101 x 81.2 cm)
Private collection

Thomas Jeckyll
*Four Seasons Gates, c.*1867
Wrought iron
104 3/4 x 148 in. (266 x 376 cm)
Made by Barnard, Bishop & Barnard, Norwich
MAK–Austrian Museum of Applied Arts /
Contemporary Art, Vienna: EI 697/28.208

Design for a billiard room, 1 Holland Park,
London, *c.*1870
Pencil and watercolour on paper
9 11/16 x 12 5/8 in. (24.6 x 32.1cm)
V&A: E.1797–1979

Overmantel, *c.*1872–5
Ebonized and green-stained wood inset with
six Japanese painted lacquer panels, bevelled
rectangular mirror, convex mirror, six Chinese
blue-and-white porcelain plates and two marble
roundels with low-relief portrait busts sculpted
by Sir Joseph Edgar Boehm
55 1/8 x 73 x 11 3/4 in. (140 x 185.5 x
29.9 cm)
Made for Heath Old Hall, Heath, Yorkshire
Leeds Museums and Galleries (Lotherton Hall):
LEEAG.FU.1999.0047
Plate 122

Fireplace surround, 1873
Cast brass
37 x 36 1/4 in. (94 x 92 cm)
Made by Barnard, Bishop & Barnard, Norwich
V&A: M.49–1972
Plate 137

Commode, *c.*1875
Walnut with ebony mouldings, leather top and
brass handle
30 x 70 x 14 in. (76.2 x 177.8 x 35.6 cm)
Possibly made by William Holland & Sons,
London
Made for 1 Holland Park, London
Gift of Thomas Stainton
V&A: W.14–1972

Wall sconce, *c.*1875
Brass
19 11/16 x 14 5/8 x 3 15/16 in. (50 x 37 x
10 cm)
Probably made by Robbins & Co., Dudley
The Birkenhead Collection

*Sunflower Andirons, c.*1876
Cast and chased brass
32 5/8 x 11 3/8 x 21 1/4 in. (83 x 29 x 54 cm)
Made by Barnard, Bishop & Barnard, Norwich
The Birkenhead Collection
Plate 136

Chair, 1878
Cast iron with painted finish; mahogany seat
32 1/4 x 14 x 13 3/4 in. (82 x 35.5 x 35 cm)
Made by Barnard, Bishop & Barnard, Norwich
The Birkenhead Collection
Plate 27

Fire surround, probably mid-1870s
Cast iron and glazed earthenware tiles
Fire surround: 36 x 37 x 2 3/8 in (91.5 x 94 x
6 cm); framed tiles: 9 1/4 x 27 3/8 x 1 5/8 in.
(23.5 x 69.5 x 4 cm)
Surround made by Barnard, Bishop & Barnard,
Norwich; tiles possibly made by Minton & Co.,
Stoke-on-Trent
The Birkenhead Collection

Jeffrey & Co.
Wall covering, *c.*1850–1900
Embossed paper with red and gold pigment
22 1/4 x 22 7/8 in. (56.5 x 58 cm)
Gift of Mrs. Margaret Warner
V&A: E.9–1945

Frederic Leighton
Pavonia, 1858–9
Oil on canvas
20 7/8 x 16 3/8 in. (53 x 41.5 cm)
Private collection
Plate 1

Mother and Child (Cherries), 1864–5
Oil on canvas
19 x 32 1/4 in. (48.2 x 82 cm)
Blackburn Museum and Art Gallery:
BLKMG.127

*The Syracusan Bride Leading Wild Beasts in
Procession to the Temple of Diana*, 1865–6
Oil on canvas
52 1/2 x 167 in. (133.5 x 424.3 cm)
Private collection
Plate 50

*The Countess Brownlow, c.*1879
Oil on canvas
91 7/8 x 52 in. (233.5 x 132 cm)
Belton House, The Brownlow Collection
(The National Trust): BEL.P.143

***The Sluggard*, 1882–5
Bronze
75 1/4 x 35 1/2 x 23 1/2 in. (191.1 x 90.2 x
59.7 cm)
Presented by Sir Henry Tate, 1894
Tate Britain, London: N01752

The Sluggard, 1885 (cast made *c.*1896)
Bronze
22 x 9 5/8 x 7 5/8 in. (56 x 24.5 x 19.5 cm)
Made in house at the Royal Academy of Arts
Royal Academy, London: 03/2203

The Bath of Psyche, c.1889–90
Oil on canvas
74 1/2 x 24 1/2 in. (189.2 x 62.2 cm)
Tate Britain, London: N01574
Plate 11

Study of the draperies for the figure of
Persephone, c.1891
Black and white chalks on paper
21 7/8 x 14 1/2 in. (55.6 x 36.8 cm)
Gift of Mrs. C.Q. Henriques through the Art Fund
V&A: E.438–1950

Liberty & Co. Ltd

Liberty's Art Furniture catalogue, 1884
8 1/2 x 10 5/8 in. (21.5 x 27 cm)
Published by Liberty & Co., London
V&A: Liberty Catalogues (4) 1884

Dress, c.1885
Striped washing silk lined with cotton
Fabric by Liberty & Co., London
Gift of Mrs. W.O. Manning
V&A: T.171–1973
Plate 173

Dress, c.1894
Silk velvet, trimmed with bands of satin-stitch
embroidery in silk, embroidered with beads,
neckline inserted with Liberty 'Hop and
Ribbon' damask, lined with silk and fastened in
front with hooks and eyes
Made by Liberty's Artistic and Historic
Costume Studio, London
V&A: T.56–1976

Albert Ludovici, Jr.

Four greeting cards, 1882
Colour lithographs on paper
Each 4 7/8 x 3 3/8 in. (12.5 x 8.5 cm)
Printed and published by Hildesheimer &
Faulkner, London
Bequeathed by Guy Tristram Little
V&A: E.2413–1953, E.2414–1953, E.2415–
1953, E.2416–1953
Plates 168–171

A.H. Mackmurdo

Title page of *Wren's City Churches*, 1882
Vellum bound book with engravings
11 3/8 x 8 7/8 in. (29 x 22.5 cm)
Engravings by G. Allen, Orpington, Kent.
Published by Hazell, Watson & Viney Ltd.,
London, 1883
V&A: NAL: 34.F.78

Henry Stacey Marks

Pilgrim Flasks (pair), 1877
Earthenware with painted decoration
Each 14 x 11 x 2 3/8 in. (35.7 x 27.8 x
6.1 cm)
Given by Lady Constance Stern
V&A: C.54–1915, C.55–1915

John Everett Millais

Esther, 1865
Oil on canvas
41 1/2 x 29 1/2 in. (105.5 x 75 cm)
Private collection

Louise Jopling, 1879
Oil on canvas
49 1/4 x 30 in. (125.1 x 76.2 cm)
Purchased with help from The Art Fund and
the Heritage Lottery Fund, 2002 National
Portrait Gallery, London: NPG 6612

Kate Perugini, 1880
Oil on canvas
61 x 43 in. (154.9 x 109.2 cm)
Collection of Katherine Woodward Mellon

Albert Moore

A Musician, c.1867
Oil on canvas
10 1/4 x 12 1/8 in. (26 x 30.7 cm)
Paul Mellon Fund
Yale Center for British Art, New Haven:
B1980.7
Plate 46

Azaleas, c.1867–8
Oil on canvas
78 x 39 1/2 in. (198.1 x 100.3 cm)
Lane Bequest, 1915
Hugh Lane Municipal Gallery of Modern Art,
Dublin: reg. no. 5
Plate 159

A Garden, 1869
Oil on canvas
68 3/4 x 34 5/8 in. (174.5 x 88 cm)
Tate Britain, London: T03064

A Venus, 1869
Oil on canvas
73 x 38 in. (185.4 x 96.4 cm)
York Museums Trust (York Art Gallery):
YORAG: 698

Five cartoons for Peacock Frieze for Front
Drawing Room, 15 Berkeley Square, London,
c.1872–3
Charcoal and white chalk on brown paper
22 x 63 in. (56 x 160 cm), 22 x 50 3/4 in.
(56 x 129 cm), 22 x 75 5/8 in. (56 x 192 cm),
22 x 53 15/16 in. (56 x 137 cm), 22 x 63 in.
(56 x 160 cm) (framed)
V&A: D.266–1905, D.255–1905, D.260–
1905, D.267–1905, D.263–1905
Plate 89

Midsummer, 1887
Oil on canvas
77 1/4 x 74 5/8 in. (196.1 x 189.6 cm)
Russell-Cotes Art Gallery & Museum,
Bournemouth: BORGM 01536
Plate 212

William Morris

Design for *Fruit* (or *Pomegranate*) wallpaper,
c.1862
Pencil, pen, ink, watercolour and body colour
on paper
24 3/8 x 25 5/8 in. (62 x 65 cm)
Made for Morris, Marshall, Faulkner & Co.,
London
Purchased with the assistance of the Art Fund
V&A: E.299–2009
Plate 107

Fruit (or *Pomegranate*) wallpaper, 1866
Block-printed paper in distemper colours
27 x 19 11/16 in. (68.6 x 50 cm)
Printed by Jeffrey & Co. for Morris, Marshall,
Faulkner & Co., London
Gift of Morris & Co.
V&A: E.449–1919
(See plate 106 for another example)

Tile panel, 1876
Slip-covered, hand-painted and glazed
earthenware blanks
63 x 36 in. (160 x 91.5 cm)
Decorated by William De Morgan
Made for Membland Hall, Devon
Gift of Mr. and Mrs. Charles Handley-Read
V&A: C.36–1972

Bird fabric, 1878
Wool, double-cloth
82 1/2 x 51 in. (209.6 x 129.5 cm)
Museum purchase, Art Trust Fund
Fine Arts Museums of San Francisco: 1996.47

Morris & Co.
Wallpaper stand-book, 1880–1917
Wooden easel stand, wallpaper samples,
leatherette cover
35 x 20 7/8 x 3 1/2 in. (89 x 53 x 9 cm)
Display book made for Morris & Co., from
their showroom at 449 Oxford Street, London
Given by Shand Kydd Ltd
V&A: E.2734 to 2866–1980

Albert George Morrow
The New Woman, theatre poster, 1894
Colour lithograph
28 1/2 x 22 5/8 in. (72.5 x 57.5 cm)
V&A: E.2682–1962
Plate 158

William Eden Nesfield
Screen, 1867
Ebonized wood with gilt and fretted decoration
and painted panels of Japanese silk paper
81 7/8 x 99 1/4 x 3/4 in. (208 x 252 x 2 cm)
Made by James Forsyth, London
V&A: W.37–1972
Plate 123

John R. Parsons
Jane Morris, 1865
Albumen print from wet collodion-on-glass
negative
7 3/4 x 5 1/8 in. (19.6 x 13 cm)
V&A: 1737–1939
Plate 2

Henry Wyndham Phillips
Portrait of Owen Jones, 1856–7
Oil on canvas
59 5/8 x 43 1/2 in. (151.5 x 110.5 cm)
Presented by Thomas Henry Wyatt, PRIBA,
1871
RIBA Library Drawings & Archives Collections,
London: POR/JONE/3

Edward Poynter
Georgiana Burne-Jones, 1870
Watercolour and pencil
14 x 10 in. (35.5 x 25.4 cm)
Private collection

Necklace, c.1881
Gilded silver and bowenite
Length: 16 1/2 in. (42 cm); diameter: 5/8 in.
(1.5 cm)
Made by Carlo Giuliano, London
Given by the American Friends of the V&A
through the generosity of Judith H. Siegel
V&A: M.9–2011

Mary Constance Wyndham (Lady Elcho), 1886
Watercolour on paper
29 7/8 x 23 1/4 in. (76 x 59 cm)
Private collection

Charles Ricketts
Cover design for *The Sphinx* by Oscar Wilde,
1894
Book bound in vellum-covered boards with
stamped gilt design
10 x 7 1/2 in. (25.5 x 19 cm)
Published by Elkin Matthews and John Lane,
Bodley Head, London
V&A: NAL: Drawer 67
Plate 234

Dante Gabriel Rossetti
Bocca Baciata, 1859
Oil on panel
12 5/8 x 10 5/8 in. (32.2 x 27.1 cm)
Gift of James Lawrence, 1980
Museum of Fine Arts, Boston: 1980.261
Plate 42

The Day Dream, 1880
Oil on canvas
62 1/2 x 36 1/2 in. (158.7 x 92.7 cm)
Bequeathed by Constantine Alexander Ionides
V&A: CAI.3
Plate 30

Frederick Sandys
Gentle Spring, c.1865
Oil on canvas
47 5/8 x 25 1/4 in. (121 x 64 cm)
Presented by Captain R. Langton Douglas in
memory of his son, Lt. Archibald Douglas,
killed in action 1916, 1923
Ashmolean Museum, Oxford: WA1923.2

Danaë in the Brazen Chamber, c.1866–7
Wood engraving
6 7/8 x 4 1/2 in. (17.6 x 11.5 cm)
Proof of the illustration engraved by J. Swain
and published in *The Century Guild Hobby
Horse* vol. 3 (1888)
V&A: E.274–1895

Proud Maisie, 1868
Pencil and crayon on paper
21 5/8 x 16 7/8 in. (55 x 43 cm)
Given by Mr. H.C. Coaks
V&A: P.7–1933

Sir William Anderson Rose, 1875
Coloured chalks on buff paper laid down
on board
30 1/8 x 24 in. (76.6 x 61 cm)
Ackland Fund
Ackland Art Museum, University of North
Carolina at Chapel Hill: 83.24.1

Arthur Severn
Whitelands Cross, 1893
Coloured gold
2 1/2 x 3 1/8 x 3/8 in. (6.5 x 8 x 0.8 cm)
Private collection, on loan to the V&A

Arthur Silver
Peacock, 1887
Roller-printed cotton
28 x 31 1/8 in. (71.1 x 79 cm)
Printed by Rossendale Printing Co., Lancashire,
for Liberty & Co. Ltd, London
Given by Rex Silver, son of the designer
V&A: T.50–1953
Plate 115

Simeon Solomon
Sleepers and the One That Watcheth, 1870–71
Watercolour on paper
13 5/8 x 17 5/8 in. (34.7 x 44.7 cm)
Leamington Spa Art Gallery & Museum:
LEAMG: A444.1954 (64/24017)

John Roddam Spencer Stanhope
**Love and the Maiden*, 1877
Tempera, gold paint and gold leaf on canvas
54 x 79 in. (137.2 x 200.7 cm)
Museum purchase, European Art Trust Fund,
Grover A. Magnin Bequest Fund and Dorothy
Spreckels Munn Bequest Fund
Fine Arts Museums of San Francisco: 2002.176

E.H. Stockwell
*Jug, 1882–3
Glass with silver mounts, handle shaped as
section of bamboo
9 7/8 x 5 3/8 in. (25 x 13.5 cm)
V&A: Circ.354–1961

Bruce James Talbert
Design for *The Sunflower* wallpaper, 1878
Watercolour and body colour on paper
15 1/4 x 21 in. (38.7 x 53.4 cm)
Made by Jeffrey & Co., London
Gift of Mrs. Margaret Warner
V&A: E.37–1945

Possibly Bruce James Talbert
Wallpaper specimen panel showing
combination of frieze, filling and dado,
c.1877–80
Woodblock print in distemper colours on paper
70 7/8 x 29 5/8 in. (180 x 52.4 cm)
Made by Jeffrey & Co., London
V&A: E.653–1953

Wallpaper specimen panel showing
combination of frieze, filling and dado,
c.1877–80
Woodblock print in distemper colours on paper
70 7/8 x 29 5/8 in. (180 x 52.4 cm)
Made by Jeffrey & Co., London
V&A: E.663–1953
Plate 111

James Jacques Joseph Tissot
Young Women Looking at Japanese Articles, 1869
Oil on canvas
29 3/4 x 21 7/8 in. (75.6 x 55.6 cm)
Gift of Henry M. Goodyear MD
Cincinnati Art Museum: 1984.217
Plate 75

Frederick Gustavus Burnaby, 1870
Oil on panel
19 1/2 x 23 1/2 in. (49.5 x 59.7 cm)
National Portrait Gallery, London: NPG 2642

Frederic Leighton: A Sacrifice to the Graces, 1872
Watercolour and body colour on paper
11 7/8 x 7 3/8 in. (30.3 x 18.8 cm)
Published in *Vanity Fair*, 29 June, 1872
Museum of London: A7376

The Fan, c.1875
Oil on canvas
15 1/4 x 20 1/2 in. (38.7 x 52.1 cm)
The Ella Gallup Sumner and Mary Catlin
Sumner Collection
Wadsworth Atheneum, Hartford, CT: 1982.158

Spring (Specimen of a Portrait), 1878
Oil on canvas
55 3/4 x 21 in. (141.6 x 53.3 cm)
Collection of Diane B. Wilsey
Page 5

Frederick Walker
The Woman in White, 1871
Gouache on paper
85 1/2 x 50 3/4 in. (217.2 x 128.9 cm)
Tate Britain, London: N02080

John William Waterhouse
**Saint Cecilia*, 1895
Oil on canvas
48 1/2 x 79 in. (123.2 x 200.7 cm)
Private collection

William Watt and Edward William Godwin
Designs from the book *Art Furniture, from
Designs by E.W. Godwin, F.S.A. and Others,
with Hints and Suggestions on Domestic Furniture
and Decorations*, 1877
Book
Each 8 x 12 1/4 in. (20.4 x 31 cm)
Published by B.T. Batsford, London
V&A Archive of Art and Design:
AAD/1994/16/3082, ADD/1988/4/508–534

George Frederic Watts
A Study with Peacock's Feathers, c.1862–5
Oil on canvas
26 x 22 in. (66 x 56 cm)
Pre-Raphaelite Inc. by courtesy of Julian
Hartnoll

Clytie, c.1867–78
Marble
28 x 23 5/8 x 17 in. (71.1 x 60.96 x 43.18 cm)
Guildhall Art Gallery, Corporation of London:
995

Blanche, Lady Lindsay, Playing the Violin, 1876–7
Oil on canvas
56 1/4 x 46 1/2 in. (143 x 118 cm)
Private collection
Plate 146

Love and Death, 1877–87
Oil on canvas
98 x 46 in. (248.9 x 116.8 cm)
The Whitworth Art Gallery, University of
Manchester: O.1887.1
Plate 149

Philip Webb
Candlesticks (pair), c.1860
Cast copper
Each 10 x 6 3/4 in. (25.5 x 17 cm)
Made by Morris, Marshall, Faulkner & Co.,
London
V&A: M.1130–1926, M.1130A–1926
Plate 133

Armchair, 1861–2
Ebonized wood with gilded bands
39 x 16 1/8 x 16 7/8 in. (99 x 41 x 43 cm)
Made by Morris, Marshall, Faulkner & Co.,
London
Society of Antiquaries of London
(Kelmscott Manor)

Design for wall decoration and cornice of Green
Dining Room in South Kensington Museum,
London, 1866
Pencil, watercolour, body colour and gold
pigment on paper
18 3/4 x 11 3/4 in. (47.6 x 29.7 cm)
Gift of Mr. H.B. Johnson
V&A: E.5096–1960

Philip Webb and William Morris
Chair, 1870–90 (designed c.1860)
Ebonized beech with rush seat
33 1/2 x 20 1/2 x 17 3/8 in. (85 x 52 x 44 cm)
Made by Morris & Co., London
V&A: Circ.288–1960

James McNeill Whistler
Venus, 1859
Etching, second of two states
5 7/8 x 8 7/8 in. (15 x 22.7 cm)
Achenbach Foundation for Graphic Arts
Fine Arts Museums of San Francisco:
1963.30.459

Symphony in White No. 1: The White Girl, 1862
Oil on canvas
96 1/8 x 53 3/4 in. (244.2 x 136.5 cm)
Harris Whittemore Collection
National Gallery of Art, Washington: 1943.6.2
Plate 14

Sketch for *Rose and Silver: Le Princesse du Pays de
la Porcelaine*, 1863–4
Oil on fibreboard
31 7/8 x 20 7/8 in. (81 x 53 cm)
Worcester Art Museum, Massachusetts:
1940.56
Plate 81

Symphony in White No. 2: The Little White Girl,
1864
Oil on canvas
30 1/8 x 20 1/8 in. (76.5 x 51.1 cm)
Tate Britain, London: N03418
Plate 59

**Sketch for *The Balcony*, *c.*1867–70
Oil on panel
24 x 19 in. (61 x 48.2 cm)
Hunterian Art Gallery: GLAHA 46359

The Lily, *c.*1870–72
Chalk and pastel on brown paper
10 3/16 x 7 in. (25.8 x 17.8 cm)
Bequest of Whitney Warren, Jr., in memory
of Mrs. Adolph B. Spreckels
Fine Arts Museums of San Francisco:
1988.10.31

*Arrangement in Grey and Black, No. 2:
Thomas Carlyle*, 1872–3
Oil on canvas
83 7/8 x 72 5/8 in. (213 x 184.5 cm)
Lent by Culture and Sport Glasgow on behalf
of Glasgow City Council
Kelvingrove Art Gallery and Museum, Glasgow

**Harmony in Grey and Green: Miss Cicely
Alexander*, 1872–4
Oil on canvas
74 7/8 x 38 1/2 (190.2 x 97.8 cm)
Bequeathed by W.C. Alexander, 1932
Tate Britain, London: N04622

Nocturne: Blue and Gold – Old Battersea Bridge,
1872–5
Oil on canvas
26 7/8 in x 20 1/8 in. (68.3 x 51.2 cm)
Tate Britain, London: N01959

Four designs for wall decoration at Aubrey
House, London, 1873–4
Charcoal and gouache on brown paper
7 1/8 x 5 in. (18.2 x 12.6 cm), 6 x 4 in. (15.1
x 10.2 cm), 7 1/4 x 5 1/8 in. (18.3 x 12.9 cm),
5 7/8 x 9 5/8 in. (14.9 x 24.5 cm)
Birnie Philip Bequest
The Hunterian Museum and Art Gallery,
University of Glasgow: GLAHA 46050, 46051,
46052, 46053
Plate 164

Nocturne, from the portfolio *Notes*, 1878
Lithotint printed on blue paper, first of two
states
6 3/4 x 10 3/16 in. (17.1 x 25.9 cm)
Published by Boussod, Valadon & Co., London
Achenbach Foundation for Graphic Arts
Fine Arts Museums of San Francisco:
1963.30.524

**The Gold Scab: Eruption in Frilthy Lucre
(The Creditor)*, 1879
Oil on canvas
73 1/2 x 55 in. (186.7 x 139.7 cm)
Gift of Mrs. Alma de Bretteville Spreckels
through the Patrons of Art and Music
Fine Arts Museums of San Francisco: 1977.11

David Wilkie Wynfield
Portrait of Frederic Leighton, PRA, *c.*1862;
printed later
Carbon print on later mount with textured
paper surface layer
7 1/2 x 6 1/8 in. (19 x 15.7 cm)
Gift of William Frederick Yeames
Royal Academy of Arts, London: 03/6188
Plate 51

Joseph S. Wyon and Alfred B. Wyon,
after a design by Lawrence Alma-Tadema
Armlet, *c.*1870
Gold set with diamonds, turquoise, ruby,
sapphires and emeralds
3 1/2 x 3 1/2 x 4 7/8 in. (9 x 9 x 12.5 cm)
Made by Jeffrey A. Cadby Limited; owned by
Laura Alma-Tadema
Collection of Jeffrey A. Cadby Limited
Plate 182

Unknown Artists
*Vase, *c.*1875
Porcelain
Height: 9 3/4 in. (25 cm)
Made by Brownfield & Sons, Stoke-on-Trent
Birkenhead Collection

Smoking cap, *c.*1875–6
Black velvet lined with quilted black ribbed
silk, top and sides embroidered with tassel of
gold thread
Stephen Calloway Collection

Butterfly brooch, *c.*1880
Gold and glass
2 1/8 x 1 3/8 x 1/2 in. (5.5 x 3.5 x 1.2 cm)
Hunterian Art Gallery, University of Glasgow:
GLAHA 54111

Tea table and tea service (six cups and saucers,
teapot, jug and sugar basin), *c.*1880
Ebonized beech with ceramic top and tea
service with prunus and cracked-ice pattern
Table: 27 1/2 x 23 5/8 x 23 5/8 in. (70 x 60 x
60 cm)
Collection of Paul Reeves

Men's aesthetic suit, *c.*1880–85
Hand-sewn and machine stitched cotton velvet
with silk-braid edges; lining of woven wool, silk
and glazed linen
Private collection, on loan to the V&A
Plate 177

Smoking jacket, *c.*1880–89
Silk taffeta, cotton embroidery floss, silk
soutache
FIDM Museum Purchase
FIDM Museum at the Fashion Institute of
Design and Merchandising, Los Angeles:
2008.5.34

Cloak, *c.*1895
Silk with embroidered velvet yoke and collar
Museum of London: 31.144

PICTURE CREDITS

AUTHOR BIOGRAPHIES

Dr Lynn Federle Orr (lead curator for the Fine Arts Museums of San Francisco) is Curator in Charge of European Art at the Legion of Honor, showcasing the European collections of the Fine Arts Museums of San Francisco. A specialist in seventeenth-century art and culture, she has organised and collaborated on many exhibitions and publications, including *Masters of Light: Dutch Artists in Utrecht during the Golden Age*; *Michael Sweerts 1618–1664*; *John Martin: Visions of the Biblical Flood*; *Monet in Normandy*; and *Birth of Impressionism: Masterpieces from the Musée d'Orsay*. She recently served on the National Endowment for the Arts Domestic Indemnification panel.

Stephen Calloway FSA (lead curator for the Victoria and Albert Museum, London) is Curator of Prints in the Word and Image Department at the V&A. He specializes in the nineteenth- and early twentieth-century periods, including the history of decoration, collecting and taste, and the art of the book. He has curated many V&A exhibitions and displays, including the Aubrey Beardsley centenary exhibition, *Corners of Paradise: William Blake, Samuel Palmer and the Ancients* and *Rex Whistler: The Triumph of Fancy* at Brighton. His books include *Twentieth-Century Decoration*, *The Elements of Style*, *Baroque*, *Baroque: The Culture of Excess* and *Aubrey Beardsley*.

Dr Sonia Ashmore investigated the formation of the V&A's collection of South Asian Textiles as part of the Fashioning Diaspora Space project funded by the Arts and Humanities Research Council, and contributed to *British Asian Style* (V&A 2010) among other publications. She is now preparing a book on the Museum's collection of muslin textiles and dress, and continuing work on Liberty & Co. and Asia.

Prof. Christopher Breward is Head of Research at the V&A. He is currently co-curating the V&A's 2012 Exhibition *British Design 1948–2012* and has written widely on British fashion culture in the nineteenth and twentieth centuries. His most recent (co-edited) publication is *British Asian Style: Fashion and Textiles, Past and Present* (V&A 2010).

Barbara Bryant is an independent art historian and consultant curator. She is the author of *G.F. Watts in Kensington: Little Holland House and Gallery* (2009), *G.F. Watts: Portraits – Fame and Beauty in Victorian Society* (2004) and the biography of Watts for the *Oxford Dictionary of National Biography*. Most recently, she published on Frederic Leighton's art collection for the reopening of Leighton House Museum (2010).

Frances Collard is Curator of British Furniture 1800–1900 in the Department of Furniture, Textiles and Fashion at the V&A. Her recent publications include 'Historic Revivals, Commercial Enterprise and Public Confusion: Negotiating Taste 1860–1890', *Journal of Design History*, 16, no. 1 (2003), pp.35–48.

Dr Colin Cruise is Research Lecturer at the School of Art, Aberystwyth University. He is currently researching the variety of narrative strategies in nineteenth-century subject painting. His most recent publication is *Pre-Raphaelite Drawing* (2011).

David Park Curry is Senior Curator of Decorative Arts, American Painting and Sculpture at the Baltimore Museum of Art and is currently charged with reinstalling Baltimore's American Wing. His most recent monograph, *James McNeill Whistler: Uneasy Pieces,* was published in 2004. That year his *Childe Hassam: An Island Garden Revisited* (1989) was reprinted.

Edwina Ehrman is a Curator of Textiles and Fashion at the V&A. She is a specialist in nineteenth-century textiles and fashion, with a particular interest in London. She is the curator of the forthcoming V&A exhibition, *The Wedding Dress: 300 Years of Bridal Fashions* and author of the associated book (forthcoming, 2011). Other publications include *The London Look: fashion from street to catwalk* (2004), of which she was a co-author, and chapters in *The Englishness of English Dress* (2002), *William Powell Frith: Painting the Victorian Age* (2006) and *Atkinson Grimshaw: Painter of Moonlight* (forthcoming, 2011).

Dr Suzanne Fagence Cooper is an Honorary Research Fellow at the V&A. She works on women and music in the Victorian art world, and her latest book is *The Model Wife: Effie Gray, Ruskin and Millais* (2010).

Dr Christine Guth teaches Asian design and material culture in the Royal College of Art/V&A postgraduate design history programme. Her recent publications include *Longfellow's Tattoos: Tourism, Collecting and Japan* (2004) and 'Hasegawa's Fairy Tales: Toying with Japan', *Res: Anthropology and Aesthetics* 53/54 (2008).

Catherine Haill is a Curator of Popular Entertainment, Theatre and Performance Department at the V&A. Her most recent publication is 'Accidents of survival. Finding a place in the V&A's theatre and performance archives', in *Scrapbooks, Snapshots and Memorabilia: Hidden Archives of Performance* (2010).

Dr Hope Kingsley is Curator for Collections and Education at the Wilson Centre for Photography, London. She writes on the aesthetics and technology of nineteenth-century art photography and recently contributed to *The Photographs of Frederick H. Evans* for the J. Paul Getty Museum.

Prof. Stefan Muthesius taught at the University of East Anglia, Norwich, and published widely on the history of architecture and design of the last two hundred years in Britain, Central and East Central Europe. His latest book is *The Poetic Home: Designing the Nineteenth Century Domestic Interior* (2008).

Prof. Leonee Ormond is Professor Emerita of Victorian Studies at King's College London. She has published a number of books, articles and editions on Victorian and early twentieth-century subjects. Her biography of George Du Maurier appeared in 1969 and her most recent book, *Linley Sambourne: Illustrator and Punch Cartoonist,* in 2010.

Dr Susan Owens is Curator of Paintings at the V&A. She is currently preparing a book on British drawings. She previously worked as Assistant Curator of the Print Room at Windsor Castle, and her publications include *Watercolours and Drawings from the Collection of Queen Elizabeth The Queen Mother* (2005). Her Ph.D. thesis (2002) was on Aubrey Beardsley's illustrations to Oscar Wilde's play *Salomé*.

Clare Phillips is a Curator in the Department of Sculpture, Metalwork, Ceramics and Glass at the V&A, with particular interest in jewellery from the late nineteenth century to the present. Her publications include *Jewels and Jewellery* (2000, revised 2008) and *Bejewelled by Tiffany* (editor, 2006); and she has contributed to the V&A's major exhibitions and books *Art Nouveau 1890–1914* (2000), *Art Deco 1910–1939* (2003) and *International Arts and Crafts* (2005).

Prof. Elizabeth Prettejohn is Professor of History of Art at the University of Bristol. Her books include *Art for Art's Sake: Aestheticism in Victorian Painting* (2007).

Lynn Roberts is a freelance art historian working mainly on the history of picture frames. She is co-author with Paul Mitchell of *Frameworks* and *A History of European Picture Frames* (both 1996), and author of 'Frames for pictures by Ford Madox Brown', in *Ford Madox Brown: A Catalogue Raisonné* (2010).

Gill Saunders is Senior Curator (Prints) in the Word and Image Department at the V&A, where she has special responsibility for wallpapers and twentieth-century and contemporary fine art prints. She is the author of *Wallpaper in Interior Decoration* (2002) and co-author/editor of *Walls Are Talking* (2010), the catalogue to a major exhibition of wallpapers by artists.

Sonia Solicari is Principal Curator at the Guildhall Art Gallery, London. Formerly Curator of the Ceramics and Glass Collection, V&A, her publications include 'Selling Sentiment: The Commodification of Emotion in Victorian Culture', *19: Interdisciplinary Studies in the Long Nineteenth Century*, 4 (2007).

Prof. Penny Sparke is Pro Vice-Chancellor, Research, and Professor of Design History at Kingston University, London. Her most recent book is *The Modern Interior* (2008).

Prof. Margaret D. Stetz is the Mae and Robert Carter Professor of Women's Studies and Professor of Humanities at the University of Delaware. She is author of *Facing the Late Victorians* (2007) and other books on late-Victorian print culture, literature, art and gender. She has curated numerous exhibitions on these topics, most recently at the Henry B. Plant Museum in Tampa, Florida, and at the Grolier Club in New York City.

Eric Turner has been a curator in the Metalwork Section of the V&A since 1976. His particular areas of expertise are associated with the collections of post-1880 metalwork and Sheffield plate. He has contributed to many publications, several conferences, and exhibitions on these subjects both in Britain and abroad, including a joint article with Simon Metcalf, 'The Conservation of a *c.*1867 Cast Iron Hat Stand, a Dresser design and original Coalbrookdale paint scheme revealed', *Decorative Arts Society 1850 to the Present* 26 (2002). He has been a Freeman of the Goldsmiths' Company since 2002.

Robert Upstone, formerly a curator at Tate Britain, is Head of Modern British Art at the Fine Art Society. He curated the *Sickert in Venice* exhibition at Dulwich Picture Gallery in 2009.

Dr Esmé Whittaker is an Assistant Curator in the Word and Image Department at the V&A, seconded to work on *The Cult of Beauty* exhibition. She recently completed a Ph.D. at the Courtauld Institute of Art, with a thesis on Arts and Crafts architecture, and is author of *V&A Pattern: Walter Crane* (2011).

ACKNOWLEDGEMENTS

Our first thanks are due to Bank of America Merrill Lynch whose enthusiastic and generous support within their munificent programme of sponsorship of arts projects has made the London showing of this ambitious exhibition possible. We also thank Liberty for additional sponsorship and their highly appropriate involvement with a show devoted to the movement in which the firm played a conspicuous part from 1875.

We are grateful to the Department for Culture, Media and Sport, and the Museums, Libraries and Archives Council for the generous provision of insurance through the Government Indemnity Scheme which has allowed us to borrow from over 70 private and institutional lenders in Britain, Europe and America.

The generosity of lenders has enabled us to bring together an unrivalled array of both the fine and decorative arts of the period and we are most grateful to the owners of pictures and other objects, many of whom have agreed part with their treasures for an unusually lengthy loan period. Our thanks go to the many private collectors and to the trustees, directors and curators and other members of staff at the museums and art galleries named in the list of exhibits, but we are equally indebted to those who have made their generous loans anonymously.

The creation of an exhibition such as *The Cult of Beauty* and its accompanying publication is a lengthy and complex enterprise in which the organisers rely upon the participation of a very wide variety of people. We are especially grateful to our distinguished contributors of chapters and shorter pieces to this volume; they brought both varied expertise and heartening enthusiasm to the project, enlivening the themes and topics covered in this book and enriching the selection of pictures and works of art chosen for display. We are also greatly indebted to a rather larger group of specialists who offered their valuable thoughts at initial round-table discussions which helped us to shape both book and exhibition. More generally, many individual debts of gratitude have been incurred, and whilst the following list will perhaps inevitably miss naming some of the great many scholars, collectors, dealers and friends who, either recently or in the past, have given their time and shared their knowledge, we would wish to express our gratitude to them all. In particular we thank:

James Adeane, Martin Beisly, Peter Brown, Julius Bryant, Barrie Bullen, John Christian, Michael Diamond, Max Donnelly, Harriet Drummond, Simon Edsor, Emma Ferry, Siegfried von Frieblisch, Juliet Hacking, Mr and Mrs Robert Henrey, Margaretta Frederick, Robert Freidus, Peter Funnell, Charlotte Gere, Michael Gregory, Christopher Gridley, Robert Harding, Colin Harrison, Simon Houfe, Lynn Hulse, Ian Jenkins, James Joll, Juliet Kinchin, Dawn Krause, Harry Lyons, Mark Samuels Lasner, Todd Longstaffe-Gowan, Jonathan Marsden, Rupert Maas, Margaret Macdonald, Jan Marsh, Angela Nevill, Christopher Newall, Richard Ormond, Linda Parry, Andrew McIntosh Patrick, Paul Reeves, Daniel Robins, Peter Rose, John S. M. Scott, Michael Seeney, Alison Smith, Julian Treuherz, Lord Vinson of Roddam Dene, Ray Walker, Giles Waterfield, Michael Whiteway and Timothy Wilson.

In addition it is a pleasure, albeit one inevitably tinged with sadness, to recall the great contribution to the study of the Aesthetic Movement made by a small group of V&A curators, independent writers, collectors and dealers – all now deceased – who laid the foundations upon which we build and who offered, over many years, both friendship and unstinting encouragement: the late Elizabeth Aslin, Shirley Bury, William Gaunt, Albert Gallichan, Lionel Lambourne, Jeremy Maas, Derek Mynott, Barbara Morris and Christopher Wood.

A great many people have made essential contributions to realising the exhibition at the V&A: Esmé Whittaker, Assistant Curator for the exhibition has matched flair in research and the preparation of texts for both exhibition and book with admirably calm organisational skills. A number of V&A colleagues have been especially generous with their time and expertise, thereby enriching the project. Particular thanks go to: Christopher Breward, Head of Research; Frances Collard, Edwina Ehrman, Susan Owens and Eric Turner. As a volunteer, Kate Marris made a valuable contribution to the early stages of research and the preparation of tombstone label texts for the exhibition.

The Cult of Beauty has come to fruition only with the help and support of a very wide range of colleagues throughout the museum; we are grateful to them all. Ruth Cribb, Exhibition Co-ordinator, carried out the complex task of organising the installation of a very large number of exhibits from many lenders. In the Exhibitions Section we also thank: Linda Lloyd Jones, Head of Exhibitions; Rebecca Lim, Head of South Kensington Exhibitions; Alex Westbrook, PA to the Head of Exhibitions & Loans/Office Administrator; Melanie Lenz and Annabel Wilton, Exhibitions Assistants, Stefanie Etow, intern; and project managers Sor-Lan Tan and Keith Flemming of Flemming Associates. In addition our thanks go to: V&A Interpretation Editor: Lucy Trench; Collections: Ruth Hibbard, Anna Wu; V&A Collections Services (Conservation): Nigel Bamforth and Mike Wheeler, Conservation Co-ordinators, and Zoe Allen, Nicola Costaros, Anne Greig, Frances Hartog and Jane Rutherston; (Technical Services): Jackie Britton, Head of Technical Services and her excellent team: Matthew Clarke, Richard Ashbridge, Jenean Plumb-Wood and James Goddard; (Photography): James Stevenson, Richard Davis; Development: Jo Ani, Laura Sears; Learning & Interpretation: Jo Banham; Press and Marketing: Damien Whitmore, Eleanor Appleby, Olivia Colling, Zoe Franklin and Elinor Hughes.

At the V&A the imaginative design of the exhibition was created by Opera. Working with the Opera team from Amsterdam: Frans Bevers, Lies Willers, Roel van Eijk, Lyske Gais de Bildt, Renata Alvares and Boaz Bar-adon proved a happy and stimulating collaboration.

For the book we warmly thank our colleagues in V&A Publishing: Mark Eastment, Frances Ambler, Clare Davis and also our editor Johanna Stephenson and designer Ray Watkins of Price Watkins.

We wish to acknowledge the contribution of our colleagues at the Fine Arts Museums of San Francisco and extend our gratitude to John Buchanan, Director of Museums; Krista Brugnara, Director of Exhibitions; Therese Chen Huggins, Director of Registration; Directors of Publications Karen Levine and Ann Heath Karlstrom. Particular appreciation is due to Melissa E. Buron, Curatorial Assistant of European Art, and McCrindle Foundation interns Alexandra Provo, Hayley Stevens, and Tess White. A special note of gratitude is extended to Marion C. Stewart, retired Associate Curator of European Paintings, who helped shape this project at its earliest stages with her knowledge and visual perception.

At the Musée d'Orsay in Paris we would also like to thank: Guy Cogeval, Director and President; Hélène Flon, Yves Badetz, Doris Grunchec and Laurence Madeline.

Our final debt of gratitude is to Mark Jones for his unfailing support throughout the project.

INDEX